PRINCIPLES

OF

HARMONY AND CONTRAST

OF

COLOURS,

AND THEIR APPLICATIONS TO THE ARTS:

INCLUDING

PAINTING, INTERIOR DECORATION, TAPESTRIES,
CARPETS, MOSAICS, COLOURED GLAZING, PAPER-STAINING,
CALICO-PRINTING, LETTERPRESS-PRINTING, MAP-COLOURING, DRESS,
LANDSCAPE AND FLOWER GARDENING, ETC.

BY

M. E. CHEVREUL,
MEMBRE DE L'INSTITUT DE FRANCE, ETC.

TRANSLATED FROM THE FRENCH
BY
CHARLES MARTEL.

SECOND EDITION.

LONDON:
LONGMAN, BROWN, GREEN, AND LONGMANS.
1855.

TO

J. BERZELIUS,

IN TESTIMONY OF FRIENDSHIP AND OF PROFOUND ESTEEM

FOR THE MAN!

IN TESTIMONY OF ADMIRATION FOR HIS WORKS!

THE AUTHOR OF THE BOOK,

M. E. CHEVREUL.

PREFACE

TO

THE SECOND EDITION.

THE rapid sale of the first edition of this translation satisfactorily proves how much such a work was needed. It may, indeed, be regarded as a national reproach that this subject of " the Harmony and Contrast of Colours " should have remained so long in a state of chaos, while a work of the scientific character and practical value like the present was extant. Long subsequent to its publication in France, after ample time had elapsed for M. Chevreul's discovery to have become known in this country, works of no practical value whatever, some indeed pernicious from their errors and obscurity, have issued from the English press, and usurped the place in our literature which this work only ought to occupy. These authors have discoursed glibly upon the "Laws of Harmonious Colouring" without even recognising the existence of the phenomena upon which these "laws" are really based — without making a single rational observation or experiment on the optical effects resulting from the juxtaposition of coloured bodies — without regarding the physiological condition of the eye while this organ is excited by the sight of colours, — in fact, without at all understanding the nature of the subject

they, with so much complacency, suppose themselves to have fully elucidated.

Others have added new testimony to the truth of the maxim "that a little knowledge is a dangerous thing;" for after superficially examining M. Chevreul's "law," they have rushed to impossible conclusions, which, not being verified, induced them to treat this "law" slightingly, as a thing of nought. By others, again, the "law" has been adopted without comprehension, and from the foolish attempt to ally it with the dogmatism of unscientific writers [1] has resulted their own and their readers' confusion.

To be thoroughly understood, this book must not merely be *read* but *studied*. The superficial reader will be constantly exposed to arriving at false conclusions, from too hasty generalisation, by which he will miss the author's aim — that of placing the subject of "contrast" upon a truly scientific basis. His reasoning and conclusions may be disputed by the empiric, but cannot be controverted, for they are based upon careful observation of natural phenomena and experiment, which every reader can easily repeat and verify for himself.

The chief error fallen into in the applications of the law of contrast is, the overlooking the influence of *contrast of tone*, or intensity; it is so important that this kind of contrast be fully recognised and appreciated, that the reader should keep his attention constantly directed to it. The nature of luminous and sombre colours should also be well understood, particularly with reference to their degree of intensity or tone.

This book will amply repay any amount of study bestowed upon it; and not merely for the subject with which

[1] The translator might instance Field, Hay, *ad hoc genus omne*.

it is occupied, but as an excellent example of the method of scientific investigation; in this respect this treatise is a model of its kind. The slightest inspection of the numerous books professing to treat of the subject which it elucidates, will serve to convince the reader that their authors are but drifting in an unknown sea, without chart or compass to guide them.

Already, in the few months that have elapsed since the publication of the first edition of this book, we may perceive the fruit of its teachings. As we pass along the busy thoroughfares, the shops of the upholsterer, the paper-hanger, the draper, and the milliner, frequently display a recognition of the law of contrast; not always, it must be admitted, in entire conformity with the principles laid down, but still a recognition, which it is to be hoped may in due time extend to a full understanding.

The translator cannot dismiss this book from his hands, without making a few remarks upon the treatment it has received at the hands of the reviewers,—critics they may not be called. In most cases, in journals of high pretensions, it was flippantly " noticed," as the phrase goes: — a few sentences garbled from the Translator's Introduction, coupled with a few taking extracts, and the reviewer's work was " bravely done." Few seemed to be aware that they had under their hands one of the most original and remarkable works that science has given to literature in the present generation, a work that owes its chief merit to its exhibition of the method of investigation enounced by our illustrious Bacon.[1]

[1] From this sweeping but well deserved censure, we must gratefully acquit certain journals which make reviewing a conscientious task. In the *Times* of September 29. 1854, and in the *Artist* of February 3. 1855, Chevreul's treatise is reviewed with discriminating and comprehensive intelligence.

In one instance [1] the author was made to say exactly the reverse of what the book shows he really does say: this serious and flagrant malversion arose apparently from the reviewer's desire *to improve* his author before he had made himself sufficiently acquainted with him.

By another [2] the translator was supposed to be ignorant of the labours of our countrymen on the subject of " The Laws of Harmonious Colouring; " he was not ignorant, however, that there are many books with pompous titles, professing to explain the principles of harmony and contrast, but which exhibit nothing more clearly than the ignorance and egotism of their authors. They resemble nothing so much as portable backgammon boards, labelled with the titles of works of standard literature. Such books in fact belong to the " dark ages," before Galileo, Newton, Bacon, Cuvier had said " let light be; " and should be placed on our shelves beside Lilly's Astrology and Moore's almanacks. That they should have found recognition at all can only be attributed to the strong desire felt by the public for instruction on the subject of colour. That they failed to satisfy that desire is but too evident upon all occasions where a knowledge of principles was necessary to the successful result of great undertakings: it is only necessary to refer to the discussions raised upon the proper colouring for the Crystal Palace, in 1851.

[1] *Art Journal,* Oct. 1854.
[2] *Blackwood's Magazine,* Nov. 1854.

AUTHOR'S PREFACE.

This work is too remote from the science which has occupied the greatest part of my life, too many subjects differing in appearance are treated of, for me not to indicate to the reader the cause which induced me to undertake it: subsequently I shall speak of the circumstances which made me extend the limits within which it first seemed natural to restrain it.

When I was called upon to superintend the dyeing department of the royal manufactories (Gobelins), I felt that this office imposed on me the obligation of placing the dyeing on a new basis, and consequently it was incumbent on me to enter upon minute researches, the number of which I clearly foresaw, but not the variety: the difficulties of my position were greatly increased by numerous perplexing questions proposed to me for solution by the directors of that establishment; I was therefore obliged to arrange my labours differently than if I had been free from every other occupation.

In endeavouring to discover the cause of the complaints made of the quality of certain pigments prepared in the dyeing laboratory of the Gobelins, I soon satisfied myself that if the complaints of the want of permanence in the light blues, violets, greys, and browns, were well founded, there were others, particularly those of the want of vigour in the blacks employed in making shades in blue and violet

draperies, which had no foundation; for after procuring black-dyed wools from the most celebrated French and other workshops—and perceiving that they had no superiority over those dyed at the Gobelins,—I saw that the want of vigour complained of in the blacks was owing to the colour next to them, and was due to the phenomena of contrast of colours. I then saw that to fulfil the duties of director of the dyeing department, I had two quite distinct subjects to treat—the one being the contrast of colours generally considered, either under the scientific relation, or under that of its applications; the other concerned the chemical part of dyeing. Such, in fact, have been the two centres to which all my researches during ten years have converged. In proportion as they are developed, those who read them will be enabled to see how much time and labour they have cost me, and I may venture to add, difficulty also,—because undertaking them at a period when my work on *Les Corps Gras d'Origine Animale*, and my *Considérations sur l'Analyse Organique*, had opened to me a field which, so to speak, I had only to reap,—in separating myself from this career, under the necessity of opening a new one; and all who have been in this position know that human weakness is felt mostly by him who would reap from the soil he has himself ploughed and sown.

The work I now publish is the result of my researches on *Simultaneous Contrast of Colours*; researches which have been greatly extended since the lecture I gave on this subject at the Institute on the 7th April, 1828. The extension they have taken is a consequence of the method which directed me in my "Researches on Fatty Bodies," the rules of which have been explained in my *Considérations sur l'Analyse Organique*. To all who are acquainted with these works, it will be evident that the present work cannot

be a collection of hypotheses (more or less ingenious), on the assortment of colours and their harmonies, and a perusal of it will doubtless convince them that it is as experimental and as exact as the two preceding works.

In fact, numerous observations on the view of coloured objects made during several months, verified by my pupils and others much accustomed in their professions to judge of colours, and to appreciate the least difference in them, have first been collected and described as proved facts. Then, in reflecting on the relations these facts have together, in seeking the principle of which they are the consequences, I have been led to the discovery of the one which I have named the *law of simultaneous contrast of colours*. Thus this work is really the fruit of the method *à posteriori*: facts are observed, defined, described, then they become generalised in a simple expression which has all the characters of a law of nature. This law, once demonstrated, becomes an *à priori* means of assorting coloured objects so as to obtain the best possible effect from them, according to the taste of the person who combines them; of estimating if the eyes are well organised for seeing and judging of colours, or if painters have exactly copied objects of known colours.

In viewing the law of simultaneous contrast of colours with reference to its application, and in submitting to experiment all the consequences which appeared to me to result from it, I have thus been led to extend it to the arts of tapestry, to the different kinds of painting, block printing, tinting, horticulture, &c.; but in order to prevent the conclusions which some readers might arrive at upon the value of the opinions I have put forth (2nd part, 2nd division), in relation to the Gobelins and Beauvais tapestries, and to Savonnerie carpets, from the examinations which they will

themselves make of these works I now state, that an entire stranger to the inspection and direction of the works executed in the workshops of the royal manufactories, as well as to the selection of patterns, my views and opinions must only be for the readers of whom I speak, as those of a private individual who has had frequent opportunities of seeing and examining works of arts in the production of which he has no influence to exercise; the duties which attach me to the Gobelins being exclusively those of director of the dyeing department. Instead of this brief review of my researches, I had at first proposed to develope in an introduction, conformably to chronological order, the series of leading ideas which have presided over the composition of this book, thinking to show by their mutual connection how I have been obliged to treat of subjects which at first sight seemed foreign to the law of simultaneous contrast of colours; but upon reflecting that a great many things are unknown to the reader, I thought a summary of my researches placed at the end of this work, would possess all the advantages of my first intention without the objections which upon reflection I discovered in it.

I beg the reader never to forget when it is asserted of the phenomena of simultaneous contrast, *that one colour placed beside another receives such a modification from it*, that this manner of speaking does not mean that the two colours, or rather the two material objects that present them to us, have a mutual action, either physical or chemical; it is really only applied *to the modification that takes place before us* when we perceive the simultaneous impression of these two colours.

L'Hay, near Paris,
 19th April, 1835.

POSTSCRIPT.

This work, written three years ago, has formed the subject of eight public lectures delivered at the Gobelins in the course of January, 1836, and January, 1838; I should have earnestly desired to publish it as soon as I had finished writing it; but the condition which I set that the price should not be too dear, notwithstanding the expense occasioned by numerous coloured plates, was an obstacle in finding a publisher, just at the time when M. Pitois-Levrault wished to become such. In stating the cause of the delay of this publication, I should certainly neglect a duty, if I did not publicly thank an illustrious foreigner for the offer he made me of the aid of his sovereign to hasten it; although I have not availed myself of it, I shall nevertheless always retain it in grateful remembrance.

Au Muséum d'Histoire Naturelle,
 1st June, 1838.

CONTENTS.

PART I.

THEORETICAL.

	Page
Introduction	3

SECTION I.

On the law of simultaneous contrast of colours, and its demonstration by experiment	6
CHAPTER I.—Method of observing the phenomena of simultaneous contrast of colours	7
Definition of simultaneous contrast	ib.
Experimental demonstration of contrast of tone	ib.
Experimental demonstration of contrast of colour	9
CHAPTER II.—The law of simultaneous contrast of colours and the formula which represents it	11
CHAPTER III.—The law of simultaneous contrast demonstrated by the juxtaposition of a given number of coloured substances	12
CHAPTER IV.—On the juxtaposition of coloured substances with white	18
CHAPTER V.—On the juxtaposition of coloured substances with black	19
CHAPTER VI.—On the juxtaposition of coloured substances with grey	21
CHAPTER VII.—The chemical composition of coloured bodies has no influence on the phenomena of simultaneous contrast	23
CHAPTER VIII.—On the juxtaposition of coloured bodies belonging to the colours of the same group of coloured rays	ib.
CHAPTER IX.—On the application of the law of contrast to the hypothesis that red, yellow, and blue are the only primary colours, and that orange, green, indigo, and violet are secondary or compound colours	25

SECTION II.

On the distinction between simultaneous, successive, and mixed contrast of colours; and an account of the connection between the experiments made by the author and those of other observers	29

	Page
CHAPTER I.—Distinction between simultaneous, successive, and mixed contrast of colours	30
CHAPTER II.—On the connection between experiments of the author and those previously made by various natural philosophers	34

SECTION III.

On the physiological cause to which the phenomena of contrast of colours were referred previously to the experiments of the author — 39

PART II.

ON THE PRACTICAL APPLICATION OF THE LAW OF SIMULTANEOUS CONTRAST OF COLOURS.

Introduction	47
Prolegomena	50
§ 1.—Definition of the words tones, scales, and hues	ib.
§ 2.—Remarks upon certain graphic constructions proposed for the representation and definition of colours and their modifications	52
§ 3.—Harmony of colours	61
1st Case.—View of a single colour	62
2nd Case.—View of different tones of the same scale of colour	ib.
3rd Case.—View of different colours belonging to scales near to each other, assorted conformably to contrast	ib
4th Case.—View of quite different colours belonging to scales very widely separated, arranged conformably to contrast	63
5th Case.—View of various colours, more or less well assorted, seen through the medium of a feebly coloured glass	ib.
1st Kind.—Harmonies of analogous colours	ib.
2nd Kind.—Harmonies of contrasts	ib.
§ 4.—Assortments of red, orange, yellow, green, blue, and violet, with white, black, and grey	64
Article 1.—Colours with white	65
A. Binary assortments	ib.
B. Ternary assortment of colours complementary to each other with white	ib.
C. Ternary assortment of non-complementary colours with white	66
Article 2.—Colours with black	69
A. Binary assortments	ib.
B. Ternary assortment of complementary colours with black	70
C. Ternary assortment of non-complementary colours with black	71
Article 3.—Colours with grey	74

	Page
A. Binary assortments	ib.
B. Ternary assortments of complementary colours with grey	74
C. Ternary assortments of non-complementary colours with grey	75
Recapitulation of the preceding observations	78

FIRST DIVISION.

Imitation of coloured objects, with coloured materials in a state of infinite division	87
Introduction	ib.

SECTION I.

Painting on the system of chiaro'scuro - - - - 90
CHAPTER I.— On the colours of the model - - - - ib.
 Article 1.— Modifications produced by coloured lights - - 91
 Article 2.— Modifications produced by two lights of different intensity 94
 Article 3.— Modifications produced by diffused daylight, reflected by a surface, all the parts of which are not in the same position relatively to the spectator - - - - - 97
CHAPTER II.— On the difference existing between a coloured object and the imitation of it made by a painter, when the spectator observes it from a different point of view from his - - - - 102

SECTION II.

Painting on the system of flat tints - - - - - 104

SECTION III.

Colouring in painting - - - - - - 107
CHAPTER I. — On the various significations of the word Colouring in painting, and in ordinary language - - - - ib.
 Article 1.— Of colouring, with regard to aerial perspective, relative to white light and to shade - - - - - 108
 Article 2.— Of colouring, with regard to aerial perspective, relative to variously coloured light - - - - - ib.
 Article 3.— Of colouring in respect to the harmony of local colours and to that of the colours of the different objects composing the picture - - - - - - 110
CHAPTER II. — Utility of the law of simultaneous contrast of colours in the science of colouring - - - - 112
 Article 1.— Utility of this law in enabling us to perceive promptly and surely the modifications of light on the model - - ib.
 Article 2.— Utility of this law in order to imitate promptly and surely the modifications of light on the model - - 114

xx CONTENTS.

 Page
Article 3. — Utility of the law in order to harmonise the colours
 which enter into a composition, with reference to those which
 must be reproduced, because they are inherent in the nature of
 the object represented - - - - - 118

SECOND DIVISION.

Imitation of coloured objects by coloured materials (threads, &c.) - 127
Introduction - - - - - - - *ib.*

SECTION I.

Gobelins tapestry - - - - - - - 129
CHAPTER I. — Of the elements of Gobelins tapestry - - 130
CHAPTER II. — On the principle of mixing coloured threads, in its re-
 lations with the art of weaving Gobelins tapestry - 131
CHAPTER III — On the principle of contrast, in connection with the
 production of Gobelins tapestry - - - - 136
CHAPTER IV. — Qualities which patterns for Gobelins tapestry must
 possess - - - - - - - - 140

SECTION II.

Beauvais tapestry for furniture - - - - - 142
CHAPTER I. — Of the elements of Beauvais tapestry for furniture - 143
CHAPTER II. — On the subjects represented on the Beauvais tapestries
 for furniture - - - - - - - *ib.*
CHAPTER III. — Of the patterns of Beauvais tapestry for furniture 144

SECTION III.

Savonnerie carpets - - - - - - - 145
CHAPTER I. — Of the elements of Savonnerie carpets - - 146
CHAPTER II. — On the principle of mixing colours in its connection
 with the manufacture of Savonnerie carpets - - 147
CHAPTER III. — On the principle of contrast of colours in its connec-
 tion with the fabrication of Savonnerie carpets - - 149
CHAPTER IV. — Conditions which must be fulfilled in the patterns of
 Savonnerie carpets - - - - - - 150
 Article 1. — 1st Condition — respective size of the figured objects - *ib.*
 Article 2. — 2nd Condition — distinct view - - - *ib.*
 Article 3. — 3rd Condition — analogy with places or persons - 151
 Article 4. — 4th Condition — distribution of colours - *ib.*
 Article 5. — 5th Condition — harmony of the carpet relatively to the
 objects which must concur with it in the decoration of an apart-
 ment - - - - - - - 152

CONTENTS.

SECTION IV.

	Page
Tapestries for hangings and carpets	154
CHAPTER I.— On tapestries for hangings	155
CHAPTER II.— Carpets	ib.
Article 1.— Carpets on the system of chiaro'scuro	ib.
Article 2.— Carpets on the system of flat tints	157
Article 3.— Carpets on a system intermediate between chiaro'scuro and flat tints	158

SECTION V.

Mosaics - - - - - - - - 159

SECTION VI.

Windows of coloured glass in large Gothic churches - - 161

THIRD DIVISION.

Colour-printing upon textile fabrics and on paper - - 163

SECTION I.

Calico-printing - - - - - - - 166

SECTION II.

Paper-staining	169
CHAPTER I.— General Remarks	170
CHAPTER II.— On the law of simultaneous contrast of colours, in relation to paper-hangings with figures, landscapes, or large flowers of varied colours	171
CHAPTER III.— On the law of simultaneous contrast of colours, in relation to paper-hangings with designs in a single colour, or in colours but slightly varied	172
CHAPTER IV.— Of the law of simultaneous contrast of colours, relatively to the borders of paper-hangings	173

SECTION III.

Printing or writing on papers of various colours	185
CHAPTER I.— Introduction	186
CHAPTER II.— On the assortment of colours with respect to reading by diffused daylight	187
Article 1.— Reading of a few minutes' duration	ib.
Article 2.— Reading of some hours' duration	189

	Page
CHAPTER III.— On the assortment of colours with respect to reading by artificial light	190

FOURTH DIVISION.

Flat tinting - - - - - - - - 191

SECTION I.
On colouring geographical maps - - - - - 192

SECTION II.
On colouring engravings - - - - - - 193

FIFTH DIVISION.

Arrangement of coloured objects of limited extent - - - 197

SECTION I.
Employment of colours in architecture - - - - 198
CHAPTER I.— On the employment of colours in Egyptian architecture 199
CHAPTER II.— On the employment of colours in Greek architecture 200
CHAPTER III.—On the employment of colours in Gothic architecture 202

SECTION II.
Applications to interior decoration - - - - 205
Introduction - - - - - - - 206
CHAPTER I.— On the assortment of stuffs with the wood of chairs - *ib.*
CHAPTER II.— On the selection of frames for pictures and engravings - - - - - - - - 208
CHAPTER III.— On the general decoration of the interiors of churches 212
CHAPTER IV.—On the decoration of museums and galleries - 215
 Article 1.— Pinacotheca, or picture galleries - - - *ib.*
 Article 2.— Glyptotheca, or sculpture galleries - - - 216
 Article 3.— Museums of natural history - - - - *ib.*
CHAPTER V.— The choice of colours for a theatre - - - 218
 Article 1.— Interior of the boxes - - - - *ib.*
 Article 2.— The fronts of the boxes - - - 219
 Article 3.— The ceiling of theatres - - - - *ib.*
 Article 4.— The drop-scene and the curtain - - - *ib.*
CHAPTER VI.— On the decoration of the interiors of houses and palaces, with respect to the assortment of colours - - 220
 § 1.— On the assortment of colours in connection with the decoration of interiors, intended to receive tapestry or paper-hangings - 221

CONTENTS. xxiii

	Page
Article 1.— The wainscoting	221
Article 2.— Hangings	222
Article 3.— Cornice of the ceiling	228
Article 4.— Chairs placed in front of the wainscoting	ib.
Article 5.— Window and bed-curtains	231
Article 6.— Doors	232
Article 7.— Windows	233
Article 8.— Carpets	ib.
Article 9.— Pictures	234

§ 2.— On the assortments of colours in interiors, the walls of which are panelled or covered with marble or stucco, or decorated with painted wood, stone, or stucco - ib.
Article 1.— Panelled interiors - ib.
Article 2.—Interiors covered with marble - 235
Article 3.—Interiors covered with stucco - 236
Article 4.—Interiors covered with wood or any kind of coating, painted in several colours - ib.

SECTION III.

Applications to clothing - 238
Introduction - 239
CHAPTER I.—Men's clothing - ib.
 § 1.—Of the advantages of contrast considered with regard to the optical strengthening or purifying of the colour of cloths for clothing - 240
 Article 1.—Of uniforms, the colours of which are complementary - ib.
 Article 2.—Uniforms of which the colours, without being complementary, are nevertheless very contrasting - 241
 Article 3.— Of a uniform composed of a single colour and white - 242
 Article 4.— Of a bi-coloured uniform, into which white enters - 243
 Article 5.— Of a bi-coloured uniform into which black enters - ib.
 Article 6.— Of a uniform in which there are more than two colours, not comprising either black or white - 244
 Article 7.— Of a uniform composed of different hues of the same colour - ib.
 Article 8.— Of uniforms composed of two tones of the same scale - ib.
 Article 9.— Of a uniform of one colour - 245
 § 2.—On the influence of superficial proportions according to which cloths of different colours are associated in many-coloured uniforms - ib.
 § 3.— Of the advantages of contrast considered with regard to the apparent freshness of cloths for clothing - 246
CHAPTER II.—On female clothing - 247
Introduction - ib.

xxiv CONTENTS.

	Page
§ 1.—On the assortment of colours in the dress of women with white skins	248
Article 1.—Distinction of the two extreme types of women with white skins	ib.
Article 2.—Of the hair and head-dress under the relation of their respective colours	249
Article 3.—Of the complexion and the contiguous drapery under the relation of their respective colours	ib.
Article 4.—Of the head-dress, in relation to the coloured rays which it may reflect upon the skin	251
§ 2.—On the assortment of colours in the dress of women with copper-coloured skins	256
§ 3.—On the assortment of colours in the dress of women with black or olive skins	ib.
1st Supposition.—The painter wishes to heighten the tint of a complexion	257
2nd Supposition.—The painter wishes to dissimulate a tint of the complexion	258

SECTION IV.

Applications to horticulture	260
Introduction	261

SUB-SECTION I.

Application of the law of contrast of colours to horticulture	262
CHAPTER I.—On the art of arranging ornamental plants in gardens, so as to derive the greatest possible advantage from the colours of their flowers	ib.
Introduction	ib.
§ 1.— Associations of flowers which relate to the harmonies of contrast	263
Article 1.—Associations of flowers which relate to the harmonies of contrast of colour	ib.
Article 2.— Associations of flowers which may be classed in relation to the harmonies of contrast of scale	265
Article 3. — Associations of flowers which relate to the harmonies of contrast of hues	266
§ 2.— Associations of flowers which relate to the harmonies of analogy	267
Article 1.— Associations of flowers which relate to the harmonies of scale	ib.
Article 2.— Associations of flowers which relate to the harmonies of analogy of hues	ib.

	Page
Chapter II.—On the art of assorting ligneous plants in gardens so as to derive the best possible advantage from the colour of their foliage	268
Chapter III.—Examples of plants which may be associated together under the relation of the colour of their flowers	270
Chapter IV.—Examples of plants which can be associated together under the relation of the colour of their foliage	289

Sub-section II.

On the distribution and planting of trees, &c. in masses	291
Introduction	ib.
Chapter I.—Of lines of plants	293
Article 1.—Of the lines of plants called Screens	394
Article 2.—Of lines of plants considered as elements of masses	295
Chapter II.—Of homogeneous masses	296
Chapter III.—Of heterogeneous or varied masses	297
§ 1.—Isolated heterogeneous or varied mass	ib.
§ 2.—Heterogeneous or varied masses, subordinated to each other	ib.
Article 1.—General considerations	ib.
Article 2.—Rules to be followed in planting heterogeneous masses subordinated to each other	299
Chapter IV.—On the principles upon which the system of planting described in the two preceding chapters is based	311

PART III.

EXPERIMENTAL ÆSTHETICS OF COLOURED OBJECTS.

Interference of the preceding principles in judging of coloured objects with respect to their colours, considered individually and in the manner under which they are respectively associated	321
Introduction	ib.

SECTION I.

Interference of the law of simultaneous contrast of colours with the judgment we exercise upon all coloured bodies, viewed under the relation of the respective beauty or purity of the colour and of the equality of the distance of their respective tones, if these bodies belong to the same scale	329
Introduction	330
Chapter I.—On the comparison of two patterns of the same colour	ib.
Chapter II.—Influence of a surrounding colour upon one colour when compared with another colour	331

CONTENTS.

	Page
CHAPTER III.— On the effect of contrast upon the browns and the lights of most of the scales of wool and silk employed in tapestry and carpets	332
CHAPTER IV.— Means afforded by contrast by which we may become certain if the tones of a scale of colour are equidistant	333

SECTION II.

Interference of the law of simultaneous contrast of colours with our judgment on the productions of different arts which address the eyes by coloured materials	334
Introduction	335
CHAPTER I.— Of the binary associations of colours considered critically	ib.
CHAPTER II.— Of the complex associations of colours reviewed critically	340
CHAPTER III.— Of the twofold influence presented under the critical point of view, that the physical condition of the coloured materials employed in various arts, and the speciality of these arts, exercise upon the particular products of each of them	341
§ 1.— Of the arts of painting with coloured materials in a state of so-called infinite division, considered relatively to the physical state of these materials, and the speciality of the art employing them	ib.
Article 1.— Painting in chiaro'scuro	342
Article 2.— Painting in flat tints	345
§ 2.— Of the arts which address the eye by employing coloured materials of a certain size, considered relatively to the physical condition of these materials, and to the speciality of the art employing them	346
Article 1.— Tapestries, carpets, mosaics, and coloured glass windows, corresponding to paintings in chiaro'scuro	347
Article 2.— Tapestries, carpets, mosaics, and coloured glass windows, corresponding to painting in flat tints	351

SECTION III.

Of the principles common to different arts which address the eye by various coloured and colourless materials	953
Introduction	354
CHAPTER I.— Principle of volume	357
CHAPTER II.— Principle of form	358
CHAPTER III.— Principle of stability	359
CHAPTER IV.— Principle of colour	ib.
CHAPTER V.— Principle of variety	360
CHAPTER VI.— Principle of symmetry	362

CONTENTS.

	Page
CHAPTER VII.— Principle of repetition	364
CHAPTER VIII.— Principle of general harmony	365
CHAPTER IX.— Principle of the suitability of the object to its destination	366
CHAPTER X.— Principle of distinct view	369

SECTION IV.

Of the disposition of the mind of the spectator in respect to the judgment he forms of an object of art which attracts his eye	371
Historical review of my researches, and final conclusion of the work	373
Concluding remarks on contrast	382
§ 1.— Of contrast considered in connection with the observation of several phenomena of nature	ib.
§ 2.— Of contrast considered with respect to the size of two contiguous objects of unequal size	383
§ 3.— Are the senses of hearing, taste, and smell submitted to contrast?	385
§ 4.— The light which the study of contrast appears to be susceptible of shedding upon several other phenomena of the understanding	394

ON

THE LAW

OF

SIMULTANEOUS CONTRAST OF COLOURS,

AND ITS

APPLICATIONS IN THE ARTS.

PART I.

THEORETICAL.

PART I.

~~~~~~~

INTRODUCTION.

FIRST SECTION.—ON THE LAW OF SIMULTANEOUS CONTRAST OF COLOURS, AND ITS DEMONSTRATION BY EXPERIMENT.

SECOND SECTION.—ON THE DISTINCTION BETWEEN SIMULTANEOUS, SUCCESSIVE, AND MIXED CONTRAST OF COLOURS; AND AN ACCOUNT OF THE CONNECTION BETWEEN THE EXPERIMENTS MADE BY THE AUTHOR AND THOSE OF OTHER OBSERVERS.

THIRD SECTION.—ON THE PHYSIOLOGICAL CAUSE TO WHICH THE PHENOMENA OF CONTRAST OF COLOURS WAS REFERRED PREVIOUS TO THE EXPERIMENTS OF THE AUTHOR.

# INTRODUCTION.

(1.) It is necessary, in the first place, to explain some of the optical principles which relate,

Firstly, to the law of Simultaneous Contrast of Colours; and Secondly, to the applications of this law in the various arts which make use of coloured materials to attract the eye.

(2.) A ray of solar light is composed of an indeterminate number of differently-coloured rays; and since, on the one hand, it is impossible to distinguish each particular one, and as, on the other, they do not all differ equally from one another, they have been divided into groups, to which are applied the terms *red rays, orange rays, yellow rays, green rays, blue rays, indigo rays,* and *violet rays;* but it must not be supposed that all the rays comprised in the same group, *red* for instance, are identical in colour; on the contrary, they are generally considered as differing, more or less, among themselves, although we recognise the impression they separately produce as comprised in that which we ascribe to *red.*

(3.) When light is reflected by an opaque white body, it is not modified in proportion to the differently-coloured rays which constitute white light; only,

A. *If this body is not polished,* each point of its surface must be considered as dispersing, in every direction through the surrounding space, the white light which falls upon it; so that the point becomes visible to an eye placed in the direction of one of these rays. We may easily conceive that the image of a body in a given position, is composed of the sum of the physical points which reflect to the eye so placed, a portion of the light that each point radiates.

B. *When the body is polished,* like the surface of a mirror for instance, one portion of the light is reflected irregularly, as in the preceding case; at the same time another portion is regularly or specularly reflected, giving to the

mirror the property of presenting to the eye, properly situated, the image of the body which sends its light to the reflector;—one consequence of this distinction is, that if we observe two plane surfaces reflecting white light differing from each other only in polish, it results that in those positions where the *non*-polished surface is visible, all its parts will be equally, or nearly equally, illuminated; while the eye, when it is in a position to receive only that which is reflected irregularly, will receive but little light from the polished surface; on the contrary, it will receive much more when it is in a position to receive light regularly reflected.

(4.) If the light which falls upon a body is completely absorbed by it, as it would be in falling into a perfectly obscure cavity, then the body appears to us *black*, and it becomes visible only because it is contiguous to surfaces which transmit or reflect light. Among black substances, we know of none that are perfectly so, and it is because they reflect a small quantity of white light, that we conclude they have relief, like other material objects. Moreover, what proves this reflection of white light is, that the blackest bodies, when polished, reflect the images of illuminated objects placed before them.

(5.) When light is reflected by an opaque coloured body, there is always

A reflection of white light,—and
A reflection of coloured light;

the latter is due to the fact that the body *absorbs* or extinguishes within its substance a certain number of coloured rays, and *reflects* others. It is evident that the coloured rays reflected are of a different colour from those absorbed; and also that, if they were combined with those absorbed, they would reproduce white light. We shall return to this subject in (6.).

Further, it is evident that opaque coloured bodies, when unpolished, reflect irregularly both white and coloured light, by which we are enabled to see their colours; and that those which are polished reflect only one portion of these two lights irregularly, while they reflect another portion in a regular manner.

(6.) Let us now return to the relation which exists between the coloured light *absorbed*, and the coloured light *reflected*, by an opaque body, which makes it appear to us of the colour peculiar to this light.

It is evident, from the manner in which we have considered the physical composition of solar light (2.), that if we reunited the total quantity of the coloured light *absorbed* by a coloured

body, to the total quantity of coloured light *reflected* by it, we should reproduce white light: for it is this relation that two differently coloured lights, taken in given proportions, have of reproducing white light, that we express by the terms

*Coloured lights complementary to each other*, or *Complementary colours.*

It is in this sense we say,
That Red is complementary to Green, and *vice versâ;*
That Orange is complementary to Blue, and *vice versâ;*
That Greenish Yellow is complementary to Violet, and *vice versâ;*
That Indigo is complementary to Orange Yellow, and *vice versâ.*

(7.) It must not be supposed that a red or yellow body reflects only *red* and *yellow* rays besides white light; they each (6.) reflect *all kinds* of coloured rays: only those rays which lead us to judge the bodies to be *red* or *yellow*, being more numerous than the other rays reflected, produce a greater effect. Nevertheless, those other rays have a certain influence in modifying the action of the red or yellow rays upon the organ of sight; and this will explain the innumerable varieties of *hue* which may be remarked among different red and yellow substances. It is also difficult not to admit that, among the differently coloured rays reflected by bodies, there is a certain number of them which, being complementary to each other, go to re-form white light upon reaching the eye.

# FIRST SECTION.

## ON THE LAW OF SIMULTANEOUS CONTRAST OF COLOURS, AND ITS DEMONSTRATION BY EXPERIMENT.

CHAPTER I. — METHOD OF OBSERVING THE PHENOMENA OF SIMULTANEOUS CONTRAST OF COLOURS.

    Definition of Simultaneous Contrast (8). Experimental Demonstration of Contrast of Tone (9). Experimental Demonstration of Contrast of Colour (13).

CHAPTER II. — THE LAW OF SIMULTANEOUS CONTRAST OF COLOURS, AND THE FORMULA WHICH REPRESENTS IT (16).

CHAPTER III. — THE LAW OF SIMULTANEOUS CONTRAST DEMONSTRATED BY THE JUXTAPOSITION OF A GIVEN NUMBER OF COLOURED SUBSTANCES (20).

CHAPTER IV. — ON THE JUXTAPOSITION OF COLOURED SUBSTANCES WITH WHITE (44).

CHAPTER V. — ON THE JUXTAPOSITION OF COLOURED SUBSTANCES WITH BLACK (53).

CHAPTER VI. — ON THE JUXTAPOSITION OF COLOURED SUBSTANCES WITH GREY (63).

CHAPTER VII. — THE CHEMICAL COMPOSITION OF COLOURED BODIES HAS NO INFLUENCE ON THE PHENOMENA OF SIMULTANEOUS CONTRAST (71).

CHAPTER VIII. — ON THE JUXTAPOSITION OF COLOURED BODIES BELONGING TO THE COLOURS OF THE SAME GROUP OF COLOURED RAYS (72).

CHAPTER IX. — ON THE APPLICATION OF THE LAW OF CONTRAST ON THE HYPOTHESIS THAT RED, YELLOW, AND BLUE, ARE THE ONLY PRIMARY COLOURS, AND THAT ORANGE, GREEN, INDIGO, AND VIOLET ARE COMPOUND COLOURS (76).

# CHAPTER I.

### METHOD OF OBSERVING THE PHENOMENA OF SIMULTANEOUS CONTRAST OF COLOURS.

*Definition of Simultaneous Contrast.*

(8.) IF we look simultaneously upon two stripes of different tones of the same colour, or upon two stripes of the same tone of different colours placed side by side, if the stripes are not too wide, the eye perceives certain modifications which in the first place influence the intensity of colour, and in the second, the optical composition of the two juxtaposed colours respectively.

Now as these modifications make the stripes appear different from what they really are, I give to them the name of *simultaneous contrast of colours;* and I call *contrast of tone* the modification in intensity of colour, and *contrast of colour* that which affects the optical composition of each juxtaposed colour. The following is a very simple method of convincing ourselves of the twofold phenomena of simultaneous contrast of colours.

*Experimental Demonstration of Contrast of Tone.*

(9.) Take two portions, $o$, $o'$, *fig.* 1., of a sheet of unglazed paper of about twenty inches square, coloured light grey by means of a mixture of whiting and lamp-black; fix them in any manner upon a piece of brown-holland, placed opposite to a window, $o$ being distant from $o'$ about twelve inches. Then take two portions $p$ and $p'$ of another sheet of unglazed paper which differs from the first by being deeper, but still a grey composed of the same black and white. Fix $p$ next to $o$, and $p'$ at about twelve inches from $p$.

If we now look at these four half-sheets $o$, $o'$, $p$, $p'$ for some seconds, we shall see that the piece $o$ contiguous to $p$ will be lighter than $o'$, while $p$ will, on the contrary, be deeper than $p'$.

(10.) It is easy to demonstrate that the modification is not equally intense over the whole extent of the surfaces of $o$ and $p$, but that it becomes gradually weaker from the line of contact.

It is sufficient to place a piece of card, *fig.* 2., cut out in the centre, upon *o p*, in such manner that *o* and *p* each present three grey stripes; as is shown in *fig.* 3., the stripes 1, 1, are more modified than the stripes 2, 2; and these latter are more modified than the stripes 3, 3.

For this modification to take place, it is not absolutely necessary for *o* and *p* to be contiguous; for if we cover the stripes 1, 1, we shall see the stripes 2, 2, 3, 3 modified.

(11.) The following experiment, the natural sequence of the two preceding (9. and 10.), is very suitable for demonstrating the whole extent of contrast of tone.

Divide a piece of card-board into ten stripes, each of about a quarter of an inch in width, 1, 2, 3, 4, 5, 6, 7, 8, 9, 10, and cover it with a uniform wash of Indian ink, *fig.* 3. (*bis.*) When it is dry, spread a second wash over all the stripes except the first. When this second wash is dry, spread a third over all the stripes except 1 and 2; and proceed thus to cover all the stripes with a flat tint, each one becoming darker and darker, as it recedes from the first (1.).

If we take ten stripes of paper of the same grey, but each of a different tone, and glue them upon a card so as to observe the preceding gradation, it will serve the same purpose.

On now looking at the card, we shall perceive that instead of exhibiting flat tints, each stripe appears of a tone gradually shaded from the edge *a a* to the edge *b b*. In the band 1, the contrast is produced simply by the contiguity of the edge *b b* with the edge *a a* of the stripe 2; in the stripe 10 it is simply by the contact of the edge *a a* with the edge *b b* of the stripe 9. But in each of the intermediate stripes 2, 3, 4, 5, 6, 7, 8, and 9, the contrast is produced by a double cause: one, the contiguity of the edge *a a* with the edge *b b* of the stripe which precedes it; the other by the contiguity of the edge *b b* with the edge *a a* of the darker stripe which follows it. The first cause tends to raise the tone of the half of the intermediate stripe, while the second cause tends to lower the tone of the other half of this same stripe.

The result of this contrast is, that the stripes, seen from a suitable distance, resemble channeled grooves (*glyphs*) more than plane surfaces. For in the stripes 2 and 3, for instance, the grey being insensibly shaded from the edge *a a* to the edge *b b*, they present to the eye the same effect as if the light fell upon a channeled surface, so as to light the part near to *b b*, while the part *a a* will appear to be in the shade; but with this difference, that in a real channel the lighted part would throw a reflection on the dark part.

SECT. I.] SIMULTANEOUS CONTRAST OF COLOURS. 9

(12.) Contrast of Tone occurs with Colours, properly so called, as well as with Grey; thus, to repeat our experiment (9. *fig.* 1.) with the two portions $o'$, $o$ of a sheet of paper of a light tone of a certain colour, and the two portions $p'$, $p$ of a sheet of paper of a deeper tone of this same colour, we shall perceive that $o$ contiguous to $p$ will be lighter than $o'$, and $p$ will be deeper than $p'$. We can demonstrate, as we have done before (10.), that in starting from the point of contact the modification is gradually weakened.

*Experimental Demonstration of Contrast of Colour.*

(13.) If we arrange as before (9. *fig.* 1.) two portions $o$, $o'$ of a sheet of unglazed coloured paper, and two portions $p$, $p'$ of a sheet of unglazed paper of a different colour from the first, but resembling it as nearly as possible in intensity, or rather in *tone* (8.) in looking at these four half-sheets $o'$, $o$, $p$, $p'$ for a few seconds, we shall see that $o$ differs from $o'$, and $p$ from $p'$; consequently the two half-sheets $o$, $p$ appear to undergo reciprocally a modification of tint which is rendered apparent by the comparison we have made of their colours with those of $o'$ and of $p$.*

(14.) It is easy to demonstrate that the modification which colours undergo by juxtaposition, is a tendency to weakening starting from the line of juxtaposition; and that it may be perceived between two surfaces without their being in contact, it is sufficient to experiment as above (10.).

(15.) I will now cite seventeen observations made in conformity with the method prescribed (9.).

*(The colours experimented with must be as nearly as possible of equal intensity.)*

| | Colours experimented with | | Modifications. | |
|---|---|---|---|---|
| No. 1. | { Red | inclines to | Violet. | |
| | Orange | ,, | Yellow. | |
| 2. | { Red | ,, | Violet, or is less Yellow. | |
| | Yellow | ,, | Green, or is less Red. | |
| 3. | { Red | ,, | Yellow. | |
| | Blue | ,, | Green. | |
| 4. | { Red | ,, | Yellow. | |
| | Indig | ,, | Blue. | |
| 5. | { Red | ,, | Yellow. | |
| | Violet | ,, | Indigo. | |

\* Instead of paper we may use lustreless stuffs or any other material which will present two equal surfaces absolutely identical in colour. Coloured paper answers very well.

| | Colours experimented with | | Modifications. | |
|---|---|---|---|---|
| No. 6. | { Orange | inclines to | Red. | |
| | Yellow | " | Bright Green, or is less Red. | |
| 7. | { Orange | " | Bright Red, or is less Brown. | |
| | Green | " | Blue. | |
| 8. | { Orange | " | Yellow, or is less Brown. | |
| | Indigo | " | Blue, or is purer. | |
| 9. | { Orange | " | Yellow, or is less Brown. | |
| | Violet | " | Indigo. | |
| 10. | { Yellow | " | Bright Orange. | |
| | Green | " | Blue. | |
| 11. | { Yellow | " | Orange. | |
| | Blue | " | Indigo. | |
| 12. | { Green | " | Yellow. | |
| | Blue | " | Indigo. | |
| 13. | { Green | " | Yellow. | |
| | Indigo | " | Violet. | |
| 14. | { Green | " | Yellow. | |
| | Violet | " | Red. | |
| 15. | { Blue | " | Green. | |
| | Indigo | " | Deep Violet. | |
| 16. | { Blue | " | Green. | |
| | Violet | " | Red. | |
| 17. | { Indigo | " | Blue. | |
| | Violet | " | Red. | |

It follows, then, from the experiments described in this Chapter, that two coloured surfaces in juxtaposition will exhibit two modifications to the eye viewing them simultaneously, the one relative to the height of tone of their respective colours, and the other relative to the physical composition of these same colours.

## CHAPTER II.

**THE LAW OF SIMULTANEOUS CONTRAST OF COLOURS, AND THE FORMULA WHICH REPRESENTS IT.**

(16.) AFTER having satisfied myself that the preceding phenomena constantly recurred when my sight was not fatigued, and that many persons accustomed to judge of colours saw them as I did, I endeavoured to reduce them to some general expression that would suffice to enable us to predict the effect that would be produced upon the organ of sight by the juxtaposition of two given colours. All the phenomena I have observed seem to me to depend upon a very simple law, which, taken in its most general signification, may be expressed in these terms: —

*In the case where the eye sees at the same time two contiguous colours, they will appear as dissimilar as possible, both in their optical composition and in the height of their tone.*

We have then, *at the same time*, simultaneous contrast of colour properly so called, and contrast of tone.

(17.) For two contiguous colours, $o$ and $p$, will differ as much as possible from each other when the complementary of $o$ is added to $p$, and the complementary of $p$ is added to $o$: consequently, by the juxtaposition of $o$ and $p$, the rays of the colour $p$, which $o$ reflects when it is seen separately, like the rays of the colour $o$ which $p$ reflects when viewed separately, rays which are active under these circumstances (7.) cease to be so when $o$ and $p$ are placed in contact; for in this case, each of the two colours losing what is analogous, they should differ the more.

The following formulæ will make this perfectly intelligible.

(18.) Let us represent:

The colour of the stripe o by the colour $a$ whiter by B;
The colour of the stripe P by the colour $a'$ whiter by B';
The complementary colour of $a$ by $c$;
The complementary colour of $a'$ by $c'$.

The colours of the two stripes viewed separately are

The colour of $o = a + B$,
The colour of $P = a' + B'$.

By juxtaposition, they become
$$\text{The colour of } o = a + \text{B} + c',$$
$$\text{The colour of } \text{P} = a' + \text{B}' + c.$$

Let us now show that what this expression comes to is, that the taking away from the colour $a$ of o the rays of the colour $a'$, and taking away from the colour $a'$ of P the rays of the colour $a$, we must suppose

$B$ reduced to two portions $\begin{cases} \text{white} = b, \\ + \text{white} = (a' + c'). \end{cases}$

$B'$ reduced to two portions $\begin{cases} \text{white} = b', \\ + \text{white} = (a + c). \end{cases}$

The colours of the two stripes viewed separately are
$$\text{The colour of } o = a + b + a' + c',$$
$$\text{The colour of } \text{P} = a' + b' + a + c.$$

By juxtaposition they become
$$\text{The colour of } o = a + b + c',$$
$$\text{The colour of } \text{P} = a' + b' + c,$$

—an expression which is evidently the same as the first, excepting the values of $B$ and $B'$.

(19.) I have stated that simultaneous contrast may influence at the same time the optical composition of the colours, and the height of their tone; consequently, when the colours are not of the same degree of intensity, that which is deep appears deeper, and that which is light, lighter; that is to say, the first appears to lose as much of white light as the second seems to reflect more of it.

*Therefore, in looking at two contiguous colours, we have*
*Simultaneous Contrast of Colour, and*
*Simultaneous Contrast of Tone.*

## CHAPTER III.

**THE LAW OF SIMULTANEOUS CONTRAST OF COLOURS, DEMONSTRATED BY THE JUXTAPOSITION OF A GIVEN NUMBER OF COLOURED SUBSTANCES.**

(20.) LET us now apply the formula to the seventeen observations of Chap. I., and we shall see that the modifications of contiguous colours are precisely such as would result from the addition to each of them of the colour which is complementary to its neighbour (18.), remarking, that I shall not review these observations in the order they were arranged above: the reader

will learn the reason in Chap. IX. But it will always be easy to find the position they occupy in Chap I., because I have appended to each its consecutive number. For the complementaries of these colours, I refer to the Introduction to Part I. (6.)

### Orange and Green. No. 7.

(21.) Blue, the complementary of Orange, added to Green, makes it bluer, or less yellow.

The complementary of Green (Red), added to Orange, the latter becomes redder, or less yellow, and brighter.

### Orange and Indigo. No. 8.

(22.) Blue, the complementary of Orange, added to Indigo, makes it bluer, or less red.

The complementary of Indigo (Orange Yellow), added to Orange, renders it yellower, or less red.

### Orange and Violet. No. 9.

(23.) Blue, the complementary of Orange, added to Violet, makes it incline to indigo.

The complementary of Violet (Greenish-Yellow), added to Orange, the latter becomes yellower.

### Green and Indigo. No. 13.

(24.) Red, the complementary of Green, added to Indigo, makes it redder, or more violet.

The complementary of Indigo (Orange-Yellow), added to Green, makes it yellower.

### Green and Violet. No. 14.

(25.) Red, the complementary of Green, added to Violet, makes it redder.

The complementary of Violet (Greenish-Yellow), added to Green, makes it yellower.

### Orange and Red. No. 1.

(26.) Blue, the complementary of Orange, added to Red, makes it incline to violet or crimson.

The complementary of Red (Green), added to Orange, makes the latter incline to yellow.

### Violet and Red. No. 5.

(27.) Greenish-Yellow, the complementary of Violet, added to Red, makes it yellower, or inclining to orange.

The complementary of Red (Green), added to Violet, makes the latter incline to indigo.

### Indigo and Red. No. 4.

(28.) Orange-Yellow, the complementary of Indigo, added to Red, makes it incline to orange.

The complementary of Red (Green), makes the Indigo blue.

### Orange and Yellow. No. 6.

(29.) Blue, the complementary of Orange, added to Yellow, makes it incline to green.

The complementary of Yellow (Indigo inclining to violet), makes the Orange redder.

### Green and Yellow. No. 10.

(30.) Red, the complementary of Green, added to Yellow, makes it incline to orange.

Indigo inclining to violet, the complementary of Yellow, added to green, makes it bluer.

### Green and Blue. No. 12.

(31.) Red, the complementary of Green, added to Blue, makes the latter incline to indigo.

The complementary of Blue (Orange), added to Green, makes it yellower.

### Violet and Blue. No. 16.

(32.) Greenish-Yellow, the complementary of Violet, added to Blue, causes it to become greenish.

The complementary of Blue (Orange), added to Violet, makes it redder.

### Indigo and Blue. No. 15.

(33.) Orange-Yellow, the complementary of Indigo, added to Blue, makes it incline to green.

The complementary of Blue (Orange), added to Indigo, makes it incline to violet.

### Red and Yellow. No. 2.

(34.) Green, the complementary of Red, added to Yellow, makes it incline to green.

The complementary of Yellow (Indigo inclining to violet), added to Red, makes it incline to violet.

### Red and Blue. No. 3.

(35.) Green, the complementary of Red, added to Blue, causes it to incline to green.

The complementary of Blue (Orange), added to Red, makes it incline to orange.

### Yellow and Blue. No. 11.

(36.) Indigo, the complementary of Orange-Yellow, added to Blue, makes the latter incline to indigo.

The complementary of Blue (Orange), added to Yellow, makes it incline to orange.

### Indigo and Violet. No. 17.

(37.) Orange-Yellow, the complementary of Indigo, added to Violet, makes it incline to red.

The complementary of Violet (Greenish-Yellow), added to Indigo, causes it to appear bluer.

(38.) It is evident that, other things being equal, the greater the difference that exists between each colour and the complementary ($c$ or $c'$) which is added to them, the more striking will be the modification of the juxtaposed colours; for when the complementary $c'$ is added to the colour o it will be identical with it, as the complementary $c$ is identical with the colour P to which it is added; and the modifications of o and P are limited to a simple augmentation of intensity of colour. But do we know, at the present day, of two coloured bodies which are capable of exhibiting to the observer two perfectly pure colours complementary to each other? Certainly not! All those substances which appear coloured by reflection, reflect, as I have said (7), besides white light, a great number of differently coloured rays. Therefore we cannot instance *a red pigment and a green*, or *an orange pigment and a blue*, or *an orange-yellow pigment and an indigo*, or, lastly, *a greenish-yellow pigment and a violet*, which reflect simple or compound colours absolutely complementary to each other, so that their juxtaposition would produce only *a simple augmentation of intensity* in their respective colours. If, therefore, it be generally less easy to verify the law of contrast with red and green, or orange and blue substances, &c., than it is with those which have been the object of the seventeen observations mentioned above (15); yet in endeavouring to verify the first, we shall see that the

colours will acquire a most remarkable brilliancy, strength, and purity, and this result, in perfect conformity with the law, is easily understood. For example, an orange-coloured object reflects blue rays, just as a blue object reflects orange rays (7). Therefore, when we put a blue stripe in contact with an orange stripe, whether we admit that the first appears to the eye to receive some blue from the proximity of the second, as this latter appears to acquire orange through the vicinity of the blue stripe, — or, which is the same thing, whether we admit that the blue stripe appears to destroy the effect of the blue rays of the second stripe, as this latter appears to destroy the effect of the orange rays of the blue stripe, — it is evident that the colours of the two objects in contact will purify each other, and become more vivid. But it may happen that the Blue will appear to incline to green or to violet, and the Orange to yellow or to red, that is to say, the modification acts not only upon the intensity of the colour, but also upon its physical composition : whatever it be, if the latter effect takes place, it is undoubtedly always much feebler than the first. Besides, if we look a certain number of times at these same coloured bands we shall see that the blue, which at first appeared greener, will soon appear more violet, and that the orange, which at first appeared yellower, will become redder, so that the phenomenon of modification, dependent upon the physical composition of colour, will not be so constant as those which are the subject of the seventeen preceding observations (15). I will now explain the previous remarks on bodies, the colours of which are as nearly as possible complementary to each other.

### Red and Green.

(39.) Red, the complementary of Green, added to Red, increases its intensity.

Green, the complementary of Red, added to Green, augments its intensity.

Such is the theoretical conclusion ; and experiment confirms it.

When we place a Green inclining more to Yellow than to Blue in contact with

    1° a Red slightly Orange,
    2° a Red slightly Crimson,
    3° an intermediate Red,

and then repeat a given number of times the observations upon each of these groups of colours, we shall witness different results ; that is to say, while in one case the Red will appear

more orange, and the Green yellower; in another, the Red will appear more violet, and the Green bluer; and we may also remark, that the change is attributable as much to a difference in the intensity of the light illuminating the colours, as to fatigue of the eyes.

When we place a Green inclining more to Blue than to Yellow in juxtaposition with
- 1° a Red slightly Orange,
- 2° a Red slightly Crimson,
- 3° an intermediate Red,

the results are the same as with the first green, with this difference, however, that in the combination of bluish-green and crimson-red, looked at for a certain number of times, the Green and the Red almost always appear yellower than when viewed separately, a result easily anticipated.

### Orange and Blue.

(40.) Blue, the complementary of Orange, added to Blue, increases its intensity.

Orange, the complementary of Blue, added to Orange, augments its intensity.

On repeating these observations with a deep Blue and an Orange which is not too red, both colours will frequently appear redder than otherwise.

### Orange-Yellow, and Indigo.

(41.) Orange-Yellow, the complementary of Indigo, added to Orange-Yellow, imparts to it greater intensity.

Indigo, the complementary of Orange-Yellow, added to Indigo, increases its intensity.

The result of observation is almost always in conformity with theory.

### Greenish-Yellow and Violet.

(42.) Greenish-Yellow, the complementary of Violet, added to Greenish-Yellow, imparts to it greater intensity.

Violet, the complementary to Greenish-Yellow, added to Violet, increases its intensity.

The result of observation is almost always in conformity with the law.

(43.) According to the Law of Simultaneous Contrast of Colours and the insensible gradation of modification commencing from the contiguous edges of the juxtaposed coloured band (11), we can represent by coloured circular spaces the modifi-

cations which the principal colours tend to induce in those which are contiguous to them.

Take circular pieces of paper, or other material, coloured red, green, orange, blue, greenish-yellow, violet, indigo, and orange-yellow, of about one inch and a half in diameter; place each one separately on a sheet of white paper; then, with a thin wash of colour, tint the white paper around the circle, with its complementary colour, gradually weaker and weaker as the tint recedes from the coloured circle. These figures are principally intended to represent the effects of contrast in a palpable manner to those persons who, not having studied physics, yet have, nevertheless, an interest in knowing these effects.

The *Red* circle tends to colour the surrounding space with its complementary *Green*.
The *Green* circle tends to colour the surrounding space *Red*.
The *Orange*          „    „    „  *Blue*.
The *Blue*            „    „    „  *Orange*.
The *Greenish-Yellow* „    „    „  *Violet*.
The *Violet*          „    „    „  *Greenish Yellow*.
The *Indigo*          „    „    „  *Orange-Yellow*.
The *Orange-Yellow*   „    „    „  *Indigo*.

## CHAPTER IV.

#### ON THE JUXTAPOSITION OF COLOURED SUBSTANCES WITH WHITE.

(44.) WHITE substances contiguous to those which are coloured, appear sensibly modified when viewed simultaneously with the latter. I admit that the modification is too feeble to be determined with entire certainty, when we are ignorant of the law of contrast; but knowing that, and seeing the modification effected by the white upon certain coloured substances, it is impossible to avoid recognising this modification in its *speciality* if at the same time the colours opposed to the white are not too deep.

### Red and White.

(45.) Green, the complementary of Red, is added to the White. The Red appears more brilliant and deeper.

### Orange and White.

(46.) Blue, the complementary of Orange, is added to the White. The Orange appears brighter and deeper.

### Greenish-Yellow and White.

(47.) Violet, the complementary of Greenish-Yellow, is added to the White. The Yellow appears brighter and deeper.

### Green and White.

(48.) Red, the complementary of Green, is added to the White. The Green appears brighter and deeper.

### Blue and White.

(49.) Orange, the complementary of Blue, is added to the White. The Blue appears brighter and deeper.

### Indigo and White.

(50.) Orange-Yellow, the complementary of Indigo, is added to the White. The Indigo appears brighter and deeper.

### Violet and White.

(51.) Greenish-Yellow, the complementary of Violet, is added to the White. The Violet appears brighter and deeper.

### Black and White.

(52.) Black and White, which may in some respects be considered as complementary to each other, conformably to the *law* of Contrast of Tone, differ more from each other than when viewed separately: and this is owing to the effect of the white light reflected by the black (4) being destroyed more or less by the light of the white stripe; and it is by an analogous action that White heightens the tone of the colours with which it is placed in contact.

## CHAPTER V.

### ON THE JUXTAPOSITION OF COLOURED SUBSTANCES WITH BLACK.

(53.) BEFORE stating the observations to which the juxtaposition of coloured and black substances has given rise, we must analyse the part the two contrasts—those of Tone and of Colour—perform in the phenomenon considered in its general bearing.

The black surface being deeper than the colour with which it is in juxtaposition, the Contrast of Tone must tend to deepen it still more, while it must tend to lower the tone of the contiguous colour, for the same reason, exactly, that White, on the other hand, if juxtaposed with it would heighten it. Thus much for Contrast of Tone.

(54.) Black substances reflect a small quantity of white light (4), and this light arriving at the eye at the same time with the coloured light of the contiguous body, it is evident that the black substances must appear tinted with the complementary of the coloured light: but the tint will be very faint, because it is manifested upon a ground having but a feeble power for reflecting light. Thus much for Contrast of Colour.

(55.) The lowering of the tone of a colour in contact with black is always perceptible; but a very remarkable fact is, the weakening of the black itself when the contiguous colour is sombre and of a nature that yields a luminous complementary, such as Orange, Orange-Yellow, Greenish-Yellow, &c.

### *Red and Black.*

(56.) Green, the complementary of Red, uniting with the Black, causes it to appear less reddish.

The Red appears lighter or less brown, less oranged.

### *Orange and Black.*

(57.) The complementary of Orange (*Blue*), uniting with the Black, the latter appears less rusty, or bluer.

The Orange appears brighter and yellower, or less brown.

### *Greenish-Yellow and Black.*

(58.) The complementary of Greenish-Yellow (*Violet*), uniting with the Black, the Black appears tinted Violet.

The Yellow is lighter, — greener perhaps; and there are some samples of Yellow which appear weaker by their juxtaposition with Black.

### *Green and Black.*

(59.) The complementary of Green (*Red*), uniting with the Black, the Black appears more Violet or reddish.

The Green inclines slightly to Yellow.

### *Blue and Black.*

(60.) The complementary of Blue (*Orange*), uniting with the Black, the Black becomes brighter.

The Blue is lighter, — greener perhaps.

### Indigo and Black.

(61.) The complementary of Indigo (*Orange-Yellow*), uniting with the Black, brightens it considerably.

The Indigo becomes brighter.

### Violet and Black.

(62.) The complementary of Violet (*Greenish-Yellow*), uniting with the Black, brightens it.

The Violet is more brilliant,—lighter,—redder, perhaps.

## CHAPTER VI.

#### ON THE JUXTAPOSITION OF COLOURED AND GREY SUBSTANCES.

(63.) IF one of the principal causes that prevent our seeing the modifications which coloured bodies tend to impart to white bodies juxtaposed with them is, the brightness of the light reflected by the latter, on the other hand, if the feeble light reflected by black bodies, is on the contrary, less favourable to our perception of the kind of modification they experience from the proximity of coloured bodies, particularly in the case where the complementary of the body is itself not very luminous, we may imagine that Grey bodies, properly selected with respect to height of tone, will, when they are contiguous to coloured substances, exhibit the phenomena of contrast of colour in a more striking manner than either black or white substances do.

### Red and Grey.

(64.) The Grey appears greener by receiving the influence of the complementary of Red.

The Red appears purer,—less orange perhaps.

### Orange and Grey.

(65.) The Grey appears bluer by receiving the influence of the complementary of Orange.

The Orange appears purer, and brighter,—yellower perhaps.

### Yellow and Grey.

(66.) The Grey appears inclining to Violet by receiving the influence of the complementary of Yellow.

The Yellow appears brighter, and less green.

### Green and Grey.

(67.) The Grey appears inclining to Red by receiving the influence of the complementary of Green.

The Green appears brighter,—more yellow perhaps.

### Blue and Grey.

(68.) The Grey appears tinged with Orange, by receiving the influence of the complementary of Blue.

The Blue appears brighter,—greener perhaps.

### Indigo and Grey.

(69.) The same as the above (68).

### Violet and Grey.

(70.) The Grey appears tinged with Yellow, by receiving the influence of the complementary of Violet.

The Violet appears purer, less tarnished.

(70.<sup>bis.</sup>) The Grey used in the preceding experiments was as free as possible from all colouring matter foreign to black. It belonged to the scale of *normal black* (see 2nd Part, 164.), that is to say, it resulted from a mixture of black and white substances as pure as could possibly be obtained: in contact with white it rendered it lighter and apparently brighter, while juxtaposed with black, it heightened it, and appeared lighter and more rusty.

(70.<sup>ter.</sup>) One result of the complementaries of colours juxtaposed with grey being more apparent than when these colours are juxtaposed with white or even with black, is, that if instead of a *normal grey* we juxtapose a tinted grey, either red, orange, yellow, &c., these tints will be singularly heightened by the complementaries which will be added to them. For example, a bluish-grey will receive a very palpable exaltation of blue from its contiguity to orange, and a yellowish-grey will take a decided green tint from the same contiguity.

## CHAPTER VII.

**THE CHEMICAL NATURE OF COLOURED SUBSTANCES HAS NO INFLUENCE ON THE PHENOMENA OF SIMULTANEOUS CONTRAST.**

(71.) ALL the experiments I have made with the view of ascertaining if the chemical nature of bodies, when placed beside each other, has any influence on the modification of their colours, have, as I expected, led me to an absolutely negative conclusion. Whatever happened to be the chemical composition of the coloured substances, provided they were identical in colour, they gave the same results. I will cite the following examples:—

Indigo or prussian-blue, cobalt, ultramarine, as nearly alike as possible, gave the same kind of modification.

Orange prepared with red lead, with annotto, or with the mixture of woad and madder, gave the same modification to the colours with which they were juxtaposed.

## CHAPTER VIII.

**ON THE JUXTAPOSITION OF COLOURED SUBSTANCES BELONGING TO THE COLOURS OF THE SAME GROUP OF COLOURED RAYS.**

(72.) WHENEVER there is a great difference between two contiguous colours, the difference is rendered more appreciable by bringing the same colour successively in contact with different colours belonging to the same group. For example,

### *Orange and Red.*

When we place near Orange a scarlet-rod, a pure red, or a crimson-red, we shall see that the Red acquires a purple, and the Orange a yellow tint.

### *Violet and Red.*

Analogous results are obtained with Violet placed in contact with scarlet-red, carmine-red, and crimson-red. The Violet always appears bluer, and the Red yellower, or less purple.

(73.) These observations clearly explain the cause of our obtaining results conformable to the formulæ, although we may have made use of coloured substances, such as stained papers or stuffs, which are far from presenting to the eye very pure colours.

(74.) The juxtaposition of coloured bands is a means of demonstrating the difficulty of fixing the types of pure colours by our pigments, at least if we do not take into consideration the law of simultaneous contrast. For instance,

1. Take Red, and place it in contact with orange-red, the first will appear purple, and the second yellower, as I have before stated; but if we put the first Red in contact with a purple-red, this latter will appear bluer, and the other yellower, or orange; so that the same Red will appear purple in one case, and orange in the other.

2. Take Yellow, and place it near orange-yellow, it will appear greenish, and the second redder; but if we put the first Yellow in contact with a greenish-yellow, this latter will appear greener, and the former more orange; so that the same Yellow will incline to green in one case, and to orange in the other.

3. Take Blue, put it in contact with a greenish-blue; the first will incline to violet, and the second will appear yellower. Put the same Blue in contact with a violet-blue, the first will incline to green, and the second will appear redder, so that the same Blue will in one case appear violet, and in the other greenish.

(75.) Thus we perceive that the colours which painters term simple or primary, Red, Yellow, and Blue, pass insensibly by their juxtaposition to the state of secondary or compound colours. Since the same Red becomes purple or orange, the same Yellow is orange or green, and the same Blue is green or violet.

## CHAPTER IX.

ON THE APPLICATION OF THE LAW OF CONTRAST TO THE HYPOTHESIS, THAT RED, YELLOW, AND BLUE ARE THE ONLY PRIMARY COLOURS, AND THAT ORANGE, GREEN, INDIGO, AND VIOLET ARE SECONDARY OR COMPOUND COLOURS.

(76.) THE experiments to which I have applied the principle of the modification that colours undergo by their juxtaposition, and the explanation which results therefrom, according to the manner in which we consider the physical composition of white light, are also clearly explained in the language used by painters and dyers, who only admit of three primary colours—red, yellow, and blue; and, as it may occur to many persons, who, partaking of the same opinion, will nevertheless desire to understand the phenomena resulting from the juxtaposition of colours, I will now proceed to explain them in conformity with their language; and, for greater perspicuity, I will take five groups of juxtaposed colours, commencing with those which include the observations to which the preceding law most readily applies. I will suppose, then, that Orange is formed of red and yellow, Green of blue and yellow, and Indigo and Violet of blue and red.

FIRST GROUP.—*Two Compound Colours having one Simple Colour for their Common Element.*

It is very easy to verify the law by observing two colours comprehended in this group. We see that by their reciprocal influence they lose more or less of the colour which is common to both. It is therefore evident that they will differ from each other in proportion to this loss.

1. *Orange and Green.*

These two colours having *Yellow* for a common element, lose some by juxtaposition: *the Orange will appear redder, and the Green bluer.*

### 2. *Orange and Indigo.*

These two colours having *Red* for a common element, lose some by juxtaposition : *the Orange appearing yellower, and the Indigo bluer.*

### 3. *Orange and Violet.*

The same as the preceding.

### 4. *Green and Indigo.*

These two colours having *Blue* as a common element, lose some by juxtaposition : *the Green appears yellower, and the Indigo redder.*

### 5. *Green and Violet.*

As the preceding.

---

SECOND GROUP.—*A Compound Colour and a Simple Colour which is found in the Compound.*

### 1. *Orange and Red.*

The Orange loses its Red, and appears yellower; and the Red becomes more Blue, differing as much as possible from Orange.

### 2. *Violet and Red.*

Violet loses its redness, and appears bluer; the Red becomes yellow, differing as much as possible from Violet.

### 3. *Indigo and Red.*

The same as the preceding.

### 4. *Orange and Yellow.*

Orange loses some yellow, and appears redder; the Yellow becomes bluer, differing as much as possible from Orange.

### 5. *Green and Yellow.*

Green loses some yellow, and appears bluer; the Yellow becomes redder, and differs as much as possible from Green.

### 6. *Green and Blue.*

The Green loses some blue, and appears yellower; the Blue becomes redder, differing as much as possible from Green.

### 7. *Violet and Blue.*

The Violet loses some blue, and appears redder; the Blue becomes yellow, and differs as much as possible from Violet.

### 8. *Indigo and Blue.*

As the preceding.

---

## THIRD GROUP.— *Two Simple Colours.*

### 1. *Red and Yellow.*

Red, in losing yellow, appears bluer; and the Yellow, by losing red, appears bluer; or, in other words, *the Red inclines to purple, and the Yellow to green.*

### 2. *Red and Blue.*

Red, in losing blue, will appear yellower; and the Blue, in losing red, will appear yellower; or, in other words, *the Red inclines to orange, and the Blue to green.*

### 3. *Yellow and Blue.*

Yellow, in losing blue, will appear redder; and Blue, in losing yellow, will appear more violet; or, in other words, *the Yellow inclines to orange, and the Blue to violet.*

---

## FOURTH GROUP.— *Two Compounds having the same Simple Colours.*

### *Indigo and Violet.*

As Indigo only differs from Violet in containing a larger proportion of blue in comparison to the red, it follows that the difference will be very considerably increased by the Indigo losing red and inclining to a greenish-blue, whilst the Violet, acquiring more red, will incline to this colour. It is evident that if the Violet loses its red, or the Indigo gains it, the two colours will approximate; but as they differ from each other, the first-named effect will ensue.

We may further explain the preceding phenomena by considering Indigo, relatively to the Violet, as *blue;* then it will lose its blue, that being common to both colours, and incline to green, and the Violet, in also losing some blue, will appear redder.

FIFTH GROUP.—*A Compound Colour and a Simple Colour which is not found in the Compound.*

1. *Orange and Blue.*
2. *Green and Red.*
3. *Violet and Greenish-Yellow.*

If we adopt the hypothesis that orange, green, indigo, and violet are *compound*, and red, blue, and yellow *simple* colours, it necessarily follows, that in opposing them in the order in which they are reciprocally complementary, and in supposing also that the colours thus in juxtaposition are perfectly free from any foreign colour, we cannot see any reason why the compound colour should lose one of its colours rather than the other, or why the simple colour should separate itself from one elementary colour rather than from the other. For example, in the juxtaposition of green and red, we can see no reason why the green should tend to blue rather than to yellow, or why the red should incline to blue rather than to yellow.

# SECTION II.

ON THE DISTINCTION BETWEEN SIMULTANEOUS, SUCCESSIVE, AND MIXED CONTRAST OF COLOURS; AND ON THE CONNECTION BETWEEN THE EXPERIMENTS OF THE AUTHOR AND THOSE MADE PREVIOUSLY BY OTHER OBSERVERS.

CHAPTER I. — DISTINCTION BETWEEN SIMULTANEOUS, SUCCESSIVE, AND MIXED CONTRAST OF COLOURS (77).

CHAPTER II. — ON THE CONNECTION BETWEEN EXPERIMENTS OF THE AUTHOR AND THOSE PREVIOUSLY MADE BY VARIOUS NATURAL PHILOSOPHERS (120).

## CHAPTER I.

**DISTINCTION BETWEEN SIMULTANEOUS, SUCCESSIVE, AND MIXED CONTRAST OF COLOURS.**

(77.) BEFORE speaking of the connection between my own observations and those of others, upon contrast of colours, it is absolutely necessary to distinguish three kinds of contrast.

The first includes the phenomena which relate to the contrast I name *simultaneous;*
The second, those which concern the contrast I call *successive;*
The third, those which relate to the contrast I name *mixed.*

(78.) In the *simultaneous contrast of colours* is included all the phenomena of modification which differently coloured objects appear to undergo in their physical composition and in the height of tone of their respective colours, when seen simultaneously.

(79.) The *successive contrast of colours* includes all the phenomena which are observed when the eyes, having looked at one or more coloured objects for a certain length of time, perceive, upon turning them away, images of these objects, having the colour complementary to that which belongs to each of them.

(80.) I hope to prove by the details which I shall give in the following chapter, that in default of this distinction, one of the subjects of optics, the most fruitful in its applications, has not generally been treated with that precision and clearness necessary to impress its importance on those who, not making any observations of their own, have been contented with reading the result of my researches up to the year 1828, which I presented to the Academy of Sciences. In fact, the distinction of the three contrasts will render it easy to appreciate what new facts my researches add to the history of vision, and to the applications deduced from the study of contrasts. I shall also add, that Dr. Plateau of Belgium, who has occupied himself for many years in reducing all these phenomena to a mathematical and physiological theory, has adopted the distinction of *simultaneous* and *successive* contrasts in his own writings.

(81.) The distinction of *simultaneous* and *successive* contrast renders it easy to comprehend a phenomenon which we may call the *mixed* contrast; because it results from the fact of the

eye, having seen for a time a certain colour, acquiring an aptitude to see for another period the complementary of that colour, and also a new colour, presented to it by an exterior object; the sensation then perceived is that which results from this new colour and the complementary of the first.

(82.) The following is a very simple method of observing the *mixed* contrast.

One eye being closed, the right for instance, let the left eye regard fixedly a piece of paper of the colour A: when this colour appears dimmed, immediately direct the eye upon a sheet of paper coloured B; then we have the impression which results from the mixture of this colour B with the complementary colour (C) of the colour A. To be satisfied of this mixed impression, it is sufficient to close the left eye, and to look at the colour B with the right: not only is the impression that produced by the colour B, but it may appear modified in a direction contrary to the mixed impression C + B, or, what comes to the same thing, it appears to be more A + B.

In closing the right eye and regarding anew the colour B with the left eye, many times running, we perceive different impressions, but successively more and more feeble, until at last the left eye returns to its normal state.

(83.) If instead of regarding B with the left eye, which becomes modified by the colour A, we observe B with both eyes, the right eye being in the normal state, the modification represented by C + B is found much weakened, because it is really C + B + B.

(84.) I advise every one who believes he has one eye more sensitive to the perception of colours than the other, to look at a sheet of coloured paper alternately with the left and with the right eye; if the two impressions are identical, he may be certain that he has deceived himself. But if the impressions are different, he must repeat the same experiment many times in succession; for it may happen that the difference observed in a single experiment, arises from one of the eyes having been previously modified or fatigued.

(85.) The experiment of which I speak appears to me to be particularly useful to painters.

I will now give some examples of *mixed contrast*.

(86.) The left eye having seen Red during a certain time, has an aptitude to see in succession *Green*, the complementary to Red. If it then looks at a Yellow, it perceives an impression resulting from the mixture of Green and Yellow. The left eye being closed, and the right, which has not been affected by the sight of Red, remaining open, it sees Yellow, and it is also possible that the Yellow will appear more Orange than it really is.

(87.) If the left eye had first seen the yellow paper, and afterwards the red, this latter would have appeared violet.
(88.) If the left eye first sees red, then blue, the latter appears greenish.
(89.) If it had first seen blue, then red, the latter would have appeared orange-red.
(90.) If the left eye first sees yellow, then blue, the latter appears blue-violet.
(91.) If it had first seen blue, then yellow, this latter would have appeared orange-yellow.
(92.) If the left eye at first sees red, then orange, this latter appears yellow.
(93.) If it had first seen orange, then red, the latter would have appeared of a red-violet.
(94.) If the left eye first sees red, then violet, the latter appears deep blue.
(95.) If it had first seen violet, then red, the latter would have appeared orange-red.
(96.) If the left eye first sees yellow, then orange, the latter appears red.
(97.) If it had first seen orange, then yellow, the latter would have appeared greenish-yellow.
(98.) If the left eye first sees yellow, then green, this latter would have appeared bluish-green.
(99.) If it had first seen green, then yellow, this latter would have appeared orange-yellow.
(100.) If the eye first sees blue, then green, this latter appears yellowish-green.
(101.) If it had first seen green, then blue, this latter would have appeared blue-violet.
(102.) If the eye first sees blue, then violet, this latter appears reddish-violet.
(103.) If it had first seen violet, then blue, the latter would have appeared greenish-blue.
(104.) If the eye first sees orange, then green, the latter appears bluish-green.
(105.) If it had first seen green, and then orange, this latter would have appeared of a reddish-orange.
(106.) If the eye had first seen orange, and then violet, the latter would have appeared blue-violet.
(107.) If it had first seen violet, and then orange, this latter would have appeared yellowish-orange.
(108.) If the eye first sees green, then violet, the latter will appear red-violet.
(109.) If it had first seen violet, then green, the latter would have appeared of a yellowish-green.

(110.) If the eye first sees red, then green, the latter will appear a little bluer.

(111.) If it had first seen green, then red, this latter would have appeared tinted violet.

(112.) If the eye first sees yellow, then violet, the latter will appear bluer.

(113.) If it had first seen violet, then yellow, this latter would have appeared greenish.

(114.) If the eye first sees blue, and then orange, the latter will appear yellower.

(115.) If it had first seen orange, then blue, the latter would have appeared a little more violet.

(116.) I must remark that all the colours (at least to my eyes) did not undergo equally intense modifications, nor were they equally persistent. For example, the modification produced by the successive view of yellow and violet, or of violet and yellow, is greater and more durable than that produced by the successive view of blue and orange, and still more so than that of orange and blue.

The modification produced by the successive view of red and green, of green and red, is less intense and less persistent.

Finally, I must remark that the *height of tone* exercises much influence upon the modification: for if, after having seen orange, we see dark blue, this latter will appear more green than violet, a contrary result to that presented by a lighter blue.

(117.) I thought that it was the more necessary to mention under a special name the phenomenon which I call *mixed contrast*, as it explains many facts remarked by dealers in coloured stuffs, and is of much inconvenience to artists who, wishing to imitate exactly the colours of their models, work at them too long at a time to enable them to perceive all the tones and modifications. I will now state two facts which have been communicated to me by dealers in coloured fabrics, and I shall refer to Part II. for the application of the study of mixed contrast to painting.

(118.) *First Fact.*— When a purchaser has for a considerable time looked at a yellow fabric, and he is then shown orange or scarlet stuffs, it is found that he takes them to be amaranth-red, or crimson, for there is a tendency in the retina, excited by yellow, to acquire an aptitude to see violet, whence all the yellow of the scarlet or orange stuff disappears, and the eye sees red, or a red tinged with violet.

(119.) *Second Fact.*—If there is presented to a buyer, one after another, fourteen pieces of red stuff, he will consider the last six or seven less beautiful than those first seen, although the pieces be identically the same. What is the cause of this error

of judgment? It is that the eyes, having seen seven or eight red pieces in succession, are in the same condition as if they had regarded fixedly during the same period of time a single piece of red stuff; they have then a tendency to see the complementary of Red, that is to say, Green. This tendency goes of necessity to enfeeble the brilliancy of the red of the pieces seen later. In order that the merchant may not be the sufferer by this fatigue of the eyes of his customer, he must take care, after having shown the latter seven pieces of red, to present to him some pieces of green stuff, to restore the eyes to their normal state. If the sight of the green be sufficiently prolonged to exceed the normal state, the eyes will acquire a tendency to see red; then the last seven red pieces will appear more beautiful than the others.

## CHAPTER II.

#### ON THE CONNECTION BETWEEN THE EXPERIMENTS OF THE AUTHOR AND THOSE PREVIOUSLY MADE BY VARIOUS NATURAL PHILOSOPHERS.

(120.) BUFFON was the first who described, under the appellation of *accidental colours* [*], several phenomena of vision, all of which he considered to have this analogy, *that they result from too great vibration,* or *from fatigue of the eye;* wherein they differ from the colours with which bodies appear to us usually coloured[†], whether these bodies decompose light by acting upon it by *reflection,* by *refraction,* or by *inflection.*

(121.) ACCIDENTAL COLOURS may arise from various causes; for example, they are perceivable under the following circumstances: —
 1. When the eye is pressed in the dark.
 2. In consequence of a blow on the eye.
 3. When the eyes are closed after having looked at the sun for a moment.
 4. When the eyes are fixed upon a small square piece of coloured paper, placed upon a white ground; then the square, if *red*, will appear bordered with a faint green; if it is *yellow*, by a blue; if it is *green*, by a purplish white; if it is *blue*, by a reddish white; and if it is *black*, by a vivid white.

[*] See *Mémoires de l'Académie des Sciences*, 1743.
[†] We must add, *when viewed separately.*

5. If, after having observed these phenomena for a considerable time, we turn our eyes to the white ground in such manner as no longer to see the small square of coloured paper, we shall then perceive a square of an extent equal to the other, and of the same colour as that which bordered the little square in the preceding experiment (4.).

(122.) I could mention several other circumstances in which Buffon observed accidental colours, but I should depart too widely from the principal object of this book, which is,—" the law of simultaneous contrast of colours and its application; " remarking, that the fourth circumstance in which Buffon observed accidental colours appertains to *simultaneous contrast*, while the fifth relates to *successive contrast*. Buffon never established the law which connects the phenomena he has described.

(123.) Scherffer, in 1754, gave great precision to the phenomena which relate to successive contrast, in demonstrating *that a given colour produces an accidental colour*, the same we now call ITS COMPLEMENTARY. He also corrected some of the observations of Buffon; and, not content with that, he sought to explain the cause of the phenomenon, as I shall show in the following section. He only briefly touched upon *simultaneous contrast*. (See his memoir, § 15., *Journal de Physique*, tom. xxvi.).

(124.) Œpinus * and Darwin † also occupied themselves with successive contrast.

(125.) Count Rumford ‡ made simultaneous contrast an object of experiment and observation, which I must dwell upon, because, among the researches made on this subject, there is none which so much resemble mine. After observing that a shadow produced in a ray of coloured light, *red* for example, on being illuminated by a ray of *white* light equal in intensity to the red, the shadow did not appear *white*, but was tinted *green*, the complementary of the red ray, when it was near an equal shadow produced in the white ray, this latter shadow being lighted by the red ray, and appearing of that colour, he demonstrated:—

1. That the result is the same when the ray of coloured

---

* *Mémoires de l'Académie de Pétersbourg, et Journal de Physique*, année 1785, tom. xxvi. p. 291.
† *Philosophical Transactions*, vol. lxxvvi., for 1785.
‡ *Experiments upon Coloured Shadows, on the Principles of the Harmony of Colours*, &c., in Philosophical Papers, &c., by Count Rumford, London, 1802. vol. i.

light is replaced by light transmitted through a glass or other coloured medium, or by coloured light reflected by an opaque coloured body.

2. That if in a circle of white paper, placed upon a large sheet of black paper laid upon the floor of a room, two bands of paper of six lines in width and two inches in length are laid side by side, one of which is covered with a powder coloured A, and the other with a grey powder composed of ceruse and lampblack, in such proportions that the light reflected by it is of equal intensity to the coloured light A, upon looking with one eye through the hand at the two bands, that which is covered with the grey powder will appear tinged with the complementary colour of A, and this complementary of A will appear as brilliant as A itself.

(126.) The author remarks that, in order to ensure success in this experiment, we must take many precautions, not only to avoid the light reflected from surrounding objects, but also to obtain a grey capable of reflecting a light equal in intensity to the coloured light. He adds that the difficulties are very great if we use pigments ground in oil, which gives their colours a brown tinge, as they never possess the purity of the colours of the spectrum.

(127.) If it be true that the experiments of Rumford correspond with those which I have made with colours in connection with white, black, and grey, and that they form a particular instance of the law of simultaneous contrast, as I have established it, it is not less true that the law cannot be deduced without making the series of researches which I have undertaken; for the experiments of Rumford exhibiting the maximum of the phenomenon, we cannot affirm that under ordinary circumstances there would be not only a modification of white, black, and grey by juxtaposed colours, but also a mutual modification of these latter. We have seen that colours become deeper by being placed in contact with white, and that they become fainter when in contact with black, the contrast, as I have demonstrated, embracing both the optical composition of the colour and the height of its tone.

(128.) Struck by observing in his experiments that a coloured ray developed its complementary, Rumford laid it down as a *principle* in the harmony of two colours *that they must respectively present coloured light in the proportions necessary to form white light*, and he advised ladies to choose their ribbons in accordance with this law. He also thought that painters might derive much benefit from an acquaintance with this principle ;

but it is evident that Rumford's principle of the harmony of colours is nothing more than the production of an ingenious fancy, and that, as he has stated it, it would be difficult to make it throw any light upon the practice of painting. I shall return to this point, however, when treating of the applications of my theory. Meanwhile it is important to mention that Rumford never made an experiment suitable for demonstrating the influence of two contiguous colours, or rather of two colours viewed simultaneously; he was unacquainted with the generality of the phenomenon, of which he had observed one fact; and if it be true that there is a harmony between two colours complementary to each other, this proposition will be entirely incorrect, if, with Count Rumford, we only admit of harmony of colours in the single instance of juxtaposition. I shall return to this subject (174, &c.).

(129.) The last author who, as an observer, has treated of accidental colours is M. Prieur de la Côte-d'Or.* Under the term *contrast*, he has treated of phenomena which belong exclusively to *simultaneous contrast*. For example, a small band of orange-coloured paper when laid upon a yellow ground appears red; while it will appear yellow upon a red ground. According to the principle laid down by M. Prieur, the accidental colour of the little band should be that which results from its own colour, minus that of the ground. *It appears,* says he, *that a certain fatigue of the eye, produced instantaneously by the intensity of the light, or more slowly by prolonged vision, concurs in producing these appearances.* But he recognised *that excessive fatigue of the organ would cause a degeneration of the colours belonging to another scale.* And he finally adds, *that the colours named accidental by Buffon, and upon which Scherffer has given an interesting memoir, belong to the class of contrasts, or at least constantly follow the same law.* It is plain that M. Prieur has not made that distinction between the classes of contrasts which I have established in the preceding chapter.

(130.) Haüy, in his *Traité de Physique*, reviews the observations of Buffon, Scherffer, Rumford, and Prieur; but notwithstanding the lucid style of the illustrious founder of crystallography, there is an obscurity which arises from the fact that he has not observed the preceding distinction, and this obscurity is particularly evident when he relates the explanations previously given of these phenomena, as I shall show in the following section.

(131.) According to what has been said, we see,

* *Annales de Chimie,* tom. liv. p. 5.

1. That the authors who have treated of contrast of colours have described two classes of phenomena, without distinguishing one from the other:
2. That Scherffer has given the law of *successive* contrast:
3. That Count Rumford has given the law of the modification experienced in a particular instance by a grey band placed beside a coloured one:
4. That Scherffer first, and subsequently M. Prieur de la Côte-d'Or, with more precision, have given the law of the modification which a small white or coloured surface experiences from the different colour of the ground upon which it is placed.

(132.) But if it be true, that in this case we perceive in the most striking manner the modification which the colour of the small extent of surface is susceptible of receiving from that of the ground, we cannot, on the other hand, appreciate the modification experienced in the colour of the ground from that of the small surface, because we see only half of the phenomena, and we should greatly err were we to think that a coloured object cannot be modified by the colour of another, unless it is much larger than the first. The manner in which I have arranged the coloured objects in my observations on simultaneous contrast has enabled me to show:—

1. That it is not indispensably necessary to the modification of one colour by another, that the first should be of greater extent than the second, since my observations have been made upon equal and merely contiguous bands.
2. That we may judge accurately of the modifications experienced by contiguous bands, by comparing them with those which are not contiguous; a condition which enables us to see the phenomenon of simultaneous contrast in the most perfect manner, and to establish its *general law*.
3. That in increasing the number of bands not in contact, or which are placed on each side of those which do touch, we see, when the eye is sufficiently distant from the two series of bands, that the influence of one of the contiguous bands is not limited to the next band in contact with it, but that it extends also to the second, and to the third, &c., although fainter in each. *Now, this influence of distance should be noted*, in order to obtain a correct idea of the generality of the phenomenon, and of the applications which may be deduced from the law which comprehends every case.

## SECTION III.

### ON THE PHYSIOLOGICAL CAUSE TO WHICH THE PHENOMENA OF CONTRAST OF COLOURS WERE REFERRED, PREVIOUSLY TO THE EXPERIMENTS OF THE AUTHOR.

(133.) SCHERFFER has given a physiological explanation of successive contrast of colours, which appears satisfactory in the cases to which it has been applied. It is based upon the following proposition, that —

*If one of our senses receives a double impression, one of which is vivid and strong but the other feeble, we do not perceive the latter. This occurs particularly when they are both of the same kind, or when the powerful action of an object upon one of the senses* IS FOLLOWED *by another of the same nature, but infinitely weaker or less violent.*

Let us now apply this principle to the three following experiments on Successive Contrast.

#### FIRST EXPERIMENT.

Look for some time at a small white square placed upon a black ground.

Ceasing to look at this, and directing the eye upon the black ground, we there perceive the image of a square, equal in extent to the white square, but, instead of being brighter than the ground, it is, on the contrary, darker.

#### *Explanation.*

The portion of the retina upon which the white light of the square acted in the first part of the experiment, is more fatigued than the remainder of the retina, which has received only a feeble impression from the faint rays reflected by the black ground; the eye being then directed upon the black ground during the second part of the experiment, the feeble light of this ground acts more strongly upon that part of the retina which has not been fatigued, than upon that part which has been: hence the image of the black square seen by that portion of the eye.

### Second Experiment.

Look for some time at a small blue square on a white ground. Turn the eye away from this, and fix it upon the white ground, it then perceives the image of an orange square.

#### Explanation.

The portion of the retina on which the light of the blue square acted in the first part of the experiment being more fatigued by this colour than the rest of the retina, it happens, during the second portion of the experiment, that the portion of the retina fatigued by the blue is disposed thereby to receive a stronger impression of orange, the complementary of blue.

---

### Third Experiment.

Look for some time at a red square on a yellow ground.
Turning the eye away, fix it upon a white ground, it perceives the image of a green square on a blue-violet ground.

#### Explanation.

During the first part of the experiment that portion of the retina which sees red becomes fatigued by this colour, while the portion which sees yellow during the latter portion is equally fatigued; consequently, in the second part of the experiment, the portion of the retina which had seen red now sees green, its complementary, whilst that portion which had seen yellow, sees blue-violet, its complementary.

(134.) These three experiments, as well as their explanations, taken at random from the memoir by Scherffer, amongst a great many others analogous, will suffice, I think, to demonstrate that it was actually the phenomenon of *successive contrast* which specially occupied that ingenious observer. Considering this, it is surprising that Haüy, in endeavouring to make known the explanation of Scherffer, should have spoken exclusively of a case of *simultaneous contrast*, a phenomenon which the latter philosopher has only casually mentioned, as I remarked above (123.). Moreover, this is Haüy's mode of expressing himself on the subject, taking as an illustration the case in which a small band of white paper is placed upon red paper —

"We may," says he, "consider the white of this band as being "composed of a bluish-green and red. But the impression of "the red colour, acting with much less force than that produced

" by the surrounding colour of the same kind, is eclipsed by the
" latter, so that the eye is only sensible of the impression of the
" green, which being, as it were, foreign to the colour of the
" ground, acts upon the organ with all its power."*

(135.) Although this explanation appears to be a natural consequence of the principle set forth by Scherffer, yet this philosopher does not appear to me to have applied it to the explanation of *simultaneous contrast*, and the passage in his memoir, quoted above (133.), is very clear: —

" This must principally take place when they (the impres-
" sions) are both of the same kind, or when the powerful action
" of an object on one sense *is followed* by another of the same
" nature, but much weaker, and less violent."

(136.) Now let us see what difference exists between Scherffer's explanation of *successive contrast*, and that attributed to him by Haüy in the case of *simultaneous contrast*. All the observations on successive contrast explained by Scherffer exhibit this result, — that the portion of the retina, which in the first part of the experiment is impressed by a given colour, sees in the subsequent part of the observation, the complementary of the given colour, and this new impression is independent of the extent of the coloured object relatively to that of the ground on which it is placed, or rather, of the objects surrounding the former.

(137.) This is not expressed in the explanation that Haüy attributes to Scherffer; in fact —

1. The portion of the retina that sees the white band placed on a red ground, sees it of a bluish-green, that is to say, of the complementary colour of the ground. Now, according to the experiments of Scherffer, this portion, fatigued by white light, *has a tendency to see, not bluish-green, but black*, which is, in a manner, the complementary of white.

2. For, to admit the explanation attributed to Scherffer, it would be necessary that the object whose colour is modified by that of another, should in general be of much smaller extent than the latter, since it is only by this excess of extent in the modifying body that we can conceive *in general* this excess of action which neutralises a part of that of the first object; I say, in general, because there are cases where it may be said that a much brighter colour might modify another, although it occupied a very small space around

---

* *Traité de Physique*, 3ᵉ édition, tom. ii. p. 272.

it. To resume, we perceive the difference between the explanation Scherffer has given of *successive contrast*, and that of *simultaneous contrast* attributed to him.

(138.) If we revert to this last experiment in order to test its value — no longer under the circumstances related by these authors, of a small band appearing to be modified only when seen on a ground — but in those where two bands of equal extent are mutually modified, not only when in contact, but when at a distance, as is shown by the result of my experiments — we may readily appreciate the difficulty that presents itself, thus : —

- 1. Let us suppose that the figure 4, Plate III., represents the image depicted on the retina of a red band R, contiguous to a blue band B ; the first will acquire orange or lose blue, and the second will acquire green or lose red. Now, it is the portion of the retina on which the image of the band R is impressed, that, according to the opinion of Scherffer, will lose its sensibility for red, as it is the portion of the retina on which is depicted the image of the band B that will lose its sensibility for blue : consequently, I do not perceive how it can be the part R which in reality loses its sensibility for blue, or how it can be the part B which loses its sensibility for red.
- 2. In my experiments, the coloured bands being of equal extent, there appears no reason in general (as in the case where a small band being placed upon a ground of large extent), that one of the bands should modify the other, by the greater fatigue it may occasion the retina.

(139.) It was doubtless owing to the difficulties presented in the explanation we have examined, that the illustrious author of the *Mécanique Céleste* was led to suggest another, which Haüy inserted in his *Traité de Physique* after that which he attributes to Scherffer. The case is still that of a small white band placed upon a red ground. The illustrious geometrician supposed, says Haüy, " that there exists in the eye a certain
" disposition, in virtue of which the red rays comprised in the
" white of the small band are attracted, as it were, at the
" moment they reach this organ, by the rays forming the pre-
" dominating red colour of the ground, so that the two impres-
" sions form only one, and that of the green colour is enabled to
" act as if it were alone. According to this method of under-
" standing the subject, the impression of the red decomposes
" that of the white, and while the actions of the homo-
" geneous rays unite together, the action of the heterogeneous

" rays, being disengaged from this combination, produces its
" separate effect." *

(140.) I shall not contest the accuracy of this explanation beyond remarking, that it admits implicitly, as a necessary consequence, that the modifying colour occupies a greater extent of surface than the colour modified: but it is probable that such an opinion would not have been given if the illustrious author had been acquainted with the true explanation of Scherffer on successive contrast, and instead of quoting a single experiment of simultaneous contrast, which does not include more than half the phenomenon, had quoted one in which differently coloured bands of equal extent were seen to modify each other, even when not in contact.

(141.) After having shown the insufficiency of these explanations of *simultaneous contrast*, it only remains to speak of the relations which appear to me to exist between the organ of vision and this phenomenon observed in the circumstances under which I have studied it. Every author who has treated of accidental colours, agrees in considering them as being the result of fatigue of the eye. If this be incontestibly true in the case of *successive contrast*, I do not believe it to be so of *simultaneous contrast;* for, in arranging the coloured bands in the manner I have done, as soon as we succeed in seeing all four together, the colours are observed to be modified before the eye becomes in the least degree fatigued; although I admit that it often requires several seconds to perceive these modifications. But is not this *time* necessary, as is that which is given to the exercise of each of our senses, whenever we wish to explain to ourselves a sensation that affects them? There is, also, one circumstance that explains the necessity of *this time* in many cases, viz.: the influence of the white light reflected by the surface modified — which is sometimes sufficiently strong to greatly weaken the result of the modification; and the greater part of the precautions suggested for seeing the accidental colours of simultaneous contrast are therefore directed to the diminution of this white light.

Moreover, it is owing to this cause that grey and black surfaces contiguous to surfaces of very pure colours, such as blue, red, yellow, are modified more by this contiguity than white surfaces are. The following experiment, accidentally presented to my notice, will give a good illustration of my idea. A coloured paper, upon which letters of a pale grey had been traced, was presented to me one evening at twilight. On first looking at it, I could not distinguish a

* *Traité de Physique*, 3ᵉ édition, tom. ii. p. 272.

single letter; but in a few minutes I contrived to read the writing, which appeared to me to have been traced with an ink of a colour complementary to that of the ground. Now, I ask, if at the moment when my vision was distinct, were my eyes more fatigued than when I first looked at the paper without being able to distinguish the letters upon it, and which were seen to be of the colour complementary to that of the ground?

(142.) Finally, I conclude from my observations, that whenever the eye sees two differently coloured objects simultaneously, the analogous character of the sensation of the two colours undergoes such a diminution, that the difference existing between them is rendered proportionably more sensible in the simultaneous impression of these two colours upon the retina.

# PART II.

## ON THE PRACTICAL APPLICATION OF THE LAW OF SIMULTANEOUS CONTRAST OF COLOURS.

PROLEGOMENA.

FIRST DIVISION.—IMITATION OF COLOURED OBJECTS BY MEANS OF COLOURED MATERIALS IN A STATE OF INFINITE DIVISION.

SECOND DIVISION.—IMITATION OF COLOURED OBJECTS BY COLOURED MATERIALS OF A CERTAIN SIZE.

THIRD DIVISION.—COLOUR-PRINTING ON TEXTILE FABRICS, AND ON PAPER.

FOURTH DIVISION.—EMPLOYMENT OF FLAT TINTS FOR COLOURING.

FIFTH DIVISION.—ARRANGEMENT OF COLOURED OBJECTS OF A CERTAIN SIZE.

# INTRODUCTION.

(143.) THE observations set forth in the First Part, together with the Law of Simultaneous Contrast, which simplifies by generalizing them, have doubtless suggested to the reader the numerous applications of which they are susceptible. This expectation, I hope, will not be disappointed by the details into which I am now about to enter—details which will prove that this work would not have attained to its aim of usefulness if I had neglected to exhibit them; for, to state them with the precision they possess, it is incumbent on me to give a series of observations altogether as precise as those which form the materials of the First Part.

(144.) The following is a tabular arrangement of the applications I propose making:—

### FIRST DIVISION.

*Imitation of Coloured Objects by means of Coloured Materials in a State of Infinite Division.*

1st *Section.*—Painting in Chiar'oscuro.
2nd *Section.*—Painting in Flat Tints.
3rd *Section.*—Colouring.

### SECOND DIVISION.

*Imitation of Coloured Objects by Coloured Materials of a certain Size.*

1st *Section.*—Gobelins Tapestry.
2nd *Section.*—Beauvais Tapestry.
3rd *Section.*—Savonnerie Tapestry.
4th *Section.*—Carpets.
5th *Section.*—Mosaics.
6th *Section.*—Stained Glass.

### THIRD DIVISION.

*Printing.*

1st *Section.*—Printing Designs upon Textile Fabrics, Calico-Printing, &c.
2nd *Section.*—Printing Designs upon Paper, Paper-Hangings, Paper-staining.
3rd *Section.*—Printing with Types upon Coloured Paper.

### FOURTH DIVISION.

*Colouring with Flat Tints* (Tinting).

1st *Section.*—Geographical Maps.
2nd *Section.*—Engravings.

### FIFTH DIVISION.

*Arrangement of Coloured Objects upon Surfaces of greater or less Extent.*

1st *Section.*—In Architecture.
2nd *Section.*—In Decorating Interiors—Dwellings, Picture Galleries, Churches, Theatres, &c.
3rd *Section.*—Clothing.
4th *Section.*—Horticulture.

# PROLEGOMENA.

§ 1. DEFINITION OF THE WORDS TONES, SCALES, AND HUES (146.)—(155.)

§ 2. REMARKS UPON CERTAIN GRAPHIC CONSTRUCTIONS PROPOSED FOR THE REPRESENTATION AND DEFINITION OF COLOURS AND THEIR MODIFICATIONS (156.)—(173.)

§ 3. HARMONY OF COLOURS (174.)—(179.)
    HARMONIES OF ANALOGY (180.)
    HARMONIES OF CONTRAST (180.)

§ 4. ASSORTMENT OF RED, ORANGE, YELLOW, GREEN, BLUE, AND VIOLET WITH WHITE, BLACK, AND GREY (181.)—(254.)

# PROLEGOMENA.

(145.) BEFORE entering upon the details of these applications, I think it necessary to offer some remarks as a prolegomena to the Second Part of this Work. They will enable me to establish several propositions or principles to which I shall frequently refer the reader, and thus avoid repetitions which occasion the objection of apparently diminishing the amount of generalization the work really possesses.

I shall give successively :
1. The definitions of many expressions applicable to colours and to their modifications:
2. The means of representing and defining these colours and their modifications by the aid of a graphic construction or diagram :
3. A classification of the Harmonies of Colours :
4. A view of the associations of the prismatic colours with White, Black, and Grey.

## § 1.

#### DEFINITION OF THE WORDS TONES, SCALES, AND HUES.

(146.) The words TONES and HUES (*nuances*) continually occur whenever colours are mentioned, both in common language as well as in that of artists; nevertheless they are not so well defined but that when either of them is used we are sure the other is not meant.

(147.) Feeling the necessity of being able to distinguish the case where one colour—BLUE, for example—is reduced with *White*, or deepened with *Black*, from that where this same colour is modified by another,—for instance, where BLUE is modified by Yellow or Red, added in such small quantities that

the BLUE still being *blue*, yet differs from what it was before the addition of Yellow or Red in being Violet or Green, I premise that in the course of this work I never apply indifferently the words Tone and Hue to these two kinds of modifications; consequently,

(148.) The word TONES of a colour will be exclusively employed to designate the different modifications which that colour, taken at its maximum intensity, is capable of receiving from the addition of White, which weakens its *Tone*, and Black, which deepens it.*

(149.) The word SCALE (*gamme*) is applied to the collection of Tones of the same colour thus modified. The pure colour is the normal tone of the scale, if this normal tone does not belong to a broken or reduced scale; *i. e.* to a scale all the tones of which are altered with Black (153.).

(150.) The word HUES (*nuances*) of a colour will be exclusively applied to the modifications which that colour receives by the addition of a small quantity of another colour.

For example, we say, the Tones of the *Blue* Scale, the Tones of the *Red* Scale, the Tones of the *Yellow* Scale, the Tones of the *Violet* Scale, the Tones of the *Green* Scale, the Tones of the *Orange* Scale.

We say Hues of Blue, to designate all the Scales the colour of which, still remaining Blue, yet differs from pure Blue; for each hue will comprehend in itself the tones which constitute a Scale more or less allied to the Blue Scale.

In the same sense we say, *hues* of Yellow, *hues* of Red, *hues* of Violet, *hues* of Green, *hues* of Orange.

(151.) I have defined TONES (tints and shades) of a colour, the different modifications which this colour, taken at its *maximum of intensity*, is susceptible of receiving from Black or White: it must be remarked that the condition *of the colour taken at its maximum of intensity for receiving Black* is absolutely essential to this definition, for, if Black is added to a Tone which was below the maximum, it passes then into another Scale; and this is the proper place to remark that artists distinguish Colours as *pure, broken, reduced, grey,* or *dull.*

---

* The author employs only one word to explain both these modifications; whereas in English we have two,—*Tint* and *Shade:*—by the former we understand that White is added to a normal colour; by the latter, we recognise the addition of Black to a similar colour. To avoid confusion, the author's term *Tones* is retained in the translation.

(152.) The *pure colours* comprehend those which are called *Simple* or *Primary*, Red, Yellow, Blue,— and those which result from their binary compounds, *Secondaries*, — Orange, Green, Violet, and their Hues.

(153.) The *broken colours* comprehend the pure colours mixed with Black, from the highest to the deepest Tone.

From these definitions, it is evident that in all the Scales of simple and binary colours the Tones which stand above the pure colour are *broken Tones*.

(154.) Artists, and particularly painters and dyers, admit that the mixture of the three primary colours in certain proportions produces *Black*, from which it becomes evident that whenever we mix these three colours in such proportions that two of them predominate, Black will result; arising from the mixture of the whole of that colour which is in small quantity with suitable proportions of the two predominant colours.

Thus, if a small proportion of Blue is added to Red and Yellow, a little Black is produced, which goes to reduce or *break* the Orange.

(155.) We must not overlook the fact, that whenever we mix pigments to represent primitive colours, we are not mixing the colours of the solar spectrum, but mixing substances which painters and dyers employ as Red, Yellow, and Blue colours.

## § 2.

REMARKS UPON CERTAIN GRAPHIC CONSTRUCTIONS PROPOSED FOR THE REPRESENTATION AND DEFINITION OF COLOURS AND THEIR MODIFICATIONS.

(156.) Several graphic constructions have been proposed, under the denomination of Tables, Scales, Colour-circles, Chromatometers, &c., for the purpose of representing, either by numbers or by a rational nomenclature, colours and their various modifications. They are generally based upon the three following propositions: —

1. There are three primary colours, — Red, Yellow, and Blue.
2. Equal parts of any two of these colours mixed together yield a pure secondary colour.
3. Equal parts of the three primary colours mixed together yield Black.

(157.) It is easy to demonstrate that the last two propositions are purely hypothetical, since they cannot be demonstrated by experiment. In fact,

1. We know of no substance which represents a primary colour, — *i. e.* which reflects but one class of coloured rays, whether pure Red, Blue, or Yellow (7).
   If we take Ultramarine for the purest Blue, it may be objected that it is not *pure*, since it also reflects Red and Violet rays as well as Blue rays.

2. From the impossibility of procuring materials of pure colours, how can it be said that Orange, Green, and Violet are composed of two simple colours mixed in equal portions? how can it be asserted that Black consists of the three simple colours mixed in equal portions?

And in this place we may also remark, that the constructors of these chromatic tables, &c. when they come to apply them, only point out mixtures which, to use their own words, do not produce the results that ought to be deduced from their pretended principles.

(158.) We cannot fail to recognise that the greater part of the substances coloured Blue, Red, or Yellow, with which we are acquainted, on being mixed with each other, only produce Violets, Greens, and Oranges, inferior in brilliancy and purity to those coloured materials which are found in nature of a pure Orange, Violet, or Green colour. A result which would explain itself if they admitted with us that each of the coloured materials mixed together reflects at least two kinds of coloured rays; and if it is admitted with painters and dyers, that when there is a mixture of materials which separately reflect Red, Yellow, and Blue, there is also produced a small portion of Black, which tarnishes the brilliancy of the mixture. Conformably to this view, it is also certain, that the Violets, Greens, and Oranges, resulting from a mixture of coloured materials, are much more brilliant when the respective colours of these materials approach each other. For example: —

When we mix Blue and Red to form Violet, the result will be better if we take a Red *tinged with Blue*, and a Blue *tinged with Red*, than if the Red or the Blue inclined to Yellow; in like manner a Blue tinged with Green, mixed with a Yellow, will yield a purer Green than if Red formed a portion of either colour.

(159.) In order to represent all the modifications which I call

*Tones* and *Hues of Colours*, as well as the relations which exist between those which are complementary to each other, I have devised the following diagram, which appears to me remarkable for its simplicity.

From a centre, *c*, I describe two circumferences, Y, *y*, Plate 2., and divide each of them by means of three radii, *c a, c b, c d*, into three arcs of 120 degrees each.

The portion of each radius contained between the two circumferences Y, *y*, I divide into twenty parts, which represent so many tones of the colours Red, Blue, and Yellow.

(160.) In each of the scales of these three colours, there is one tone which, when pure, represents in its purity the colour of the scale to which it belongs; therefore I name it the *normal tone of this scale*.

If we represent a unit of the surface *s* covered entirely with the pigment which reflects the normal colour, and if we suppose that this pigment is on the surface in a quantity equal to 1., we can represent the tones *above* the normal tone by the unit of surface covered with 1 of the normal colour *plus* Black, in quantities which increase with the number of the *tones* (shades), and we can represent the tones *below* the normal tone by the unit of surface covered with a fraction of the quantity 1 constituting the normal tone mixed with quantities of White, increasing as the tone is of a lower number; and which contains more White the smaller the number indicated on the tone.

If the tone 15 of the Red scale is the normal tone, the normal tone of the Yellow scale will be a lower number, while the normal tone of the Blue scale will be of a higher number. This depends upon the unequal degree of brilliancy or luminousness of the colours.

(161.) If we divide each arc of 120 degrees into two of 60 degrees, and carry these points of division from the circumference to the centre *y*, and divide these radii into twenty parts, commencing at *y*, it will represent twenty tones of the scales of Orange, of Green, and of Violet; and I may remark, that the colours which lie at the extremity of each diameter are *complementaries* of each other.

It would be easy to divide each arc of 60 degrees into arcs of 30 degrees, and so obtain radii upon which might be represented twenty tones of scales, which I shall name Red-Orange, Orange-Yellow, Yellow-Green, Green-Blue, Blue-Violet, Violet-Red.

By dividing each arc in five, for example, and drawing five radii, which I will divide into twenty parts each, setting out from the circumference Y, we obtain sixty new scales.

(162.) Commencing with Red, I shall designate them as follows:—

| a. Red. | e. Yellow. | i. Blue. |
|---|---|---|
| 1st Red. | 1st Yellow. | 1st Blue. |
| 2nd Red. | 2nd Yellow. | 2nd Blue. |
| 3rd Red. | 3rd Yellow. | 3rd Blue. |
| 4th Red. | 4th Yellow. | 4th Blue. |
| 5th Red. | 5th Yellow. | 5th Blue. |
| b. Red-Orange. | f. Yellow-Green. | k. Blue-Violet. |
| 1st Red-Orange. | 1st Yellow-Green. | 1st Blue-Violet. |
| 2nd Red-Orange. | 2nd Yellow-Green. | 2nd Blue-Violet. |
| 3rd Red-Orange. | 3rd Yellow-Green. | 3rd Blue-Violet. |
| 4th Red-Orange. | 4th Yellow-Green. | 4th Blue-Violet. |
| 5th Red-Orange. | 5th Yellow-Green. | 5th Blue-Violet. |
| c. Orange. | g. Green. | l. Violet. |
| 1st Orange. | 1st Green. | 1st Violet. |
| 2nd Orange. | 2nd Green. | 2nd Violet. |
| 3rd Orange. | 3rd Green. | 3rd Violet. |
| 4th Orange. | 4th Green. | 4th Violet. |
| 5th Orange. | 5th Green. | 5th Violet. |
| d. Orange-Yellow. | h. Green-Blue. | m. Violet-Red. |
| 1st Orange-Yellow. | 1st Green-Blue. | 1st Violet-Red. |
| 2nd Orange-Yellow. | 2nd Green-Blue. | 2nd Violet-Red. |
| 3rd Orange-Yellow. | 3rd Green-Blue. | 3rd Violet-Red. |
| 4th Orange-Yellow. | 4th Green-Blue. | 4th Violet-Red. |
| 5th Orange-Yellow. | 5th Green-Blue. | 5th Violet-Red. |

I do not attach any importance to this nomenclature, but employ it merely as being the simplest to distinguish the seventy-two scales of which I have spoken. We may augment the number indefinitely, by inserting as many as we choose between those already designated.

(163.) Let us now represent the gradation of each of the colours of the scales in the circle by the addition of *Black*, progressively increasing in quantity until we arrive at pure black.

To this end, let us imagine a quadrant the radius of which is equal to that of the circle, and disposed so as to turn upon an axis perpendicular to the centre of the circle. Divide this quadrant.

    1. By concentric arcs, $x$, $y$, which coincide with the circumference of the circle marked by the same letters.

    2. By ten radii, 1, 2, 3, 4, 5, 6, 7, 8, 9, 10.

Divide each of these radii into twenty parts, representing twenty tones corresponding with each of the tones of the scale represented on the circle.

(164.) I suppose that the tenth radius comprises the gradations of normal Black, which is supposed to envelope the hemisphere described by the motion of the quadrant upon its axis:

this Black, mixed in decreasing quantities with increasing quantities of White, gives twenty tones of normal Grey, which ends by melting into White, situated above the first tone. I suppose also that the normal tone of each of the scales taken upon the radii of the quadrant, 1, 2, 3, 4, 5, 6, 7, 8, 9, is formed of a mixture of Black with the colour of any one of the scales contained in the circle—for example, of the Red scale,—and in such proportion that the normal tone 15 of this scale being represented by a unit of surface covered with 1 or $\frac{10}{10}$ of Red,

The tone 15 of the scale of the 1st radius of the quadrant $= \frac{9}{10}$ Red $+ \frac{1}{10}$ Black.
The tone 15 of the scale of the 2nd radius of the quadrant $= \frac{8}{10}$ Red $+ \frac{2}{10}$ Black.
The tone 15 of the scale of the 3rd radius of the quadrant $= \frac{7}{10}$ Red $+ \frac{3}{10}$ Black.
The tone 15 of the scale of the 4th radius of the quadrant $= \frac{6}{10}$ Red $+ \frac{4}{10}$ Black.
The tone 15 of the scale of the 5th radius of the quadrant $= \frac{5}{10}$ Red $+ \frac{5}{10}$ Black.
The tone 15 of the scale of the 6th radius of the quadrant $= \frac{4}{10}$ Red $+ \frac{6}{10}$ Black.
The tone 15 of the scale of the 7th radius of the quadrant $= \frac{3}{10}$ Red $+ \frac{7}{10}$ Black.
The tone 15 of the scale of the 8th radius of the quadrant $= \frac{2}{10}$ Red $+ \frac{8}{10}$ Black.
The tone 15 of the scale of the 9th radius of the quadrant $= \frac{1}{10}$ Red $+ \frac{9}{10}$ Black.

It is understood that these proportions relate to the effect of the mixtures upon the eye, and not to material quantities of the Red and Black substances.

(165.) We see then:
1. That each of these tones 15, composed of Colour and Black, reduced by White and deepened by Black, gives a scale of twenty tones, the more broken the nearer they approach the scale of normal black.
2. That the quadrant, by its motion on the axis of the circle, represents the scales of every other colour besides red, broken with black. These broken scales are equidistant, and each is formed of equidistant tones.
3. That every colour is thus included in an hemisphere, the circular plane of which comprises the pure colours, the central radius, black and the intermediate space and the pure colours broken by different proportions of black.

(166.) Let us now return to the hemispheric construction, as described, and see the advantages it possesses for representing the reduction of pure colours by white, their gradation by black, and their modifications by mutual mixture, comprising the modification of hues and of breaking: let us now examine the possibility of realising them by means of coloured materials.

(167.) To establish the hemispheric construction, we have supposed,—

1. That the normal tone of each of the scales comprised in the circular plane is *visually* as pure as possible.
2. That the tones bearing the same number in all the scales, both the pure as well as the broken tones, are *all visually* of the same height (*hauteur*).
3. That, if we take three tones of the same number in three consecutive scales, the tone of the intermediate scale is the mean of the colours of the extreme scales.

Consequent upon these suppositions, it is easy to explain the modifications of a pure colour in departing from its normal tone.

(168.) These modifications are produced in the following manner:—

1. *The pure colour goes not out of its scale.*

   In this case the modification is in the direction of the radius of the circle; in going from the normal tone towards the centre it takes white, whilst in going from the normal tone towards the circumference it takes black.

2. *The pure colour goes out of its scale by the addition of black.*

   In this case all the normal tones of the different scales comprised in the quadrant perpendicular to the circle have for a starting-point the normal tone of one of the pure scales of the circle with which the quadrant coincides. This normal tone, resulting from a quantity of coloured material represented by unity, covering an unit of surface $s$, the normal tones of the quadrant result from the mixture of black with a fraction of an unit of the coloured matter. These mixtures compose broken colours, each of which covers the unit of surface $s$, and which are at the same height as the normal tone of the pure colour. The fraction of the quantity of coloured material is smaller in all the normal broken tones, the nearer the scales to which these tones belong approach the vertical axis of the hemisphere.

   Besides each normal tone of the scales of the quadrant is modified, like the normal tones of the scales of the circle, by quantities of white increasing towards the centre, and quantities of black increasing towards the circumference.

3. *The pure colour is modified by the addition of another pure colour.*

   In this case it forms hues more and more approach-

ing itself, according as the quantities of the second colour are in smaller proportion.

These modifications are made circularly and in such manner that the tones retain their numbers.

(169.) Thus, if we admit, with painters and dyers, that there are only three primary colours, and that, in combining them in pairs, we obtain all the pure compound colours, and that by combining them in threes, we produce all the broken (*rompue ou rabattue*) colours, we perceive how it is possible, under this hypothesis, to represent by the hemispherical construction every modification of colour.

(170.) Another advantage possessed by this diagram is, that it gives to painters, dyers, decorators, in a word, to all artists who can apply the law of simultaneous contrast, the complementaries of every pure colour, because the colours which are found at the extremities of the same diameter of the circular plane are complementaries of each other. For example, we not only see that Red and Green, Yellow and Violet, Blue and Orange, are upon the same diameter; but we see also that it is the same with Orange-red and Blue-green, with Orange-yellow and Blue-violet, with Yellow-green and Violet-red, with No. 1. Red and No. 1. Green, . . . . . . in the same manner all colours opposite to each other are mutually complementary.

(171.) Once we know the complementary of a colour in juxtaposition with another, it is easy, according to the principle of mixing, to determine the modification which the second must receive from the first, since this modification is the result of the mixture of the complementary with the colour juxtaposed. In fact, if there is no difficulty to meet, when the result is that of a mixture *non*-complementary to a simple colour—red, yellow, and blue with a binary, orange, green, and violet (it being understood that we now speak the language of painters) (76.), there is really no greater difficulty when the result is a mixture of two binary colours; because it is sufficient to remark that the complementary being much less intense than the colour with which it is mixed, the result is given if we subtract from the latter binary that portion of its simple colour, which, with the complementary, forms white, or, what amounts to the same thing, neutralises it.

### EXAMPLES.

1. Orange added as a complementary to Green neutralises a part of the Blue of this latter, and consequently makes it appear less Blue or more Yellow.

2. Orange added as a complementary to Violet neutralises a

portion of the Blue of the latter, and consequently makes it appear less Blue or more Red.

3. Green added as a complementary to Violet neutralises a portion of the Red of this latter, and consequently makes it appear less Red or more Blue.

These three examples, derived from the juxtaposition of Blue and Green, Blue and Violet, Red and Violet, may be easily explained, if we subtract from the binary colour a portion of its simple colour, which is identical with the juxtaposed colour: thus,

1. Blue subtracted from Green makes it appear yellower.
2. Blue subtracted from Violet makes it appear redder.
3. Red subtracted from Violet makes it appear bluer.

(172.) What must we now do so that this diagram shall become as useful as, from what precedes, we may imagine it can be? It is to put it in practice everywhere, so as to render the language uniform, as we are in the habit of doing in the determination of temperature by the thermometer.

To this end, we must take invariable types of colour, either from the solar spectrum, from polarised light, from the Newtonian rings, or from colours developed in a constant manner by any method, then imitate them as faithfully as possible by means of coloured materials, which we apply on the circular plane of the chromatic diagram. The number of these types of colour must be sufficiently large to represent the principal colours, so that a practised eye may be enabled, without difficulty, to insert all the tones of a scale, and all the hues of which the types may be wanting. In fact, it is necessary that the hemispherical diagram thus drawn should present terms sufficiently near to enable us to employ the various natural pigments, as well as those prepared artificially.

(173.) Before concluding this article, I must insist upon one point; on the possibility of imitating the *types of colours supposed to be pure*, by using coloured materials, which, as I have said before, are seldom or never so (7). For it is in this respect that I consider the realisation of my chromatic construction to be entirely different from that in which analogous constructions are conceived in employing Carmine as the type of Red, Gamboge as the type of Yellow, and Ultramarine or Prussian Blue as the type of Blue, &c.

When it is wished to imitate a pure type, take the pigment which approaches nearest to it; if it differs materially, we must endeavour to correct the difference by another pigment, always observing to take the colour as little removed as possible from that we seek to correct. If a good result is not obtained by this mode of mixture, we put the pigment on the

place it must occupy in the plane. Take, for example, the type of Blue: it is evident that Ultramarine inclines a little to Violet; then we must endeavour to neutralise this latter hue by mixing some Yellow, of a green rather than of an orange hue. If this mixture is unsatisfactory, we must try Saunders's Blue (*la cendre blue*), of the first quality. If this does not exactly represent the type of Blue, it will come much nearer, but by inclining more to Green than to Violet.

Being unable to imitate the type, we must put Ultramarine and Saunders's Blue in the places they respectively occupy as hues of Blue, and leave the place of the type vacant. I have no doubt that an artist who uses coloured materials as an element of his art will derive a very great advantage from the efforts he may make to put each of these elements in the place it should occupy in the construction.

Let us now recur to the advantages of the hemispheric chromatic construction.

1°. *It represents all the modifications resulting from mixing Colours.*

Thus we see: —

(*a.*) How any colour whatever, reduced by white and deepened by black, can, without going out of its scale, give rise to an infinite number of tones; I say infinite, because we can insert as many as we please between the tone 1 and the 20th tone.

(*b.*) How the pure colours, in being modified by each other, can yield an infinite number of hues; for between any two contiguous hues of the circle, we may interpose as many as we choose.

(*c.*) How the normal tone of a pure colour, represented by a quantity equal to 1, covering an unit of surface, is the point of departure of the normal tones of the scales tending towards black; these normal tones being represented by black and a quantity of colouring matter less than the unit, constitute mixtures which cover the unit of surface *s*, and colour it with a tone which has the same number as the normal tone of the pure scale to which it belongs. It is understood that in setting out from this tone to the corresponding tone of normal black, we can insert as many mixtures of colour and black as we choose. The modifications of colours thus indicated by the hemispheric construction, render it extremely easy to comprehend the definitions we have given of the words scales, tones, hues, pure and broken colours.

2°. *It affords the means of knowing the complementary of every Colour, since the names written at the two extremities of the same diameter indicate the colours complementary to each other.*

#### EXAMPLES.

(*a.*) Suppose we place Blue and Yellow in juxtaposition; at one extremity of the diameter, we read the word *Blue*, and at the opposite, the word *Orange*. By this we see that the Blue tends to impart Orange to the Yellow. Again, at the extremity of the diameter where we read the word *Yellow*, at the opposite we read the word *Violet*. We see by this that the Yellow tends to impart Violet to the Blue.

(*b.*) Suppose we place Green and Blue in juxtaposition; at one extremity of the diameter we read the word *Green*, and at the opposite the word *Red*. We see by this that the Green tends to give Red to the Blue, making it Violet. Again, at the extremity of the diameter where we read the word *Blue*, at the opposite we read the word *Orange*. But what will become of the mixture of Green and Orange? To ascertain this, it will suffice to reflect that the Orange tends to neutralise the Blue (its complementary in the Green), and that as it is always too feeble to neutralise all the Blue, its influence is limited to neutralising a portion of it, from whence it results that Green contiguous to Blue will appear yellower than it really is.

(*c.*) When we place Green and Yellow in juxtaposition, we may perceive in the same manner that the Green will give Red to the Yellow, and make it incline to Orange, and that Violet, the complementary of Yellow, by neutralising some Yellow in the Green, will make the latter more Blue or less Yellow.

> 3°. *A third advantage of this diagram, which distinguishes it from the ordinary chromatic constructions is, to present both of the preceding advantages* (1° *and* 2°) *without rendering it necessary to colour it.*

We perceive, then, that it has a practical utility independent of the difficulty attendant upon any attempt to colour it.

> 4°. *A fourth advantage of this construction is to make apparent to all artists who employ coloured materials of a given size (particularly such as the weavers of Gobelins' Tapestry), the relation of number which must exist between the tones of different scales when worked together.*

### § 3.

#### HARMONY OF COLOURS.

(174.) The eye has an undoubted pleasure in seeing Colours, independent of design and every other quality in the object which exhibits them, and a suitable example to demonstrate this is the wainscoating and other wood work of an apartment

in one or more flat tints which really only attract the eyes, and affects them more or less agreeably, according as the painter has assorted the colours well or ill. The pleasure we experience in this case through the agency of the organ of sight, from the actual impressions of colours, is quite analogous to that experienced through the medium of taste from the actual sensations of agreeable savours.

Nothing can give us so exact an idea of the pleasure we derive through the sense of sight as the distinguishing, with reference to the Colours themselves, the several cases in which we experience agreeable impressions.

### I$^{st}$ Case.
#### View of a single Colour.

(175.) Every person whose eye is well organised has certainly experienced pleasure in fixing their attention upon a sheet of white paper on which fall the rays of coloured light transmitted by a coloured glass, whether it is Red, Orange, Yellow, Green, Blue, or Violet.

The same sensation takes place when we look upon a sheet of paper stained with one or another of these colours.

### II$^{nd}$ Case.
#### View of different Tones of the same Scale of Colour.

(176.) The simultaneous view of the series of tones of the same scale which begins with White and terminates with brown-Black, is undoubtedly an agreeable sensation, especially if the tones are at equal intervals and sufficiently numerous — for example, from eighteen to thirty.

### III$^{rd}$ Case.
#### View of different Colours belonging to Scales near to each other assorted conformably to Contrast.

(177.) The simultaneous view of different colours belonging to scales more or less near to each other may be agreeable, but the assortment of the scales which produce this effect is exceedingly difficult to obtain, because the nearer the scales are allied, the more frequently it happens that not only one of the colours injures its neighbour, but the two injure each other reciprocally. The painter can nevertheless make use of this harmony by sacrificing one of the colours, which he lowers to make the other more brilliant.

### IVth CASE.
*View of quite different Colours belonging to Scales very widely separated, arranged conformably to Contrast.*

(178.) The simultaneous view of complementary colours, or of binary unions of colours, which, without being complementary, are nevertheless very different, is also undoubtedly an agreeable sensation.

### Vth CASE.
*View of Various Colours, more or less well assorted, seen through the Medium of a feebly coloured Glass.*

(179.) Different colours, more or less well assorted according to the law of contrast, being seen through a coloured glass which is not sufficiently deep as to make us see all the colours of the tint peculiar to the glass, afford a spectacle which is not without its charm, and which evidently stands between that produced by tones of the same scale, and that by colours more or less well assorted; for it is evident that if the glass was deeper in colour, it would cause every object to appear entirely of its own peculiar colour.

(180.) We conclude from this that there are six distinct harmonies of colours, comprised in two kinds.

### Ist KIND.
#### Harmonies of Analogous Colours.

1. The *harmony of scale*, produced by the simultaneous view of different tones of a single scale, more or less approximating.
2. The *harmony of hues*, produced by the simultaneous view of tones of the same height, or nearly so, belonging to scales more or less approximating.
3. The *harmony of a dominant coloured light*, produced by the simultaneous view of different colours assorted conformably to the laws of contrast, but one of them predominating, as would result from seeing these colours through a slightly stained glass.

### IInd KIND.
#### Harmonies of Contrasts.

1. The *harmony of contrast of scale*, produced by the simultaneous view of two tones of the same scale, very distant from each other.
2. The *harmony of contrast of hues*, produced by the simultaneous view of tones of different height, each belonging to contiguous scales.

3. The *harmony of contrast of colours*, produced by the simultaneous view of colours belonging to scales very far asunder, assorted according to the law of contrast: the difference in height of juxtaposed tones may also augment the contrast of colours.

## § 4.

### ASSORTMENTS OF RED, ORANGE, YELLOW, GREEN, BLUE, AND VIOLET WITH WHITE, BLACK, AND GREY.

(181.) It will not be contrary to the object proposed in the second part of this work, to introduce in this place some observations relative to the kind of beauty of a certain number of arrangements of primitive colours with White, Black, and Grey; but, before exhibiting them, I cannot insist too much upon the fact, that they are not given as a rigorous deduction from scientific rules; for they are but the expressions of my peculiar idea; yet I hope that many classes of artists, particularly dress-makers, decorators of all kinds, designers of patterns for textile fabrics, paper-hangings, &c., will find advantage in consulting them.

(182.) The *Ground*, as well as the *interval* we place between the coloured materials, having some influence upon the effect of colours, I apprise the reader that all my observations have been made with coloured, black, white, and grey circles of $\frac{4}{10}$ths of an inch in diameter, separated by equal intervals of $\frac{4}{10}$ths of an inch; thirteen circles arranged in a straight line forming a series.

(183.) The series intended to enable us to appreciate the effect of white was upon a ground of normal *grey*; that to enable us to appreciate the effect of Black and of Grey was upon a *White* ground slightly tinged Grey. It is necessary to remark that the *coloured* circles placed apart were upon black grounds, which could not but exercise some influence.

(184.) The colours which have been the object of my observations, are Red, Orange, Yellow, Green, Blue, and Violet. When considered in respect to their brilliancy, the differences which they present are sufficiently great to admit of their being divided into two groups: the one containing Yellow, Orange, Red, and bright Green; the other Blue and Violet, which, at the same height of tone, have not the brilliancy of the first. I shall call the first group *luminous colours*, the second *sombre colours*; nevertheless, I must observe that the deep and broken tones of the luminous scale may in many cases be assimilated with the sombre colours, in the same manner that the light tones of Blue and Violet can sometimes be employed as luminous colours in certain assortments.

## ARTICLE 1.
### *Colours with White.*
#### A. BINARY ASSORTMENTS.

(185.) All the primitive colours gain by their juxtaposition with White; that is certain; but the resulting binary assortments are not equally agreeable, and we remark that the height of tone of the colour has a great influence upon the effect of its assortment with White.

The binary assortments in the order of greatest beauty are as follows:—

*Light Blue*    and *White.*
*Rose*          and *White.*
*Deep Yellow*   and *White.*
*Bright Green*  and *White.*
*Violet*        and *White.*
*Orange*        and *White.*

Dark Blue and dark Red produce, with White, too strong a contrast of tone to allow of their association being as agreeable as that of their light tones.

Yellow, being a light colour, for the opposite reason we must take the normal tone, or the highest tone of pure Yellow, to produce the best possible effect.

Dark Green and Violet contrast too much in tone with White to allow of their association being as agreeable as that made with the light tones of these colours.

Finally, the objection which can be made to the combination of Orange with White is, too much brilliancy; nevertheless I should not be astonished if many persons preferred it to the association of Violet with White.

#### B. TERNARY ASSORTMENT OF COLOURS COMPLEMENTARY TO EACH OTHER WITH WHITE.

(186.) It is to me impossible to establish an order of beauty between the binary associations of complementary primary colours; what I shall say will reduce itself to an examination of the effect of White interposed, whether it be between the binary complementary assortment, or between each of the complementary colours.

### *Red and Green.*

(187.) 1. Red and Green are the complementary colours most equal in height; for Red, under its relation of brilliancy, holds a middle place between Yellow and Blue, and in Green the two extremes are united.

2. The assortment *White, Red, Green, White*, &c. is decidedly not superior to the preceding (1), still less when the colours are not deep.
3. The assortment *White, Red, White, Green, White,* &c. seems to me inferior to the preceding (2).

### Blue and Orange.

(188.) 1. *Blue and Orange* are more opposed to each other than Red and Green, because the less brilliant colour, Blue, is isolated; whereas the most brilliant are combined in Orange.
2. The assortment *White, Orange, Blue, White,* &c. is agreeable.
3. The assortment *White, Orange, White, Blue, White,* &c. is the same.

### Yellow and Violet.

(189.) 1. Yellow and Violet form the most distinct assortment under the relation of height of tone, since the least intense colour or the lightest, Yellow, is isolated from the others.

It is from this great contrast of tone that deep Green-yellow, but at the same time pure, mixes better with light Violet than light Yellow with deep Violet.
2. The assortment *White, Yellow, Violet, White,* &c. appears to me inferior to the preceding (1).
3. The assortment *White, Yellow, White, Violet, White,* &c. appears to me inferior to the preceding (2).

C. TERNARY ASSORTMENT OF NON-COMPLEMENTARY COLOURS WITH WHITE.

### Red and Orange.

(190.) 1. *Red and Orange* are very bad together.
2. The assortment *White, Red, Orange, White,* &c. is not at all preferable.
3. The assortment *White, Red, White, Orange, White,* &c. is not so bad as the preceding, because White being favourable to all colours, its interposition between colours which injure each other can only produce an advantageous effect.

### Red and Yellow.

(191.) 1. *Red and Yellow* do not assort badly, especially if the Red is more Purple than Scarlet, and the Yellow more Green than Orange.
2. The assortment *White, Red, Yellow, White,* &c. is preferable to the preceding (1).
3. The assortment *White, Red, White, Yellow, White,* &c. is still better.

### Red and Blue.

(192.) 1. *Red and Blue* are passable, especially if the Red inclines more to Scarlet than to Crimson.
The dark tones are preferable to the light tones.
2. The assortment *White, Red, Blue, White,* &c. is preferable to the first (1).
3. The assortment *White, Red, White, Blue, White,* &c. is preferable to the second (2).

### Red and Violet.

(193.) 1. *Red and Violet* do not assort well together, nevertheless some natural productions present them to us; for example, the Sweet-pea.
* 2. The assortment *White, Red, Violet, White,* &c. is not so bad as the preceding (1).
3. The assortment *White, Red, White, Violet, White,* &c. is preferable to the second (2).

### Orange and Yellow.

(194.) 1. *Orange and Yellow* are incomparably better than Red and Orange.
2. The assortment *White, Orange, Yellow, White,* &c. is agreeable.
3. The assortment *White, Orange, White, Yellow, White,* &c. is not so good as 2, nor perhaps as 1, because there would be too much White.

### Orange and Green.

(195.) 1. *Orange and Green* do not go badly together.
2. The assortment *White, Orange, Green, White,* &c. is preferable to 1.
3. The assortment *White, Orange, White, Green, White,* &c. is perhaps preferable to 2.

### Orange and Violet.

(196.) 1. *Orange and Violet* are passable, but not so good as Orange and Green: the contrast in the latter

case is greater than in the assortment Orange and Violet.

2. The assortment *White, Orange, Violet, White,* &c. is preferable to the preceding (1).
3. The assortment *White, Orange, White, Violet, White,* &c. is preferable to the latter (2).

### Yellow and Green.

(197.) 1. *Yellow and Green* form an agreeable assortment.
2. The assortment *White, Yellow, Green, White,* &c. is much more agreeable than the preceding (1).
3. The assortment *White, Yellow, White, Green, White,* &c. is inferior to the preceding, and perhaps to the first.

The inferiority of 3 appears to me to be owing to there being too much light for the Green.

### Yellow and Blue.

(198.) 1. The assortment *Yellow and Blue* is more agreeable than that of Yellow and Green, but it is less lively.
2. The assortment *White, Yellow, Blue, White,* &c. is perhaps preferable to the preceding (1).
3. The assortment *White, Yellow, White, Blue, White,* &c. is perhaps inferior to the preceding (2).

### Green and Blue.

(199.) 1. *Green and Blue* have a mediocre effect, but less so when the colours are deep.
2. The assortment *White, Green, Blue, White,* &c. is better.
3. The assortment *White, Green, White, Blue, White,* &c. is also of a better effect, because the light is more equally divided.

### Green and Violet.

(200.) 1. *Green and Violet,* particularly when they are light, form an assortment preferable to the preceding. Green and Blue.
2. The assortment *White, Green, Violet, White,* &c. is decidedly not superior to the preceding (1).
3. The assortment *White, Green, White, Violet, White,* &c. is certainly inferior to the latter (2).

### Blue and Violet.

(201.) 1. *Blue and Violet* go badly together.

2. The assortment *White, Blue, Violet, White*, &c. is but little to be preferred to the preceding (1).
3. The assortment *White, Blue, White, Violet, White*, &c. is not so bad as the latter (2).

### ARTICLE 2.
### *Colours with Black.*

(202.) I do not know whether the custom of using Black for mourning should act as an impediment to our employing it in an infinite variety of cases where it would produce excellent effects; however that may be, it can be allied in a most advantageous manner not only with sombre colours, to produce harmonies of analogy, but also with light and brilliant colours, to produce harmonies of contrast entirely different from the first. The Chinese artists, it appears to me, have excellent judgment in employing them, for I have frequently seen furniture, paintings, ornaments, &c. where they have employed them most judiciously.

I recommend artists, to whom this paragraph is particularly directed, to give some attention to the following observations, not doubting that many will find it profitable to them.

#### A. BINARY ASSORTMENTS.

(203.) No assortment of the primitive colours with Black is disagreeable: but between these assortments there exists a generic difference of harmony, which the binary assortments of White with the same colours do not present to nearly the same degree. For in these latter the splendour of the White is so dominant, that, whatever be the difference of light or of brilliancy observable between the different colours associated, there will always be harmony of contrast, as must follow from what has already been stated (44—52) of the influence of White in elevating the tone and augmenting the intensity of the colour which is next to it. If we examine the binary assortments of Black under the relation which now occupies our attention, we shall perceive that the deep tones of all the scales, and also the tones of the Blue and Violet scales, which, properly speaking, are not deep,—form with them harmonies of analogy and not of contrast, as do the unbroken tones of the scales of Red, Orange, Yellow, Green, and the very light tones of the Violet and Blue scales. Finally, we must add, conformably to what has already been said (55), that the assortment of Black with sombre colours, such as Blue and Violet, the complementaries of which, Orange and Greenish Yellow, are luminous, may di-

minish the contrast of tone, if the colours are in juxtaposition with Black, or are not far distant; and in this case the Black loses much of its vigour.

*Blue and Black, Violet and Black,* make assortments which can only be successfully employed when we require obscure colours.

The first assortment is superior to the second.

The bright assortments which present harmonies of contrast appear to me in the rank of beauty.

*Red or Rose and Black, Orange and Black, Yellow and Black,* lastly *light Green and Black.*

Respecting Yellow, I repeat that it must be brilliant and intense, because Black tends to impoverish its tone (58).

B. TERNARY ASSORTMENT OF COMPLEMENTARY COLOURS WITH BLACK.

### Red and Green.

(204.) 1. *Red, Green,* &c.
2. *Black, Red, Green, Black,* &c.

This arrangement being entirely different from the first, it is very difficult to decide upon their relative beauty.

3. *Black, Red, Black, Green, Black,* &c. appears to me inferior to the preceding (2), because there is too much Black.

### Blue and Orange.

(205.) 1. *Blue, Orange,* &c.
2. *Black, Blue, Orange, Black,* &c.

I prefer the first to the second, the proportion of obscure colours being too strong relatively to the Orange.

3. *Black, Blue, Black, Orange, Black,* &c.

This arrangement pleases me less than the first.

The effect of Black with Blue and Orange is inferior to that of White.

### Yellow and Violet.

(206.) 1. *Yellow, Violet,* &c.
2. *Black, Yellow, Violet, Black,* &c.
3. *Black, Yellow, Black, Violet, Black,* &c.

The second assortment is superior to the third, because the proportion of sombre colours with Yellow is too strong in the latter.

The first appears to me superior to the second.

C. TERNARY ASSORTMENT OF NON-COMPLEMENTARY COLOURS WITH BLACK.

*Red and Orange.*

(207.) 1. *Red, Orange,* &c.
2. *Black, Red, Orange, Black,* &c.
3. *Black, Red, Black, Orange, Black,* &c.

The Orange and Red injure each other, and it is advantageous to separate them with Black; the third assortment is preferable to the second, and both are preferable to those where White replaces the Black.

*Red and Yellow.*

(208.) 1. *Red, Yellow,* &c.
2. *Black, Red, Yellow, Black,* &c.
3. *Black, Red, Black, Yellow, Black,* &c.

The two latter assortments appear to me superior to the first, and there are certainly many persons who will prefer them to the arrangement where White replaces the Black. I cannot too strongly recommend the assortments 2 and 3 to artists, to whom these observations are particularly directed.

*Red and Blue.*

(209.) 1. *Red, Blue,* &c.
2. *Black, Red, Blue, Black,* &c.
3. *Black, Red, Black, Blue, Black,* &c.

The assortment 2 is preferable to 3, because there are too many sombre colours in the latter, and they differ too much from Red.

The effect of Black upon the binary assortment Red and Blue is inferior to that of White.

*Red and Violet.*

(210.) 1. *Red, Violet,* &c.
2. *Black, Red, Violet, Black,* &c.
3. *Black, Red, Black, Violet, Black,* &c.

Red and Violet injure each other reciprocally. There is an advantage in separating them with Black; but it does not produce so good an effect as White. It is difficult to say whether the assortment 3 is preferable to 2, for this reason, that, if in the latter Red is near the Violet, the

defect can be more than compensated for in 3, by the predominance of sombre colours over Red.

### Orange and Yellow.

(211.) 1. *Orange, Yellow,* &c.
2. *Black, Orange, Yellow, Black,* &c.
3. *Black, Orange, Black, Yellow, Black,* &c.

Orange and Yellow being very luminous, the Black combines very well in the assortments 2 and 3; and if the assortment White, Orange, Yellow, White, is preferred to the assortment 2, I believe that in the assortment 3 the Black has a superior effect to White.

### Orange and bright Green.

(212.) 1. *Orange, Green,* &c.
2. *Black, Orange, Green,* &c.
3. *Black, Orange, Black, Green, Black,* &c.

The Black combines very well with Orange and Bright Green, for the same reason that it does with Orange and Yellow. If in the assortment 2 we prefer White to Black, I think we cannot in the assortment 3.

I recommend to artists the combination of Black with the binary assortments Orange and Yellow, and Orange and Green.

### Orange and Violet.

(213.) 1. *Orange, Violet,* &c.
2. *Black, Orange, Violet, Black,* &c.
3. *Black, Orange, Black, Violet, Black,* &c.

Black does not combine so well as White with Orange and Violet, because the proportion of obscure colours is too great relatively to Orange, a very vivid colour.

### Yellow and Green.

(214.) 1. *Yellow, bright Green,* &c.
2. *Black, Yellow, Green, Black,* &c.
3. *Black, Yellow, Black, Green, Black,* &c.

For the reason stated above (211), Yellow and bright Green being luminous colours, Black combines very well with them; and if

in the assortment 2, we prefer the effect of White to Black, I think we cannot do so in the assortment 3.

*Yellow and Blue.*

(215.)
1. *Yellow, Blue,* &c.
2. *Black, Yellow, Blue, Black,* &c.
3. *Black, Yellow, Black, Blue, Black,* &c.

If the assortment 2 is preferable to 3, I think it is inferior to the first. Black does not appear to me to combine so well as White in the Yellow and Blue assortment.

*Green and Blue.*

(216.)
1. *Green, Blue,* &c.
2. *Black, Green, Blue, Black,* &c.
3. *Black, Green, Black, Blue, Black,* &c.

Although the Green and Blue do not combine very well, yet the addition of Black is decidedly not advantageous, because of the increased proportion of sombre colours. Under this relation White has a better effect than Black.

*Green and Violet.*

(217.)
1. *Green, Violet,* &c.
2. *Black, Green, Violet, Black,* &c.
3. *Black, Green, Black, Violet, Black,* &c.

If the Black does combine better with Green and Violet than with Green and Blue, still its ternary assortments are inferior to the binary, and to the ternary assortment in which it is replaced by White.

*Blue and Violet.*

(218.)
1. *Blue, Violet,* &c.
2. *Black, Blue, Violet,* &c.
3. *Black, Blue, Black, Violet, Black,* &c.

If Blue and Violet are colours which do not combine well together, and which it is advantageous to separate from each other, we must recognise that Black in isolating them does not relieve the sombre colour; but, on the other hand, the harmony of the assortments 2 and 3 is more agreeable as a harmony of analogy than the harmony of contrast presented by the White

with the same colours. There are cases where the combination Black, Blue, and Violet may be advantageous, when it presents to view diversified, but not brilliant, tones.

### ARTICLE 3.
### *Colours with Grey.*

(219.) All the primary colours gain in brilliancy and purity by the proximity of Grey; yet the effects are far from being similar, or even analogous, to those which result from the proximity of the same colours with White. There is nothing surprising in this, when we consider that if White preserves to each colour its character, and even heightens it by contrast, it can never itself be taken for a colour properly so called; as Grey, on the contrary, can be so, it happens that it produces with the darkest colours—such as Blue, Violet, and the deep tones in general—assortments which enter into analogous harmonies; whilst, with colours naturally brilliant—such as Red, Orange, Yellow, and the light tones of Green—they form harmonies of contrast. Now, although White contrasts more with the sombre colours than with those which are naturally luminous, we cannot observe between White and these two classes of colours the difference which we distinguish between Grey and these same colours. Moreover, we might anticipate this result from what I said on the binary assortments with Black (203).

#### A. BINARY ASSORTMENTS.

(220.) *Grey and Blue, Grey and Violet,* form assortments, the harmony of analogy of which is agreeable, but less, however, than that of Black with the same colours.

*Grey and Orange, Grey and Yellow, Grey and light Green,* form assortments of harmony of contrast, in like manner agreeable: perhaps they are less so than those where Grey is replaced by Black.

*Grey and Rose* are a little dull, and inferior to the assortment *Black and Rose.*

All the binary assortments of Grey, except, perhaps, that of Orange, are inferior to the binary assortments of White.

#### B. TERNARY ASSORTMENTS OF COMPLEMENTARY COLOURS WITH GREY.

##### *Red and Green.*

(221.) 1. *Red, Green,* &c.
    2. *Grey, Red, Green, Grey,* &c.
    3. *Grey, Red, Grey, Green, Grey,* &c.

If it is difficult to say whether the addition of Grey is advantageous to the binary assortment of Red and Green, we cannot say that it is injurious.

The third assortment is, perhaps, inferior to that where Grey is replaced by Black.

*Blue and Orange.*

(222.) 1. Blue, Orange, &c.
2. Grey, Blue, Orange, Grey, &c.
3. Grey, Blue, Grey, Orange, Grey, &c.

I prefer the first assortment to both the others.

*Yellow and Violet.*

(223.) 1. Yellow, Violet, &c.
2. Grey, Yellow, Violet, Grey, &c.
3. Grey, Yellow, Grey, Violet, Grey, &c.

Although the assortments 2 and 3 may be brighter than the assortments where Grey is replaced by Black (206), nevertheless, the binary assortment appears to me preferable to the ternary.

C. TERNARY ASSORTMENTS OF NON-COMPLEMENTARY COLOURS WITH GREY.

*Red and Orange.*

(224.) 1. Red, Orange, &c.
2. Grey, Red, Orange, Grey, &c.
3. Grey, Red, Grey, Orange, Grey, &c.

The assortments 2 and 3 are preferable to the binary assortment. The third is preferable to the second. Altogether, Grey produces a better effect than White with Red and Orange, but the effect is inferior to that with Black.

*Red and Yellow.*

(225.) 1. Red, Yellow, &c.
2. Grey, Red, Yellow, Grey, &c.
3. Grey, Red, Grey, Yellow, Grey, &c.

Although Grey combines well with Red and Yellow, it has not an effect so decidedly advantageous as Black has in the binary assortment.

### Red and Blue.

(226.) 1. *Red, Blue,* &c.
    2. *Grey, Red, Blue, Grey,* &c.
    3. *Grey, Red, Grey, Blue, Grey,* &c.

The assortment 2 is preferable to 3; I dare not say to the first. The effect of Grey is inferior to that of White.

### Red and Violet.

(227.) 1. *Red, Violet,* &c.
    2. *Grey, Red, Violet, Grey,* &c.
    3. *Grey, Red, Grey, Violet, Grey,* &c.

The assortment 3 appears to me superior to 2, and the second to the first; but it is difficult to say if Grey is superior to Black; I am certain it is inferior to White.

### Orange and Yellow.

(228.) 1. *Orange, Yellow,* &c.
    2. *Grey, Orange, Yellow, Grey,* &c.
    3. *Grey, Orange, Grey, Yellow, Grey,* &c.

The assortment 3 appears to me preferable to the assortment 2; the harmony of contrast is less intense than with Black.

The assortment 3 is perhaps superior to the assortment of White, Orange, White, Yellow, White.

### Orange and Green.

(229.) 1. *Orange, Green,* &c.
    2. *Grey, Orange, Green, Grey,* &c.
    3. *Grey, Orange, Grey, Green, Grey,* &c.

Grey combines well with Orange and Green, but it does not contrast so agreeably as Black or White.

### Orange and Violet.

(230.) 1. *Orange, Violet,* &c.
    2. *Grey, Orange, Violet, Grey,* &c.
    3. *Grey, Orange, Grey, Violet, Grey,* &c.

The binary assortment appears to me preferable to the other two.

The assortment 2 is preferable to 3.

If the Grey is a little dull with Orange and Violet, it has not the same inconvenience as Black in causing too great a predominance of sombre colours.

*Yellow and Green.*

(231.) 1. *Yellow, Green,* &c.
2. *Grey, Yellow, Green, Grey,* &c.
3. *Grey, Yellow, Grey, Green, Grey,* &c.

Grey combines well with Yellow and Green; but the assortments 2 and 3 are a little dull, and inferior to those in which Black replaces Grey.

*Yellow and Blue.*

(232.) 1. *Yellow, Blue,* &c.
2. *Grey, Yellow, Blue, Grey,* &c.
3. *Grey, Yellow, Grey, Blue, Grey,* &c.

The two assortments 2 and 3 are inferior to the 1st. The Grey is heavy with Yellow and Blue; its effect then is inferior to that of White, and perhaps also to that of Black.

*Green and Blue.*

(233.) 1. *Green, Blue,* &c.
2. *Grey, Green, Blue, Grey,* &c.
3. *Grey, Green, Grey, Blue, Grey,* &c.

Grey, in its combination with Green and Blue, has not the same objection as Black, but it has an inferior effect to White.

*Green and Violet.*

(234.) 1. *Green, Violet,* &c.
2. *Grey, Green, Violet, Grey,* &c.
3. *Grey, Green, Grey, Violet, Grey,* &c.

Grey is not employed advantageously with Green and Violet; it is inferior to White in the ternary assortments, and perhaps I should also give preference to Black.

*Blue and Violet.*

(235.) 1. *Blue, Violet,* &c.
2. *Grey, Blue, Violet, Grey, &c.*
3. *Grey, Blue, Grey, Violet, Grey, &c.*

The remarks made (218) in the assortment of Black with Blue and Violet are applicable to the assortment with Grey, taking into account, to a certain extent, the difference of tone which exists between Grey and Black.

## RECAPITULATION OF THE PRECEDING OBSERVATIONS.

(236.) I will now give a *resumé* of the observations which appear the most striking on reading the foregoing paragraphs, premising, however, that I do not pretend to establish laws fixed upon scientific principles, but to enounce general propositions, which express my own peculiar ideas.

### 1st Proposition.

(237.) *In the Harmony of Contrast the complementary assortment is superior to every other.*

The tones must be, as nearly as possible, of the same height, in order to produce the finest effect.

The complementary assortment in which White associates most advantageously is that of Blue and Orange, and the reverse is that of Yellow and Violet.

### 2nd Proposition.

(238.) *The primaries Red, Yellow, and Blue, associated in pairs, will assort better together as a harmony of contrast than an arrangement formed of one of these primaries and of a binary colour, of which the primary may be regarded as one of the elements of the binary colour in juxtaposition with it.*

#### Examples.

| | | |
|---|---|---|
| Red and Yellow | accord better than | Red and Orange. |
| Red and Blue | ,, ,, | Red and Violet. |
| Yellow and Red | ,, ,, | Yellow and Orange. |
| Yellow and Blue | ,, ,, | Yellow and Green. |
| Blue and Red | ,, ,, | Blue and Violet. |
| Blue and Yellow | ,, ,, | Blue and Green. |

### 3rd Proposition.

(239.) *The assortment of Red, Yellow, or Blue, with a binary colour which we may regard as containing the former, contrast the better, as the simple colour is essentially more luminous than the binary.*

Whence it follows that in this arrangement it is an advantage for the Red, Yellow, or Blue, to be of lower tone than the binary colour.

### Examples.

Red and Violet accord better than Blue and Violet.
Yellow and Orange  „    „   Red and Orange.
Yellow and Green   „    „   Blue and Green.

### 4th Proposition.

(240.) *When two colours are bad together, it is always advantageous to separate them by White.*

In this case we know that it is more advantageous to place White between each colour than in an assortment where the two colours are together between White.

### 5th Proposition.

(241.) *Black never produces a bad effect when it is associated with two luminous colours. It is therefore often preferable to White, especially in an assortment where it separates the colours from each other.*

### Examples.

1. *Red and Orange.*

Black is preferable to White in the arrangements 2 and 3 of these two colours.

2. *Red and Yellow.*
3. *Orange and Yellow.*
4. *Orange and Green.*
5. *Yellow and Green.*

Black with all these binary assortments produces harmony of contrast.

### 6th Proposition.

(242.) *Black, in association with sombre colours, such as Blue and Violet, and with broken tones of luminous colours, produces harmony of analogy, which in many instances may have a good effect.*

The harmony of analogy of Black associated with Blue and Violet, is preferable to the harmony of contrast of the assortment White, Blue, Violet, White, &c., the latter being too crude.

### 7th Proposition.

(243.) *Black does not associate so well with two colours, one of which is luminous, the other sombre, as when it is associated with two luminous colours.*

*In the first instance the association is much less agreeable in proportion as the luminous colour is more brilliant.*

#### Examples.

With all the following assortments Black is inferior to White.
1. *Red* and *Blue*.
2. *Red* and *Violet*.
3. *Orange* and *Blue*.
4. *Orange* and *Violet*.
5. *Yellow* and *Blue*.
6. *Green* and *Blue*.
7. *Green* and *Violet*.

With the assortment *Yellow* and *Violet*, if it is not inferior to White, it never produces anything but a mediocre effect in its associations.

### 8th Proposition.

(244.) *If Grey never produces exactly a bad effect in its association with two luminous colours, in most cases its assortments are nevertheless dull, and it is inferior to Black and White.*

Among the assortments of two luminous colours there are scarcely any besides those of Red and Orange with which Grey associates more happily than White.

But it is inferior to it, as also to Black, in the arrangements *Red and Green, Red and Yellow, Orange and Yellow, Orange and Green, Yellow and Green.*

It is also inferior to White with *Yellow and Blue.*

### 9th Proposition.

(245.) *Grey, in association with sombre colours, such as Blue and Violet, and with broken tones of luminous colours, produces harmonies of analogy which have not the vigour of those with Black; if the colours do not combine well together, it has the advantage of separating them from each other.*

### 10th Proposition.

(246.) *When Grey is associated with two colours, one of which is luminous, the other sombre, it will perhaps be more advantageous than White, if this produces too strong a contrast of*

tone; on the other hand, it will be more advantageous than Black, if that has the inconvenience of increasing too much the proportion of sombre colours.

### Examples.

Grey associates more favourably than Black with—
1. *Orange* and *Violet.*
2. *Green* and *Blue.*
3. *Green* and *Violet.*

### 11th PROPOSITION.

(247.) *If, when two Colours combine together badly, there is in principle an advantage in separating them by White, Black, or Grey, it is important to the effect to take into consideration —*
1. The height of tone of the Colours, and
2. The proportion of sombre to luminous colours, including in the first the broken brown tones of the brilliant scales, and in the luminous colours, the light tones of the Blue and Violet scales.

### Examples.

(a.) *Take into consideration the height of tone of the colours.*

(248.) The effect of White with Red and Orange is inferior as their tone becomes higher, especially in the assortment *White, Red, Orange, White,* &c., the effects of the White being too crude.

On the contrary, Black unites very well with the normal tones of the same colours, that is to say, the highest tones, without any mixture of Black.

If Grey does not associate so well as Black with Red and Orange, it has the advantage of producing a less crude effect than White.

(b.) *Take into consideration the proportion of sombre to luminous colours.*

(249.) Whenever colours differ very much, either in tone or in brilliancy from the Black or White with which we wish to associate them, the arrangement where each of the two colours is separated from the other by Black or White, is preferable to that in which the Black or the White separate each pair of colours.

Thus the assortment White, Blue, White, Violet, White, &c, is preferable to the assortment White, Blue, Violet, White, &c.,

because the separation of the brilliant from the sombre is more equal in the first than in the second. I should add, that this has something more symmetrical relatively to the position of the two colours, and I must remark that the principle of symmetry influences our judgment of things more than is generally recognised.

It is also in conformity with the above, that the assortment Black, Red, Black, Orange, Black, &c., is preferable to the assortment Black, Red, Orange, Black, &c.

(250.) Some remarks appear to me also necessary to prevent false conclusions being drawn from the preceding propositions.

(251.) 1°. In all the preceding remarks, the colours, including White, Black, and Grey, are supposed to occupy an equal superficial extent of surface, and placed at equal distances apart; for without these conditions, the results will be different from those described: — for example, I have preferred the assortment White, Red, White, Yellow, White, to the assortment White, Red, Yellow, White. I shall notice those cases where the latter is preferable to the former, in treating of the arrangement of flowers in gardens, on the subject of Yellow and Rose flowers, which present less coloured surface than the White flowers with which they are associated.

I have spoken of the good effects of Black and Green separated, and I may add that Green designs upon a Black ground are also agreeable; but it does not follow that black lace, superimposed upon a green stuff, will have a good effect, at least on the optical quality of Black, for this acquires a Red tint, which assimilates with a faded colour.

(252.) 2°. I have said, that the more colours are opposed, the easier it is to assort them, because they do not experience by their mutual juxtaposition, any modification which renders them disagreeable, as generally happens to colours which are very nearly alike. Must we then conclude that, with two colours which have in this case been indicated to an artist to be employed with liberty to modify them to a certain point, he must endeavour to increase the effect of contrast rather than that of analogy? Certainly not! for frequently the latter is preferable to the former. For example: — take Orange-Red, and a pure Red, instead of increasing the Yellow in

the Orange-Red, or of giving a Violet hue to the Red, it sometimes will be preferable to incline towards the harmony of scale or of hue by endeavouring to make the Orange one of the light tones of a scale whose Red will be brown.

(253.) 3°. It is in conformity with this manner of observing that, when we would avoid the bad effect of two adjacent colours by White, Black, or Grey, we must see if, instead of a harmony of contrast, there will not be more advantage in obtaining the harmony of analogy.

(254.) 4°. Finally, when, in working these associations, we employ not normal Grey, but a coloured Grey, we are always sure of obtaining an effective harmony of contrast, by taking a Grey coloured with the complementary of the colour opposed to it. Thus an Orange-Grey, or Carmelite-Brown, or Marron, has a goo effect with light Blue.

# FIRST DIVISION.

IMITATION OF COLOURED OBJECTS, WITH COLOURED MATERIALS IN A STATE OF INFINITE DIVISION.

INTRODUCTION.

FIRST SECTION.—PAINTING ON THE SYSTEM OF CHIARO'SCURO.

SECOND SECTION.—PAINTING ON THE SYSTEM OF FLAT TINTS.

THIRD SECTION.—COLOURING IN PAINTING.

# FIRST DIVISION.

IMITATION OF COLOURED OBJECTS, WITH COLOURED MATERIALS IN A STATE OF INFINITE DIVISION.

## INTRODUCTION.

(255.) COLOURED materials (pigments), such as Prussian Blue, Chrome-Yellow, Vermilion, &c., are infinitely divided, so to speak, when ground, either pure, or mixed with a white material, in a gummy or oily liquid.

*The reproduction of the images of coloured objects with these pigments is called* THE ART OF PAINTING.

(256.) There are two systems of Painting, the one consists in representing as accurately as possible, upon the flat surface of canvas, wood, metal, walls, &c., an object in relief, in such manner that the image makes an impression upon the eye of the spectator similar to that produced by the object itself.

(257.) From this we learn that we must manage the light, the vivacity of colour for every part of the image which in the model receives direct light, and which reflects it to the eye of him who regards the object from the point where the painter placed himself to imitate it; while the parts of the image corresponding to those which, in the same object, do not reflect to the spectator as much light as the first, — either because they reflect it, in another direction, or because the salient points protect them more or less from the daylight, — must appear in colours more or less dimmed with black, or, what is the same thing, by shade.

It is, then, by the vivacity of White or coloured light, by the enfeebling of light by means of Black, that the painter manages, with the aid of a plane image, to attain all the illusion of an object in relief. The art of producing this effect by the distribution of light and shade constitutes essentially what is termed the art of *Chiaro'scuro.*

(258.) There exists a means of imitating coloured objects much simpler in its facility of execution than the preceding. It consists in tracing the outline of the different parts of the model, and in colouring them uniformly with their peculiar colours. There is no relief, no projections; it is the plane image of the object, since all the parts receive a uniform tint: this system of imitation is *painting in flat tints*.

# FIRST SECTION.

CHAPTER I.— On the Colours of the Model (259.)—(298.)

CHAPTER II.— On the difference existing between a coloured object and the imitation of it made by a painter, when the spectator observes it from a different point of view from his (299.) (300.)

# SECTION I.

PAINTING ON THE SYSTEM OF CHIARO'SCURO.

## CHAPTER I.

ON THE COLOURS OF THE MODEL.

(259.) ARE the modifications which we perceive in a single coloured object—for example, in a blue or red stuff, &c.—indeterminable when these stuffs are seen as the drapery of a vestment or as furniture, presenting folds more or less prominent, or are they determinable under given circumstances? This is a question which I shall undertake to resolve. First, let us distinguish three cases where these modifications of colours may be observed.

> 1st CASE. *Modifications produced by coloured lights falling upon the model.*
>
> 2nd CASE. *Modifications produced by two different lights — as, for example, the light of the sun, and diffused daylight—each lighting distinct parts of the same object.*
>
> 3rd CASE. *Modifications produced by diffused daylight.*

(260.) To render these matters easier of comprehension, we will suppose that in the two first cases the lighted surfaces are plane, and that all their superficial parts are homogeneous, and in the same conditions, except that of lighting in the second case. In the third case we shall consider the position of the spectator viewing an object lighted by diffused daylight, the surface of which is so disposed as not to act equally in all its parts upon the light which it reflects to the eye of the spectator.

## ARTICLE 1.
### *Modifications produced by Coloured Lights.*

(261.) These modifications result from coloured rays emanating from any source whatever, falling upon a coloured surface, which is at the same time lighted by diffused daylight.

(262.) The following observations have been made by partially exposing coloured stuffs to the sun's rays transmitted through coloured glass. The portion of stuff protected from these rays was lighted by the direct light of the sun. It is important to remark, that the portion of stuff which received the action of the coloured rays being exposed to diffused daylight, reflected also rays of that light which it would have reflected in case it had been protected from the influence of the rays transmitted to it through coloured glasses.

(263.) 1. *Modifications produced by Red Light.*

    When Red rays fall upon a Black stuff, it appears of a Purple-Black, deeper than the rest, which is lighted directly by the sun.

    Red rays falling upon a White stuff, make it appear Red.

    Red rays falling upon a Red stuff, make it appear redder than upon that part lighted at the same time by the sun.

    Red rays falling upon an Orange-coloured stuff, make it appear redder than the part lighted at the same time by the sun.

    Red rays falling upon a Yellow stuff, make it appear Orange.

    Red rays falling upon a Green stuff, produce different effects, according to the tone of the Green: if it is deep, it produces a Red-Black; if it is light, there is a little Red reflected, which gives a reddish grey.

    Red rays falling upon a light Blue stuff, make it appear Violet.

    Red rays falling upon a Violet stuff, make it appear Purple.

(264.) 2. *Modifications produced by Orange Light.*

    Orange rays falling upon a Black stuff, make it appear of a Marron or Carmelite-Brown colour.

    Orange rays falling upon a White stuff, make it appear Orange.

    Orange rays falling upon an Orange stuff, make

it appear of an Orange more vivid, more intense than the part lighted at the same time by the sun.

Orange rays falling upon a Red stuff, make it appear Scarlet.

Orange rays falling upon a Yellow stuff, make it appear Yellow-Orange.

Orange rays falling upon a Green stuff, make it appear of a Yellow-Green, if the Green is light; and of a Rusty-Green, if it is deep.

Orange rays falling upon a Blue stuff, make it appear of an Orange-Grey, if the Blue is light; and of a Grey in which the Orange is less vivid, if it is deep, which is not the colour given to a black stuff by the same Orange rays.

Orange rays falling upon a dark Indigo-Blue stuff, appear of an Orange-Marron.

Orange rays falling upon a Violet stuff, appear of a Red-Marron.

(265.) 3. *Modifications produced by Yellow Light.*

Yellow rays falling upon a Black stuff, make it appear of a Yellow-Olive.

Yellow rays falling upon a White stuff, make it appear of a light Yellow.

Yellow rays falling upon a Yellow stuff, make it appear (relatively to the part lighted by the sun) of a Yellow-Orange colour.

Yellow rays falling upon a Red stuff, make it appear Orange.

Yellow rays falling upon an Orange stuff, make it appear more Yellow than the part lighted by the sun.

Yellow rays falling upon a Green stuff, make it appear Yellow-Green.

Yellow rays falling upon a Blue stuff, make it appear Yellow-Green, if it is light, and of a Green-Slate if it is deep.

Yellow rays falling upon a deep Indigo stuff, make it appear of an Orange-Yellow.

Yellow rays falling upon a Violet stuff, make it appear of Yellow-Marron.

(266.) 4. *Modifications produced by Green Light.*

Green rays falling upon a Black stuff, make it appear of a Green-Brown.

[Sect. I. Chap. I.] ON THE COLOURS OF THE MODEL. 93

Green rays falling upon a White stuff, make it appear Green.
Green rays falling upon a Green stuff, make it appear more intense and brilliant.
Green rays falling upon a Red stuff, make it appear of a Brown.
Green rays falling upon an Orange stuff, make it appear of a faint Yellow, a little Green.
Green rays falling upon a Yellow stuff, make it appear of a very brilliant Yellow-Green.
Green rays falling upon a Blue stuff, make it appear Greener, according to its depth.
Green rays falling upon a dark Indigo stuff, make it appear a dull Green.
Green rays falling upon a Violet stuff, make it appear of a Bluish-Green-Brown.

(267.) 5. *Modifications produced by Blue Light.*

Blue rays falling upon a Black stuff, render it of a Blue-Black, deeper than the part lighted by the sun.
Blue rays falling upon a White stuff, make it appear Blue.
Blue rays falling upon a Blue stuff, render the colour more vivid than the part lighted by the sun.
Blue rays falling upon a Red stuff, make it appear Violet.
Blue rays falling upon an Orange stuff, make it appear of a Brown having an exceedingly pale tint of Violet, if the glass transmits Violet rays with the Blue.
Blue rays falling upon a Yellow stuff, make it appear Green; if the rays are transmitted by a deep Blue glass, coloured with oxide of cobalt, the stuff will appear of a Brown, having a Violet tint, less apparent if the light is vivid.
Blue rays falling upon a Green stuff, make it appear of a Blue-Green; but feebler than when they fall upon a White stuff.
Blue rays falling upon a deep Indigo stuff, make it appear of a dark Blue-Indigo.
Blue rays falling upon a Violet stuff, make it appear of a dark Blue-Violet.

(268.) 6. *Modifications produced by Violet Light.*

    Violet rays falling upon a Black stuff, render it of a very faint Violet-Black.
    Violet rays falling upon a White stuff, make it appear Violet.
    Violet rays falling upon a Violet stuff, make it appear of a deeper Violet.
    Violet rays falling upon a Red stuff, make it appear of a Red-Violet-Purple.
    Violet rays falling upon an Orange stuff, make it appear of a light Red.
    Violet rays falling upon a Yellow stuff, make it appear Brown with an excessively pale tint of Red.
    Violet rays falling upon a Green stuff, make it appear light Purple.
    Violet rays falling upon a Blue stuff, make it appear of a fine Blue-Violet.
    Violet rays falling upon a dark Indigo stuff, make it appear of a very deep Blue-Violet.

(269.) It is understood that to represent the preceding phenomena correctly we must take into account — the facility with which coloured light penetrates every kind of glass — the colour more or less intense of the stuff upon which the coloured light falls — and the kind of scale to which the coloured stuff and that of the transmitted coloured light respectively belong.

## ARTICLE 2.

*Modifications produced by two Lights of different Intensity.*

(270.) I shall distinguish two modifications of this kind.

1. The modification by the light of the sun falling upon one part of the surface of a coloured body, while the other part is lighted by diffused daylight.
2. The modification produced when two parts of the same object are unequally illuminated by diffused light.

### 1st MODIFICATION.

*An Object lighted partly by the Sun, and partly by diffused Daylight.*

(271.) To observe this kind of modification properly we must extend upon a table exposed to the sun a piece of stuff, A B, $2\frac{1}{2}$ inches square (Plate III. fig. 1.), and place in the middle a

[Sect. I. Chap. I.] ON THE COLOURS OF THE MODEL. 95

piece of Black wire, $f, f'$; then put parallel to this thread, and in the middle, between A and B, two wires, $e, e'$, and $g, g'$, of about $\frac{3}{10}$ths of an inch in width. The extremity, $g'$, is fixed upon a perpendicular plane, $h, h'$, of 1 and $\frac{2}{10}$ths of an inch in length, and sufficiently high, so that $f, f'$, being in the plane of the direction of the solar rays, the plane $h, h$, covers exactly with its shadow all the part B of the stuff.

(272.) 1. *If the stuff is Red*, the lighted portion A is more Orange or less Blue than the part B, which is in shade; and the portion $a$ is more Orange than the portion $a'$, as the portion $b$ is Bluer or more Crimson than the portion $b'$.

(273.) 2. *If the stuff is Orange*, the lighted part is more Orange or less Grey than the part which is in the shade, and the portion $a$ is deeper, more vivid than the portion $a'$, as the portion $b$ is more Grey, and duller than $b'$.

(274.) 3. *If the stuff is Yellow*, the lighted part is more vivid, more Orange than the part which is in the shade; $a$ is more so than $a'$, as $b$ is duller than $b'$.

(275.) 4. *If the stuff is Green*, the lighted part is less Blue or more Yellow than the part which is in the shade; and the portion $a$ is of a yellower Green than the portion $a'$, as the portion $b$ is Bluer than $b'$.

(276.) 5. *If the stuff is Blue*, the lighted part is less Violet, and more Green than the part which is in shade; and the portion $a$ is greener than the portion $a'$, as $b$ is more Violet or less Green than $b'$.

(277.) 6. *If the stuff is Indigo*, the lighted part is redder or less Blue than the part in the shade; and the portion $a$ is redder than the portion $a'$, as the portion $b$ is deeper or Bluer than the portion $b'$.

(278.) 7. *If the stuff is Violet*, the lighted part is less Blue than the part in the shade; and the portion $a$ is redder than the portion $a'$, as $b$ is bluer than $b'$.

## II$^{nd}$ Modification.

*Two contiguous parts of the same object viewed simultaneously, when they are unequally lighted by the same diffused Light, differ from each other not only in height of tone, but also in the optical composition of Colour.*

(279.) Although this modification cannot be essentially different to the preceding, nevertheless, seeing the disposition there has been hitherto to neglect it, it will, I believe, be useful to describe how we can observe it, and repeat in what direction are the modifications of Red, Orange, Yellow, Green, Blue, and Violet.

Place half-a-sheet of coloured paper (Plate III. fig. 2.) upon the partition, *b*, of a chamber, receiving diffused daylight by a window, *f*: place another half-sheet upon the partition *a* in such a manner that it will be lighted directly by the diffused light; while the other is only indirectly lighted by the light diffused from the walls, floor, and ceiling; it being understood that the diffused light thus reflected must be only White light, then stand at *c*, so as to see both half-sheets at once. I shall designate that which is upon the partition *a*, and the most lighted, by A, and the other which is upon the partition *b*, and less lighted, by B, letters which in the plate indicate the respective positions of the half-sheets.

### Effects.

#### Red Colour.

The half-sheet B is deeper and more of a Crimson-Red, or less Yellow, than the half-sheet A.

#### Orange Colour.

The half-sheet B is deeper, and of an Orange redder, or less Yellow, than the half-sheet A.

#### Yellow Colour.

The half-sheet B is duller, and of a greener Yellow than the half-sheet A.

#### Green Colour.

The half-sheet B is deeper, and of a Green less Yellow or more Blue than the half-sheet A.

#### Blue Colour.

The half-sheet B is deeper, and of a Blue, I shall not say more Violet, but less Green than the half-sheet A.

### Violet Colour.

The half-sheet B is deeper, and of a Violet less Red, or more Blue, than the half-sheet A.

(280.) The deduction from these observations is, that the colour of the same body varies not only in intensity or *tone*, but also in *hue*, according as it is lighted directly by the sun, by diffused daylight, or by diffused reflected light. This result must never be overlooked whenever we attempt to define the colours of material objects.

### ARTICLE 3.

*Modifications produced by diffused Daylight, reflected by a surface, all the parts of which are not in the same position relatively to the spectator.*

(281.) Distant bodies are rendered sensible to the eye, only in proportion as they radiate, or reflect, or transmit the light which acts upon the retina.

According to the laws of reflection (for it is useless, in the object I propose to myself, to treat of cases where the light which penetrates the eye has been refracted), it happens that those portions of a surface which are in relief or intaglio, must reflect the light in such manner that the eye of a spectator, in a given position, will see these parts very diversely lighted, with respect to the intensity of reflected light, so that the parts of this surface will be, relatively to the eye, in the same condition as the homogeneous parts of a plane surface, which are illuminated by lights of unequal intensity.

There will be this difference nevertheless; that the parts of the surface of a body which appears to us in intaglio, or especially in relief, being but feebly varied in the greater number of contiguous parts, there will generally be a gradual diminution in the effects which were presented to us by the case where we have studied the modifications which appear when two plane homogeneous surfaces are lighted by diffused lights of unequal intensity. The sphere presents a remarkable example of the manner in which light is distributed upon a convex surface relatively to the eye of an observer who views it from a given position.

(282.) I shall not occupy myself with this gradation of white light between parts illuminated thereby and those which do not appear so, I only regard the principal modifications, and take for examples the cases where they are as evident as possible. These modifications can be reduced to the four following.

1st MODIFICATION, *produced by the maximum of white light which the surface of a coloured body is capable of reflecting.*

(283.) Other things being equal, the more the surface of a body is polished the more it will reflect white and coloured light: thus, a stick of red sealing-wax when broken, presents in the fractured parts a duller and more tarnished colour than the outside. On the other hand, if we observe this same outside surface suitably placed, we shall perceive a white stripe parallel to the axis of the cylinder, produced by a quantity of colourless reflected light, so considerable that the red light reflected from this stripe is insensible to the eye which observes it. The white light reflected by a coloured body can then be of sufficient intensity to render the colour of the body insensible in some of its parts.

2nd MODIFICATION, *produced by those parts of a coloured surface which send to the eye, in proportion to the coloured light, less of white light than the other parts differently lighted, or differently placed in relation to the spectator.*

(284.) When the eye sees certain parts of the surface of a polished coloured object, or more or less smooth where not polished, which reflects to it, proportionally to the coloured light, less of the white light than the other parts differently illuminated, or differently placed, in relation to the spectator, the first parts will appear, in most cases, of a more intense tone of colour than the second. — We will cite the following

*Examples.*

1. *Example.* A cylinder of red sealing-wax presents, starting from the white stripe mentioned above, a red colour, deeper in proportion as less white light reaches the eye. Thus, in a certain position where the white stripe appears to be in the middle of the cylinder, the part most lighted will appear coloured, reflecting a red inclining to scarlet, while that which is the least lighted reflects a red inclining to crimson.

2. *Example.* If the eye is directed into a gold vase of sufficient depth, the gold does not appear yellow, as on the exterior surface, but of a red-orange, because less white light in proportion to coloured light reaches the eye in the first case than in the second. It is for this reason that the concave parts of gold·ornaments appear redder than the convex.

3. *Example.* The spiral thread of a piece of twisted silk or wool held perpendicularly before the eye, so that it can be

viewed in a direction opposite to the light, appears of a colour much more decided than the rest of the surface.

4. *Example.* The folds of bright draperies present the same modification to an eye properly placed: the effect is particularly remarkable in yellow silk stuffs, and in sky-blue; for we can easily understand that it is less marked when the stuffs are not so bright, and of dark colours.

5. *Example.* There are some stuffs which appear to be of two tones of the same scale of colour, and sometimes also of two tones of two contiguous scales, although the weft and the warp of these stuffs are of the same tone and the same colour. The cause of this appearance is very simple: the threads which, parallel to each other, form the design, are in a different direction to the threads which constitute the ground of the stuff. Thence, whatever may be the position of the spectator with regard to the stuff, the threads of the design will always reflect coloured and white light in a different proportion to the threads of the ground; and according to the position of the spectator, the design will appear to be now lighter, now darker, than the ground.

3rd MODIFICATION, *produced when one part of the surface of an object, coloured or not coloured, reflects little or no light to the eye of the spectator.*

(285.) When one part of the surface of a body which is in the field of vision of the spectator sends little or no light to his eyes, either because this part is not directly lighted, or because the light it reflects is not in a suitable direction, then it appears black, or more or less dark.

4th MODIFICATION. *The colour complementary to that of a coloured object, developed in one of its parts in consequence of simultaneous contrast.*

(286.) One natural consequence of the law of simultaneous contrast in general, and of the effect of a colour upon grey and black in particular, is, that, since the same object presents some parts more or less obscure, contiguous to parts where we see the colour peculiar to the object, the first part will appear tinted of the complementary to this colour; but to observe this effect, it is necessary that the grey part reflects to the eye white light, and little or none of the coloured light which the object naturally reflects.

(*a.*) 4th *Modification in a single-coloured stuff.*

(287.) For example, if the eye is directed from the back of a chamber towards a window which admits daylight, and a

person clothed in a new blue coat, dyed with indigo or Prussian blue, looks through the window on the objects which are outside (Plate III. fig. 3.), the eye will see the part *b* of the coat different from the part *a*, because the nap of the cloth is disposed in a contrary direction to *b* in *a*: *a* appears of a fine blue, while *b* will be of an orange-grey, by the effect of contrast of the blue part with a part that reflects very little white light to the eye, without, or almost without, blue light.

Besides, the pile of the nap loses its regular position; in fact, as it wears, the cloth becomes dull and tarnished, the coloured light is reflected irregularly from all points, and if the effect is not absolutely destroyed, it is at least much weakened.

If the garment be of a deep green, the grey part will appear reddish: if it be of a violet-marron or claret, the grey part will appear yellow.

(288.) The complementary is only developed upon cloths of dark and sombre colours; thus, red, scarlet, orange, yellow, and light-blue garments, do not exhibit it, because they have always too much of the essential colour which is reflected. The modification is limited to that where one of the parts is more strongly illuminated by diffused light than the other (279.).

(289). It is superfluous to remark that in a drapery where the pile lies all in one direction, but which exhibits folds, these, in changing the direction of the nap, may determine the modification presented by blue and dark-green clothes, as also by violet-marron.

(290.) There is still another circumstance where the fourth modification will appear evident; it is when we look upon a series of light tones, blues, rose, &c. (belonging to the same scale,) of a skein of silk or wool placed upon an easel in such manner that one half of the same skein presents to the eye the threads disposed in a contrary direction to those of the other half. The half of the skein which does not reflect coloured light to the eye, appears tinted with the complementary of the other half which does reflect it.

### (*b*) 4th *Modification in a stuff presenting a dark and a light tone belonging to the same scale.*

(291.) If we place in juxtaposition a dark tone and a light tone of the same scale well assorted, the light tone will appear of the colour complementary to the scale to which it belongs. This modification is too important in the explanation of certain phenomena often exhibited by the products of the calico-printer to permit of my passing it over hastily.

(292.) When we look for several seconds on a fabric dyed

with a coloured ground, and on which we put patterns intended to be white, but which, owing to the imperfection of the process employed, retain a light tone of the colour of the ground, the patterns will appear of the complementary to this latter. Thus upon a ground of yellow chromate of lead, they will appear *violet;* upon a ground of orange-chrome they will appear *blue; rose* upon a green ground, &c.: to dispel the illusion, and recognise the true tint of the pattern, it is only necessary to cover the ground with paper perforated with the design of the pattern, which then permits us to see only the pattern coloured like the ground. The influence of the dark tone upon a feeble tone is then such that not only is the latter neutralised, but also the place it occupies upon the cloth appears tinted with its complementary colour.

(293.) From the preceding observations, it may be deduced that we may have a printed cotton, the design of which, although coloured, will appear to most eyes white, and not of the complementary of the ground. For those eyes which see it thus, the perception of the phenomenon of contrast will correct the imperfection of the art of the calico-printer.

(294.) In the lectures upon Contrast which I gave in 1836 at the Gobelins, I remarked that, in applying paper (cut for the purpose) upon the lights of a blue drapery of the Virgin, in a tapestry representing the *Holy Family*, after Raphael, we saw them of light blue, although, when they were seen surrounded with darker blue tones, they appeared of an orange tint.

(295.) In conclusion, the fourth modification is observed:—

1. Every time that a monochromous object of a dark and not very vivid colour is seen in such manner that one portion reflects to the eye the colour which is peculiar to it, while the other portion reflects only a feeble light scarcely coloured.
2. Every time that a stuff presents two tones of the same colour at a suitable distance from each other.

(296.) We can conceive, without difficulty, that if the modification is not manifested with monochromous objects of vivid colours, as yellow, scarlet, &c., it is because that part of the surface of these objects which reflects the least light to the eye reflects, nevertheless, always sufficient of its peculiar colour to neutralise the complementary that the coloured light of the illuminated portion tends to develope. If I am not deceived, I believe that this effect tends to enfeeble the coloured light of the shaded part.

(297.) Although in this chapter I do not propose to treat of the modifications presented by coloured stuffs with white designs, yet, as it is a case which belongs to the developments in which I am engaged, I cannot avoid mentioning them in this place. If we observe a sky-blue silk with white flowers, the weft of which is in an opposite direction to the weft of the blue ground, we shall see the flowers white, if they are placed in the most favourable manner to receive the white light reflected by them; while, in the contrary position, we shall see these flowers absolutely orange. There is still much white light reflected; but it is not sufficiently vivid to neutralise the development of the complementary of the ground.

(298.) In painting, we recognise two kinds of perspective, the *linear* and the *aerial.*

*The first* is the art of producing, upon a plane surface, the lineaments and contours of objects and their various parts in the relations of position and size in which the eye perceives them.

*The second* is the art of distributing, in a painted imitation, light and shade, as the eye of the painter perceives them in objects placed in different planes, and in each particular object which he wishes to imitate upon a surface.

It is evident that aerial perspective comprehends the observation and reproduction of the principal modifications of colours which I have just examined in succession, and that *true and absolute colouring* in painting can only be as faithful a reproduction of this as possible.

## CHAPTER II.

ON THE DIFFERENCE EXISTING BETWEEN A COLOURED OBJECT AND THE IMITATION OF IT MADE BY A PAINTER, WHEN THE SPECTATOR OBSERVES IT FROM A DIFFERENT POINT OF VIEW FROM HIS.

(299.) THERE is a vast difference between the most perfect imitation of a coloured object and the object itself, upon which we will now dwell a moment, because it is not sufficiently appreciated. Imitation is true, relative to delineation, the distribution of light and shade, and all the resulting modifications of colour, only in the same position where the painter stood in regard to his model: for out of this position, every thing rela-

tively to the spectator varies, more or less; while in the imitation he sees the light, shadows, and lines which circumscribe them, and the modifications of colour, constantly in the same manner, whatever be the point of sight.

For example; a spectator who, in a room opposite a window, observes the back of a person in a new blue coat (Pl. III. fig. 3.), which is placed between him and the window, the part $a$ of the coat is blue, and the part $b$ an orange-grey. Let the spectator advance in such manner as to see the profile of this person; if, then, he looks at the parts $a$ and $b$, they will appear to him different from what they were before he changed his position.[*]

If the painter had painted the coat from the point of view where the spectator was at first, he would have coloured the part $a$ of a fine blue, and the part $b$ probably of orange-grey.

If, now, the spectator regards the imitation of the coat from the position where he was in the second place, when he saw the person in profile, he will always see the part $a$ blue, and the part $b$ of an orange-grey, although in this position the model coat no longer presents these modifications.

Besides, I must insist upon demonstrating a thing which is really very simple.

In fine, because lights, shades, and modifications of colours, and the outlines which circumscribe each part, preserve invariably the same relation in a picture made upon a plane, it evidently follows that this imitation produces the same impression, although we observe it from very different points from that where the painter was placed to represent his model.

(300.) It is for this reason, also, that a person who looks at the painter while he is painting his portrait on the canvas, appears in this portrait to look at the spectator, whatever may be the position of the latter with regard to the picture.

---

[*] There is a position where the spectator will see the part $a$ of an orange-grey, and the part $b$ of a fine blue.

# SECTION II.

#### PAINTING ON THE SYSTEM OF FLAT TINTS.

(301.) In painting in flat tints, the colours are neither shaded nor blended together, nor modified by the coloured rays coming from objects near that which the painter has imitated.

In pictures which belong to this kind of painting, the representation of the model is reduced to the observance of linear perspective, to the employment of vivid colours in the first planes, and to that of pale and grey colours in the more distant.

If the choice of contiguous colours has been in conformity with the law of simultaneous contrast, the effect of the colour will be greater than if it had been painted on the system of *Chiaro'scuro*. When, therefore, we admire the beauty of the colours of the paintings in flat tints which come from China, we must, in comparing them exactly with ours, take into consideration the system followed in them, otherwise we should exercise a false judgment by comparing pictures painted on different systems.

(302.) If it is indisputable that painting in flat tints preceded that in chiaro'scuro, it will, I think, be an error to believe that at the point we have arrived at in Europe, we must renounce the first to practise the second exclusively, for in every instance where painting is an accessory and not a principal feature, painting in flat tints is in every respect preferable to the other.

(303.) The essential qualities of painting in flat tints necessarily reside in the perfection of the colours and outlines. These outlines contribute to render the impressions of colours stronger and more agreeable, when, circumscribing forms clothed in colours, they concur with them in suggesting to the mind a graceful object, although in fact, the imitation of it does not give a faithful representation.

(304.) We may, in conformity with what has been said, consider that painting in flat tints will be advantageously employed,

1. When the objects represented are at such a distance that the finish of an elaborate picture would disappear.
2. When a picture is an accessory, decorating an object whose use would render it improper to finish it too highly, on account of its price — such are the paintings which ornament screens, work-boxes, tables, &c. — in this case, the objects preferable as models are those whose beauty of colours and simplicity of form are so remarkable, as to attract the eye by outlines easily traced, and by their vivid colours:— as birds, insects, flowers, &c.

# SECTION III.

## ON COLOURING IN PAINTING.

CHAPTER I.—ON THE VARIOUS SIGNIFICATIONS OF THE WORD COLOURING, IN PAINTING AND IN ORDINARY LANGUAGE.
(305.)—(322.)

CHAPTER II.—UTILITY OF THE LAW OF SIMULTANEOUS CONTRAST OF COLOURS IN THE SCIENCE OF COLOURING.
(323.)—(366.)

# SECTION III.

## COLOURING IN PAINTING.

### CHAPTER I.

ON THE VARIOUS SIGNIFICATIONS OF THE WORD COLOURING IN PAINTING AND IN ORDINARY LANGUAGE.

(305.) I HAVE elsewhere (298.) defined *true or absolute colouring* to be—the faithful reproduction in painting of the modifications which light enables us to perceive in the objects which the painter selects for his models. But, for want of analysing these modifications, the word *colouring* usually defined— *the result of the application, upon a plane surface, of coloured materials (pigments) with which the painter imitates a natural, or represents an imaginary object*—receives in its applications to the simplest as well as to the most complex pictures, (when we regard them under the two-fold relation of the number of colours employed, and of the number of objects painted,) significations so diverse, according to the kind of pictures, the taste and knowledge of the persons using this word, that my object will not be attained if, to the various significations it has in ordinary language, I do not apply the analysis which I have made of the different elements of *absolute colouring*.

(306.) After what has been stated, I believe that in the ordinary use of the word *colouring*, we allude to the manner, more or less perfect, in which the painter has complied with the rules —

1. *Of aerial perspective relative to white light and to shade, or, in other words, irrespective of colour;*
2. *Of aerial perspective relative to variously coloured light;*
3. *Of the harmony of local colours, and of that of the colours of the different objects composing the picture.*

## Article 1.

Of Colouring *with regard to aerial perspective, relative to white light and to shade.*

(307.) We must not believe that the employment of many colours in a composition is indispensable to give the name of *colourist* to the artist, for in painting in *camaïeu,* the simplest of all, in which we only distinguish two colours, including white, the artist will be honoured with the title of *colourist,* if his work presents lights and shades distributed as they are upon the model, leaving out, of course, those modifications arising from colours which he had not on his palette; and, to convince ourselves that the expression is not unjust, it will suffice to remark that the model might very well appear to the painter coloured in a single colour, modified by light and shade; in the same sense this name can always be applied to the engraver, who by means of his burin, reproduces a picture as faithfully as possible in respect both to the aerial perspective of its different planes, and to the relief of each particular object.

## Article 2.

Of Colouring *with regard to aerial perspective, relative to variously coloured light.*

(308.) It may happen that the imitation is perfectly faithful, or the reverse.

### A. *Perfectly faithful imitation.*

(309.) A painter who has faithfully reproduced the aerial perspective, with all its modifications of white and coloured light and of shade, has a *true or absolute colouring* (298.); but I do not pretend to conclude that the imitation in which this quality is found will be universally judged as perfect as that in which this quality is not found, at least in the same degree.

### B. *Imperfectly faithful imitation.*

(310.) This is the place to examine the principal cases which may occur when we observe pictures in which the modifications of differently-coloured light are not faithfully imitated.

(311.) First Case.—*A painter has perfectly seized upon all the modifications of white and coloured light, but in his imitation all the modifications, or a part only, are more prominent than in nature.*

It almost always happens that *true, but exaggerated, colouring* is more agreeable than *absolute colouring;* and we cannot conceal from ourselves that many persons who experience pleasure in seeing the modifications of exaggerated coloured oght in a picture, do not feel the same pleasure from the sight if the model, because the modifications corresponding to those which are imitated in excess, are not sufficiently prominent to be evident to them.

Besides, the relish of the eye for an excess of the exciting cause is essentially analogous to the inclination we have for food and drink of a flavour and odour more or less prominent; and this result is conformable to the comparison I have established (174.) between the pleasure we experience at the sight of vivid colours, leaving out every other quality in the object presenting them, and the pleasure resulting from the sensation of agreeable savours.

In our judgment of a picture whose colour appears *exaggerated*, and which is not in the place for which the painter destined it, we must not forget to take into account the light of the place which it is to occupy, and the distance from which the spectator views it, otherwise we incur the risk of greatly deceiving ourselves.

(312.) SECOND CASE. — *A painter has perfectly seized all the modifications of light which bring forward the planes and the relief of objects; the modifications of the coloured light of his picture are true, but the colours are not those of his model.*

This case comprehends those pictures in which there is a dominant colour which is not in the model. This dominant colour is often called *the tone of the picture, and the tone of the painter,* if he uses it habitually.

We should form a very just idea of these pictures if we supposed that the artist had painted them while looking at his model through a glass which had precisely the same colour, to enable him to perceive the tint which predominates in his imitation. We can also cite, as an example of this kind of imitation, a landscape painted from its reflection in a black mirror, because the effect of the picture is very soft and harmonious.

We also understand how it happens that a picture comprised under this head may have an agreeable or disagreeable dominant colour; and that the expressions *brilliant or warm colouring* or *cold and dull colouring* applies to those pictures the colours of which are unfaithful to the model, but which have an agreeable or disagreeable effect.

### Article 3.

*Of colouring in respect to the Harmony of Local Colours and to that of the Colours of the different Objects composing the Picture.*

(313.) The colouring of a picture may be *true* or *absolute*, and yet the effect may not be agreeable, because the colours of the objects have no harmony. On the contrary, a picture may please by the harmony of the local colours of each object, by that of the colours of objects contiguous to each other, and yet may offend by the gradation of the lights and shades, and by the fidelity of the colours. In a word, it offends by *true or absolute* colouring; and the proof that it might please is, that pictures in flat tints, the colours of which are perfectly assorted to the eye, although opposed to those which we know belong to the objects imitated, produce, under the relation of general harmony of colours, an extremely agreeable effect.

### *Result of the preceding Considerations.*

(314.) The general conclusions resulting from the analysis just made of the word Colouring in ordinary language, is that the epithet *Colourist* may be applied to painters endowed in very different degrees with the faculty of imitating coloured objects by means of painting.

(315.) They who know all the difficulties of *chiaro'scuro* and drawing may give the name of Colourists to painters remarkable for the skill with which they bring out objects placed upon the different planes of their pictures, by means of correct drawing, and a skilful gradation of light and shade, even when their pictures do not exactly produce every modification of coloured light, and have not this harmony of different colours properly distributed to complete the effects of perfect colouring.

(316.) They who have no facility in judging of painting, or who are ignorant of the art of *chiaro'scuro*, are generally inclined to refuse the title of Colourist to those painters of whom we have spoken, while they unhesitatingly accord it to others who have reproduced the modifications of coloured light, and tastefully distributed the different colours in their pictures. Besides, colour so powerfully influences the eyes, that frequently those who are strangers to painting can only conceive a Colourist skilful, where the tints are vivid, although he may have failed in the manner in which he has represented differently-coloured objects upon the canvas.

(317.) We see, by this, how the judgment of many persons

brought to bear upon the same picture, will differ from each other, according to the importance which they respectively attach to one quality of colouring rather than to another.

($318_1$.) Let us now consider what a perfect Colourist must be, or rather the conditions which every painter must fulfil in a picture, to whom this qualification can be applied.

(319.) For a painter to be a perfect Colourist, he must not only imitate the model by reproducing the image faithfully, in respect to aerial perspective relative to the variously coloured light, but also, the harmony of tints must be found in the local colours, and in the colours of the different objects imitated ; and this is the place to remark, that if in every composition there are colours inherent to the model which the painter cannot change without being unfaithful to nature, there are others at his disposal which must be chosen so as to harmonise with the first. It is a subject to which we shall return in the next chapter (343.).

(320.) I have now defined what a painter is, a perfect Colourist — conformably to the analysis I have made of the word *Colouring;* and considered the painter by himself,— that is to say, without comparing him with others ; we must now consider this definition in relation to contemporary painters, and those old enough for their pictures to have undergone some change, and that the varnish covering them is more or less yellow.

(321.) It is evident that, when the pictures have been recently painted, and they represent familiar objects, we can always see if the painter has fulfilled all the conditions of a perfect Colourist, by comparing the model with his representation.

(322.) After what has been said, it is evident that when a change in the colours of a picture has been effected by time, it is impossible to determine whether the artist who painted it should be called a *perfect Colourist* (319.) But if we recall what I have said of the painter who has correctly seized all the modifications of light adapted to bring out the distances and the relief of objects —who has represented the modifications of coloured light with perfect truth, but which are not those of the model (312), we may very easily conceive how, at this day, after one, two, or three centuries, we can give the name of *Colourist* to Albano, Titian, Rubens, and others.

In fact, now-a-days, the pictures of these great masters present to us gradations, more or less perfect, of light and shade and such harmonies of colours, that it is impossible to mistake

112    COLOURING IN PAINTING.    [PART II. DIV. I.

and not to admire them; and the idea that so many pictures not more than twenty or five-and-twenty years old, painted by artists of undoubted skill, have lost in colour more than the preceding, also increases our admiration for the latter.

## CHAPTER II.

UTILITY OF THE LAW OF SIMULTANEOUS CONTRAST OF COLOURS IN THE SCIENCE OF COLOURING.

(323.) AFTER having defined the principal modifications which bodies experience when they become sensible to us by means of the white or coloured light which they reflect; after having examined painting and defined colouring conformably with the study of these modifications, — it remains for me to speak of the law of contrast of colours, with respect to the advantages the painter will find in it when required —

1. To perceive promptly and surely the modifications of light on the model.
2. To imitate promptly and surely these modifications.
3. To harmonise the colours of a composition, and having regard to those which must necessarily be found in the imitation, because they are inherent to the nature of the objects which he must reproduce.

### ARTICLE 1.

*Utility of this Law in enabling us to perceive promptly and surely the Modifications of Light on the Model.*

(324.) The painter must know, and especially *see*, the modifications of white light, shade, and colours which the model presents to him in the circumstances under which he would reproduce it.

(325.) Now what do we learn by the law of *simultaneous contrast of colours?* It is, that when we regard attentively two coloured objects at the same time, neither of them appears of the colour peculiar to it, that is to say, such as it would appear if viewed separately, but of a tint resulting from the peculiar colour and the complementary of the colour of the other object.

On the other hand, if the colours of the objects are not of the same tone, the lightest tone will be *lowered*, and the darkest tone will be *heightened*; in fact, they will appear by the juxtaposition different from what they really are.

(326.) The first conclusion to be deduced from this is, that the painter will rapidly appreciate in his model the colour peculiar to each part, and the modifications of tone and of colour which they may receive from contiguous colours. He will then be much better prepared to imitate what he sees, than if he was ignorant of this law. He will also perceive modifications which, if they had not always escaped him because of their feeble intensity, might have been disregarded because the eye is susceptible of fatigue, especially when it seeks to disentangle the modifications whose cause is unknown, and which are not very prominent.

(327.) This is the place to return to *mixed contrast* (81. and following), in order to make evident how the painter is exposed to seeing the colours of his model inaccurately. In fact, since the eye, after having observed one colour for a certain time, has acquired a tendency to see its complementary, and as this tendency is of some duration, it follows, not only that the eyes of the painter, thus modified, cannot see correctly the colour which he had for some time looked at, but also another which might strike them while this modification lasts. So that, conformably to what we know of mixed contrasts (81. &c.), they will see — not the colour which strikes him in the second place, — but the result of this colour and of the complementary of that first seen. It must be remarked, that besides the defect of clearness of view which will arise in most cases from the want of exact coincidence of the second image with the first, — for example, the eye has seen a sheet of green paper A (Pl. III. fig. 4.), in the first place, and in the second place regards a sheet of blue paper B of the same dimensions, but which is placed differently — it will happen that this second image, not coincident in all its surface with the first A' as represented in the figure, the eye will see the sheet B violet only in the part where the two images coincide. Consequently this defect of perfect coincidence of images will be an obstacle to the distinct definition of the second image and of the colour which it really possesses.

(328.) We can establish three conditions in the appearance of the same object relative to the state of the eye; in the first, the organ simply perceives the image of the object without taking into account the distribution of colours, light, and shade; in the second, the spectator, seeking to properly understand this

distribution, observes it attentively, and it is then that the object presents to him all the phenomena of simultaneous contrast of tone and colour which it is capable of exciting in us. In the third circumstance, the organ, from the prolonged impression of the colours, possesses in the highest degree a tendency to see the complementary of these colours; it being understood that these different states of the organ are not interrupted, but continuous, and that, if we examined them separately, it was with the view of explaining the diversity of the impression of the same object upon the sight, and to make evident to painters all the inconveniences attendant upon a too prolonged view of the model.

I have no doubt that the dull colouring with which many artists of merit have been reproached, is partly due to this cause, as I shall show more minutely hereafter (366.).

### ARTICLE 2.

*Utility of this Law in order to imitate promptly and surely the Modifications of Light on the Model.*

(329.) The painter, knowing that the impression of one colour beside another is the result of the mixture of the first with the complementary of the second, has only to mentally estimate the intensity of the influence of this complementary, to reproduce faithfully in his imitation the complex effect which he has under his eyes. After having placed upon his canvas the two colours he requires, as they appear to him in the isolated state, he will see if the imitation agrees with his model; and, if he is not satisfied, he must then recognise the correction which has to be made. Take the following examples:—

#### 1st EXAMPLE.

(330.) A painter imitates a white stuff, with two contiguous borders, one of which is red, the other blue; he perceives each of them changed by virtue of their reciprocal contrast; thus the red becomes more and more orange, in proportion as it approaches the blue, as this latter takes more and more green as it approaches the red. The painter, knowing by the law of contrast the effect of blue upon red, and reciprocally, will always reflect that the green hues of the blue, and the orange hues of the red, result from contrast, consequently in making the borders of simply red and blue, reduced in some parts by white or by shade, the effect he wishes to imitate will be reproduced. In case it is found that the painting is not

sufficiently marked, he is sure of what he must add without departing from the truth, otherwise he must exaggerate a little (311.).

### 2nd EXAMPLE.

(331.) A grey pattern drawn upon a yellow ground—the ground may be of paper, silk, cotton, or wool; according to its contrast, the design will appear of a lilac or a violet colour (66.).

The painter who would imitate this object, which I suppose to be a tapestry, a vestment, or any drapery whatever, can reproduce it faithfully with grey.

(332.) These two examples are appropriate to explain the difficulties, encountered by painters who are ignorant of the law of contrast of colours.

For, the painter, ignorant of the reciprocal influence of blue and red, is of opinion that he must represent what he sees; consequently he adds green to his blue, and orange to his red; as, in the second example, he will trace a pattern more or less violet upon the yellow ground; now what would happen? Why, the imitation would never be perfectly faithful; it would be exaggerated; supposing, of course, that, at first, the painter had perfectly seized the modifications of the model, and subsequently having perceived the exaggeration of his imitation, he has not retouched it sufficiently to produce a perfectly faithful effect. If he had arrived at this latter result, it is evident it would only be after a greater or less number of trials, since he must have effaced what was first done.

### 3rd EXAMPLE.

(333.) I cite a third example of the influence of contrast, no longer relating to colours like the two preceding; but relative to the different tones of the same colour, which are contiguous to each other.

Several bands in juxtaposition, 1, 2, 3, 4 (Pl. I. fig. 3. *bis.*), of different tones in flat tints of the same scale, form part of an object which a painter has to reproduce in a picture; to imitate it perfectly, it is evident that he must paint in flat tints; but this object will appear to the eye a channeled surface, the line where the two bands touch will appear like a relief by the effect of contrast of tone (9—11), it follows if the painter is ignorant of this, he will reproduce, not an absolute copy of the model, but an exaggerated one; or if, dissatisfied with his first imitation, he arrives at a faithful reproduction of the model, it will be after attempts more or less numerous. I the more willingly cite this

example, because it gave me the opportunity of making one of the most skilful paper-stainers appreciate the utility of the law of simultaneous contrast. In going with him over his factory, he showed me a chimney-board representing a child whose figure stood out from a ground formed of two circular bands in grey flat tints 1 and 2. (Plate III. fig. 5.); the first was higher than the second; the phenomenon of contrast of tone was manifested at the borders *a, a*, of the two bands, in such a manner, that the part of the band 2 contiguous to the band 1, was darker than the rest, as the part of the band 1, contiguous to 2, was lighter than the rest, conformably to what has been stated above (11.). This effect not being what the skilful artist wished to obtain, he inquired of me how it was to be avoided. I replied that the grey of the band 2 must be reduced with white in proportion as it approached the border *a, a*, and, on the contrary, to strengthen with black in proper gradations the grey of the band 1, setting out from the same border, and I proved to him *that to imitate the model faithfully, we must copy it differently from what we see it.*

(334.) The manner in which I have examined contrast must convince the painter of the correctness of the six following principles.

### 1st *Principle.*

(335.) Put a colour upon a canvas, it not only colours that part of the canvas to which the pencil has been applied, but it also colours the surrounding space with the complementary of this colour.

Thus (*a*). A Red circle is surrounded with a Green aureola, which grows weaker and weaker, as it extends from the circle.

(*b.*) A Green circle is surrounded with a Red aureola.
(*c.*) An Orange circle is surrounded with a Blue aureola.
(*d.*) A Blue circle is surrounded with an Orange aureola.
(*e.*) A Yellow circle is surrounded with a Violet aureola.
(*f.*) A Violet circle is surrounded with a Yellow aureola.

### 2nd *Principle.*

(336.) To place White beside a colour is to heighten its tone; it is the same as if we took away from the colour the white light which enfeebled its intensity (44—52.).

### 3rd *Principle.*

(337.) Put Black beside a colour, it weakens its tone; in some cases it impoverishes it, such is the influence of Black

upon certain Yellows (55.). It is, in fact, to add to Black the complementary of the contiguous colour.

### 4th *Principle.*

(338.) Put Grey beside a colour, it is rendered more brilliant, and at the same time it tints this Grey with the complementary of the colour which is in juxtaposition (63.).

From this principle results the consequence that in many cases where Grey is near to a pure colour in the model, the painter, if he wishes to imitate this Grey, which appears to him tinted of the complementary of the pure colour, need not have recourse to a coloured Grey, as the effect ought to be produced in the imitation by the juxtaposition of the colour with the Grey which is near it.

Besides, the importance of this principle cannot be doubted, when we consider that all the modifications which monochromous objects may present (excepting those which result from the reflections of coloured light emanating from neighbouring objects), belong to the different relations of position between the parts of the object and the eye of the spectator, so that it is strictly true to say, that, to reproduce by painting all these modifications, it suffices to have a colour exactly identical to that of the model and black and white. In fact, with White we can reproduce all the modifications due to the weakening of the colour by light, and with Black, those which are necessary to heighten its tone. If the colour of the model in certain parts gives rise to the manifestation of its complementary, because these parts do not return to the eye sufficient of colour and white light to neutralise this manifestation, the modification of which I speak is reproduced in the imitation by the employment of a normal grey tone properly surrounded with the colour of the object.

If the preceding proposition is true, I recognise the necessity in many cases of employing, with the colour of the object, the colours which are near to it; that is to say, the hues of the colour. For example, in imitating a rose, we can employ red shaded with a little yellow, and a little blue, or, in other terms, shaded with orange and violet; but the green shadows which we perceive in certain parts arise from the juxtaposition of red and normal grey.

### 5th *Principle.*

(339.) To put a dark colour near a different, but lighter colour, is to heighten the tone of the first, and to lower that of the second, independently of the modification resulting from the mixture of the complementaries.

An important consequence of this principle is that the first

effect may neutralise the second, or even destroy it altogether: for example, a light Blue placed beside a Yellow, tinges it Orange, and consequently heightens its tone; while there are some Blues so dark relatively to the Yellow, that they weaken it, and not only hide the Orange tint, but even cause sensitive eyes to feel that the Yellow is rather Green than Orange; a very natural result, if we consider that the paler the Yellow becomes, the more it tends to appear Green.

### 6th *Principle.*

(340.) Put beside each other two flat tints of different tones of the same colour, Chiaro'scuro is produced, because, in setting out from the line of juxtaposition, the tint of the band of the highest tone is insensibly enfeebled; while setting out from the same line, the tint of the band of the lowest tone becomes heightened: there is then a true gradation of light (333.).

The same gradation takes place in all the juxtapositions of colours distinctly separated.

(341.) If I am not deceived, the observance of these principles, and especially the perfect knowledge of all the consequences of the last three, exercises a very happy influence upon the art of painting, in giving to the artist a knowledge of the colours which he cannot possess before the law of their simultaneous contrast has been developed, and followed in its consequences as it now is.

(342.) The painter, it appears to me, will gain, not only in the rapidity with which he will see the model, but also in the rapidity and truth with which he will be able to reproduce the image. Among the details which he endeavours to render, there are many which, due to contrast either of colour or of tone, will produce themselves. I presume that the Greek painters, whose palette was composed of White, Black, Red, Yellow, and Blue, and who executed so many pictures which their contemporaries have spoken of with intense admiration, painted conformably to the simple method of which I speak; attaching themselves to great effects, many minor ones resulted.

### ARTICLE 3.

*Utility of the Law in order to harmonise the Colours which enter into a Composition with reference to those which must be reproduced, because they are inherent in the Nature of the Object represented.*

(343.) In all, or nearly all, the compositions delineated in

painting, we must distinguish the colours which the painter is under the necessity of using, and those which he is at liberty to choose, because they are not, like the former, inherent in the model (319.).

For example, in painting a human figure, the colour of the flesh, the eyes, and the hair, are fixed by the model, but the painter has a choice of draperies, ornaments, background, &c.

(344.) In a historical picture, the flesh colours are, in the majority of the figures, at the choice of the painter, as are also the draperies, and all the accessories, which can be designed and placed as desired.

(345.) In a landscape, the colours are given by the subject, yet not so arbitrarily but we can substitute for the true colour the colour of a neighbouring scale; the artist can choose the colour of the sky, imagine numerous accidental effects, introduce into his composition animals, draped figures, carriages, &c., the form and colour of which may be selected in such manner as to produce the best possible effect with the objects peculiar to the scene.

(346.) A painter is also master of his choice in a dominant colour, which produces upon every object in his composition the same effect as if they were illuminated by a light of the same colour, or, what amounts to the same thing, seen through a coloured glass (179.).

(347.) If the law of contrast affords different methods of imparting value to a colour inherent in the model, genius alone can indicate which method a painter should prefer to others in realising his idea upon the canvas, and so render it evident to the sight.

(348.) Whenever we would attract the eye by colours, doubtless the principle of *harmony of contrast* must be our guide. The law of simultaneous contrast indicates the means by which the pure colours may be made to give value to each other; means which, although spoken of, are but little understood, as may be seen in the crowd of portraits in vivid tints so badly assorted, and in those numerous small compositions in tints broken with grey, where we look in vain for a pure tone, which, however, from the subjects represented in them, are eminently adapted to receive all the vivid colours which the painter in flat tints employs.

(349.) The contrast of the most opposite colours is as agreeable as possible, when they are of the same tone. But if crudity is feared, by using too great intensity of colours, we must have recourse to the light tones of their respective scales.

(350.) When the painter breaks tones with grey, and wishes to avoid monotony, or when upon planes which are distant, but not sufficiently so to render the differences of colour inappreciable, he wishes every part to be as distinct as possible, he must have recourse to the principle of harmony of contrast, and mix grey with his colours.

This method of bringing out a colour by contrast, in employing either light tones complementary or more or less opposed; or broken tones more or less grey, and of tints complementary to each other; or in employing a broken tone of a tint complementary to a contiguous colour more or less pure, — ought to particularly fix the attention of portrait painters. A portrait of a lady may have a very mediocre effect, because neither the colour of the dress nor of the background have been properly selected.

(351.) The portrait painter must endeavour to find the predominating colour in a complexion he has to paint; once found and faithfully reproduced, he must seek what among the accessories at his disposal will give value to it. There is a very prevalent error that the complexion, in women, to be beautiful must consist only of red and white; if this opinion is correct for most of the women of our temperate climate, it is certain that, in warmer climes, there are brown, bronzed, copper-complexions even, endued with a brilliancy, I may say beauty, appreciated only by those who in pronouncing upon a new object, wait until they have got rid of habitual impressions, which (although the majority of men do not know it) exercise so powerful an influence upon the judgment of objects seen for the first time.

(352.) I had at first intended to introduce here some examples of the colours most advantageous to set off the complexions of women; but, upon reflection, I have preferred to include them in the section where I have treated of the application of the law of contrast to dress.

(353.) Suppose a painter would always derive the greatest possible advantage from colours without being under the necessity of multiplying them; if he had to paint the draperies of a single colour, he might have recourse advantageously to the coloured rays emanating from neighbouring bodies, whether they are perceptible to the spectator, or out of sight. For example, a green or yellow light falling upon part of a blue drapery, makes it green, and by contrast, heightens the blue-violet tone of the rest; a golden yellow light falling on part of a purple drapery imparts to it a yellow tone, which makes the purple of the rest come out, etc.

(354.) The principle of harmony of contrast then procures for the painter who undertakes to produce the effects of chiaro'-scuro, the means of realising, with respect to brilliancy of colours and distinctness of parts, effects which the painter who graduates neither the shadows nor the lights produces without difficulty by means of flat tints.

(355.) After having treated of the utility of the law of simultaneous contrast in the employment of pure opposite colours, and of colours broken by grey, opposed in the same manner, when we require to multiply pure and varied colours, either in objects whose very various parts permit this employment, or, in a multitude of accessories, it remains for me to treat of the case where the painter, wishing less diversity in the object, less variety in the colours, employs only with reserve the *harmony of contrast*, preferring to it, the more easily to attain his end, the *harmony of scale* and the *harmony of hues.*

(356.) The greater the number of different colours and accessories in a composition, the more the eyes of the spectator are distracted, and the more difficulty is experienced in fixing the attention. If, then, this condition of diversity of colours and accessories is obligatory on the artist, the more obstacles there are to surmount when he wishes to draw and fix the attention of the spectator upon the physiognomy of the figures which he would reproduce, whether these figures represent the actors in one scene only, or whether they are simply portraits. In the latter instance if the model has a common physiognomy, which recommends itself neither by the beauty nor expression of its features, and still more if he must conceal or dissemble a natural defect, all that is accessory to this physiognomy, all the resources of contrasted colours well assorted together, must come to the aid of the painter.

(357.) But if the inspired artist feels all the purity of expression, all the nobility and loftiness of character pertaining to his model, or if a physiognomy, to most eyes common-place, strikes him by one of those expressions, which he judges to belong only to men animated by noble ideas in politics, science, arts, and literature, it is to the physiognomy of such models that he should address himself; upon these he should fix his chief attention, so that, in reproducing them upon his canvas, no one can mistake the resemblance, nor overlook the feeling which guided his pencil. Everything being accessory to the physiognomy, the drapery will be black or of sombre colours; if ornaments relieve them, they will be simple, and always in connection with the subject.

(358.) When from this point of view we examine the *chefs-d'œuvre* of Vandyck, and trace the beauty of their effect to the simplicity of the means by which it is produced, and consider the elegance of their attitudes, which always appear natural, the taste which presides over the selection of the draperies, ornaments, in a word, all the accessories, — we are struck with admiration for the genius of the artist, who has not had recourse to those means of attracting attention so much abused at the present day, either by giving to the most vulgar person a heroic attitude, to the most common-place physiognomy the pretence of profound thought, or in seeking extraordinary effects of light; for example, in filling the figure with a strong light while the rest of the composition is in shade.

(359.) These reflections fully indicate the point of view a historical painter must take when he would particularly fix the attention upon the physiognomy of the persons who take part in a remarkable scene. Only we must observe that the more he would employ allied scales, the more care must he take to choose such as do not lose too much by their mutual juxtaposition.

(360.) There is another important observation to make; which is, to avoid as much as possible the reproduction of the same kind of images as ornaments of different objects. Thus, figures clothed in draperies with large flower-patterns which a painter has placed in a room where the carpet and porcelain vases repeat the same images to the spectator, have never an unobjectionable effect, because they make it troublesome for the eye to separate the different parts of the picture, which the similarity of ornaments tend to confound together. It is also on the same principle that the painter must generally avoid placing beside the faithful reproduction of a model, the reproduction of an imitation which repeats this model. For example, when he paints a vase of flowers, the artist produces most effect, other things being equal (supposing that he wishes to fix the attention upon the flowers he paints from nature), in painting the vase of white or grey porcelain, instead of a vase upon which a profusion of similar objects has already been enamelled.

(361.) Now to finish what I proposed saying upon Colouring, it remains to treat of the case where a painter wishes a certain colour to predominate in his composition ; or, to speak more correctly, the case where the scene he represents is lighted by a coloured light diffused over every object. The better to comprehend my meaning, he must not only take simultaneous contrast into consideration, but also the modifications which

result from the mixture of colours (171.), comprising the recomposition of white light by means of a proper proportion of the differently-coloured elementary rays.

(362.) Whenever a painter would make a coloured light predominate in a composition, he must attentively study the article in which we have examined the principal cases of the modifications of light resulting from coloured rays falling upon bodies of various colours (pp. 91, and following); he must understand, that although the coloured light chosen imparts value to certain colours of the objects upon which it falls, it also impoverishes and neutralises others. Consequently, when the artist is decided upon employing a predominant colour, he must renounce certain others; for if he does not, the effect produced will be false.

(363.) For example, if in a picture the colour orange predominates, for the colouring to be true, it must necessarily follow—

1°. That the purples must be more or less red;
2°. That the reds must be more or less scarlet;
3°. That the scarlets must be more or less yellow;
4°. That the orange must be more intense, more vivid;
5°. That the yellows must be more or less intense and orange;
6°. That the greens lose their blue, and consequently become yellower;
7°. That the light blues become more or less light grey;
8°. That deep indigo becomes more or less marron;
9°. That the violets lose some of their blue.

We clearly see, then, that orange light heightens all the colours which contain red and yellow, while, neutralising a portion of blue in proportion to its intensity, it destroys, wholly or in part, this colour in the body which it illuminates, and consequently disturbs the greens and the violets.

(364.) From the studies which I have made of pictures with reference to the true imitation of colouring, it appears to me that painters of interiors have, other things being equal, more power than historical painters in faithfully reproducing the modifications of light. Supposing that I am not in error, perhaps the following causes will explain this remark.

In the first place, is it not because historical painters attach more importance to the attitudes and physiognomy of their figures than to the other parts of their composition, seeking less to reproduce a number of small details, the faithful imitation of which is the peculiar merit of the painter of interiors?

In the second place, is it not because the historical painter is never in a position to see all the scene he would represent, like the painter of interiors, who, having constantly his model before him, consequently sees it completely, as he would imitate it upon the canvas?.

(365.) We shall conclude these reflections by a general remark: it is, that in every composition of small extent, the colours, as well as the objects represented, must be distributed with a kind of symmetry, so as to avoid being what I can express only by the term *spotty*. In fact, it happens, for want of a good distribution of objects, that the canvas is not filled in some parts, or, if it is, there is evident confusion in many places; so, also, if the colours are not distributed properly, it will happen that some of them will be spotty, because they are too isolated from the others. For further consideration of this subject, we must call the attention of the reader to what has been said in § 4 of the Prolegomena (249 and 251.).

(366.) From what has been said, I believe that those painters who will study the mixed and simultaneous contrasts of colours, in order to employ the coloured elements of their palette in a rational manner, will perfect themselves in *absolute colouring* (298), as they perfect themselves in linear perspective by studying the principles of geometry which govern this branch of their art. I should greatly err, if the difficulty in faithfully representing the image of the model, encountered by painters ignorant of the law of contrast, has not with many been the cause of a colouring dull and inferior to that of artists who, less careful than they in the fidelity of imitation, or not so well organised for seizing all the modifications of light, have given way more to their first impressions. Or, in other words, seeing the model more rapidly, their eyes have not had time to become fatigued; and, content with the imitation they have made, they have not too frequently returned to their work to modify it, to efface, and afterwards reproduce upon a canvas soiled by the colours put on in the first place, which were not those of the model, and which will not be entirely removed by the last touches. If what I have said is true, there are some painters to whom the axiom, *Let well alone*, will be perfectly applicable.

## SECOND DIVISION.

### IMITATION OF COLOURED OBJECTS WITH COLOURED MATERIALS OF A DEFINITE SIZE.

INTRODUCTION.

FIRST SECTION.—GOBELINS TAPESTRY.

SECOND SECTION.—BEAUVAIS TAPESTRY FOR FURNITURE.

THIRD SECTION.—SAVONNERIE CARPETS.

FOURTH SECTION.—TAPESTRIES FOR HANGINGS AND CARPETS.

FIFTH SECTION.—MOSAICS.

SIXTH SECTION.—COLOURED GLASS WINDOWS OF LARGE GOTHIC CHURCHES.

# SECOND DIVISION.

## IMITATION OF COLOURED OBJECTS BY COLOURED MATERIALS (THREADS, ETC.).

### INTRODUCTION.

(367.) IMITATIONS resembling more or less those of painting can be made with materials of a certain thickness, such as threads of wool, silk, and hemp, adapted to the fabrication of Gobelins and Beauvais tapestries; the woollen threads exclusively employed in fabricating Savonnerie carpets; the small regular and irregular prisms of mosaics, and the coloured glass of the windows of gothic churches.

(368.) The tapestries of Gobelins and of Beauvais, and also the carpets of Savonnerie and certain very elaborate mosaics, may all be considered as works which resemble the method of painting in *chiaro'scuro;* while the windows of gothic churches correspond more or less exactly to painting in *flat tints*. It is the same also with tapestries for hangings and carpets which, instead of being fabricated with scales of at least sixteen or eighteen tones, as they are in the royal manufactories, are fabricated with scales composed of three or four tones only; and, far from mixing threads of various colours or tones of one scale, with the intention of imitating the effects of *chiaro'scuro*, the coloured objects reproduced present to the eye small monochromous bands of a single juxtaposed tone.

(369.) There are also some works which reproduce coloured designs by a kind of mixed system, because these designs are the result of the juxtaposition of monochromous single-tinted parts of a palpable size; but in juxtaposing these portions, the effects of *chiaro'scuro* have been sought by making use of the gradations of scale or the mixture of hues. Such are ordinary mosaics, carpets, embroidered tapestries, &c.

(370.) Patterns exercise so much influence in the tapestries and carpets of the royal manufactories, that I consider it necessary to offer some reflections, arising from numerous observations I have had occasion to make on the kind of painting best

suited to this purpose, hoping they will interest artists who occupy themselves with works of this class, and who seek to understand the principal object of this kind of painting. When they have once determined the principal effects which they aim at producing, they will see what points of ordinary painting may be sacrificed to obtain the first. They will thus be able to arrive at a conclusion as to what must be done for perfecting the *special portion of their imitation*. It is by starting both from the physical condition of the coloured elements the Gobelins weaver employs, and from the texture of the tapestry, that I deduce the necessity of representing in this kind of work only large objects well defined, and particularly remarkable for the brilliancy of their colours. I prove by analogous reasonings that the patterns for hangings must recommend themselves more by opposite colours than by minute finish in the details. Finally, after having regarded in an analogous manner the patterns of carpets, I endeavour to prove by the same considerations that to pretend to rival painting by the coloured elements of mosaics or stained glass, is to establish a confusion most detrimental to the progress of arts absolutely distinct from painting, both in their object and the means of attaining it.

(371.) The principles truly essential to these arts of imitation being once deduced from their individual *speciality*, are found to be established beyond dispute, it becomes easy to distinguish between the efforts by which we may hope to attain true perfection and those which can only bring about the opposite result.

# SECTION I.

### GOBELINS TAPESTRY.

CHAPTER I. — OF THE ELEMENTS OF GOBELINS TAPESTRY (372.)—(375.).

CHAPTER II.— ON THE PRINCIPLE OF MIXING COLOURED THREADS, IN ITS RELATIONS WITH THE ART OF WEAVING GOBELINS TAPESTRY (376.)—(380.).

CHAPTER III.— ON THE PRINCIPLE OF CONTRAST, IN CONNECTION WITH THE PRODUCTION OF GOBELINS (381.)—(388.).

CHAPTER IV. — QUALITIES WHICH PATTERNS FOR GOBELINS TAPESTRY MUST POSSESS (389.)—(392.).

# CHAPTER I.

### OF THE ELEMENTS OF GOBELINS TAPESTRY.

(372.) THE Elements of Gobelins Tapestry are two in number:—
>the warp (la *chaine*), and
>the weft (la *trame*).

The *warp* is formed of uncoloured woollen threads, extended vertically in front of the workman.

The *weft* is formed of coloured threads, which entirely cover the threads of the warp.

With variously coloured threads of a certain diameter we imitate all the colours of the most perfect pictures.

(373.) The art of the tapestry-weaver is based upon the *principle of mixing colours*, and on *the principle of their simultaneous contrast.*

(374.) There is a *mixture of colours* whenever materials of various colours are so divided and then combined that the eye cannot distinguish these materials from each other: in which case the eye receives a single impression; for example, if the materials are a blue and a yellow of the same strength, and in proper proportions, the eye receives an impression of green.

(375.) There is a *contrast of colours* whenever differently coloured surfaces are properly arranged and susceptible of being seen simultaneously and perfectly distinct from each other; and we must remember that, if a blue surface is placed beside a yellow surface, instead of inclining to green, they, on the contrary, differ from each other, and acquire red.

## CHAPTER II.

### ON THE PRINCIPLE OF MIXING COLOURED THREADS, IN ITS RELATIONS WITH THE ART OF WEAVING GOBELINS TAPESTRY.

(376.) WITH a certain number of scales of different colours, pure and broken with black, we may by mixing them produce an infinite variety of colours.

The mixtures are of two kinds ;

(377.) Firstly, we mix a thread of the 4tht one of the scale of a colour $A$, with a thread of the 4th tone of the scale of a colour $A'$, more or less analogous to $A$.

*This is mixture by Threads.*

It is not made upon figured silks.

(378.) Secondly, the weft is worked so as to interweave together either the threads of a scale of the colour A, or the threads of a scale of the colour $A'$ mixed with the threads of a scale B, or with the threads of the scale B mixed with the threads of a scale $B'$ more or less analogous to that of B.

*This is mixture by Hatchings.*

(379.) We can understand by this, how with these two kinds of mixture we can imitate all the tones and all the various colours of the pictures which serve as patterns for tapestry.

(380.) In the mixtures by threads and by hatchings, it is always indispensable to take into consideration the facts of which I have spoken,(158.) ; and I am the more urgent on this subject, because M. Deyrolle, director at the Gobelins, perfectly understanding the processes of his art, has had the kindness to execute, at my request, different mixtures of coloured silk threads in a piece of tapestry, to enable me to prove the remarks I have made ; they lie at the foundation of all the arts the palettes of which, so to speak, are composed of coloured threads, and have also the advantage of referring to the same rules the art of modifying by mixture the colours of coloured substances, whether they are in a state of infinite division or of appreciable extent.

The mixtures which I am about to mention were made with

threads of two colours taken at the same tone; each thread covered the warp; they were arranged parallel to each other and were stretched perpendicularly to the warp. When the mixture was composed of an equal number of threads of each colour, it presented very narrow stripes of equal size, and alternately of different colours. To make mixtures of coloured threads understandingly, we must satisfy the three following rules. The first two are principal, because they result directly from the observation of facts; the third is secondary, because it is the natural deduction from the facts comprised in the first two.

### I. RULE.—CONCERNING THE BINARY MIXTURE OF PRIMARY COLOURS.

*When we unite Red with Yellow, Red with Blue, Yellow with Blue, the threads must not reflect a palpable quantity of the third primary Colour, if we would have Orange, Violets, and Greens as brilliant as it is possible to obtain them by this method.*

### EXAMPLE.

#### A. *Red and Yellow.*

3 Red threads with 1 Yellow thread
2 Red threads with 1 Yellow thread
1 Red thread with 1 Yellow thread
3 Yellow threads with 1 Red thread
2 Yellow threads with 1 Red thread

yield mixtures which appear to the eye as they must do in proportion to the two colours mixed. There is no appearance of Grey in any of these mixtures when we employ a Red more inclining to Orange than to Crimson, and a Yellow more inclining to Orange than to Green.

#### B. *Red and Blue.*

3 Red threads with 1 Blue thread
2 Red threads with 1 Blue thread
1 Red thread with 1 Blue thread
3 Blue threads with 1 Red thread
2 Blue threads with 1 Red thread

give mixtures which appear to the eye as they must do relatively to the proportion of the two colours mixed. If we use a Red and a Blue inclining to Violet, the mixture will contain no Grey.

SECT. I. CHAP. II.] MIXTURE OF COLOURED THREADS. 133

C. *Yellow and Blue.*

4 Blue threads with 1 Yellow thread
3 Blue threads with 1 Yellow thread
2 Blue threads with 1 Yellow thread
1 Blue thread with 1 Yellow thread

give mixtures which appear to the eye as they must appear relatively to the proportions of the two colours mixed. If we use a Yellow and a Blue, inclining to Green more than to Red, the mixture will contain little or no Grey.

Experiment on all the preceding mixtures demonstrates the rule enounced above, or rather this rule is only the expression of a generalisation of facts.

II. RULE. — CONCERNING THE MIXTURE OF COMPLEMENTARY COLOURS.

*When we mix Red and Green, Orange and Blue, Yellow and Violet, the colours are more or less completely neutralized, according as they are more or less perfectly complementary to each other, and as they are mixed in proper proportions. The result is a Grey, the tone of which is generally higher than that of the colours mixed, if these latter are of a suitably high tone.*

EXAMPLES.

D. *Red and Green.*

$d$. 3 Red threads with 1 Green thread give a dull Red.

2 Red threads with a Green thread give a duller and deeper Red than the pure Red employed.

1 Red thread with 1 Green thread give a Reddish Grey, the tone of which is a little higher than that of the preceding mixture.

3 Green threads with 1 Red give a Green Grey, the tone of which is higher than the Green or the Red.

2 Green threads with 1 Red give a Grey less Green, and of a higher tone than the two colours.

$d'$. In repeating the same mixtures with higher tones of the same scales of Green and Red, we remark, that the tone of the mixture of 2 Green threads with 1 Red thread is higher relatively to that of the colours mixed, than it is in the mixtures $d$.

$d''$. 1 Red thread and 1 Yellowish Green thread give a *Carmelite* Brown, or an Orange-Grey, the tone of which is equal to that of the colours mixed.

$d'''$. 1 Red thread and 1 Bluish-Green thread, give a copper-coloured mixture, or Catechu-Brown, of a higher tone than that of the colours mixed.

### Conclusion.

From this we may conclude that red and green threads, properly assorted and in suitable proportions, yield *grey*.

### E. *Orange and Blue.*

*e*. 3 Orange threads with 1 Blue thread, give a dull Orange.

2 Orange threads with 1 Blue thread, give a duller Orange.

1 Orange thread with 1 Blue thread, give a Chocolate-Grey, browner than the colours mixed.

3 Blue threads with 1 Orange thread, give a Violet-Grey.

2 Blue threads with 1 Orange thread, give a Violet-Grey, redder than the preceding.

*e'*. The results are the same with deeper tones than the preceding, except that the corresponding mixtures are browner.

*e''*. 3 Orange threads with 3 blue threads present a remarkable phenomenon according to the intensity of the light and the position from which it is viewed; the tapestry being placed in a vertical plane before the incident light, when the warp is horizontal, we perceive *blue* and *orange* rays; but if the warp is vertical, we may then see the upper part of each blue band *violet*, and its under part, as well as the upper part of each orange band, *green*, while the rest of each of these latter bands will appear *red*, bordered on the lower part with *yellow*. We may also see the upper part of each blue band *violet*, and its under part, as well as the upper part of each orange band, *green*, and the rest of each of these bands *red*, bordered in the lower part with *green*, and in the upper part with *yellow*. We say that they may be seen in this manner, because if the light was strong enough for distinct vision, we should not see the horizontal blue and orange bands.

### F. *Yellow and Violet.*

3 Yellow threads with 1 Violet, give a Greyish-Yellow.

2 Yellow threads with 1 Violet, give a Yellow-Grey.

1 Yellow thread with 1 Violet, give a Grey, much nearer *normal grey* than the preceding.

3 Violet threads and 1 Yellow, give a Greyish-Violet.

2 Violet threads and 1 Yellow, give a dull Violet, greyer than the preceding.

It is remarkable that in observing the mixture of a yellow with a violet thread, at a greater distance than that at which they appear neutralized, the yellow is so much weakened in proportion to the violet, that the mixture appears of a dull violet.

Yellow and Blue exhibit an analogous result.

III. RULE.—CONCERNING THE MIXTURE OF THE THREE PRIMARY COLOURS, IN SUCH PROPORTIONS THAT THEY DO NOT BECOME NEUTRALIZED, BECAUSE ONE OR THE OTHER OF THEM IS IN EXCESS.

*When we unite Blue, Red, and Yellow in such proportions that they do not neutralize each other, the result is a colour much greyer or more broken than if the proportion of complementary Colours was more equal.*

This rule is the result of the first two; but it was indispensable to enounce it, to comprehend all those cases which may be presented in a mixture of coloured threads, relatively to the point of view which occupies us.

For, as Red mixed with a Greenish-Yellow has given a *Carmelite* mixture, as above-mentioned (380. $d'''$), I shall add the following:—

(1.) *Crimson-Red and Greenish-Yellow*, give much duller mixtures, the nearer these colours are being neutralized. A mixture of 1 crimson-red with 1 greenish-yellow thread, produces a brick or copper-orange, the tone of which is higher than that of the colours mixed.

(2.) *Scarlet-Red and Greenish-Blue*, give mixtures which are without vigour or purity, relatively to the corresponding mixtures made with crimson-red and violet-blue.

(3.) Red worked with Blue-Grey, gives Violet mixtures, which are not so dull as the preceding, because the colours contain no yellow.

(4.) The Red of the mixture (3.), worked with a Green-Grey, gives mixtures much duller than the preceding, as might have been expected on account of the yellow contained in the green-grey.

(5.) Orange and Blue-Violet, give very dull mixtures.

(6.) Orange and Red-Violet, give dull mixtures; but redder or less blue than the preceding.

## CHAPTER III.

### ON THE PRINCIPLE OF CONTRAST, IN CONNECTION WITH THE PRODUCTION OF GOBELINS TAPESTRY.

(381.) IF it is important to understand the law of contrast when we wish to imitate a given coloured object by painting, as I have previously stated (323. and fol.), it is much more so when we proceed to imitate a model picture in tapestry; for if the imitation of the painter compared with his model does not faithfully reproduce the colours, the artist has on his palette the means of correcting any defect he perceives, since he can without much inconvenience frequently efface and reproduce the same part of his picture. The weaver has not this resource; it is impossible for him to alter his colours without undoing his work, and doing over again entirely the defective part. Now this requires more or less time, always considerable; for tapestry-weaving is exceedingly slow work.

What, then, must the Gobelins weaver do to avoid the defect I have pointed out? Why, he must thoroughly understand the effect of contrast to know the influence which the part of the copy he proposes to imitate receives from the colours surrounding it, and so judge what coloured threads it will be proper for him to choose. The following examples will explain better than the most profound reasoning, the necessity for the tapestry-worker to possess a knowledge of the law of contrast.

### 1st EXAMPLE.

(382.) A painter has delineated two coloured stripes in a picture, one red, the other blue. They are in contact, and, consequently, the phenomenon of contrast between two contiguous colours would have arisen, if the painter had not sustained the red contiguous to the blue stripe by blue, and if he had not sustained the blue stripe by making it red or violet next to the red stripe (330.).

A weaver wishes to imitate these two stripes: if he is ignorant of the law of contrast of colours, after choosing the wools or silks for imitating the pattern before him, he is sure to make two stripes which will produce the phenomenon of contrast, because he will have selected his wools or silks of only one blue and one red, to imitate two stripes of different colours, each of

which appears to the eye as homogeneous throughout, but which the painter has only succeeded in making so by neutralizing the phenomenon of contrast which the stripes would undoubtedly have presented if they had each been painted of a uniform colour.

### 2nd Example.

(383.) Suppose the painter has painted the stripes with uniform colours, then contrast will arise, so that the red contiguous to the blue will appear orange, and the blue contiguous to the red will appear greenish.

If the weaver be ignorant of the law of contrast, in attempting to imitate his model, he will be sure to mix yellow or orange with his red, and yellow or green with his blue, in those parts of the stripes which come in contact. Hence the resulting contrast will be more or less exaggerated than if he had obtained the effect of the painting by working the two stripes with homogeneous colours.

### 3rd Example.

(384.) Suppose a weaver has to copy the series of ten grey bands in flat tints (fig. 3. *bis.*) which was described in our First Part (13.), it is evident that, if he is ignorant of the effect of contrast of contiguous bands, he will exaggerate it in the imitation; for, instead of working ten tints of the same scale, so as to produce ten bands in flat tints, he will make ten bands, each of which will be graduated conformably to what he sees; and it is extremely probable that he will have recourse to lighter and darker tones than those which correspond exactly to the model; consequently, it is very probable that he will want a greater number of tones than would have been necessary had he known of contrast, and it is certain that the copy will be an exaggeration of the model.

### 4th Example.

(385.) When we attentively observe the rosy flesh-tints of a great many pictures, we perceive in the shadows a green tint more or less apparent, resulting from the contrast of rose with grey. (I presume that the painter has made his shadows without using green, and that he has not corrected the effect of contrast by using red). Now a weaver ignorant of the effect of rose upon grey, in imitating the shaded part will have recourse to

a green-grey, which will exaggerate an effect that would have been produced naturally by employing a scale of pure grey (without green).

This example serves to demonstrate that if a painter has himself exaggerated the effects of contrast in his imitation, these effects will be still more exaggerated in the copy made in tapestry if we do not guard against the illusions produced by the causes now mentioned.

(386.) Beside these examples, I shall cite, as a new application of the law of simultaneous contrast of colours to the art of the Gobelins weaver, the explanation of a fact mentioned in the Introduction.

For seventy years, to my knowledge, they have complained at the Gobelins of a want of force in the black dyes of the workshops of the royal manufactories, when they were used in making the shadows of draperies, particularly those of blue, indigo, and violet; the facts cited concerning the juxtaposition of black with blue, indigo, and violet (60, 61, 62), and explained conformably to the law, of the extremely brilliant complementaries of these three colours modifying the black, in making known the true cause of the phenomenon, have proved that the reproach addressed to the dyer was unfounded, and that the inconvenience of these juxtapositions could only be made to disappear or diminish by the art of the weaver.

The following observations were made by M. Deyrolle:—

From a pattern of a piece of drapery representing a very deep fold, he executed two pieces of tapestry, differing in this,—that the one (No. 1.) was worked with single tones of the violet scale of wool, while the other (No. 2.) was worked with these same tones, but the depth of the fold was made exclusively with black instead of violet-brown wool.

In diffused light, rather feeble than strong, and at the first aspect, the effect of No. 1. was more sombre than that of No. 2., and it presented more harmony of analogy; viewed more attentively, an effect of contrast was perceived much more marked in No. 2. than in No. 1., resulting from the black juxtaposed with light violet, which bordered the depth of the fold, rendering this violet lighter, redder, or less blue, than the light violet corresponding to No. 1. appeared: the black of No. 2. also, by the influence of the complementary, greenish-yellow, with the contiguous light violet, contrasted more than the deep violet-brown of No. 1.; I say more; for this latter receives from the proximity of its bright tone a light tint of greenish-yellow.

In an intense diffused light, the effect of contrast was greatly increased.

Thus, as might have been expected, there was greater difference of contrast between the light and the shadow in No. 2. than in No. 1., and the different parts of the latter, viewed as dependencies of one whole, presented an effect more harmonious than that presented by No. 2.

Two pieces of tapestry representing the same pattern, the one with the tones of the blue scale, and the other with the same tones and black, gave rise to remarkable analogies; but the differences were less marked than between the two violet pieces.

The preceding examples induce me to believe that there are cases in working tapestry, especially with the blue and violet scales, where it appears advantageous to employ the deepest tones of these scales in preference to black; and that if we would have more contrast than we had in the preceding examples, we must juxtapose with the deep tones lighter tones of the same scales than would have been employed if we had used black. In a word, the rule which appears to me must guide us, will be, to produce between the brown and the light of the same scale, the same contrast of tone which would have been produced by the juxtaposition of black.

(387.) The facts stated in this Chapter demonstrate superabundantly, I think, that, whenever the weaver is uncertain about the true appreciation of a colour he wishes to imitate, he must circumscribe this part of his pattern with a paper cut out by which he can exactly compare it with the colour of the threads he proposes to employ.

(388.) I shall terminate this Chapter by affirming that patterns of a fine colour painted on the system of *chiaro'scuro*, and combining the qualities of perfect colouring (298.), can be reproduced in tapestry by employing only the local colour, its nearest hues, white, and normal grey. In fact, every part where the local colour appears with the single modification of its hues, being contiguous to other parts, which in the original pattern present to the painter modifications due to an excess or enfeebling of white light, consequently it happens, that when these latter parts have been reproduced by the weaver with white and normal grey, they will receive, from the proximity of the first parts (seat of the local colour), the same modifications that the corresponding parts of the model present to the painter.

M. Deyrolle, whom I have many times quoted, has executed, according to this mode of seeing, a very effective piece of tapestry representing flowers. This is, then, another example of the harmony of theory with the practice of art.

## CHAPTER IV.

**QUALITIES WHICH PATTERNS FOR GOBELINS TAPESTRY MUST POSSESS.**

(389) In order to fully comprehend what are the qualities which model-pictures for Gobelins tapestry must possess, it is indispensable to decide upon the *speciality* in the imitation peculiar to this kind of work.

(390.) The weaver imitates objects with coloured threads of a certain diameter. These threads are applied round the threads of the warp. The surface produced by them is not uniform, but hollowed in furrows, those which are parallel to the threads of the warp being lower than the others which are perpendicular to it; the effect of these furrows is the same as a series of dark parallel lines would produce upon a picture which would be cut at right angles by another series of finer parallel lines, less dark than the preceding. There is this difference, then, between a tapestry and a painting:—

> 1°. That the first never presents those blended colours which the painter obtains so easily, by mixing or dividing his pigments to an infinite degree by means of a more or less viscid vehicle.
>
> 2°. That the symmetry and uniformity of the furrows of tapestry are opposed to the lights being as vivid and the shadows as vigorous as they are in a painting; for if the furrows obscure the lights the salient parts of the threads which are in the shades have the inconvenience of enfeebling the latter by the light they reflect.
>
> 3°. That the lines which circumscribe the different objects in a painting, although straight or curved in every direction, may be of an extreme fineness without ceasing to be perfectly distinct; while the threads of the weft and the warp, always crossing at right angles, are an obstacle to a similar result whenever the lines of the pattern do not exactly coincide with these threads.
>
> 4°. Let us add, that the painter has other resources, to increase the brilliancy of the lights and the vigour of the shadows which are denied to the weaver. For

instance, he opposes opaque body-colours to glazing-colours (pigments); he modifies an object of a single colour by varying the thickness of the layer of paint he places on the canvas; also, up to a certain point, he can produce modifications by changing the direction of the strokes of his pencil.

(391.) From this state of things, I conclude that, to raise the effects of tapestry as nearly as possible to those of painting it is requisite: —

1°. That the objects be represented of such a size that the point where the spectator must be placed to see them properly, does not permit of his distinguishing the coloured elements from each other, nor the furrows which separate them, so that not only the threads of two mixed scales (377.), and the hatchings of different scales more or less distant, interwoven together (378), are confounded in a colour homogeneous to the eye, notwithstanding the definite dimensions of the variously coloured elements constituting this colour, but also that the cavities and salient parts appear as a uniform surface;

2°. That the colours be as vivid and as contrasted as possible, so that the lines which circumscribe the different objects be more distinct, and that the lights and shadows be as different as possible.

(392.) It is now evident that patterns for tapestry must not only recommend themselves by correct outline, and elegant forms, but they must represent large objects, figures draped rather than nude, vestments decorated with ornaments rather than simple and uniform; lastly, by colours varying and contrasting as much as possible;—consequently everything relating to miniature by minuteness or by finish in details is foreign to the special object of tapestry.

# SECTION II.

### BEAUVAIS TAPESTRY FOR FURNITURE.

Chapter I. — Of the Elements of Beauvais Tapestry for Furniture (393.)—(394.).

Chapter II. — On the Subjects represented on the Beauvais Tapestry for Furniture (395.).

Chapter III.— Of the Patterns of Beauvais Tapestry for Furniture (396.)—(398.).

## CHAPTER I.

#### OF THE ELEMENTS OF BEAUVAIS TAPESTRY FOR FURNITURE.

(393.) THE elements of Beauvais Tapestry for furniture are essentially the same as those of Gobelins tapestry; but with this difference, that the light and the middle tones of the scales employed are of silk, while in the Gobelins tapestry these tones are almost always of wool; on the other hand, the scales of Beauvais are less varied in colour than those of the Gobelins, and their tones are less numerous. Besides, the working of the threads is the same in both kinds of tapestry, so that, the employment of coloured threads resting in like manner on the knowledge and observance of the principle of mixture and the principle of contrast of colours, I need not add to what I have already said on this subject in the preceding Section.\*

(394.) I must remark that the furrows caused by the weft and the warp have not the same objection they have in the Gobelins tapestry (390.). In fact, the regular grain of the tapestry for furniture is so far from producing a bad effect in the image represented thereon, that we are obliged to give the appearance of this grain to many paper-hangings by means of parallel lines cutting it, or by points symmetrically placed.

## CHAPTER II.

#### ON THE SUBJECTS REPRESENTED ON THE BEAUVAIS TAPESTRIES FOR FURNITURE.

(395.) The subjects represented on the tapestries of Beauvais for furniture are simpler than those on the Gobelins tapestry, as they are generally limited to ornaments, flowers, animals, particularly birds and insects; I say generally, because formerly they produced small pictures for screens, chairs, glass doors, &c.

\* Chaps. II. and III.

## CHAPTER III.

#### OF THE PATTERNS OF BEAUVAIS TAPESTRY FOR FURNITURE.

(396.) THE objects, although generally smaller than those seen on Gobelins Tapestry, being of simpler form, often symmetrical, offer less difficulty of execution, in order to be distinctly seen; and the nature of these objects also does not absolutely require he employment of colours much varied in their tones and hues; for I suppose that the Beauvais weaver does not pretend to rival the painter, consequently, when he represents flowers, for instance, he does not require a model painted in the manner which a pupil of Van Spændonck would make a picture or a drawing for a botanical work.

(397.) In the models of tapestries for furniture, we too often neglect the opposition of grounds with the dominant colour of the subjects placed upon them. For instance, if it is a crimson ground ornamented with a garland of flowers, it is necessary that Blue, Yellow, and White flowers compose the greater part of it. If we place on it Red flowers, they will tend to become Orange rather than Purple;— they must be surrounded with Green leaves contiguous to the ground. When it is a greenish ground, Red and rose flowers must, on the contrary, predominate over the others. If the ground is dead-leaves, then Blue, Violet, White and rose flowers detach themselves completely.

(398.) The patterns of tapestry for furniture must possess the qualities which we have desired in those of the Gobelins. Thus, graceful and simple forms detaching themselves completely from the ground upon which they stand, clothed with the purest and most harmoniously selected colours, are preferable to all others. The harmonies of contrast of colour must generally predominate over those of analogy.

# SECTION III.

## SAVONNERIE CARPETS.

Chapter I. — On the Elements of Savonnerie Carpets (399—403.).

Chapter II. — On the Principle of mixing Colours in its connection with the manufacture of Savonnerie Carpets (404—405.).

Chapter III. — On the Principle of Contrast of Colours in its connection with the fabrication of Savonnerie Carpets (406.).

Chapter IV. — Conditions which must be fulfilled in the patterns of Savonnerie Carpets (407—420.).

# CHAPTER I.

### SAVONNERIE CARPETS.

(399.) THE manufacture of Savonnerie Carpets is entirely different from that of Gobelins Tapestry.

The elements of these Carpets are three in number: —

    1°. *Woollen Threads*, mostly *white*, forming the warp of the carpet;

    2°. *Woollen Threads* of various *tints*, which are knotted to the first;

    3°. *Hempen Threads*, which serve to bind the threads of the warp together.

(400.) I. *Warp.* The woollen threads constituting the warp are properly suspended in the loom, parallel to each other, and at equal intervals.

(401.) II. *Dyed Wool.* This is, properly speaking, the coloured element of Savonnerie Carpets.

Although the scales of dyed wool are not so numerous as those of the Gobelins Tapestry, yet they are sufficient for imitating all the hues of a painting, as may easily be understood when we know that the thread employed in the production of a carpet must always be complex: it is composed of five or six threads. For to imitate a pattern painted in various colours on the system of *chiaro'scuro*, the complex thread is composed of threads of 2, of 3, of 4, of 5, and even of 6 different colours; there is, then, a wide latitude in modifying colours according to the *principle of mixing*.

In making a ground, the complex thread is composed of five or six threads of the same tone of the same colour.

The tones of each scale are almost always sixteen or eighteen in number.

When a complex thread is composed of threads belonging to different scales, those which are united must generally have the same number, with respect to their height of tone, in the scales to which they respectively belong. If we deviate from this rule, it is when we take into consideration the different alterability of mixed colours; for instance, when we mix Violet threads with Red threads, the former should be of a higher number than the

Sec. III. Ch. I.] ELEMENTS OF SAVONNERIE CARPETS. 147

second, because they change more under the influence of atmospheric agencies.

Every compound thread is fixed to a thread of the warp by means of a peculiar knot, and perpendicularly to the direction of this latter : this is called *le point*. When a certain number of coloured threads are thus fixed, appearing to the eye as a coloured line which is at right angles with the warp, we cut these threads perpendicularly to their axis, so that the coloured surface of a Savonnerie Carpet shows the interior of the coloured wool exposed by this section.

(402.) III. *Hempen Threads.* On attempting to consolidate *le point*, or, in other terms, the threads of dyed wool which have been knotted upon the threads of the warp, we employ a double hempen thread, called *duite*, and a single hempen thread, called *trame*, which is generally coloured Blue, Grey, or Black. These threads form, with those of the warp, a true canvas, which is completely concealed when the carpet is laid; then the spectator only sees a plane parallel to that of the warp, upon which the imitation of the model appears: this plane is the upper surface of a true woollen velvet.

(403.) We see how the weaving of a Savonnerie Carpet differs from that of tapestry; and if we also refer here the beauty of the effects to the knowledge and observance of the principles of the mixture and contrast of colours, there are some remarks to be made relatively to the special application of these principles to carpet-making, because this application is not absolutely identical with that of the same principles to the manufacture of Gobelins Tapestry. This will be demonstrated in the two following Chapters.

## CHAPTER II.

### ON THE PRINCIPLE OF MIXING COLOURS IN ITS CONNECTION WITH THE MANUFACTURE OF SAVONNERIE CARPETS.

(404.) THE mixing of colours in the manufacture of Savonnerie carpets is always performed by mixing differently coloured threads, as was mentioned above (401.); consequently we do not, as in the Gobelins tapestry, make *mixtures by hatchings* (378.).

L 2

We may easily understand that we can graduate a colour by juxtaposing threads of this colour lighter and lighter, in proportion as they are removed from the highest tone. In a similar manner we may understand how we can make one colour pass into another, by juxtaposing compound threads in which the proportion of the first colour diminishes, with other compound threads in which the second colour increases.

(405.) The mixture by threads is the most important thing for the beauty and richness of the colours: but if it is true that, in order to make it successfully, it is sufficient to observe the rules laid down before (380.), when speaking of Gobelins tapestry, and that under this relation it would appear superfluous to refer to this subject — yet, in consequence of the worker in tapestry making use of threads composed of five or six threads, which may be variously coloured (401.), he finds by this that he is much more exposed to error than the Gobelins weaver is, when he proceeds to mix threads which he desires should retain the richness of their colours. Such, then, is the motive which determines me to consider anew the art of mixing coloured threads in making Savonnerie carpets.

I. RULE.— *Respecting the Mixing Red and Yellow threads, Red and Blue threads, and Yellow and Blue threads.*

Whenever the weaver wishes to produce by mixture a vivid Orange, Violet, or Green, he must only mix such threads as in the combination will present these two colours solely. Consequently the compound thread must consist only of threads belonging to the two elementary scales or to their intermediate hues; in the case where he wishes to modify the tone of one of the colours or both, he must mix different tones of the same scale. But it is not useless to remark that the mixture of three threads of the tones 3, 4, and 5, of the same scale well graduated gives the same result as if we had taken three threads of tone 4.

II. RULE.— *Respecting the complementary mixture of Red and Green threads, Orange and Blue threads, Yellow and Violet threads.*

These mixtures giving rise to Grey, the weaver cannot add brilliant colours without the latter being broken or tarnished by the former, precisely as they would be if we had added Grey to them. One consequence of this rule, then, is never to admit complementary colours into mixtures which are intended to compose brilliant colours.

III. RULE.—*Respecting the mixture of threads of complementary colours, but in such proportions that they do not completely neutralize each other.*

The weaver must not have recourse to mixtures which belong to the third rule, except when he intends breaking or tarnishing his colours : and it is evident that the less he retains of a colour in excess over the quantities of those which are mutually complementary, the more this excess in the former will be broken by mixture with the latter.

We see, then, that we can break the colours without having recourse to broken tones, and that if we would make one colour pass into another without running into Grey, we must avoid every juxtaposition of colours which, by confusing the eye, would produce the effect of mixed complementary colours (380.).

## CHAPTER III.

#### ON THE PRINCIPLE OF CONTRAST OF COLOURS IN ITS CONNECTION WITH THE FABRICATION OF SAVONNERIE CARPETS.

(406.) IF it be true that a knowledge of the principle of contrast is less necessary to the worker of Savonnerie than it is to him of the Gobelins, yet it would be a mistake to suppose that the first can remain ignorant of it without disadvantage.

In fact, although the worker of Savonnerie need not so assiduously copy his model faithfully in its colouring as the Gobelins weaver, and as the five or six differently coloured threads which he can unite to form a compound thread may be very favourable to the gradation, and to the passage of one colour into another, yet this same liberty which permits of a slight departure from the colours of the model, imposes the obligation of making him produce the best possible effect.

Can he follow a better guide than the law of contrast when he seeks to attain this aim?

## CHAPTER IV.

**CONDITIONS WHICH MUST BE FULFILLED IN THE PATTERNS OF SAVONNERIE CARPETS.**

(407.) THE Savonnerie weaver working from the same painted patterns as the weaver of the Gobelins and of Beauvais, I next speak of the principal conditions which these patterns must fulfil, in order that the carpet reproducing the pattern may fully realise our intention.

### ARTICLE 1.
*1st Condition—Respective size of the figured objects.*

(408.) The size of the objects represented must be in proportion to the extent of the whole of the carpet: great trophies and ornaments suit only large carpets, and simple patterns are best adapted to small ones.

(409.) On the other hand, if the apartment to which the carpet is fitted has a defect in the proportion of the breadth to its length, the designer must take care to avoid increasing this defect to the eye by his design, and the manner in which he distributes his masses.

### ARTICLE 2.
*2nd Condition — Distinct View.*

(410.) All the parts vividly coloured, and having well defined patterns, must be visible in their entirety, when the furniture is placed in the position it is intended to occupy in the chamber to which the carpet is fitted, this apartment being what is commonly called *arranged*.

For example : —

The border of a carpet upon which chairs, couches, sofas, &c. are placed, must be black or brown : in the case where preference is given to a ground uniform with the pattern, this latter must be very simple, and composed only of two or three tones of colours much deeper than those of the rest of the carpet, when this does not exhibit large dark masses ; and it is by deep tones of the blue and violet scales, and also with those of other scales (218.), that we have the opportunity of recalling the harmonies of analogy.

(411.) The actual border of a carpet must not be under the

chairs. It must appear as a continuous frame to all the objects represented upon the carpet, and this framing must not be interrupted by the hearth.

(412.) If a piece of furniture must be placed in the middle of the apartment, or rather of the framing, the figures of the carpet must be executed in conformity; that is to say, in such manner that they commence at the line circumscribing the place occupied by the furniture, and extend beyond this place.

(413.) Every trophy or design presenting a well circumscribed object, or, in other terms, every design without lines parallel to the border, must be seen in all its parts, so that the eye can embrace the whole without difficulty. And it must also always have a sufficient interval between the border and the trophies, or, more generally, the objects circumscribed, to which the artist desires to draw the chief attention.

## ARTICLE 3.

*3rd Condition.—Analogy with places or persons.*

(414.) Other objects than arabesques or imaginary figures, depicted on a large carpet, must possess some analogy with the purpose of the apartment where the carpet is laid, offering some allusion either to places or persons.

## ARTICLE 4.

*4th Condition—Distribution of Colours.*

(415.) The colours must be distributed in such manner as to give value to every part of the carpet, not only in each particular object, but also in the union of objects forming a single composition.

*Of the local Colours and the Colours of each particular object.*

(416.) Every object must be perfectly detached from the ground upon which it is placed. If rose or red predominates in an object, the ground must be neither crimson nor scarlet, nor violet; if blue predominates, the ground must generally be neither violet nor green. If the object is yellow, orange must be forbidden to the ground. For the rest, I shall refer to what I have said above (396, 397, 398.) in speaking of the conditions which must be fulfilled in reference to the patterns for Beauvais tapestry for furniture.

*Of the General Harmony of Colours in a Carpet.*

(417.) There are some important observations to be made upon the general harmony of colours, which is frequently neglected by the designer of patterns for this kind of fabric; yet without it, the effect in a carpet is injured, whatever may be the perfection with which each particular object is rendered.

(418.) If the carpet represents many separate objects, they must each have a dominant colour which accords with those of the other objects, either by the dominant colours belonging to different tones of the same scale or by these colours contrasting with each other, which produces a more satisfactory effect.

The whole of these objects must detach themselves from the ground, which will generally be duller than they are, the light being almost always diffused (*censée*) from the centre of the composition.

The manner in which the objects are circumscribed, and the nature of the lines circumscribing each of them, contribute greatly to render a composition harmonious or discordant. For instance, squares or parallelograms, which attract the eye by their size and their brilliant colours, have a bad effect with circular or elliptical figures, especially when they are very near together.

## Article 5.

*5th Condition — Harmony of the Carpet relatively to the Objects which must concur with it in the Decoration of an Apartment.*

(419.) For a carpet to produce the best possible effect, it is not enough that it be made in the best manner, that the pattern is excellent, and that the distribution of the colours leaves nothing to be desired; it is also requisite that it be in harmony with the decorations of the apartment into which it is put, or, in other terms, that it possesses certain relations of *suitability*, not only of size proportionate to the nature of the ornaments, the facility with which the eye seizes the *ensemble* of the composition, the skill which has governed the distribution of the large masses of colours,— but also in the harmony of these same colours with those of the objects which concur with the carpet to furnish a given apartment; it is under this latter relation only that I shall now make some remarks, which will be concluded further on, when I come to examine the decorations of rooms.

(420.) The method of rendering with respect to the colours

the harmony of a large carpet as facile as possible with the other furniture of the same apartment, is at first to make the light commence from the centre of the carpet; it is there — that is to say, in the part most distant from the chairs, hangings, &c.—that we can employ without inconvenience the most vivid and strongly contrasted colours.

In placing a much less brilliant part between this vivid picture in the central part of the framing, we can also give to the framing colours so vivid as to glare upon the contiguous parts, still without injuring the colour of the chairs, hangings, &c.

# SECTION IV.

## TAPESTRIES FOR HANGINGS AND CARPETS.

CHAPTER I.—ON TAPESTRIES FOR HANGINGS (421.).

CHAPTER II.—ON CARPETS (422—428.).

# CHAPTER I.

### ON TAPESTRIES FOR HANGINGS.

(421.) GOBELINS tapestry and Beauvais tapestry for furniture, produced on the system of painting in *chiaro'scuro*, require in their production so much time, care, and skill on the part of the artists who execute them, that their price is much too high to permit them to become articles of commerce. Without inquiring if it be right or wrong to prefer stained papers to woollen hangings; fabrics in a single colour, chintzes, or in patterns to tapestries for furniture, I shall say, that with scales of five or six tones at most, we can execute works of the latter kind on the system of flat tints (368.), which have a good effect, and at a price such as, if I am not mistaken, would bring them into commerce if fashion adopted them.

# CHAPTER II.

### CARPETS.

### ARTICLE 1.

#### CARPETS ON THE SYSTEM OF CHIARO'SCURO.

(422). THE taste for carpets, now-a-days so widely extended, far from diminishing, will doubtless increase, just as in modern times has occurred in respect to glazed windows in our houses. If the Savonnerie carpets are too dear for commerce, such is not the case with those others which, made in imitation of them after patterns painted on the system of *chiaro'scuro*, are extensively manufactured in France and other countries.

(423.) These carpets cost much less than those of Savonnerie, because they contain much less wool, which is generally of in-

ferior quality: the colours also are not so durable; they are worked, too, with scales less varied in colour, and of fewer tones; lastly, as these fabrics are not so elaborate, they are made much more rapidly than those of the royal manufactories.

(424.) If the intrinsic qualities of Savonnerie carpets and those of ordinary carpets are really so different, we should be much mistaken if we supposed that the difference is evident on the first superficial examination, or that it can be always recognised on a more prolonged examination by a person ignorant of the difficulties of this class of works. What most persons look for in a carpet is brilliant colours. The manufacturer knowing the taste of his customers, does well to conform to it, and he attains his aim by using fewer broken tones, and more pure and vivid colours than are employed in the royal manufactories. He thus obtains greater appearance of effect at less expense, and I am convinced that in many instances where at Savonnerie they mix a great many coloured threads together, it requires much skill and knowledge in mixing their complementaries, to prevent the brilliant colours extinguishing each other: this danger does not exist, or occurs much less frequently, in the manufacture of ordinary carpets.

(425.) The considerations I have put forth on the mixing of colours, lead to the opinion that every workman who would make himself acquainted with the method of producing the carpets of Savonnerie, will, by very simple means, arrive at results the success of which appears to me certain, when, after being well imbued with the rules prescribed (380. and 405.), he will attain to a system of experience calculated to reveal to him what most of his fellow-workers are ignorant of, — the value of the colours of his palette, and in this value we comprise the knowledge of the resulting colour he will obtain, either by mixing a given number of threads of the same scale, but of different tones, or by mixing a given number of differently coloured threads belonging to different scales.

The first experiments he should make will have for their object the fixing the *minimum* number of the tones of his scales after he has fixed the number of woollen threads which compose his compound threads; for we know that if he puts three threads into a compound thread, with a scale of the same number of tones, he could by mixing obtain a greater number of mixed tones than if the compound thread was only binary. Suppose it is a scale composed of ten tones, and that we required to make a triple compound thread; two threads of the tenth tone with one thread of the ninth tone will give a mixed tone nearer to the tenth

than if we were obliged to mix one thread of the tenth tone with one thread of the ninth tone to produce a binary compound thread; by which we may learn that by the triple mixture we can obtain many more mixed tones, intermediate between the first and the tenth, than we can obtain from the binary mixture.

After having determined upon the number of tones which shall compose his scales, he will next fix upon the number of unbroken scales which will be necessary for him to compose brilliant hues, bearing in mind rule first: and further, he will employ threads for a complex thread, and, other things being equal, he may contrive mixtures which will belong to other distinct scales, and which will be inserted between the scales that have been mixed.

This determination made, he will next prepare his *greys* resulting from the mixture of his complementary scales in conformity with our second rule : taking into account the *breaking*, or the *greying* which the complementary mixtures will give to the threads of pure colour with which they are combined.

Finally, he will see which are the scales of broken colours, as well as the greys more or less pure, it is important for him to have.

In all the preceding it is understood that it is only the question of graduated colours, and not of colours for grounds.

## ARTICLE 2.

### *Carpets on the System of Flat Tints.*

(426.) In most cases where it is required to select a carpet for apartments of a medium size, and especially for small rooms, I should give the preference to carpets in flat tints, because it is possible to have a very beautiful effective work, without the price being too high, while in paying much dearer for a carpet of another kind, resembling pictures, we shall be far from having the best in this sort.

Carpets in flat tints are most favourable to the brilliancy of colours; in fact, the straight or undulating bands of the *dessins points* of Hungary, the palms, where Yellow is opposed to Violet, Orange to Blue, Green to Red, &c., produce the most brilliant contrasts. But I only recommend the employment of these carpets for places where their brilliant colours can injure neither the furniture nor the hangings ; for instance, in rooms where the hangings, the stuffs of the chairs, are grey, white, black, or selected so as to accord harmoniously with the carpet by their colours and patterns.

(427.) The most effective carpets are also those which present detached flowers upon a brown ground, with a garland in the centre, in flat tints, and perfectly assorted according to the law of contrast.

## ARTICLE 3.

*Carpets on a system intermediate between Chiaro'scuro and Flat Tints.*

(428.) I have no special remarks to add to the preceding on this kind of carpet; I shall only observe that those which approach the nearest to carpets in flat tints, appear to me preferable to those in which the designer has endeavoured to imitate Savonnerie carpets.

# SECTION V.

### MOSAICS.

(429.) THE name *Mosaics*, as is well known, is given to the coloured imitations of a painted pattern, by employing fragments of marble, stones, different coloured enamels, suitably cut, which are united together side by side, and also fastened together by means of a fine mortar or cement.

If it were possible to make a mosaic with elements as fine and as compact as the threads of tapestry, the work would appear to occupy a place between an oil-painting and a Gobelins tapestry: it resembles the latter, because it is the result of the juxtaposition of coloured elements of an appreciable size: and it approaches to the nature of a picture by a uniform surface rendered brilliant by means of the polish it has received; besides, the contrast of opaque and vitreous elements resembles that of opaque and glazing colours in oil-painting.

But, in having regard to the preceding considerations relative to the special qualities of each kind of imitation, mosaic being made to serve for pavement, or at least to be exposed to the changes of weather, the humidity of ground floors, &c., resistance to these destructive agents must be its essential quality: on the other hand, the place it generally occupies in edifices does not permit the eye to seize all the details we look for in a picture; we wander from the aim when we pretend to give to works of this nature the finish of painting: we then confound two arts entirely distinct in aim, and also in the nature of the coloured elements which each of them makes use of.

# SECTION VI.

COLOURED GLAZING OF LARGE GOTHIC CHURCHES.

# SECTION VI.

**WINDOWS OF COLOURED GLASS IN LARGE GOTHIC CHURCHES.**

(430.) I now proceed to examine, according to the preceding views, the coloured glass windows which combine so powerfully with architecture in giving to vast Gothic churches that harmony which we cannot fail to recognise whenever we enter them, after having admired the variety and boldness of their exterior details, and which place these structures among objects of art, in the rank of those which impress most by their size, the subordination of their various parts, and, lastly, by their complete fitness to the purposes to which they are applied. The stained glass of Gothic churches, by intercepting the white light which gives too vivid and unsuitable a glare for meditation (as they only transmit coloured light) have always the most beautiful effect. If we seek the cause, we shall find it not only in the contrast of their colours so favourably opposed, but also in the contrast of their transparency with the opacity of the walls which surround them and of the lead which binds them together. The impression produced on the eye, in virtue of this twofold cause, is the more vivid the more frequently and the longer they are viewed each time.

(431.) The windows of a Gothic church are generally either circular, or pointed at the tops in *ogive*, with vertical sides. The stained glass of the first usually represent great rose-windows, where yellow, blue, violet, orange, red, and green, appear jewels of the most precious stones. The windows of the second almost always represent, amid a border or a ground analogous to the rose-windows, a figure of a saint in perfect harmony with those which stand in relief about the portals of the edifice; and these latter figures, to be appreciated at their true value, must be judged as *parts of a whole*, and not as a Greek statue, which is intended to be seen isolated on all sides.

(432.) The glass composing the different parts of a human figure is of two kinds: *the one has been painted on its surface* with pigments, afterwards vitrified (glass painting); *the other is*

*melted with the material that colours it* (glass staining); generally the first enters into the composition of the nude parts of the figure, as the face, hands, and feet; and the second enters into that of the drapery: all the pieces of glass are united by strips of lead. What has struck me as being most effective in windows with human figures is the exact observance of the relations of size of the figures and of the intensity of the light which renders them visible, with the distance at which the spectator is placed; a distance at which the strips of lead which surround each piece of glass appear only as a line, or as a small black band.

(433.) It is not necessary for an effective whole that the *painted glass*, viewed closely, should exhibit fine hatchings, careful stippling, or blended tints; for, with the coloured stained glass for draperies, they must compose a system which compares with painting in flat tints; and certainly we cannot doubt that a painting on glass, executed entirely according to the system of *chiaro'scuro*, will have this disadvantage over the other, without speaking of the cost of execution, that the finish in the details will entirely disappear at the distance at which the spectator must be placed, and that the view of the whole will be less distinct; *for the first condition which must be fulfilled by every work of art intended to attract the eye is, that it be presented without confusion and as distinctly as possible.* Let us add that paintings on glass executed on the method of *chiaro'scuro* cannot receive the borders and grounds of rose-windows (431.) which give so fine an effect of colour, as they have less brilliancy and transparency than the glass in which the colouring material has been incorporated by means of fusion (432.), and, lastly, they are less capable of resisting the injuries of time.

(434.) Variety of colours in these windows is so necessary for them to attain the best possible effect (as those which represent figures entirely nude, edifices, in a word, large objects of a single colour, or slightly tinted), that, whatever may be the perfection of their execution under the relation of finish and truth of imitation, they will have an inferior effect to those windows composed of pieces of varied colours suitably contrasted. Yet I must not omit to instance the bad effect which results from the mixture of coloured glass with *transparent* colourless glass, at least when the latter has a certain extent of surface in a window; but at the same time I recognise the effect obtainable by mixing *ground* glass with coloured glass, and also of small pieces of colourless transparent glass framed in lead, so that at the distance at which they must be viewed, they produce the

effect of a symmetrical juxtaposition of white parts with black parts.

(435.) I conclude we must refer the causes of the beautiful effects of coloured church-windows —

1°. To their presenting a very simple design, the different well-defined parts of which may be seen without confusion at a great distance.

2°. To their offering a union of coloured parts distributed with a kind of symmetry, which are at the same time vividly contrasted, not only among themselves, but also with the opaque parts which circumscribe them.

(436.) Coloured windows appear to me to produce all the effect of which they are really capable only in a vast edifice where the differently coloured rays arrive at the eye of the spectator placed on the floor of the church, so scattered by the effect of the conical figure of the rays of light emanating from a single point, that they impinge upon each other, whence results an harmonious mixture, which is not found in a small structure lighted by stained windows. It is this intimate mixture of the coloured rays, transmitted in a vast edifice, which permits of tapestries being placed on the ground floor when the lower walls have no colourless glass windows; it is evident that if tapestries are placed too near stained windows, they must lose all the harmony of their colours, as when blue rays fall upon red draperies, yellow rays upon blue draperies, &c.

Thus, when we have to put coloured glass in a window, it appears to me necessary to take into consideration not only their beauty, but also the effect which the coloured lights they transmit will have upon the objects they illuminate.

(437.) The coloured windows of a large church appear to me as real transparent tapestries, intended to transmit light, and to ally themselves harmoniously with the sculptures on the exterior, which destroy the monotony of the high walls of the edifice, and with the different ornaments of the interior, among which tapestries must be taken into account.

(438.) I shall sum up my ideas on the employment of stained-glass for windows in the following terms:—

1°. They produce all the effect of which they are really susceptible, only in rose windows, bay-windows, or pointed windows of large Gothic churches.

2°. They produce all their effect only when they present the strongest harmonies of contrast, not of colour-

less transparent glass with the black produced by the capacity of the walls, iron bars, and strips of lead, but of this Black with the intense tones of Red, Blue, Orange, Violet, and Yellow;

3°. If they represent designs, these must always be as simple as possible, and admit of the harmonies of contrast;

4°. While admiring windows of which a large number consist of paintings upon glass of undoubted merit, especially in examining the difficulties overcome, I avow that it is a kind which should not be much encouraged ; because the product has never the merit of a picture properly so called, as it is more costly, and will produce less effect in a large church than a stained window of much lower price.

5°. Windows of a pale grey ground with light Arabesques have a very poor effect wherever they are placed.

I shall recur to the employment of stained windows in churches when I treat of the relations of the law of contrast with the decoration of the interiors of churches.

# THIRD DIVISION.

## COLOUR-PRINTING UPON TEXTILE FABRICS AND ON PAPER.

First Section.—Calico-Printing.

Second Section.—Paper-Staining.

Third Section.—Printing or Writing on Papers of Various Colours.

# SECTION I.

### CALICO-PRINTING.

(439.) The object I have in view in this Chapter, is the examination of the *optical* effects produced by patterns when printed upon woven fabrics, but not the *chemical* effects which arise between them and the stuffs upon which they are printed.

For a considerable period of time printing on textile fabrics was limited, so to speak, to cotton cloths: only of late years has it been extended to fabrics of silk and wool for furniture and clothing.

This branch of industry has undergone an immense extension, fashion having accepted these products with much favour; but whatever may be the importance of the subject in a commercial point of view, I must treat it briefly, because this book is not directed exclusively to that branch of inquiry, and, moreover, all the preceding part is intimately connected with it, and to go deeply into details would expose us to the inconvenience of repetition with no compensating advantage. I shall content myself with stating many facts which serve to show that, for want of knowing the law of contrast, the cotton manufacturer and the printers of woollen and silk stuffs are constantly exposed to error in judging the value of recipes for colouring compositions, or rather to mistake the true tint of the designs which they have themselves applied upon grounds of a different colour.

#### A. FALSE JUDGMENT OF THE VALUE OF RECIPES FOR COLOURING COMPOSITIONS.

(440.) At a calico-printer's they possessed a recipe for printing green, which up to a certain period had always succeeded, when they fancied it began to give bad results. They were lost in conjecture upon the cause, when a person, who, at the Gobelins had followed my researches on contrast, recognised that the green of which they complained, being printed upon a ground of blue, tended to become yellow, through the influence

of orange, the complementary of the ground. Consequently, he advised that the proportion of blue in the colouring composition should be increased, in order to correct the effect of contrast. The recipe modified after this suggestion gave the beautiful green which they had before obtained.

(441.) This example demonstrates that every recipe for colouring compositions intended to be applied upon a ground of another colour must be modified conformably to the effect which the ground will produce upon the colour of the composition. It proves also that it is much easier for a painter to correct an effect of contrast than it is for a calico-printer, supposing that both are ignorant of the law of contrast: for if the first perceives in painting a green pattern on a blue drapery that the green comes too yellow, it is sufficient for him to add a little blue to the green, to correct the defect which strikes him. It is this great facility in correcting the ill effect of certain contrasts which explains why they so often succeed in so doing without being able to account for it.

B. TRUE TINTS OF DESIGNS PRINTED UPON COLOURED GROUNDS MISUNDERSTOOD.

(442.) In treating of the modifications perceptible in bodies through the medium of light, I have instanced cottons of a coloured ground printed with patterns which the calico-printer intended making colourless; but, owing to the imperfection of the process, were really of the colour of the ground, but of an excessively light tint (292, 293.), we may be satisfied of this by looking at them after they are isolated from the ground by means of a white paper cut out with the pattern. I have remarked that, notwithstanding their colour, the eye judges them to be colourless, or of the tint complementary to that of the ground.

(443.) I will now explain the cause of these appearances, because they have been the subject of questions frequently addressed to me by manufacturers of printed stuffs and by drapers; it is due to the law of simultaneous contrast of colours. In fact, when the patterns appear white, the ground acts by contrast of tone (9.); if they appear coloured, (and this appearance generally succeeds to that where they appear white), the ground then acts by contrast of colour (13.); the manufacturer of printed stuffs, therefore, will not seek to attribute the cause of these phenomena to the chemical actions manifested in his operations.

(444.) Ignorance of the law of contrast has among drapers and manufacturers been the subject of many disputes, which I have been happy to settle amicably, by demonstrating to the parties that they had no possible cause for litigation in the cases they submitted to me. I will relate some of these, to prevent, if possible, similar disputes.

Certain drapers having given to a calico-printer some cloths of a single colour, — red, violet, and blue, — upon which they wished black figures to be printed, complained that upon the *red* cloths he had put *green* patterns, upon the *violet* the figures appeared *greenish-yellow*, — upon the *blue* — they were *orange-brown* or *copper*-coloured, instead of the *black*, which they had ordered. To convince them that they had no ground for complaint, it sufficed to have recourse to the following proofs:—

1°. I surrounded the patterns with white paper, so as to conceal the ground; the designs then appeared black.

2°. I placed some cuttings of black cloth upon stuffs coloured red, violet, and blue; the cuttings appeared like the printed designs, — *i.e.* of the colour complementary to the ground, although the same cuttings, when placed upon a white ground, were of a beautiful black.

(445.) Finally, the following are the modifications which black designs undergo upon different coloured grounds:—

Upon *Red* stuffs, they appear *Dark-Green*.
Upon *Orange* stuffs, they appear of a *Bluish-Black*.
Upon *Yellow* stuffs, they appear *Black*, the violet tint of which is very feeble, on account of the great contrast of tone.
Upon *Green* stuffs, they appear of a *Reddish-Grey*.
Upon *Blue* stuffs, they appear of an *Orange-Grey*.
Upon *Violet* stuffs, they appear *Greenish-Yellow-Grey*.

These examples are sufficient to enable us to comprehend their advantage to the printer of patterns which are complementary to the colour of the ground, whenever he wishes to mutually strengthen contiguous tints without going out of their respective scales.

# SECTION II.

## PAPER-STAINING.

Chapter I. — General Remarks (446—447.).

Chapter II. — On the law of simultaneous Contrast of Colours in relation to Paper-hangings with figures, Landscapes, or large Flowers of various Colours (448—449.).

Chapter III. — On the law of simultaneous Contrast of Colours in relation to Paper-hangings with Designs in a single Colour, or in Colours slightly varied (450—453.).

Chapter IV. — On the law of simultaneous Contrast of Colours in relation to the borders of Paper-hangings (454—500.).

# SECTION II.

## PAPER-STAINING.

### CHAPTER I.

#### GENERAL REMARKS.

(446.) At the point to which the manufacture of paper-hangings has now arrived, we may, without exaggeration, assert that a knowledge of the law of contrast of colours is indispensably necessary to the artists who are engaged in this branch of industry with the intention of carrying it to perfection.

I consider as essential to their instruction the study of the First Division (Part II.), where I have treated of the imitation of coloured objects by means of coloured materials in a state of extreme division, as well as most of the facts treated of in the Second Division directed to the imitation of coloured objects by means of coloured materials of a certain magnitude.

(447.) We cannot really estimate the true relations between the law of contrast and the art of paper-staining without dividing the papers into the several categories to which the law is applicable; it is not applicable to all, as there are some papers of but a single colour.

I rank in the first category papers having figures and landscapes, as well as those representing flowers of different sizes and of varied colours, not intended for borders. Of all kinds of paper-hangings those in this category approach the nearest to painting.

Papers with patterns of one colour, or of colours but slightly varied, form a second category.

Finally, I rank in the third category those employed as borders.

## CHAPTER II.

ON THE LAW OF SIMULTANEOUS CONTRAST OF COLOURS IN RELATION TO PAPER-HANGINGS WITH FIGURES, LANDSCAPES, OR LARGE FLOWERS OF VARIED COLOURS.

(448.) THE study which I have prescribed (446.) to artists occupied in fabricating paper-hangings is in some measure that of the generalities, and at the same time the specialities immediately applicable to every composition, which reminds us of a picture, or, in other words, the tapestry of figures and landscapes; but, whatever be the merit of paper-hangings of this category, and the difficulty which has to be surmounted in executing them in a satisfactory manner, nevertheless, they are not sought by persons of refined taste, and they do not appear to me destined to be so in future any more than at the present time; for the twofold reason, that the taste for arabesques painted upon walls or upon wood, and that for lithographs, engravings, and paintings is every day increasing. For if these three last objects do not absolutely prohibit, as do arabesques painted on walls, every kind of paper-hangings, they exclude at least all those with figures and landscapes in various colours.

(449.) The applications of the law of contrast to the fabrication of paper-hangings of the first category are so easy when we thoroughly understand the divisions of the book to which I referred (446.), that, in order to prove the advantage to be derived from knowing this law, I shall be content to refer to the bad effect presented by contiguous bands of two tones of the same scale of grey (serving as the ground to the figure of an infant), in consequence of the contrast of tone arising from their juxtaposition (333.); for we cannot doubt that the artist who consulted me to remove the ill-effect of which I speak, would not have produced it at all had he known the law of contrast, because he would in that case have made the dark band lighter, and the light band darker at the contiguous parts.

## CHAPTER III.

ON THE LAW OF SIMULTANEOUS CONTRAST OF COLOURS IN RELATION TO PAPER-HANGINGS WITH DESIGNS IN A SINGLE COLOUR, OR IN COLOURS BUT SLIGHTLY VARIED.

(450.) The remarks I have made respecting the modifications to be employed in the recipes of colouring compounds used in printing patterns of stuffs upon grounds of another colour (440.), are also applicable to the printing of patterns upon paper-hangings.

(451.) It is also the same with the remarks contained in the same Chapter (444.), which refer to the modifications black patterns undergo through the colour of the grounds upon which they are printed. The observations which I relate, although applicable to every case where black is placed upon a coloured ground, have been chiefly suggested by patterns made on woollen stuffs for ladies' mantles, and also upon furniture:—it appears to me that I had better unite to these observations all those which concern other designs than black. The reason which prevents me is, that the patterns of woollen stuffs for furniture or mantles, which are executed in the best taste, are those with black figures, or more generally of figures much darker than the ground.

Paper-hangings, I do not say the most tasteful, but those most convenient for use, prevent very light grounds with white or grey figures; I have preferred speaking, as far as they are concerned, of the modifications which similar designs may receive from coloured grounds; and the observations which I have already made upon them, determine me to proceed in this manner.

(452.) Grey patterns upon papers tinted of a light colour exhibit the phenomenon of maximum contrast; that is to say, the grey appears coloured with the complementary of the ground.

Thus, conformably to the law (63.) *Grey* patterns
    Upon a *Rose* ground appear - - - *Green.*
    Upon an *Orange* ground they appear - *Blue.*
    Upon a *Yellow* ground they appear - *Violet* or *Lilac.*
    Upon a *Green* ground they appear - *Rose.*
    Upon a *Blue* ground they appear - - *Orange-Grey.*
    Upon a *Violet* ground they appear - *Yellow.*

(453.) I cite these facts as examples proper to instruct artists, because, to my knowledge, in manufactories of paper-hangings disputes arise between the proprietors and the preparers of the colours; for instance, a few years ago the proprietor of one of the first manufactories in Paris, wishing to print grey patterns upon grounds of apple-green and of rose, refused to believe that his colour-preparer had given *grey* to the printer at all, because the designs printed on these grounds appeared coloured with the complementaries of the colour of the ground. It was only at the period when the colour-preparer attended a lecture I gave at the Museum of Natural History, in 1829, for M. Vauquelin, hearing me speak of the mistakes that these contrasts of colours might occasion, he suspected the cause of the effects which he had produced without knowing why, and which had really caused him much annoyance.

## CHAPTER IV.

### OF THE LAW OF SIMULTANEOUS CONTRAST OF COLOURS, RELATIVELY TO THE BORDERS OF PAPER-HANGINGS.

(454.) Every uniform paper, or one belonging to the second category, must receive a border, generally darker and more complex in design and colour than the paper which it frames.

The assortment of two papers exercises a very great influence on the effects they are capable of producing, for each of them may be of a fine colour, ornamented with designs in the best taste, yet their effect will be mediocre or even bad, because the assortment will not conform to the law of contrast. I shall return to this subject in the Fifth Division, because this chapter is exclusively devoted to the consideration of the borders themselves.

(455.) The ground of a border contributes greatly to the beauty of the pattern, whether flowers, ornaments, or any other object that the designer puts upon it. We cannot treat of this influence in an absolute or methodical manner. I shall select a certain number of remarkable facts, which I have had occasion to observe, and I shall principally dwell on those from which we can deduce conclusions, which, apparently not immediately flowing from previous observation, might escape many readers, in spite of the great interest they have in knowing

them, without taking into account that the exhibition of these facts will give me occasion to apply the law of contrast to cases where we have designs presenting always many tones of the same scale, and of different hues, and also often of different scales, more or less distant from each other,— that is to say, I shall not occupy myself with simple borders presenting black designs upon a uniform Grey ground, for I have already spoken of the modifications which in this case black designs undergo (445.), and grey designs also (452.), in treating of the printing of designs upon stuffs and paper-hangings, from patterns of a single colour, to those slightly varied.

(456.) The following observations have been made under these circumstances,— viz. :

The design of a border, whether ornaments, flowers or any other object had been cut out and pasted upon a white card.

Designs identical with the preceding which had been pasted upon cardboard were then cut out and placed upon grounds of black, red, orange, yellow, green, blue and violet, then compared not only by myself, but also by many persons whose eyes are much accustomed to seeing colours. The results were noted in writing when we had perfectly agreed upon their value.

### I.—Borders of eight inches in height representing gilt ornaments upon different grounds.

(457.) These ornaments executed by the ordinary processes of paper-staining, contained no particle of metallic gold; yellow lakes and oranges of different tones and shades had been exclusively employed in their production. After having enounced the modifications which the painted gilt-ornaments experience from the colour of the grounds, I shall indicate th oe which the metallic gilt ornaments receive comparatively from these same grounds; this comparison presenting results which appear to me interesting.

#### (a.) Black Ground.

(458.) When we look at painted gilt-ornaments placed upon this ground, with the intention of comparing them with the identical ornaments placed on a white ground, the former appear much more distinct than the latter, because the Yellows and Orange-Yellows, colours eminently luminous, and the Black ground, which reflects no light, give rise to contrast of tone, which the White ground, essentially luminous, cannot give with colours which are themselves luminous.

We perceive, then, as we might expect, after what has been said of the effect of Black in contrast (53.), that the colours superimposed upon it are lowered in tone; but it must be noted that Yellows and Orange-Yellows, far from being weakened, according to the remark made above (58.), might cause the Black to gain in purity.

In considering the effects of two grounds more attentively, we see that the Black imparts a Red to the ornaments, and it is important to remark, that the brightness of this Red, instead of reddening the Yellows, really gilds them. I call attention to this result, because we shall see (460.) an effect of Red ground which, without consideration, would lead us to believe it to be contrary to that which now occupies us. Such is the motive that induces me to insist upon this point, so that we may well understand how Black, in taking away some Grey, imparts brilliancy, and how this Grey, which may be considered as a tarnished or broken Blue, may with Yellow produce an Olive colour. It is also necessary to remark that the gilt ornaments in question present an Olive-Grey tint, which, far from being diminished by the White ground, is exalted by it.

Finally, if the Black ground lowers the tone of the colours, while White heightens them, it lowers Yellow more in proportion than Red, and consequently renders the ornaments redder than they appear upon a White ground; finally, in taking away Grey, it purifies the colours, and acts also by giving them some Red, or by taking away some Green.

### Metallic Gilt Ornaments.

(459.) Gilt ornaments detach better from Black than from White; but the Orange colour is weakened and really impoverished; the Black ground then does not purify the real gilt as it does the painted ornaments.

### (b.) Deep-Red Ground.

(460.) The Yellows are more luminous, the *ensemble* with the painted ornament is clearer, more brilliant, less Grey, than upon a White ground.

> Red much deeper than the ornament weakens the tone of it, and this effect is also augmented by the addition of its complementary, Green, a bright colour.

This example has much importance in enabling us to see how the red colour, which appears as though it could be of but little

advantage to ornaments, because it tends to weaken them by making them greener, is, however, on the whole, favourable, because the lightening or the weakening of the colour is more than compensated for by the brilliancy of the complementary of the ground which is added to the Yellow; we shall return to this effect in a moment (468.). There is this analogy between the influence of the Red ground and that of the Black ground, that the tone of the colours is weakened; but there is this difference, that the ornaments are green upon the first, while they are orange upon the second.

### Metallic Gilt Ornaments.

(461.) The Red ground is not so advantageous for gilt ornaments as it is for the painted imitations of them, because the metal loses too much of its Orange colour, and under this relation it appears inferior to gold upon a Black ground.

The Red ground appears darker and more Violet than the ground upon which painted ornaments are placed.

Grounds of a light Red are still less favourable to the gold than Red grounds of a dark tone.

---

### (c.) *Orange Ground deeper than the Ornaments.*

(462.) The painted ornaments are bluer or rather greener than upon a White ground. The Yellow and Orange are singularly lowered in tone.

This ground, then, is very disadvantageous to ornaments, as we might have expected.

### Metallic Gilt Ornaments.

(463.) Orange is not favourable to them; the metal becomes too white; on the other hand, the Orange ground is redder and more vivid than that upon which the painted ornaments are placed.

---

### (d.) *Yellow Ground of Chromate of Lead, more brilliant than the Yellow of the Ornaments.*

(464.) The Yellow of the painted ornaments is excessively enfeebled by the complementary of the ground, Violet, which is added to it; the ornaments appear Grey in comparison with those upon a White ground.

### Metallic Gilt Ornaments.

(465.) The Yellow ground is not so unfavourable to gilt ornaments as it is to the painted ones. The first assortment may in certain cases be recommended.

The Yellow appears more intense, and perhaps greener.

---

### (e.) Bright Green Ground.

(466.) The painted ornaments are darker upon a bright Green ground than upon a Red or White ground; they have acquired some Red; but this is not the brilliant tint which is given to them by Black: it is a brick-red tint.

> It follows from the comparison of the effects of ornaments upon Red and upon Green grounds, that the first is much more advantageous than the second, because it adds an essentially brilliant tint to the colour of the ornaments; while the latter, adding some Red, or subtracting some Green, produces a brick-red.

### Metallic Gilt Ornaments.

(467.) Upon a bright Green ground, they acquire Red, as do the painted ornaments; but the Red, not diminishing the brilliancy of the metal, but, on the contrary, augmenting the intensity of its colour, produces an excellent effect.

The Green ground is more intense and bluer than the same ground upon which the painted ornaments are placed.

(468.) The study of the effects of Red and of Green grounds upon painted ornaments on the one hand, and upon gilt ornaments on the other, is extremely interesting to paper-stainers and decorators; it demonstrates to them the necessity of taking into consideration, in the juxtaposition of bodies which it is proposed to associate, the brilliancy which these bodies naturally possess, and the brilliancy we wish to impart to them when they have none. The preceding examples (460, 461. 466, 467.) very clearly explain why the paper-stainer will prefer dark Red instead of Green for his gilt ornaments, and why a decorator will prefer Green to Red for the colour of the hangings of a show-room of gilt bronzes; besides, we can appreciate the difference that exists between these two hangings, in seeing how the Green ground is preferable to the Red in warehouses of gilt clocks.

#### (f.) *Blue Ground.*

(469.) Observation agrees perfectly with the law; it is really upon a Blue ground that painted ornaments (the dominant colour of which is the complementary of this ground) show to the greatest advantage in respect to intensity of the gold-yellow colour; this effect more than compensates for the slight difference which may result from the Red ground giving a little more brilliancy. The ornaments upon the latter ground, compared with those on the Blue, are less coloured, and appear whiter.

#### *Metallic Gilt Ornaments.*

(470.) They accord as well as the painted Ornaments; the Blue ground is deeper and less Violet than that upon which painted ornaments are placed.

#### (g.) *Violet Ground.*

(471.) Conformably to the law the Violet ground giving Greenish-Yellow to the painted ornaments is favourable to them; they appear upon this ground less Olive-Grey, more brilliant than upon the White ground, and less Green than upon the Red ground.

#### *Metallic Gilt Ornaments.*

(472.) They stand out quite as well from this ground, which is raised in tone, and the Violet appears bluer, or less Red.

(473.) It is remarkable that the gilt ornaments, compared with their painted imitations, heighten all the grounds upon which they are placed. We cannot say that this metal causes the grounds to lose any of their brilliancy; for Orange, taking some Red by the juxtaposition of the gold, appears nevertheless more brilliant than the Orange in juxtaposition with the painted ornaments. The gold, by its Orange colour, gives in addition some Blue, its complementary, to bodies which environ it.

II.—BORDER OF FOUR INCHES IN HEIGHT, REPRESENTING ORNAMENTS COMPOSED OF FESTOONS OF BLUE FLOWERS OF WHICH THE EXTREMITIES ARE ENGAGED IN THE GREY LEAVES OF THE ARABESQUES.

(474.) As a second example, I take these ornaments, opposed in some sort to the preceding by their dominant colour, which is Blue.

### Black Ground.

(475.) Grey lowered three tones in comparison with Grey upon White, less reddish.

Blue flowers lowered two tones at least.

### Red Ground.

(476.) The Grey is greenish; while upon White it is reddish.

The Blue flowers are lowered three tones, and the Blue inclines to Green.

### Orange Ground.

(477.) Grey much lowered; less Red than upon White.

Flowers paler, and of a Blue less Red or less Violet than upon a White ground.

### Yellow Ground.

(478.) Grey higher than upon White ground, more Violet.

Flowers of a more Violet-Blue, less Green than upon a White ground.

### Green Ground.

(479.) The Grey is reddish, while upon a White ground it appears greenish.

The Blue takes some Red or some Violet, but it loses much of its vivacity; it resembles some Blues of the silk-vat, which, in ceding some Yellow to the water, become Blue-Violet or Slate-colour.

### Blue Ground.

(480.) The Blue ground being fresher than that of the ornament, it follows that it *Oranges* the Blue of the flowers; that is to say, it *Greys* them in the most disagreeable manner.

The Grey ornament is *Oranged* and lighter than upon the White ground.

### Violet Ground.

(481.) Grey lowered, yellowed, impoverished, Blue tends to Green, and impoverished.

### III.—Border of five inches and a half in height, representing roses with their leaves.

#### Black Ground.

(482.) This border is particularly useful to serve as an example of the effect of two colours, Red and Green, which are very common in the vegetable world, and often represented upon paper-hangings.

(483.) The Green is less Black, lighter, fresher, and purer, and its brown tones redder than upon a White ground: with respect to its light tones, I see them yellower; while, on the contrary, they appeared bluer to three persons accustomed to observe colours. This difference, on the other hand, as I at last found, was due to my comparing together the *ensemble* of leaves upon a Black ground with that of leaves upon a White ground; while the other persons instituted their comparison more particularly between the Browns and the light tones of Green placed upon the same ground. This difference in the manner of seeing the same objects will be the subject of some remarks hereafter.

Rose lighter, yellower than upon a White ground.

#### On a dark Red Ground.

(484.) Green more beautiful, less Black, lighter than upon a White ground.

> Rose more Lilac perhaps than upon a White ground. The good effect of the border upon this ground is due chiefly to the greatest part of the Rose not being contiguous to Red but to Green, because the *ensemble* of the border and the ground exhibits flowers the Rose of which contrasts with the Green of their leaves, while the same Green contrasts with the Red of the ground, which is deeper and warmer than the colour of the flowers.

#### On an Orange Ground.

(485.) The Green lighter, a little bluer than upon a White ground.

> Rose much more Violet than upon a White ground. The general effect is not agreeable.

### On a Yellow Ground.

(486.) Green bluer than upon a White ground.
Rose more Violet, purer than upon a White ground.
The *ensemble* exhibits a good effect of contrast.

*On a Green Ground, the tone of which is nearly equal to that of the lights of the Leaves, and the hue of which is a little bluer.*

(487.) Green of the leaves lighter, yellower than upon a White ground.
Rose fresher, purer, more velvety, than upon a White ground.
Ground of an agreeable effect, from harmony of analogy with the colour of the leaves, and from harmony of contrast with the rose of the flowers.

### On a Blue Ground.

(488.) Green lighter, more golden than upon a White ground.
Rose yellower, less fresh than upon a White ground.
Although the green leaves do not exactly produce a bad effect upon the ground, yet the roses lose much of their freshness, and the appearance of the *ensemble* is not agreeable.

### On a Violet Ground.

(489.) Green yellower, clearer than upon a White ground.
Rose faded.
If the ground does not injure the Green of the leaves, then it injures the rose so much that it is not agreeable.

---

IV.—BORDER OF SIX INCHES IN HEIGHT, REPRESENTING WHITE FLOWERS, SUCH AS CHINA ASTER, POPPY, LILY OF THE VALLEY, ROSES; SOME RED FLOWERS, SUCH AS THE ROSE, WALL-FLOWER; SOME SCARLET OR ORANGE, SUCH AS THE POPPY, POMEGRANATE, TULIP, BIGNONIA; AND VIOLET FLOWERS, SUCH AS LILAC, VIOLETS; AND TULIPS, WITH GREEN LEAVES.

(490.) This border was remarkable for the pleasing association of the flowers among themselves, and of these flowers with their leaves. In spite of the multiplicity of colours, and of the shades of red and violet, there was no disagreeable juxtaposition, except that of a pomegranate next to a rose; but the contact only took place at a point, and the two flowers were in very different positions.

### Black Ground.

(491.) The *ensemble* clearer than upon a White ground.

Orange finer, brighter than upon a White ground.
White the same.
Green clearer, redder.
The roses and the violets gain nothing from the Black.

### Red-Brown Ground.

(492.) *Ensemble* clearer than upon a White ground.

Whites and Greens effective.
An orange-flower, contiguous to the ground, for the reason explained above (460.), acquires a brilliancy which it has not upon a White ground.

### Orange Ground.

(493.) *Ensemble* more sombre, more tarnished than upon a White ground.

Orange-flowers and roses tarnished, lilacs bluer.
This assortment is not good.

### Yellow Ground.

(494.) The orange-flower contiguous to the ground evidently loses some of its vivacity, in comparison with the White ground.

The Whites are less beautiful than upon a Red ground.
The Greens are bluer than upon a White ground.
The roses become bluer, the violets acquire some brilliancy.
The whole effect is good, because there is but little Yellow in the border, and but little Orange contiguous to the ground.

### Green Ground.

(495.) The ground being purer than the Green of the leaves had not a good effect relatively to these latter. On the other hand, the Green in the border was in too small a quantity to produce a harmony of analogy, and it had not sufficient Red for a harmony of contrast.

### Blue Ground.

(496.) The Oranges have a good effect, the Greens were reddened as well as the Whites. The roses and the lilacs lost some of their freshness.

> This arrangement did not produce a good effect, because there was not sufficient Yellow or Orange in the border.

### Violet Ground.

(497.) Orange more beautiful than upon a White ground.
> Roses and violets especially less beautiful than upon a White ground.
> A mediocre assortment.

### Grey Ground.

(498.) As might be easily premised, this ground was extremely favourable to all the colours of the border, without exception.

---

(499.) The examination we have made of four sorts of borders has this twofold advantage, that it enables us to verify exactly the conclusions which are directly deducible from the law of simultaneous contrast of colours, besides presenting to us the effects which we could scarcely have deduced from the same law without the aid of experiment. I now speak —

1°. Of the influence which a complementary exercises by its quality of luminousness upon the colour to which it is added (460.).

2°. Of the very different manner in which not only different people, but even the same person, will judge of the colours of a more or less complex pattern having a certain number of colours, according to the attention the spectator gives at a certain moment to the different parts (483.).

(500.) The examination which we have made of the border of roses with their leaves (No. 3.), and especially of that of the border of flowers varied in their forms and hues (No. 4.), makes us feel the necessity of a knowledge of the law of contrast to assort the colours of objects represented upon a border,

with the colour which serves as a ground to them. The examination of the border No. 4. has well demonstrated experimentally that this assortment presents so much the more difficulty, as we wish to have the grounds of a purer tint, and more varied colours in the objects we intend placing on them : besides, in demonstrating the good effect of grey, as a ground for these latter objects, it has furnished the example of a fact which may be deduced from the law, and which is in perfect accordance with what practice has long since taught us.

# SECTION III.

## PRINTING OR WRITING ON PAPERS OF VARIOUS COLOURS.

CHAPTER I.—INTRODUCTION (501—505.).

CHAPTER II.—ON THE ASSORTMENT OF COLOURS WITH RESPECT TO READING BY DIFFUSED DAYLIGHT (506—519.).

CHAPTER III.—ON THE ASSORTMENT OF COLOURS WITH RESPECT TO READING BY ARTIFICIAL LIGHT (520.).

## CHAPTER L.

### INTRODUCTION.

(501.) HAVING made it a rule in this work never to state any observations which I have not myself verified, whenever I do not quote the name of the author, I must mention that, not possessing every requisite for the examination of the subject of this section, I am obliged to develope certain points only: at the same time I shall indicate those which I have not treated as I desired.

(502.) It is not possible to pass a profound judgment on the different assortments of colours with respect to the use which can be made of them in reading, whether of printed or written characters, or by any other means, so far as regards —

   A. The duration of the reading;

   B. And the kind of light which illumines the printed or written paper.

### A. INFLUENCE OF DURATION IN THE READING.

(503.) From the different conditions in which the eye is found when it is apt to perceive the phenomena of simultaneous, successive, and mixed contrasts of colours (77. and following), we conclude, that, in order to judge of the effect upon the sight of the assortments we can make between the colour of the letters, and that of the paper, with regard to the degree of facility that different assortments respectively present in the reading, it is necessary to take into consideration the length of time during which we read; for it may happen, that one assortment will be more favourable than another during a brief reading, while the contrary will take place if the reading is prolonged during several hours; besides, the first assortment, presenting the greatest contrast to the second, will, by the same reason, be more favourable to a reading of short duration, while it will be less so to a prolonged reading, because then, in consequence of the intensity of its contrast, it will fatigue the organ more than the second.

### B. INFLUENCE OF THE KIND OF LIGHT WHICH ILLUMINES PRINTED OR WRITTEN PAPER.

(504.) The light we employ to supply the place of that of the sun changing the relations of colour under which the same bodies appear to us when they are illumined by this latter light, it is evident that if we neglected this difference of relation it would give rise to error, because any assortment of colours which might be more favourable to the reading under diffused daylight might be less so in the light of a candle, lamp, &c.

(505.) Conformably to the distinction I have just established, I am about to examine in the two following Chapters—

1°. The influence of different assortments of colours which we may make use of in writing and printing to render more or less easy a reading of characters printed or traced in any manner, continued for some minutes or hours, by diffused daylight.

2° The influence of the same assortments when they refer to a short or prolonged reading made by artificial light.

## CHAPTER II.

### ON THE ASSORTMENT OF COLOURS WITH RESPECT TO READING BY DIFFUSED DAYLIGHT.

#### ARTICLE 1.

#### *Reading of a few Minutes' Duration.*

(506.) THE reading of letters printed or written upon paper is done without fatigue only where there is a marked contrast between the letters and the ground upon which they are presented to the eye. The contrast may be of tone or of colour, or both.

#### *Contrast of Tone.*

(507.) Contrast of tone is the most favourable condition for distinct vision, if we consider White and Black as the two extremes of a scale comprehending the gradation from normal Grey; in fact, Black letters upon a White ground present the maximum of contrast of tone, and the reading is made in a perfectly distinct manner, without fatigue, by diffused daylight,

affording the proof of what I advance : finally, all those whose sight is enfeebled by age, know how the want of light, or, what amounts to the same thing, how the Grey tint of paper, in diminishing the contrast of tone, renders it difficult to read the letters which they could well do without difficulty in a vivid light, or, what is the same, upon papers White or less Grey than that of which we speak.

(508.) Black characters upon Grey paper are difficult to read : this is the reason we do not print or trace with a coloured ink upon paper of the colour of this ink, even if there be a great difference between the two tones.

### Contrast of Colour.

(509.) To appreciate the influence of this contrast, the colour of the letters and that of the paper must be taken at the same height of tone, in order to perceive the effect of mutual contrast of two colours only.

(510.) According to the distinction we have made of luminous and sombre colours in equality of tone (184.), it is evident that the contrast most favourable to distinct vision will be that of a luminous colour, such as Red, Orange, Yellow, with a sombre colour, such as Violet, Blue, and that in this case the effect will be at its maximum, if the colours are complementary, as Orange and Blue, Yellow and Violet, &c.

(511.) I have already remarked that Red and Green afford a complementary assortment which presents the least contrast of luminousness, because under this relation the Red is placed between the elements of Green, of which the one, Yellow, is the brightest colour, and the other, Blue, is the most sombre (187.). Thus, Red and Green are complementary colours, the least suitable to be opposed to each other in writing or printing coloured characters upon coloured grounds.

### Contrast of Tone and of Colour.

(512.) If the contrast of Black and White is the most favourable to distinct vision, and if the contrast of two colours taken at equal height of tone is favourable only in the degree of one being sombre and the other luminous, then we must necessarily conclude that, whenever we would wish to deviate from the opposition of Black and White, we must at the same time make a contrast of tone and of colour, otherwise the reading of letters which are not in this condition of contrast with their ground, will be fatiguing or difficult.

(513.) Next to the opposition of Black with White, come

those of Black with the light tones of luminous colours, such as Red, Orange, and Yellow; then those of these same light tones with deep Blue.

(514.) The opposition of luminous colours such as those of Red and Orange, of Red and Yellow, of Orange and Yellow, yield nothing favourable to view: it will be better, I believe, to avoid their associations.

(515.) In all the preceding, I have spoken only of the opposition of tone and colour existing between the letters and the ground upon which we read them; it remains for me to treat the questions whether it is advantageous for the reader that the letters be darker than the ground, as they generally are in printing and writing with Black ink upon white and coloured paper, or whether the inverse case is preferable; or, finally, if the two cases present equal advantages. Not having had at my disposal every requisite for resolving these questions, I have not occupied myself with them. I shall limit myself to the single remark that, the letters presenting much less extent of surface than the paper which serves as their ground, there is a superiority of clearness in the particular assortment generally adopted, and clearness is always favourable to distinct vision.

(516.) I will now give some examples of Black characters printed upon coloured paper; commencing with those which appeared to me the easiest to read.

    1°. Black characters upon White paper.
    2°. Black characters upon light Yellow paper.
    3°. Black characters upon light Yellow-Green paper.
    4°. Black characters upon light Orange paper.
    5°. Black characters upon light Blue paper.
    6°. Black characters upon Crimson-Red paper.
    7°. Black characters upon deep Orange paper.
    8°. Black characters upon deep Red paper.
    9°. Black characters upon deep Violet paper.

I shall remark that I read almost as well upon light Orange as upon light Yellow-Green paper.

(517.) I have every reason to believe that other eyes than mine would require some change in the order I have assigned to the preceding assortments.

## Article 2.
### Reading of some Hours' Duration.

(518.) The order which may be established between different

assortments of colours relatively to the greater or less facility which they respectively present for a reading of some minutes' duration will doubtless differ among some persons from the order in which the same person would range them in a reading of some hours' duration.

Thus, there may be such an assortment of black letters with coloured paper which, being less favourable to a reading of a quarter of an hour than the assortment of black letters on white paper, will be preferred to this latter by a person to whom the contrast of black and white, seen during many hours, would cause more fatigue than would be occasioned by reading the same letters upon yellow, green, blue, &c., paper, properly selected both as to the height of tone and hue. Unfortunately, I have not been able to make comparative proofs sufficiently prolonged for me to quote positive results; for I have only had at my disposal a few loose sheets of paper of different colours upon which black characters were printed.

(519.) I have not yet touched upon an element appertaining to the subject which now occupies us, which seems to me worthy of consideration. I allude to a property possessed in variable degrees by colours,—viz.: that of leaving upon the organ which has perceived them during a certain time the impression of their respective complementaries (116.). It is clear that the more durable this impression is, other things being equal, the less will the organ be disposed to receive distinctly new impressions, for there must necessarily be superpositions of different images, like in the mixed contrast (327.), which, not being coincident, will tend to render the actual effect less marked than it might otherwise be.

## CHAPTER III.

#### ON THE ASSORTMENT OF COLOURS WITH RESPECT TO READING BY ARTIFICIAL LIGHT.

(520.) I HAVE made but very few observations on the subject of this chapter. Yet, I believe, I am right in affirming that by diffused daylight I read for some minutes black letters printed on yellow paper more easily than black letters printed upon pale yellow-green paper, while with the light of a lamp the contrary took place.

# FOURTH DIVISION.

## FLAT TINTING.

First Section. — Map Colouring.
Second Section. — Colouring Engravings.

## SECTION I.

#### ON COLOURING GEOGRAPHICAL MAPS.

(521.) THE colouring of Geographical Charts, as is well known, gives many advantages in presenting readily to the eyes their different component parts, whether continent, empire, kingdom, or republic; state or country. Until lately, the colouring of maps has always depended upon the caprice of the colourer; yet it appears to me there are some rules which it would not be useless to observe.

>(522.) *Firstly*, the colours should be as pale as possible, especially those which are naturally sombre, as blue and violet, so that the reading of the names may always be easy; but preference must be given to the luminous colours, red, orange, yellow, and light green, and to employing only their bright tones.

>(523.) *Secondly*, all the parts which have some common relation together should receive a single colour, each part being distinguished from the contiguous parts by a difference of tone.

(524.) To attain this end it is not necessary to employ as many different tones as there are parts to be distinguished; it suffices that we can perceive the difference of tone in the contiguous parts without difficulty.

Suppose, for example, there are thirteen divisions in a map, which, although very small, are distinguished one from the other by means of five tones of a single scale. In case we found that certain tones would be too near each other, we could give them an extremely light tint of the colour of the nearest scale.

For instance, if we found that the tone 2, which is near the tone 1, was not sufficiently distinct from it, we could, if the colour was rose, give it a tint of crimson-red.

(525.) If we had a surface contiguous to the preceding, we would have to choose the complementary of the first colour; if we had a second surface, we would have to take a colour distinct from the other two. For example, supposing we had rose and green, we take yellow for the second.

(526.) We could proceed in an analogous manner when we would represent the currents of the ocean; that is, have recourse to the tones of a blue scale, which is the colour usually devoted to water.

## SECTION II.

### ON COLOURING ENGRAVINGS.

(527.) At a period when so many persons have sought the means of rendering accessible to every mind much of the knowledge which was previously limited to the few, they have not overlooked the advantage that can be derived from coloured engravings, in presenting to the eyes productions which we wish to impress on the memory, or, by presenting them in one view to those who, having studied them, might have forgotten the generalisation they offer. The application of colours to these points is, in some respects, an extension of the colouring of geographical maps and plans.

(528.) Without partaking of the infatuation of many persons for engravings so much as to consider they take the place of books which treat specially of the knowledge to which these pictures refer, I am convinced, however, that by pointing out to the student their relation to the principal facts of the subject he is studying, especially in habituating him to create those pictures for his own use,—I am convinced, I repeat, that these pictures are one of the best elements of instruction we possess, at the present day; and I also think that, if they have had undoubted advantages in the study of the natural sciences, especially in that of geology, they will not have less in any other study when we make a rational use of them, concurrently with the study of the details connected with the general relations they express.

(529.) It is, doubtless, a matter of indifference whether we employ one colour or another in a given engraving; yet, in considering the object of these engravings, it is clear that all which can concur to facilitate the conception of the relations they represent, and aid the memory in retaining them, is a means of perfecting their execution.

(530.) The advantages we may derive from the colouring of engravings are, I consider, of many kinds.

### 1. Advantage in the general Distinctness of Parts.

(531.) The different parts of a picture may be distinguished—
1°. By the colours of different scales;
2°. By different tones of the same scale;
and all that has been said in the last subdivisions, treating of colouring a geographical chart, is applicable to engravings.

### 2. Advantage in the Distinctness of different Objects, either by Order of Superposition or by Order of Succession.

(532.) If, in a picture, we represent objects superimposed in a certain order, we can conveniently represent each of them by one of the colours of the solar spectrum, taken in the order it is found, beginning with red, for example, and taking successively orange, yellow, green, blue, purple, and violet. In the case where the number of these colours is insufficient, we can take different tones of their scales, and we can also modify these tones by having recourse to the scales nearest to the scale to which they relate.

(533.) It is evident that, by the same artifice, we can represent a succession of persons or things.

### 3. Advantage in the Connection or Mixture of different Parts.

(534.) By the juxtaposition of divers colours, each representing a different object, we can represent the connection of these objects; so also by the mixture of different colours, each representing a different object, we can represent the union, fusion, or mixture of these objects, in having regard —

1°. To the formation of the binary colours, such as
  Orange = Red + Yellow.
  Green = Yellow + Blue.
  Violet = Blue + Red.

2°. To the formation of the tertiary colours, represented by the binary colours more or less tarnished with black.
  In mixing, we can express the proportion of each of the elementary colours by a number.

(535.) Something would be wanting in the expression of my ideas on the use that can be made of coloured engravings, if I did not anticipate an objection, which will certainly occur to the minds of many of my readers; it is the inconvenience they think will arise by devoting certain colours to subordinate objects, through relations which may be more or less modified, if not

greatly altered, by the progress of knowledge. This is a graver objection than it appears at first aspect, because, upon reflection, it does not differ at bottom from that which was lately raised against the utility of methodical or rational nomenclatures in the progressive sciences.

(536.) I was the first to recognise the inconvenience of strictly definite names to designate material objects, when the relations upon which these names rest are of a variable nature, or when, being the expression of a certain manner of interpreting the facts to which they relate, this view becoming changed, the nomenclature is then found more or less in direct opposition to it. For instance, according to the rules of chemical nomenclature, the term *muriate of oxide of sodium*, signifying the combination of *muriatic acid* with the *oxide of the metal sodium*, was applied to *common salt*, at a period when it was believed that such, in fact, was its composition. But later researches having induced the belief that it contains neither acid nor oxide of sodium, but two simple elements, *chlorine* and *sodium*, we give it the name of *chloride of sodium*.

These expressions are opposed to each other. Thus, from the first it results that the 0·6034 parts of the salt represent the *muriatic acid* and *oxygen*, and, conformably to this result, it is thought that these bodies were in suitable proportions to each other to constitute an *oxygenated muriatic acid*, while the result of the second expression is, that the 0·6034 of the weight of marine salt, instead of belonging to a compound body, *oxygenated muriatic acid*, belongs to a simple body, *chlorine*. Let us examine the real inconvenience of this state of things, in order to ascertain if it is sufficiently important to induce us to abandon an excellent method of expressing these relations by a rational nomenclature.

(537.) It is evident that when a theory comes to be changed, the nomenclature, which was a concise expression of it, renders instruction more difficult than it would be if the nomenclature was insignificant; but this difficulty, of short duration, disappears when the theory which replaces the old comes in its turn to be summed up in the new nomenclature, which, equally methodical as the first, has also its advantages. Thus, in taking the preceding example, we see that the nomenclature of the muriatic compounds had only a positive inconvenience at the epoch when they proposed the new theory of chlorine by the terms of the old nomenclature; but this, once replaced by the new, order was immediately re-established, and the old is entered in the archives of science, where it still serves those who wish to study the history of the variations of chemical

theory, as, when it was considered to be the expression of the truth, it served him who wished to study the elements of the science on which it depended.

(538.) In speaking of the utility of methodical or rational nomenclatures, I have no wish to defend the abuses to which they are liable. I have supposed that they rest *upon a system of perfectly definite facts, and which had already been the object of discussions sufficiently numerous and profound, so that their interpretation might be considered as definite relatively to the state of knowledge at the epoch when this interpretation took place.*

(539.) I consider this digression necessary to clearly develope my idea respecting the utility of colouring engravings according to the principles I have proposed. Once these principles are understood by those who employ this methodical or rational colouring, the use of pictures thus treated will greatly aid the understanding of the text to which they are annexed, either for students who see them for the first time, or for the learned who consult them with the intention of recalling things forgotten: finally, the relations between given objects expressed by colours, becoming altered with the progress of knowledge, or by the difference of opinion existing between contemporary authors, the same principles directing the employment of colours in engravings should express these variations. To those who consult them, these pictures will render services analogous to those rendered by methodical nomenclature applied to the same subject, in the study of the variations in science. I conceive, also, under the historical relation, we can employ this colouring in a way which those who have not reflected upon the subject are far from suspecting.

# FIFTH DIVISION.

## ARRANGEMENT OF COLOURED OBJECTS OF LIMITED EXTENT.

FIRST SECTION.—ON THE EMPLOYMENT OF COLOURS IN ARCHITECTURE.

SECOND SECTION. — APPLICATION TO INTERIOR DECORATION.

THIRD SECTION.— APPLICATIONS TO CLOTHING.

FOURTH SECTION. — APPLICATIONS TO HORTICULTURE.

    1ST SUB-SECTION.—APPLICATION OF THE LAW OF CONTRAST OF COLOURS TO HORTICULTURE.

    2ND SUB-SECTION.—ON THE DISTRIBUTION AND PLANTING VEGETATION IN MASSES.

# SECTION I.

## EMPLOYMENT OF COLOURS IN ARCHITECTURE.

CHAPTER I.—EMPLOYMENT OF COLOURS IN EGYPTIAN ARCHITECTURE (540—545.).

CHAPTER II.—EMPLOYMENT OF COLOURS IN GRECIAN ARCHITECTURE (546—548.).

CHAPTER III.—EMPLOYMENT OF COLOURS IN GOTHIC ARCHITECTURE (549—555.).

## CHAPTER I.

#### ON THE EMPLOYMENT OF COLOURS IN EGYPTIAN ARCHITECTURE.

(540.) THE Egyptians employed various colours, such as red, yellow, green, blue, white, to decorate their monuments.

(541.) Lancret, author of the text of that part of the work on Egypt which relates to its monuments and antiquities, while expressing his astonishment at this practice, remarks, nevertheless, *that all those who have seen the Egyptian monuments can attest that when they looked at these paintings, even for the first time, they did not strike them disagreeably;* he afterwards enounced his opinion, *that if at first the colours appear distributed arbitrarily, it is because we have not combined a sufficient number of observations upon this matter, and that it will one day be found that this part of the arts of the Egyptians was, like all the rest, submitted to inflexible rules.*

(542.) Champollion the younger expresses himself in these terms on the application of colours to Egyptian architecture: "I should wish to introduce into the great temple of Ipsamboul "all those who refused to believe in the elegant richness that "painted sculpture adds to architecture: in less than a quarter "of an hour I engage that they will *perspire* all their pre- "judices, and that their *à priori* opinions will quit them by "every pore."

(543.) If we look attentively at plate 18. of the great work on Egypt, being a *coloured perspective view taken from the portico of the great Temple of the Isle of Philæ*, we see that the walls, ceilings, and columns are covered with hieroglyphics, symbolical figures, and allegorical pictures, all coloured.

(544.) These hieroglyphics were intended to be read; consequently it was necessary to make them very distinct from the remainder of the surface of the stone in which they are generally *cut in relief;* for, in colouring them, they become more distinct than they would be by relief alone. But if the Egyptians had been guided by the principle of distinct view only, they would have constantly coloured them for the same kind of stone in a single colour, which would have been chosen in such a manner as to have come out in the highest possible relief upon

the ground; but this they have not done: they have employed different colours. Here there is no doubt they have been led to this by the marked taste of the Eastern nations for colours; as to any symbolical use which they may have made of each in particular, it does not devolve on me to explain.

(545.) Once admit the fact of colouring hieroglyphics, the colouring of other figured objects which accompany them appears to have been a necessary consequence, so as to bring out certain symbols and allegories more distinctly and more agreeably by the effect of their various colours, or because it was understood that if the hieroglyphics only were differently coloured, there would be no harmony between them and the other figured objects.

In fact, if we attentively consider the paintings in plate 18. of the work upon Egypt above mentioned (543.), no one can mistake the harmony between the hieroglyphics and the other painted objects; and this is so true, that we should not feel shocked by the sight of these coloured hieroglyphics, even were we ignorant of the nature of their written characters, and therefore mistook them for figures traced by the whim of the artist. In my opinion this harmony clearly justifies the passages from Lancret and Champollion the younger above quoted (541. and 542.).

Supposing the colouration of the ornaments accessory to the hieroglyphics had determined that of the latter, and not inversely as I had supposed it, there would be no reason to come to a different conclusion.

## CHAPTER II.

#### ON THE EMPLOYMENT OF COLOURS IN GREEK ARCHITECTURE.

(546.) THE discovery of Greek temples coloured on the exterior is doubtless a very remarkable fact in Archæology; for if these monuments appeared to many persons to reject the application of colours in their external decoration, they were assuredly made by the Greeks. Now it is impossible not to admit that it was among this people that the alliance of colours with architecture was made, not at the epoch of its decline, but at a period when they erected monuments in the best style: in fact, the ruins of coloured temples discovered by the excavations made

in Greece, Italy, and Sicily, in places where many Greek colonies prospered, have this characteristic in an unmistakeable degree.

(547.) If we seek the cause which has determined the Greek architect to seize upon one of the most powerful means that the painter has of addressing the eye, we shall find it especially, I think, in a taste for colours, rather than in the intention of rendering the various parts of an edifice more distinct from each other by colouring them differently, and of substituting painted ornaments for ornaments in relief, whether sculptured or moulded, or of augmenting the relief these ornaments already possessed; finally, the communication of the Greeks with the Egyptians may have induced them to imitate the latter in this application of colours to monuments.

(548.) In the coloured drawings of Greek monuments which I have been able to procure, I have remarked not only the number of colours employed in these monuments, *white, black, red, yellow, green,* and *blue,* but also the use which has been made of them under the relation of *variety* and *purity of tint,* of *distinct view of the parts,* and of the *harmony of the whole.*

In the work of the Duke de Serra di Falco upon the Antiquities of Selinus, we see coloured designs, representing the ruins of Greek temples, where the principal lines, such as the fillets of the architrave and those of the cornice, are *red;* the mutules *blue,* and their guttæ *white;* the triglyphs *blue,* their channels *black,* and their guttæ *white;* and the more extended parts of the frieze and the cornice as well as the architrave are of light *yellow.*

We see that *red,* a luminous colour, designated the greater part of the principal lines; that *blue* associated with *black* in the triglyphs and their channels, formed an harmonious *ensemble* distinct from the neighbouring parts : also, that the dominant colour, light yellow, produced a much better effect to what it would if the most intense or the most sombre colours had predominated. Finally, the colours were distributed in the most intelligent manner possible without being motley, presenting a variety and lightness in the tints, with easy separation of parts.

## CHAPTER III.

#### ON THE EMPLOYMENT OF COLOURS IN GOTHIC ARCHITECTURE.

(549.) In the great Gothic churches, colour has rarely been employed on the exterior, except in a few cases, and always in a restrained manner, and without injury to the general harmony; for the colour we meet with on porches and in niches is altogether insignificant under the point of view which occupies us; and besides, there is nothing to show that it was not added long after the erection of the structure where it is found.

One thing I most admire in these vast edifices is the art, or, if you will, the luck with which they have succeeded in actually doing without colour, by having recourse only to architecture and sculpture, to give to the exterior of the edifice a variety which in no respect injures the imposing effect of the whole; for the elevated walls of the nave, and those of the aisles parallel to them, are they not remarkable? first, when we regard the great windows which, in interrupting the continuity, destroy that gloomy and disagreeable aspect possessed by every large wall which is not pierced with light; and, again, when we regard their mutual connection by means of light arches, which, sustained on the one part by the buttresses of the nave, and on the other, by the pillars which rise from the walls of the aisles, surpass it in height, and by their projection without, contribute so effectually with the windows and their ornaments to remove all monotony from the lateral façades of the edifice; are they not also remarkable, even where there are no lateral entrances, with regard to general harmony, by the manner in which the windows and their ornaments, the pillars and their flying buttresses, connect with the façade of the nave, where at the first aspect it would appear that the architect had concentrated all the ornaments, so varied, light, and slender, which decorate it? *

---

\* I beg the reader to perceive in the preceding lines, the enunciation of profound impressions which from my youth I have experienced at the sight of these monuments, and not that of a judgment which would lead him to suppose it my intention to give the Gothic church as a type for imitation in preference to every other. I repeat, I express these impressions, and nothing more. I do not inquire if this architecture has its rules, before admiring the constructions which it has produced. In speaking of

(550.) It is in regarding Gothic churches from the preceding point of view, in comparing their different façades with those of the greater part of modern churches, in which generally a single façade seems to have fixed the attention of the architect, as is shown, for instance, in the Church of St. Géneviève by Soufflot, that so many persons are led to regard Gothic architecture as essentially that of the Catholic religion, and to consider it as having resolved the problem of building long and high walls, where the principles of form, solidity, variety, clear view, perfect harmony of all the principal parts (however each may be varied in its details), and suitableness of the building to its purpose, may have been completely observed on the exterior.

(551.) If we now penetrate the interior of these churches, then the magic of the colours of the stained windows will complete all the enjoyments the sight can receive from colour allied to architecture, enjoyments which strengthen the power of the religious sentiment only in those who enter these edifices to address their prayers to the God of Christians.

(552.) M. Boisserée, author of a work, full of original and profound research, on the Cathedral of Cologne, thinks that the ceilings of Gothic churches ought, according to a general custom, to represent the celestial vault, and be painted blue, studded with stars of metal gilt.

(553.) If painting has from the beginning really concurred with architecture, and even with painted sculpture in the interior decoration of Gothic churches, it must have been very secondary, and on the system of flat tints, from the moment wherein it is decided to put in windows of stained glass; for no painting applied upon an opaque body, such as stone, wood, &c., could sustain itself beside the brilliant coloured lights transmitted by the glass: and if this painting has been graduated according to the rules of chiaro'scuro, all its merit in the eye of the spectator disappears, for want of pure and white light, the only kind suitable for lighting it.

(554.) Is it true that the vicinity of stained glass necessarily requires, as an effect of harmony, painting on the contiguous walls? Without deciding absolutely in favour of the contrary opinion, I shall avow, that, after reflecting a long time upon

light arches, sustained on the one hand by the buttresses of the nave, and on the other by the pillars of the walls of the aisles, I do not inquire if these are the stays which the weakness of the art which built them has raised to insure stability. I consider them simply as establishing between two walls a relation which does not displease me, because it is in consonant relation with all that accompanies it.

I shall return to this subject in Part Third.

the deep impressions I have received in great Gothic churches, where the walls presented only the simple effects of light and shade upon a uniform surface of stone, where no other colours struck my eyes but those transmitted by the stained glass,— I shall avow, I say, that the sight of more varied effects would have appeared to me an error against the principle of suitability of that place to its destination; and this opinion was strongly fortified upon seeing, after the coronation of Charles X., the fine vault of the ancient cathedral of Rheims, which had been painted for the occasion in blue, sprinkled with *fleurs-de-lis*: I was reminded of the impression which I experienced some years before, when it presented to my sight only the uniform colour of the stone.

(555.) To enter into further details on the decoration of the interiors of large Gothic churches would encroach upon one of the chapters of the following section, where I shall examine this kind of decoration, not specially, but generally, independently of a given architectural form.

# SECTION II.

## APPLICATIONS TO INTERIOR DECORATION.

INTRODUCTION (556.).

CHAPTER I.—ON THE ASSORTMENT OF STUFFS WITH THE WOOD OF CHAIRS (557—563.).

CHAPTER II.—ON THE ASSORTMENT OF PICTURES, ENGRAVINGS, AND LITHOGRAPHS WITH THEIR FRAMES (564—572.).

CHAPTER III.—ON THE GENERAL DECORATION OF THE INTERIORS OF CHURCHES (573—581.).

CHAPTER IV.—ON THE DECORATIONS OF MUSEUMS AND GALLERIES OF ART (582—589.).

CHAPTER V.—ON THE CHOICE OF COLOURS FOR THEATRES (590—598.).

CHAPTER VI.—ON THE INTERIOR DECORATION OF DWELLINGS WITH RESPECT TO THE ASSORTMENT OF COLOURS (599—655.).

## INTRODUCTION.

(556.) The title of this section is so general, that I must briefly indicate the subjects which I have thought proper to comprehend in it, and the order in which they will be examined.

I shall treat in succession —

    1°. On the assortment of stuffs with the wood of chairs, &c.

    2°. On the assortment of frames with the pictures, engravings, and lithographs which they circumscribe.

    3°. On the general decoration of interiors of churches.

    4°. On the decoration of museums, galleries, &c.

    5°. On the choice of colours for theatres.

    6°. On the decoration of interiors — houses, palaces, &c. — with regard to the assortment of colours.

## CHAPTER I.

#### ON THE ASSORTMENT OF STUFFS WITH THE WOOD OF CHAIRS.

(557.) When we would assort the colour of a stuff with that of a wood for furniture, we must distinguish two conditions; that where we would obtain the greatest possible advantage from two colours by each giving value to the other; and that where, considering the stuff and the wood as one object, we regard only the colour of the stuff relatively to that of the objects which, with the chair, compose the furniture.

It is evident, then, that, in the first instance, we must have between the two parts of the chair — the stuff and the wood — harmony of contrast; and in the second, harmony of analogy.

## First Case.

(558.) Nothing contributes so much to enhance the beauty of a stuff intended for chairs, sofas, &c., as the selection of the wood to which it is attached; and, reciprocally, nothing contributes so much to increase the beauty of the wood as the colour of the stuff in juxtaposition with it. After what has been said, it is evident that we must assort —

 Violet or blue stuffs with yellow woods; such as citron, the roots of the ash, maple, satin-wood, &c.
 Green stuffs, with rose or red coloured woods, as mahogany.
 Violet- or blue-greys are equally good with yellow woods, as green-greys are with the red woods.

But in all these assortments, to obtain the best possible effect it is necessary to take into consideration the contrast resulting from height of tone; for a dark blue or violet stuff will not accord so well with a yellow wood as a light tone of the same colours; and it is for this reason that yellow does not assort so well with mahogany as with a wood of the same colour, but not so deep.

(559.) Among the harmonies of contrast of tone that we can make with wood which we leave of the colour which is peculiar to it, as ebony, its brown colour permits its employment with light stuffs to produce contrasts of tone, rather than contrasts of colour. We can also employ it with very brilliant, intense colours; such as poppy, scarlet, aurora, flame-colour, &c.

(560.) When we employ painted woods instead of those which retain their natural colour, it is better, for a given stuff, to paint the wood of such colour as will best assort with the stuff. For assortments of this kind, I believe we cannot do better than refer to the examples of the assortments of the principal colours with white, black, and grey. (Part II., Prolegomena, § 4. p. 64., and following.)

## Second Case.

(561.) Ebony wood, on account of its brown colour, may be employed with dark stuffs to produce the assortments of analogy. In this case it can be allied with brown tones, and with red, blue, green, and violet. It is scarcely necessary to remark that these assortments prevent our employing with ebony white and yellow inlaying wood, which can be used with more or less

advantage when we employ assortments which enter into the case of harmonies of contrast (559.).

(562.) Frequent use is made of crimson woollen velvet with mahogany. This assortment, which is related to the harmony of analogy, is preferable to many others, by the sole consideration of the great stability of the colour of the stuff, and, consequently, independent of every idea of harmony. This induces me to examine it under several relations, that we may make the best possible use of it, according to the particular aim in view.

When, in assorting crimson with mahogany, we wish to produce the harmony of analogy, in marking out the lines where the wood and stuff touch, we can employ a cord or narrow galloon of yellow, or of golden yellow, with gilt nails; or, better still, a narrow galloon of green or black, according as we wish the border to be more or less prominent.

In assorting the same colours, we are guided by the twofold motive of the stability of the crimson colour and of the beauty of the mahogany; we must necessarily increase the distance which separates the stuff from the wood, by making the black or green stuff of the border wider.

(563.) It is in consequence of the red woods always losing more or less of their beauty by the juxtaposition of red stuffs that we can never ally mahogany to colours which belong to the vivid reds, such as poppy, cherry; and more particularly to orange-reds, such as scarlet, nacarat, aurora; for these colours are so bright, that, in taking away from this wood its peculiar tint, it becomes no better than oak or black-walnut.

## CHAPTER II.

#### ON THE SELECTION OF FRAMES FOR PICTURES AND ENGRAVINGS.

(564.) IF a frame is necessary to a picture, engraving, or drawing, to isolate them from the different objects which are found in their vicinity, it is always more or less injurious to the illusion the painter or designer has wished to produce, when they occupy the place destined for them. It is a fact of which I shall speak hereafter (584.). I only purpose in this chapter to examine the relation of colour which must exist between the frame and the object it surrounds.

(565.) Gilt frames accord well with large pictures painted in

oil, when these latter do not represent gildings, at least so near the frame, as to render it easy for the eye to compare the painted gold with the metal itself.

I will instance a bad effect of this proximity: a Gobelins tapestry after Laurent, represents a genius armed with a torch, near which is a gilt altar, executed in yellow silk and wool, which are entirely eclipsed by the metallic brilliancy of the gilt bronzes profusely spread over the mahogany frame which holds the tapestry. This is one of the most suitable examples for convincing us that the richness of a frame may not only be a fault against art, but also against common sense.

(566.) Bronze frames which have but little yellow brilliancy do not injure the effect of an oil picture which represents a scene lighted by artificial light, such as that of candles, torches, a conflagration, &c.

(567.) When black frames, such as ebony, detach themselves sufficiently from an oil painting, they are favourable to large subjects; but whenever they are used, it is necessary to see if the browns of the painting or drawing which are contiguous do not lose too much of their vigour.

(568.) A grey frame is favourable to many landscape scenes painted in oil, particularly when, the picture having a dominant colour, we take a grey lightly shaded with the complementary of that colour.

(569.) Gilt frames accord perfectly with black engravings and lithographs, when we take the precaution of leaving a certain extent of white paper round the subject.

(570.) Frames of yellow wood, or of a colour called *bois*, accord very well with lithographic landscapes; it is possible to greatly modify the appearance of the design by mounting it on tinted paper, when we do not desire the effect of a white margin.

(571.) The following observations, easily repeated, are very suitable to demonstrate the influence of coloured frames. I took nine proofs, as similar as possible, of the same lithographic subject, having a surface of $10\frac{3}{4}$ inches, by $15\frac{1}{4}$. It was a view of Lake Zurich. They were pasted on cardboards of equal size, and each one introduced into a deal-wood frame of $2\frac{1}{2}$ inches in width; then I introduced into the frame between the lithograph and the wood a border of tinted cardboard of $2\frac{1}{3}$ inches in width, so that the eight proofs were entirely isolated from the wood by a coloured band. I compared each of them with the ninth, which was in a frame isolated from the wood by a white band of $2\frac{1}{3}$ inches in breadth.

P

### Black border.

A vivid diffused light has a great influence in changing the tones of a picture: it weakens them, and we must understand that the light tones, lose more than the half-tones, and the browns still more. The browns which are distant from the border appear blacker than when surrounded by the white border, in consequence of the enfeebling of the tone of the lights and the half-lights near the black border.

If the black does not heighten the red of the lithographic ink, it certainly does not enfeeble it.

### Grey Border.

If it does not enfeeble the lights and the half-tones like the black, on the other hand, it does not heighten them like the white, it imparts to them some red. But a remarkable effect exhibited is a harmony of perspective, if I may so express myself, which takes place neither with black nor with white. The effect of which I speak proceeds in part from the analogy of the grey border with the colour of the lithograph: it is evident that this border destroys in part the bad effect of the frame, which I shall describe hereafter (584.).

### Red Border.

The browns near the border appear lighter, and those which are distant appear deeper, than the corresponding browns with the white border; the whites are whiter; the general effect of the landscape is less red, or greener, with the red border.

### Orange Border.

It produces a contrary effect to grey, relative to the harmony of analogy of the perspective. In fact, the blue which the orange gives to the lithograph enfeebles neither the browns nor the half-tones; but it greatly enfeebles the lights, and gives at the same time more brilliancy to the whites, by destroying the tan (*roux*), or more exactly, the orange contained in this tan-colour (for the tan is but orange or yellow + red + black).

### Yellow Border.

All the browns and the half-tints take more tone than in the white border. The whites acquire a little vivacity by losing some yellow, and a remarkable effect is, the bringing the perspective nearer to the spectator, contrary to the effect of the

grey border, if the daylight is intense; for, in the contrary case, the whites are darkened, becoming lilac.

It is easy to perceive that the violet tint arising from the contrast of yellow neutralises some yellow in the lights, at the same time it heightens the black of the browns from the same cause; and thus brings the perspective nearer; but as the effect of contrast is more evident in a feeble than in a vivid light, the whites of the picture, in order to appear more vivid with the yellow border than with the white one, require that the daylight be sufficiently strong not to tint them with violet.

### Green Border.

It weakens the browns: it reddens the half-tints, the lights and the whites, but the latter more feebly; the whites, in the green border, are less light than in the white.

As with the yellow, the complementary tint of the border is much more apparent when the daylight is less vivid.

The effect of green is agreeable.

### Blue Border.

The effect of this border is most definite, and certainly the most remarkable of all those we can obtain by the juxtaposition of a coloured band with a lithograph. The orange shade to which it gives rise, spreading over the landscape, produces the harmony of a dominant colour (179.), and changes the aspect of the lithograph surrounded by white to that of a drawing in bistre or sepia on india-paper. Doubtless the reddish tint of the lithographic ink, combining with the complementary orange arising from the juxtaposition of the blue, produces the remarkable effect of which I speak. ($70^{ter.}$)

Any one who prefers the effect of sepia upon india-paper to the lithograph upon white paper can change the latter to the former by a simple blue border.

### Violet Border.

The browns near the border lose much of their tone; the half-tints are greener; the whites and the lights are yellower than in the white border.

---

(572.) To conclude; the rule to be followed in assorting a frame to a picture is, that its colour, brightness, and ornaments

also, shall injure neither the colours nor the shadows, nor the lights of the picture, nor the ornaments represented in it.

When we proceed to interpose a border between the frame and an engraving plain or coloured, we must take into consideration —

> 1°. The effect of the height of tone of this border upon the different tones of the design;
>
> 2°. The effect of the complementary of the colour of the border upon the colour of the design;
>
> 3°. The intensity of the diffused light which is considered most suitable to light the design. Because for a given border the mutual relations between the browns, the half-tints, the lights, and the whites, change with the intensity of the daylight, and change more for a given composition with certain borders than with others.

A composition of small or medium size may be painted in such manner that the artist will be obliged beforehand to choose the frame for himself and to paint up those parts of his picture which are contiguous, but in such a way that they shall harmonise with it.

## CHAPTER III.

### ON THE GENERAL DECORATION OF THE INTERIORS OF CHURCHES.

(573.) IN the preceding section I have treated of the employment of colours in architecture under a general point of view, and I have only incidentally enounced my individual opinion upon the colour employed in the interior decoration of Gothic churches, having been led irresistibly to speak of this by the continuous harmony which the stained-glass windows establish, as much as is possible between the exterior and interior decoration. I now return to the subject, no longer to treat of it relatively to a given architectonic form, but to consider it under a general point of view.

Conformably to the principle enounced above (370.), of judging the productions of art by the rules drawn from the nature of the materials employed, I establish two distinct classes of churches, not according to their form, but to a fun-

damental consideration which subordinates the interior decoration to the quality of the light, coloured or colourless, diffused through plain or coloured glass.

### A. *Churches with Stained Glass.*

(574.) From the bad effect of the mutual proximity of white and stained glass (434.), it results that where one is employed in a church the other must be excluded, at least in the nave, choir, — in a word, in all that the spectator can embrace at one point of view, for the colourless glass in some of the chapels of the aisles is of no consequence in the general effect.

(575.) As I have said (553.), if we must have pictures near stained windows, they should be flat, or present subjects as simple as possible, since their effects are entirely sacrificed to those of the stained glass.

(576.) Strictly speaking, we can place pictures in a large church where the light is transmitted through coloured glass; but for the view to be satisfactory, they must necessarily encounter such a union of conditions, that it is a well-founded assertion to say that they will almost always be found out of place, or, what is the same thing, will not occupy a position to be appreciated as if they were placed elsewhere. In fact, if the pictures are not at a certain distance from the glass; if the coloured lights which emanate from them are not, by their mutual admixture, in the requisite proportions for producing white light, or, at least, a very faintly coloured light; finally, if this white or very feebly coloured light is insufficient to lighten the interior of the church properly, as would be in the case of the diffused light transmitted through white glass, the pictures will lose their colour, unless they have been executed with reference to the nature of the light transmitted in a given place by the stained windows; but this case is, to my knowledge, never realised. It is, then, in consequence of the preceding conditions not being met, that in treating of the windows of Gothic churches (436.), I have only spoken of tapestries, and not of the pictures which may be found on their walls.

### B. *Churches with White Glass Windows.*

(577.) Churches with white glass windows harmonise with every ornament we can imagine in the employment of wood, marbles, porphyry, granite, and the metals. Mosaics may ornament the floors and adorn the walls with true pictures, as we see in St. Peter's at Rome; painting in fresco, in oil, plain and coloured sculptures, also combine to ornament the interior.

(578.) In churches of this class, the profusion of riches at the disposal of the decorator, far from being always of advantage to him, is sometimes the cause of difficulties, because the more varied the objects he has to arrange, the easier it becomes for him to depart from the object which it would be necessary to attain, so as to present such objects only as are in keeping with the place he wishes to embellish. It is not enough to have precious woods, marbles, metals, pictures, he must also make these objects harmonise in such a way that the extent of their respective surfaces be in proper proportions, and also pass from one to another without confusion to the contiguous limits; and yet without shocking cultivated tastes.

Thus, he must avoid putting coloured marbles contiguous to the white stone of which the walls are constructed; he must also avoid surrounding bas-reliefs in white stone with slabs or borders of red or green marble.

(579.) The Cathedral of Cologne for churches with *coloured* glass, and St. Peter's at Rome for those with *white* glass, are two types which it will be sufficient to mention, when we wish to demonstrate that beauty is compatible with different systems. Which of these types is to be preferred to the other? This is one of those questions which I consider it idle to attempt to solve absolutely, if we record our admiration to the one on condition of proscribing the other. But if we study it with the intention of examining why either is to be admired, we shall arrive at some satisfactory conclusion upon these works of art.

(580.) In setting out with the principle of the fitness of these edifices to their purpose, I have admitted that the Gothic church, with its architectonic ornaments and stained glass, leaves nothing to be desired on the score of religious sentiment, so admirably adapted is the interior illumination to meditation, so well have the objects we find there been chosen, that, far from distracting the attention by worldly images, they have been well selected for exciting a pious ardour to raise our prayers to heaven.

(581.) Although admiring the marvels which the arts have accumulated in churches where white light freely enters, and although I acknowledge the effects which certain pictures of the first class are capable of producing on the Christian mind, yet I cannot omit remarking, that the churches where we see these decorations resemble museums of art more than temples consecrated to prayer, and that under this aspect they do not appear to me to fulfil in the same degree the conditions imposed by the principle of fitness of edifices to their purpose as Gothic churches with stained glass windows.

## CHAPTER IV.

#### ON THE DECORATION OF MUSEUMS AND GALLERIES.

(582.) WE give the name of museum to those edifices intended to contain products of art, such as statues, pictures, medals, &c., and natural productions, such as minerals, stuffed animals, &c.

(583.) The essential condition which these edifices must fulfil, is, that the light be as white and as vivid as possible; but always diffused, and distributed equally and in the most suitable manner upon all the objects exhibited to the spectator, so that they may be viewed without fatigue, and seen distinctly in every part.

#### ARTICLE 1.
#### *Pinacotheca, or Picture Galleries.*

(584.) There is generally a disposition to prodigality of ornaments and gilding in picture galleries; without pretending that they should be absolutely proscribed as decoration, yet I believe that there is less inconvenience in sinning by omission than by commission; in fact, the pictures are the valuable objects, and it is upon them that we must endeavour to fix the sight, instead of seeking to distract it by various objects more or less brilliant, such as ornaments which by their own splendour, injure the ornaments which the painter has represented on his canvas. Let me add that one of the most injurious things to the effect of pictures is their accumulation, their cramming all together; the position they then occupy being so different from that for which the painters destined them, destroys part of the illusion which each would produce if it was in its proper place. It is only the intelligent connoisseur and amateur who, on seeing a picture exhibited in a gallery, experience all the effect which the artist has wished to produce, because they only know the best point of view, and while their attention is fixed upon the work they are observing, they conclude by no longer seeing the surrounding pictures, and not even the frame of the one they contemplate. If a frame is necessary to isolate a picture from strange objects surrounding it, yet we cannot omit to recognise that the contiguity of the

frame to the picture is exceedingly destructive to the illusion of perspective: and it is this which explains the difference we remark between the effect of a framed picture and the effect of this same picture when seen through an opening which permits us to see neither frame nor limits: the effect then produced recalls all the illusion of the diorama.

## Article 2.

### *Glyptotheca, or Sculpture Galleries.*

(585.) Statues of white marble or stone, as well as plaster casts, stand out well in a gallery, the walls of which are of a pearly-grey colour, and if we would augment the whiteness of the statues by neutralising the red hue the marble, stone, and even the plaster might have, we could then colour the walls with chamois or orange-grey colour.

If, on the contrary, we preferred giving to the statues a warm colour, which many sculptors esteem so highly, the walls must be of blue-grey.

Painted green, they will give to the statues a rosy tint, which is not disagreeable.

As to the tone of their colour, it must be lower, the brighter we wish the sculptures to be, other things being equal.

(586.) When there are bronzes, the colour of the walls of the gallery must be determined by that which we wish to predominate in the statues; because, as is very well known, the metallic alloy of which they are formed is susceptible of yielding two very different tints: one *green*, which is acquired by exposure to the action of the atmosphere; the other the peculiar *golden* tint which it possesses when not oxidised. If we wish to exalt this green tint, the colour of the walls of the gallery must be *red;* while they must be *blue* to bring out the brilliancy of the metallic bronze which has not experienced the action of atmospheric agencies.

(587.) We must not omit to notice that the walls of the gallery must be considered as giving rise to effects of contrast, and not to those of reflection.

## Article 3.

### *Museums of Natural History.*

(588.) If it is allowable to give to the walls of museums a

positive colour, to render the aspect of the statues collected therein more agreeable, it will be very objectionable to do so when it is a question of galleries intended to receive the products of nature; for these latter must appear to the eyes of the naturalist who surveys them for the purpose of studying their physical properties, with the colour peculiar to each individually; consequently the interior of cabinets, glass-cases, and drawers, must necessarily be white, or normal grey very light in tone; for the object is to see the specimens as distinctly as possible, and everything which tends to weaken the light will be contrary to the object we have in view.

(589.) In speaking of museums of natural history, I should reproach myself, if to what precedes I did not add one consideration, which, although foreign to that of colour, belongs nevertheless to my subject, because it treats of the contrast of the simultaneous view of objects which differ greatly in respect to size or volume. We must not place objects of natural history at too great a height, because in such a position it would not be possible to see them easily and distinctly. The conditions for seeing them being fulfilled, it is evident that there must not be too great an interval between the upper portion of the cases, &c. which contain the objects and the ceiling or roof of the edifice; for without insisting upon the inconvenience of the lost space, too great an extent of surface above the cases will have the additional objection of making the objects appear too small, and of giving rise to the idea that they are only temporarily placed there, for we cannot believe it to be premeditated to establish this disproportion between the objects presented to view and the edifice adapted to receive them.

The objections of which I speak will also be increased by great architectonic objects, such as pillars, pilasters, columns, which, attracting the eye by their regular form and symmetrical position, distract the attention from the collection, and diminish the objects contained in it; for when the eyes are directed to these objects they inevitably bring the mind to compare their bulk with that of the great pillars, pilasters, and columns which so readily influence the mind according to *the principles of distinct view, volume, regular and ornamental form, symmetrical arrangement* and *repetition,* by means of which architecture acts upon us through the medium of sight.

## CHAPTER V.

#### THE CHOICE OF COLOURS FOR A THEATRE.

(590.) FROM the importance given to the lighting of a theatre, we might conclude that light colours would generally predominate; for no one can be ignorant how much light such dark colours as blue and crimson require, in order to become illuminated.

(591.) Under the relation of Colour I distinguish four principal parts in a theatre: —

>The interior of the boxes,
>The fronts of the boxes,
>The ceiling,
>The drop-scene and the curtain.

### ARTICLE 1.
### *Interior of the Boxes.*

(592.) The linings of the boxes of a theatre should never be rose-red, wine-red, or light crimson, because these colours have the serious disadvantages of making the skin of the spectators appear more or less green. To be convinced of this truth, it is sufficient to make the following experiment.

Place two half-sheets of paper coloured rose, wine-lees, or light crimson, $o$, $o'$, and two sheets of paper flesh-coloured, $p$, $p'$, as represented in fig. 1. Pl. 1.; in observing them simultaneously, we perceive that $p$ loses much of its rose relatively to $p'$, and that $o$ has become more violet than $o'$; finally, $o$ and $p$ injure each other mutually; a result easily understood, since the two colours losing red, $p$, which has the least, must appear of a greenish-yellow, and $o$, which has the most, will appear more violet.

(593.) If we replace the half-sheets $o$ and $o'$, by half-sheets of a light green, an effect absolutely contrary to the preceding will be observed; that is to say, $p$ will appear more rose than $p'$, and $o$ will appear of a more intense green, more brilliant than $o'$. These experiments, repeated by artificial light, give the same result as by daylight.

(594.) We may conclude, then, that, whenever we would enhance the value of rose complexions by means of a coloured ground, the colour least favourable will be rose, and the most favourable pale green.

(595.) I must remark that the height of tone of the green colour exercises an influence upon the result; for a very deep green, acting by contrast of tone, will so enfeeble the tone of the complexion, that the contrast of colour, properly so called, will be insensible: a deep red, by the influence of analogy, *blanches* the complexion.

ARTICLE 2.

*The Fronts of the Boxes.*

(596.) There are many reasons why the fronts of the boxes have less influence on the complexion than the interiors, which, being usually of a uniform colour, serve, so to speak, as a ground to the faces of the persons occupying the boxes; while the fronts, always painted in colours more or less varied, being more distant from the complexions, would lose much of their influence, if care was taken to cover them with green Utrecht velvet, their borders stuffed with hair: though, whatever it may be, it is, I believe, always well not to choose red for the dominant colour, and to be moderate in the gildings, in order that the gold of the toilet may come out better.

ARTICLE 3.

*The Ceiling of Theatres.*

(597.) The ceiling can only exercise influence upon the audience by reflection. We may put on it, without inconvenience, red paintings and gilding.

ARTICLE 4.

*The Drop-scene and the Curtain*

(598.) What I have said of the ceiling is applicable to the drop-scene and the curtain; yet I must remark that the latter

being more exposed to sight than the ceiling, if it has a red or rose colour, it presents the objection of disposing the eyes to see green as a consequence of successive contrast (79.). A green curtain, on the contrary, disposes the eyes to see rose, and under this relation is preferable to the first.

In the chapter on the dress of females (see the following section), I shall give some original details respecting the influence which the draperies exercise on the complexion, according as they produce the effects of contrast or of reflection.

## CHAPTER VI.

#### ON THE DECORATION OF THE INTERIORS OF HOUSES AND PALACES, WITH RESPECT TO THE ASSORTMENT OF COLOURS.

(599.) AFTER having treated of the conditions which the carpet must fulfil with regard to the dimensions of the apartment it is intended to occupy—of the conditions which must be found in the paper-hangings—of the adaptation of stuffs to the wood of the furniture—of the adaptation of pictures, engravings, &c., to their frames—I shall next consider the mutual relations of the different articles of furniture of an apartment in their respective colours.

(600.) The following is the order in which I shall examine the matters which are the object of this Chapter:—

> 1st *Paragraph.* Concerns the adaptation of colours relatively to the interiors which we wish to decorate with tapestry or paper-hangings.

> It comprehends the following articles:—
>> 1st. The wainscoting, mounted with its cornice, or moulding.
>> 2nd. The tapestry or hangings, commencing at the moulding, and terminating at the cornice of the ceiling.
>> 3rd. The cornice of the ceiling.
>> 4th. The chairs placed against the wainscoting.
>> 5th. The window-curtains; and, if it is a sleeping apartment, the bed-curtains.
>> 6th. The doors.

7th. The windows.
8th. The carpet.
9th. The pictures.

2nd *Paragraph.* Concerns the adaptation of the colours relatively to interiors, the walls of which are panneled or covered with marble, stucco, or ornamented with paintings on wood, stone, or plaster.

It comprehends the following articles:—

1st. Wainscoted interiors.
2nd. Interiors covered with marble.
3rd. Interiors covered with stucco.
4th. Interiors of painted wood, stucco, stone, &c.

§ 1.

ON THE ASSORTMENT OF COLOURS IN CONNECTION WITH THE DECORATION OF INTERIORS, INTENDED TO RECEIVE TAPESTRY OR PAPER-HANGINGS.

ARTICLE 1.

*The Wainscoting.*

(601.) Wainscotings are used more particularly to conceal the walls, to preserve the furniture from damp on the lower stories (in which case they receive paint, which could not be durably applied on a humid wall); finally, they are used to preserve the hangings from the blows of the chairs, or more generally from the blows of the furniture placed before it.

Hence, the height of the wainscot from the floor should be exactly that of the chairs.

In this way, the hangings are protected from injury; and besides, the border of the hangings will not be hidden from sight, as happens when the chairs rise above the wainscot, a very common defect in modern apartments, which is doubtless owing to the fact that builders, requiring in a house of given height as many stories as possible, compel the architect to reduce the height of the rooms, which creates the necessity of reducing the height of the wainscoting; thus, in diminishing that of the hangings, we augment to the eye the defect of proportion in the story.

(602.) Now-a-days, except in old mansions, we seldom meet

with wainscoting rising above the chairs and other furniture, which it is usual to place before them. The sight of the upper part of the wainscoting is so little agreeable, that it shocks some persons, who cannot perceive the bad effect of a wainscoting which the chairs rise above. This feeling arises, probably from the fact that the furniture should be more valuable than what it conceals, and that a piece of furniture taller than the wainscoting appears more distinct to the sight than when we see a wainscoting above it with which it has more analogy than it has with the hangings. Finally, the portion of the wainscoting which exceeds the furniture in height, considered relatively to the part concealed, offends the principle *of distinct view* more than the part of the hangings which is uncovered relatively to that which may be concealed by a piece of the furniture.

(603.) From this fact, that the wainscotings are generally concealed by the furniture placed before them, we may conclude that they must be of a dark, rather than of a light colour, and that if they have ornaments, these must be simple, and not prominent. The wainscoting may be considered as serving as a ground to the furniture, whenever it is not entirely concealed by the latter. We shall see hereafter what colour is necessary to be given them that they may suit their purpose.

Article 2.

*Hangings.*

A. *Hangings properly so called.*

(604.) In consequence of an apartment never being too lights since we can diminish the daylight by means of blinds, curtains, &c., and, on the other hand, when night brings the most vivid and economic light, other things being equal, it is necessary, on that account, for the hangings to be of a light and not of a dark colour, so that, in place of absorbing light, they reflect much of it.

1. *Hangings of a uniform Colour, including Paper-hangings* (447.).

(605.) We proscribe all dark hangings, whatever be their colour, because they absorb too much light; we proscribe also, red and violet hangings, because they are exceedingly unfavourable to the colour of the skin.

It is for this latter reason that we reject the light tones of the red and violet scales.

Orange is a colour that can never be much employed, because it fatigues the eye too much by its great intensity.

Among the simple colours, there is really scarcely any which are advantageous except yellow and the light tones of green and of blue.

Yellow is lively: it combines well with mahogany furniture, but not generally with gilding. I say generally, because there are some instances where this alliance can be made (615. and 629.).

Light-green is favourable to pale complexions as well as to rosy; to mahogany furniture and to gilding.

Light-blue is less favourable than green to rosy complexions, especially in daylight; it is particularly favourable to gilding, and it does not injure mahogany, and associates better than green with yellow or orange woods.

(606.) White or whitish hangings of a light grey (either normal, green, blue, or yellow), uniform or with velvet patterns of the colour of the ground, are also good for use.

(607.) When we choose hangings upon which to place a picture, they must be uniform, and establish the greatest contrast possible between its colour and that which predominates in the picture, if the hangings are not of normal grey. I shall speak again of this assortment (640.).

2. *Hangings presenting a pure Colour with some White, or several Tones belonging to the same Scale or to neighbouring Scales, including Paper-hangings of the second Category* (447.).

(608.) All that I have said of hangings of uniform pure colours is applicable to hangings in which one of these colours is allied to white, with this exception, however, that these latter evidently reflect more light with equality of tone, and that they are not so suitable for pictures, whenever their tone is light. Besides, among effective hangings of this kind, there is scarcely any other than ticking or the papers which imitate it, in which the colour allied with white is darkened, and it is well known that these latter hangings are intended for places which do not admit of pictures.

(609.) Hangings in the best taste are those —

1°. Which present designs of a light tone, either normal or coloured grey, upon a white ground, or the reverse, and in which the pattern is at least equal in

extent of surface to the ground ; for a small pattern has a very mediocre effect, at least in a large room.

2°. Patterns of two or more tones of the same or of very near scales assorted conformably to the Law of Contrast.

(610.) Unfortunately, it is only stained papers which present hangings of a clear grey or of very light colours, because the fabrics we would tint with light tones of the colours we recommend would not resist the decolouring atmospheric agencies sufficiently, to enable us to employ them economically, so advantageously as paper-hangings.

3. *Hangings with varied and brilliant Colours, representing Flowers, Insects, Birds, Human Figures, Landscapes, comprehending Paper-hangings of the first Category* (447.).

(611.) I have no remark to make on these hangings, which are generally either painted canvas or stained papers, except that they have been employed in decorating large apartments ; and what we call *chintzes* are only suitable to small rooms, such as cabinets, boudoirs, &c. In every case these hangings, in consequence of their vivid colours and their patterns being more or less complex, do not admit of pictures ; and moreover, inasmuch as hangings with landscapes and human figures should exhibit themselves distinctly to the sight in all their extent, they must therefore not be concealed by the furniture in any of their parts.

B. *Borders to Hangings.*

(612.) When we proceed to adapt a border to a monochromous hanging, or to one presenting a dominant colour, we must first determine whether we can have recourse to a harmony of analogy or to a harmony of contrast; in all cases the border ought to detach itself more or less from the hangings which it is intended to circumscribe and separate from contiguous objects. I will now examine the borders most suitable to the three groups of hangings which I have previously distinguished (447.).

1. *Borders for Hangings of a Uniform Colour* (605.).

a. *Hangings of a Uniform pure Colour* (605.).

(613.) Harmony of contrast is the most suitable to papers of a uniform pure colour, such as yellows, greens, and blues, consequently we recommend for the dominant colour of the border the complementary of that of the hangings, whether this border

represents ornaments, arabesques, flowers, or imitations of stuffs, either fringes or tissues. But as every contrast of colour ought not generally to offer at the same time a contrast of tone, then the general tone of the border must only surpass that of the hangings by the number of degrees necessary to avoid a deadening effect in the assortment. If a double border is required,— for example an interior border of flowers, and an exterior border, — the latter must be of a much deeper tone than the other, and must always be smaller.

(614.) Among the colours suitable for borders we recommend the following as harmonies of contrast: —

    1°. For yellow hangings, violet and blue mixed with white; when it is the question of a fringe, of flowers garnished with their leaves, or of ornaments.

    2°. For green hangings, red in all its hues, in fringes, flowers, or ornaments; the painted gilt-yellows upon a dark red ground; the borders of brass.

    3°. For white hangings orange and yellow; whether in fringes, flowers, or ornaments; the borders of brass: these are much better on blue than on green.

(615.) Among the harmonies of analogy, I recommend the following: —

For yellow hangings, a border of brass (629.).

b. *White or Whitish Hangings of Normal Grey, Pearl Grey, or very pale coloured Grey, of a uniform Colour, or with a Velvet Pattern of the Colour of the Ground* (606.).

(616.) Papers of this kind admit of borders of all colours, but we must nevertheless avoid too great a contrast of tone in a border where we find one or more pure colours; for the intense tones of blue, violet, red, green, are too crude to combine with the light grounds of which we speak.

Borders gilt by means of gold-leaf or of brass accord well with these grounds, especially with the whites or the grey whites.

If a grey presents a tint of green, of blue, or of yellow, we may use borders of the complementary of these tints taken many tones above, or of a grey, deeply tinged with this same complementary.

(617.) Among the harmonies of analogy, we may take for grey hangings borders of some tones higher than they are, and of a grey which may contrast with their tint but very lightly.

2. *Borders for Hangings which present a pure Colour with White, or many Tones belonging either to the same Scale or to contiguous Scales* (608. and following).

(618.) All that has been said on the assortment of borders with hangings of a uniform pure colour (613.) is applicable not only to the assortment of borders to hangings where a pure colour is combined with white, but also to the assortment of borders to paper of many tones of the same scale or of neighbouring scales.

(619.) As to the assortment of the border with colours presenting white or grey patterns, I must refer to what has been said above (616.)

3. *Borders for Hangings of varied and brilliant Colours, representing Flowers, Insects, &c.* (611. and following).

(620.) For the most simple hangings of this sort, *chintzes*, we must have analogous borders.

> For hangings which present larger patterns than chintzes, and which are repeated like those of these latter, a binding of galloon suffices.

(621.) Hangings with human figures, landscapes, in a word, all those which are pictures, require a frame either of painted, gilt, or bronzed wood, or, better still, a border imitated by painting.

### *Colour of the Wainscoting relatively to the Hangings.*

(622.) After speaking of the height of the wainscoting, I said (603.) that I should return to speak of the colour most suitable to it. But before treating of particular cases, I must distinguish two general cases, according to whether the assortment of the hangings with the border enters into the harmonies of contrast of colour, or whether it enters either into the harmonies of contrast of scale or of contrast of hues, or into the harmonies of analogy.

---

1st Case.— *The Assortment of the Hangings and the Border enters into the Contrast of Colour.*

(623.) The colour of the wainscoting, or its dominant colour if it is of several tints (which must generally be more or less approximating), may be—

> 1°. The same as that of the border, but a little darker, and especially more or less broken with Black;

SECT. II. CH. VI.] TAPESTRY AND PAPER-HANGINGS. 227

    2°. Grey lightly tinted with the colour of the border, and taken at the same tone or very near it;

    3°. The complementary of the colour of the hangings, in the case where the dominant colour of the border, although contrasting with that of the hangings properly so called, is not its complementary. If we employ a complementary lightly broken with Black, the moulding must be picked out in Brown on the tints of the border and the wainscoting;

    4°. A Grey complementary to the colour of the hangings, always in the case where the border is not of the complementary of the hangings;

    In the four preceding cases, we bring out upon the colour of the hangings properly so called, that of the wainscoting, which we always tarnish more or less. By this means the colour of the hangings and the wainscoting are agreeably harmonised, and the border suitably separates these two parts, in contrasting the colour with the hangings, and in contrasting brilliancy and tone with the wainscoting;

    5°. A normal Grey of many tones, with which we may combine White.

(624.) Without absolutely proscribing the assortment where the colour of the wainscoting is the same as that of the hangings, but duller or deeper, yet I should say that in general it has a poor effect, and this arises particularly from the fact, that the colour of the border, which contrasts with that of the hangings and of the wainscoting, is in too feeble superficial proportion relatively to the other; and this defect is much more striking when the tone of the hangings and of the wainscoting is higher.

2ND CASE.— *The Assortment of the Hangings and the Border enters either into the Harmonies of Contrast of Scale or of Contrast of Hue, or into the Harmonies of Analogy.*

(625.) The colour of the wainscoting, or its dominant colour, if it is of several tints, which must generally be more or less approximating to each other, may be —

    1°. The complementary of the colour of the hangings, but more or less broken, and a little deeper;

2°. Grey complementary to the colour of the hangings;

3°. A colour which, without being complementary, contrasts with that of the hangings;

4°. Grey, tinted by a colour which, without being complementary to that of the hangings, contrasts with them.

(626.) When the hangings are white, or of an extremely feeble tone of colour, and the border does not stand out very strongly by its colour, we may make a harmony of tone or of hue with the tint of the wainscoting. For example, white, or nearly white hangings, with a gilt or brass border, harmonises well with a wainscoting which differs only by some tones more of the colour of the hangings, whether that colour belongs to the same scale or to a neighbouring scale.

### Article 3.

#### *Cornice of the Ceiling.*

(627.) The cornice of a white ceiling must be of light colours, and but little varied. In general, it is for the painter to see what colours are most suitable, which must besides not accord with those of the hangings, but with the tints of the wainscoting. He must carefully avoid having white parts which can be confounded with the ceiling, if that is white, and, on the other hand, of colours too distant from each other, as regards the height of tone, and of their respective scales; in a word, we must particularly avoid whatever will cause too much difference between the parts of the whole. When the hangings are white, or of a very pale grey, with a gilt or brass border, the cornice may present ornaments of the same material, and in this case they may stand upon a white, or upon a grey, a little deeper than that of the hangings.

### Article 4.

#### *Chairs placed in front of the Wainscoting.*

(628.) We must also, in this circumstance, distinguish the general case where we can have harmony of contrast of colour, and that where we can have harmony of contrast either of scale or hue, or harmony of analogy.

### 1st General Case.— *Contrast of Colour.*

(629.) The colour of the covering of chairs should be complementary to that of the hangings, properly so called, or, more generally, the same as that of the border, because this may be different from its complementary and contrast, nevertheless, with the tint of the hangings. We see, then, that in the general case which occupies our attention the chairs contrast with the hangings, as may also the wainscoting; but the colour of the chairs being pure, it will also be purified by that of the wainscoting, which, with this motive, we have advised to be deadened.

There are a few remarks to be made: —

    1°. The case of clearest contrast, *i. e.*, where the colours of the hangings and the chairs are complementary,— is the most favourable to distinct vision, as well as to successive contrast, whenever we observe separately the hangings, and afterwards look at the chairs separately, and *vice versâ*.

    2°. In the case where the colour of the hangings and of the chairs contrast without being complementary, we must take into consideration the degree of *light* inherent in the colour of the hangings. For example, if they are Blue, and the border is Yellow, the covering of the furniture being Yellow of a shade more golden than citron, this stuff must be of a much higher tone than the Blue tone of the hangings, and the tone of the wood of the chairs, &c., must be still higher than the Yellow, to avoid a dull appearance.

    3°. We may border the stuff at the parts contiguous to the wood, either with well assorted dark colours, or with the same colour as the hangings, but of a higher tone: there is also a means of harmonising the hangings and the furniture in uniting the same colours, but in inverse proportions.

    4°. When, instead of sofas, arm, and other chairs, there is a *divan* which entirely conceals the wainscoting, we must take the complementary colour of the hangings, and in this case it is more advantageous that the colour of the border, instead of being complementary to that of the

ground, forms with it a contrast of scale or of hue. It is in this circumstance particularly that yellow hangings bordered with brass in relief (615.), with a violet-coloured divan, will produce an excellent effect, at least by daylight; for we must not forget that Yellow, as well as Violet, loses in artificial light.

5°. We regard as harmony of contrast of colour light hangings of a pure colour with furniture of a Grey, the colour of which is very sensibly complementary to that of the hangings.

2ND GENERAL CASE.—*Contrast of Scale, or of Hue; Harmony of Analogy.*

(630.) The arrangements which enter into this general case will concern rooms differing in dimensions, and, according as they belong to the lively or grave harmonies, they will concern rooms of very different destinations.

### 1. *Bright Assortments.*

(631.) In small rooms — such, for example, as boudoirs, where the hangings are bright — a harmony of contrast of hue, of scale, or a harmony of analogy, is generally preferable to a harmony of contrast of colour, if the hangings are uniform, or if they have a dominant colour: but if it has a decided colour allied to white, as ticking, a watered stuff, or better, if it presents patterns of various colours, such as *chintzes,* the furniture most suitable will be a divan of the same material as the hangings; and we may remark that it is conformable with the object of boudoirs, or of similar places, to diminish apparently their extent to the eye, by employing only one material for the hangings and the chairs, intead of seeking to fix the eye upon distinct objects.

(632.) In large rooms there is an arrangement of good effect,— viz. white, or grey almost white, hangings with furniture of a pure colour, such as red, yellow, green, blue, and violet. When we employ these pure colours, we must only heighten the tone of that which is suitable to avoid a faded appearance. Sky-blue is the most suitable for this arrangement; crimson, which is also employed, is too harsh, especially if the room is neither very large nor well lighted.

### 2. *Grave Assortments.*

(633.) Assortments of this kind belong to places devoted to

quiet meetings, such as libraries, museums, studies, &c. In general, the smaller the place, or, what comes to the same thing, the less space there is to receive the hangings, the more the assortment must enter into the harmony of analogy.

The tapestry or the hangings must present only normal grey, or a grey of a colour more or less broken; the chairs must be black or of a dark grey, either normal or coloured; and in this case we can take a grey tinted with the complementary of the colour of the grey of the hangings. If more contrast is desired, we can have recourse to the brown tones of this complementary of the colour which tints the grey of the hangings.

### Article 5.

#### Window- and Bed- curtains.

(634.) The window-curtains, and those of the bed, if it is a sleeping chamber, are similar to each other: they require —

    1°. To be White, of silk or of embroidered muslin;
    2°. To be coloured;
    3°. To be composed of a White and a coloured curtain.

Let us now see, when the curtains are not White, what colour is the most suitable. I distinguish two general cases, comprehending many particular ones.

1st General Case.—*The Chairs have a decided Colour, such as Red, Yellow, Green, Blue, or Violet.*

    (*a*) *Particular Case.*—The hangings have a pure colour, contrasting favourably with that of the chairs.

    The curtains will generally be of the colour of the chairs, and their borders will be of the colour of the hangings.

    (*b*) *Particular Case.*—The hangings are not of a pure colour.

    The curtains will be —

    1°. Of the colour of the chairs;
    2°. Of the colour of the hangings with a border of the colour of the chairs.

2ND GENERAL CASE.—*The Chairs are Grey, or of a very broken Colour.*

(a) *Particular Case.*—The hangings are of a decided colour.

The curtains will be —

1°. Of the colour of the chairs, with a border of the colour of the hangings;

2°. Of the complementary of the hangings, or of a colour contrasting favourably with them; the colour of the border will be that of the hangings.

(b) *Particular Case.*—The hangings of a Grey colour or White.

The curtains will be —

1°. Of the colour of the chairs;

2°. Of a pure colour, which will assort the better with the Grey of the hangings, in proportion as it is complementary to the colour of the Grey, if this latter does not belong to the scale of normal Grey.

ARTICLE 6.

*Doors.*

(635.) The doors, by their use, size, and position relative to the plane of the wall, being absolutely distinct from the wainscoting, should be distinguished from it by their colour, notwithstanding the contrary practice of painters, who make them the same.

(636.) We should paint their different parts in many low tones of the same, or of approximating scales, and always according to the harmony of analogy, because it is a question of the parts of one object. The colour of the doors should be of normal grey, or of a grey tinged with the colour of the hangings or of its complementary, which will thus always unite with the hangings, either by harmony of analogy or by harmony of contrast. It is particularly through the clearness of the tones or of the hues that the doors will be distinguished from the wainscoting. The door-frame should be darker than the door itself.

## ARTICLE 7.
### *Windows.*

(637.) The windows should be like the doors, according to a rule which has been generally observed for a long time. The fastenings must be black, bronzed, or of brass.

---

## ARTICLE 8.
### *Carpets.*

(638.) From what I have said of the distribution of colours in carpets intended for large apartments, as those of mansions (420.), it is clear that, whatever may be the dominant colours of the subjects represented in their central part, under the relation of brilliancy and contrast, they will always be separated from the chairs by an interval sufficient to prevent discord with the colour of these latter, and the one will not be injured by the other.

(639.) As for the carpets of small rooms, or those of moderate size, we must distinguish two cases relatively to the colours of their furniture.

> 1$^{st}$ *Case.* The more numerous the furniture is, the more numerous and vivid these colours are, the more we must control their brilliancy; and the carpet most suitable will be one of simple colours and pattern. In many cases an assortment of Green and Black will have a good effect.
>
> 2$^{nd}$ *Case.* If the furniture is of a single colour or of many tones, either of the same colour or of approximating scales, we can, without detriment, employ a carpet of brilliant colours, and thus establish a harmony of contrast between them and the dominant tint of the furniture.
>
> But if the furniture is of mahogany, and we wish to bring out its colour, then we must not have either Red, Scarlet, or Orange, as a dominant colour in the carpet.

In a word, in the first case, to get the best effect of the colours of the furniture, the colours of the carpet must enter into the harmonies of analogy more or less sombre; while, in the second, where harmony of contrast of colour does not exist in the

furniture, we can, if we choose, have recourse to this harmony in the carpet without inconvenience.

### Article 9.
#### *Pictures.*

(640.) Whenever we would place pictures on hangings, the latter must be of a single colour, or of two very similar colours, if they are not tones of the same scale. Besides, the pattern of these hangings of two neighbouring colours, or of two tones of the same scale, must be as simple as possible. Finally, whenever we place a picture on coloured hangings, for the effect to be supportable, we must always take care that the dominant colour of the hangings be complementary to the dominant colour of the picture.

(641.) Engravings and plain lithographs must never be placed beside oil paintings or coloured drawings.

(642.) Pearl grey, or normal grey a little deeper, is a good tint to receive engravings and plain lithographs in gilt or yellow wood frames.

(643.) Yellow hangings can receive with advantage landscapes in which green grass and leaves and a blue sky predominate. The most suitable frames in this case are those of violet ebony (*Palixandre*), or wood painted grey or black. Gilt frames have not a bad effect on the picture, but the gold of the frame and the yellow of the hangings do not contrast sufficiently to most eyes.

(644.) Oil-paintings in gilt frames are effective on hangings of olive-grey, more or less deep, according to the tone of the picture. The carnations and the gold assort well on a similar ground. Papers of a deep green, and even of a deep blue, may also be advantageously employed in many cases.

### § 2.

ON THE ASSORTMENTS OF COLOURS IN INTERIORS, THE WALLS OF WHICH ARE PANELLED OR COVERED WITH MARBLE OR STUCCO, OR DECORATED WITH PAINTED WOOD, STONE, OR STUCCO.

### Article 1.
#### *Panelled Interiors.*

(645.) If we seek to explain rationally the use of panelling

the walls of interiors from top to bottom, and leaving the surface of the wood apparent, we find it arises from the necessity of preserving the walls from the humidity and cold which would result from the contact of our organs with the stone; and also in the intention of showing to persons who meet in a panelled room that this object has been accomplished.

(646.) Panelled apartments were much more common in past times than they are at the present day; which we must not be surprised at when we consider, on the one hand, the cost of a suitable wood, and the necessity of a clear day to light a panelled room, for the surface of a costly wood is generally sombre;— and, on the other hand, the present taste for decorations more or less charged with ornaments, which it is so easy to satisfy by means of paper-hangings, tissues, and other accessories. In spite of this direction of taste, I think there is also in large suites of apartments two rooms to which a panelling more or less finished will be very suitable: these are the dining and the billiard-rooms, where we meet with any other aim than that of conversation, or of exhibiting an elegant toilette. The scene being, as it were, concentrated on the dining or billiard tables, there is no cause to distract the attention by clothing the walls with varied ornaments. In the case where an interior is panelled, the floor should be parqueted; for a pavement of tiles, stones, or marbles will be out of keeping.

(647.) The colour of the curtains for panelled interiors must be chosen conformably to the preceding principles. For example —

>White curtains will heighten the tone of the woodwork;
>Blue curtains will bring out the golden tint of many woods, especially of polished oak.

## Article 2.

### *Interiors covered with Marble.*

(648.) It is only ground-floors, halls, great staircases, and galleries (which, although covered, are exposed to injury from the air entering by various openings), bath-rooms, dining-halls, and billiard-rooms,— that can be covered with marble.

The marble well preserves the interior it covers from the humidity derived from the earth, which penetrates by the capillary attraction of the walls; but the sensation of *cold*

which we experience upon touching it, is so identified in our minds with its very aspect, that a large surface covered with marble appears chilling, and is in contradiction with us whenever we require warmth. If marble perfectly suits a bathroom, it cannot be rationally employed in dining or billiard-rooms, except when these rooms are placed under such conditions as require coolness.

(649.) We can arrange marbles together on the principle of harmony of contrast or of harmony of analogy. Bronze adapts itself very well. I must remark, that, if we would also add granite and porphyry, the lower layers must be composed of these latter; we can use them as wainscotings, on account of their greater durability and stability under the influence of atmospheric agencies.

(650.) Curtains are not suited to marbles: blinds are preferable to them.

### Article 3.

#### *Interiors covered with Stucco.*

(651.) Stucco is generally prepared to imitate marble. Wherever the latter is employed, stucco can be also; only it does not so well resist atmospheric agencies.

(652.) We can ornament stucco imitating white marble, with landscapes, flowers, fruits, &c., by means of a process which consists in incorporating, while it is soft, pastes of various colours, which are placed together as in the elements of a mosaic (429.) I believe, conformably to the manner in which I have regarded marble in the decoration of interiors, that the stucco should be made to imitate mosaic rather than painting.

### Article 4.

#### *Interiors covered with Wood or any kind of Coating painted in several Colours.*

(653.) The painting we can put on a wainscot which is not fine enough to be seen uncovered, or, more generally upon a surface of any kind, has for its object the—

    1°. Imitation of hangings, properly so called;
    2°. Imitation of a wood more or less costly;
    3°. Imitation of marble.

I have nothing in particular to say concerning these three kinds of imitation, considered either under the relation of association of colours employed in their decoration, or in considering the suitability of the places relatively to the preference which we must accord to one of them over the other, because this would be a repetition of what has been developed already in this chapter.

(654.) But there is a kind of decorative painting of which I must say a few words, — viz. arabesques upon a white or pale grey ground. It is common in galleries, ball-rooms, large saloons, and also in bed-chambers. When we decorate with arabesques places which require to be warmed, we must endeavour to imitate pictures rather than mosaics.

(655.) The more carefully arabesques are executed, the more variety they will present in their forms and colours, and the less we must seek to make them resemble draperies with which they are associated; thus, white curtains, with a simple and, at the same time, ample border, or curtains of a slightly elevated tone of colour, or of an extremely simple design, should have the preference over curtains which are related to arabesques by their vivid colours, by varied patterns, or by a striking colour; in a word, the colour of the curtain, if it has any, must be sacrificed to that of the arabesques.

# SECTION III.

## APPLICATIONS TO CLOTHING.

INTRODUCTION (656.).
CHAPTER I.—MEN's CLOTHING (657—680.).
CHAPTER II.—WOMEN's CLOTHING (681—730.).

## INTRODUCTION.

(656.) In explaining the applications of the law of contrast which form the subject of this Section, my intention is, in the instance of male clothing, to treat principally the question of the association of colours in military uniforms, as a matter of state economy; and in the case of female clothing, of deciding the question of the associations which are most suitable when sitting for a portrait. The first question is entirely one of administrative economy; the second belongs solely to the domain of art.

Under the latter relation, I shall attain the aim proposed, if, in the views set forth, the portrait painter finds the means of selecting associations of colours which, by imparting to his works more brilliancy and harmony, render them thereby less susceptible of appearing antiquated when the prevailing fashion of his time is forgotten.

Some readers may suppose, that, having already treated * of many particulars of portrait painting, I ought to have then considered the question just referred to: my motive for doing otherwise was, that in the section *On Colouring*, if I could not omit mentioning this branch of painting, it was without giving the developments into which I am now about to enter, because not only would they have been out of proportion with the rest of the subject, but also certain details would not have been sufficiently elucidated, as I hope they will be by many facts which I have spoken of only in that part of the work which follows the section *On Colouring*.

## CHAPTER I.

### MEN'S CLOTHING.

(657.) It is a fact known to many persons that a uniform composed of cloths of different colours may be worn much longer

* Second Part, 1st Division, Section 3rd.

and appear better to the eye, although nearly worn out, than a suit of a single colour, even when this latter is of a piece of cloth identical with one of those composing the first. The law of contrast gives the reason of this fact perfectly, as I shall show in the following article, in demonstrating the advantage of the assortment of colours for military uniforms in an economical relation.

§ 1.

OF THE ADVANTAGES OF CONTRAST CONSIDERED WITH REGARD TO THE OPTICAL STRENGTHENING OR PURIFYING OF THE COLOUR OF CLOTHS FOR CLOTHING.

ARTICLE 1.

*Of Uniforms, the Colours of which are complementary.*

(658.) Let us suppose a uniform of Red and Green, like that of many regiments of cavalry; by the law of contrast, the two colours, being complementary, mutually strengthen each other; *the Green renders the Red redder, and the Red renders the Green greener.* I suppose the augmentation of colour resulting from contrast to be one tenth for each of the cloths, the colour of which, seen separately, is represented by unity; by means of the juxtaposition each colour becomes then equal to $1 + \frac{1}{10}$; I suppose also that a dress made simply of green or of red cloth, after having been worn a year, has lost one tenth of its colour; it is evident that a uniform composed of green and of red cloth, after being worn for the same length of time, will not appear to the eye formed of two cloths which will have lost each one tenth of their original colour, since *the Green gives Red to the Red, and the Red gives Green to the Green*; and if we do not admit that the strengthening is precisely equal to one tenth of the original colour, nevertheless observation proves that the real fraction which expresses it is not far from that, so that if, on the supposition I have made, we cannot say that at the year's end a piece of a bi-coloured uniform exhibits cloths which have exactly the same colour as that of each new cloth seen separately, yet we are obliged to admit that the difference is small; I forgot to say that the two colours are taken at the same tone.

(659.) This reasoning applies to bi-coloured uniforms, of which the colours, as Orange and Blue, Violet and Greenish-yellow, Indigo and Orange-yellow, are complementary to each other; only we must take into account the difference of tone more or less great that may exist between them, when they are

not taken at the same tone, as I have supposed in the preceding example.

(660.) Deep Orange and Blue are susceptible of making a good uniform; but the blue cloth must not be too deep to combine favourably with the bright Orange.

(661.) Violet and Greenish-Yellow, as deep as possible, such as can be obtained from *woad*, are susceptible of forming a fine uniform for light cavalry. The only objection is to the violet colour, which is durable only when it is the result of the mixture of the vat of cochineal and indigo blue, and when it is taken at a certain height of tone.

## ARTICLE 2.

*Uniforms of which the Colours, without being complementary, are nevertheless very contrasting.*

(662.) Among the colours which are not mutually complementary, but of which the contrast is agreeable, and consequently advantageous for uniforms, I shall cite particularly Blue and Yellow, Blue and Scarlet, Green and Yellow.

### Blue and Yellow.

(663.) These two colours accord well together; the Blue gives an Orange tint to the Yellow, much more evident when the tone of the latter is higher, and that of the Blue is lower. In its turn, under the same conditions, the Yellow communicates to the Blue a Violet tint, which brightens it; if the Blue has a disagreeable Green tint, the Yellow neutralises it; but if there exists a great difference of *tone* between the two colours, the contrast arising from this difference might go so far as to render insensible the effect resulting from contrast of colours; and besides, up to a certain point, the deep Blue will appear Black or less Violet, as the Yellow, in weakening itself, may appear Green.

### Blue and Scarlet.

(664.) Deep Blue and Scarlet-Red make a good assortment for a uniform; the first, by its Orange complementary, gives more fire to the Scarlet-Red, and this latter, in adding its complementary, Greenish-Blue, to the deep Blue, brings it up to Blue, properly so called; for we must not forget that deep Blue tinted with Indigo or Prussian Blue, is rather Violet than pure Blue.

In this assortment is included the uniform of Indigo-Blue and Madder-Red of many regiments in the French army. There is no doubt, that for show, a lighter Blue and an Orange-Madder purer, and consequently less dull and less rosy than the actual colours, would be preferable, if no White enters into the uniform.

### Green and Yellow.

(665.) Green and Yellow form an association pleasing to the eye by its gaiety, which especially suits a cavalry uniform. But it should be remarked, that to obtain the most suitable assortment, the Green must be lighter and yellower than that which accords well with Red, for the twofold reason that the Yellow which is in juxtaposition with Green, neutralising by its Violet a portion of the Yellow of the Green cloth, exalts the Blue, and consequently removes some of the brilliancy of the Green; besides, this effect constantly tends to increase, because the Yellow of the green cloth is sooner altered than its Blue. On the other hand, the yellow cloth receiving some Red by its juxtaposition with Green, it must not be taken too Orange.

This case may serve as an example, — in opposition to that where I have cited the assortment Green and Red complementaries, with the intention of demonstrating the economical advantage of assortments of contrast of colour in general (658.), to make us clearly comprehend that in the assortments of colours suitable to military uniforms, a good selection is much more difficult to make the further it is removed from the contrast of complementaay colours.

### Article 3.

### *Of a Uniform composed of a Single Colour and White.*

(666.) After the remarks I have made on the increase of tone that the juxtaposition of White gives to colours (52.), and from the order that I have established between the assortments of Blue, Red, Yellow, Green, Orange, and Violet with White (185.), I have but little to add upon uniforms presenting these associations. We must not lose sight of the fact, that at the same time the colours are heightened, their respective complementaries ally themselves to White, and produce effects the more evident, other things being equal, the higher the tone of the colours is taken. If the White is reddened, the juxtaposition of Blue will augment the tint; that of Violet will lighten it by yellowing it; that of Green will exalt the red colour; finally, that of Yellow, and especially that of Orange, will enfeeble it.

(667.) A white uniform has a good effect, not only when white trousers are worn with a white coat, a white coat with the collar and facings of a pure colour suitably chosen, but also when trousers of a light colour are worn, for example, sky-blue with a coat white or faced of the same colour as the trousers, or of a colour which will suitably accord with them. Finally, white trousers associate well with a coat of one colour.

### ARTICLE 4.

*Of a bi-coloured Uniform, into which White enters.*

(668.) White, associated with two colours to compose a uniform-coat, produces a really good effect only with blue and orange, blue and red. It has a weaker effect with green and yellow, and with blue and yellow: this is, however, as we might expect from what I have said of associations of two pure colours with white (185. and following).

(669.) If white does not associate equally well with two colours to form a coat, it has always a good effect when it is worn as trousers with a bi-coloured coat. For example, with a light or dark-blue coat and orange; with a light or dark-blue coat and red, with a sky-blue coat and yellow, with a green and red coat, and with one of green and yellow.

Nothing is better suited to demonstrate the advantage of white associated with blue and with red than the difference we remark between a dark-blue coat and madder-red trousers, worn without white leather facings, and the effect of the same uniform worn with these latter.

### ARTICLE 5.

*Of a bi-coloured Uniform, into which Black enters.*

(670.) Black is susceptible of entering advantageously into the composition of many uniforms composed of two bright colours; such as Red, Scarlet, Orange, Yellow, bright Green, for example; a plain scarlet coat, or one with facings of a yellow more green than orange, or also of a green, or of a delicate blue, accord perfectly well with black trowsers.

Finally, black trousers may be associated with sombre colours in uniforms which are not required to be visible from a distance.

## ARTICLE 6.

*Of a Uniform in which there are more than Two Colours, not comprising either Black or White.*

(671.) If we can put three colours into a uniform, particularly red, blue, and yellow, without producing a bad effect, nevertheless I give the preference to bi-coloured uniforms, with which white or black are suitably associated; and I also seize this occasion to remark, that if the sight of many colours is more agreeable to the eye than a single one, there is, notwithstanding, all kinds of inconveniences in presenting to the eyes too large a number at one time, whether these colours are distributed over different objects, or upon distinct parts of the same object.

## ARTICLE 7.

*Of a Uniform composed of different Hues of the same Colour.*

(672.) Strictly speaking, it is possible to make some agreeable assortments of colours belonging to contiguous scales, or, what is the same thing, to the same hue of colour; yet the difficulty of succeeding in assortments of this kind, and the facility of succeeding in those of contrast of colour, determine me to reject the former, at least whenever we use brilliant colours; for in uniforms of sombre colours they may be employed.

In order to explain my views against the assorting of different hues of the same colour, I shall cite :—

The ill effects of the uniforms of French troops where there is a juxtaposition of madder-red and cochineal-red; such as the uniform of dragoons, where the facings of the coat are cochineal-red, and the trousers are madder-red.

## ARTICLE 8.

*Of Uniforms composed of Two Tones of the same Scale.*

(673.) The association of two tones of the same colour for a uniform is not agreeable; in fact, the lightest tone loses some of its colour, and if the deep tone acquires it, this is seldom or never an advantage. Besides, it will be useless to dwell upon this subject, since practice is altogether dependent on theory.

## Article 9.

### Of a Uniform of One Colour.

(674.) If uniforms which present contrasts of colour are advantageous in an economical point of view, if uniforms of light colours are advantageous when we wish to impress an enemy by the number of combatants opposed to him, there are cases where, far from deploying battalions and squadrons, with the intention of rendering visible extended lines, we seek, on the contrary, to conceal the presence of riflemen or sharpshooters. For the latter, and also if we wish to establish a kind of hierarchy between different corps by means of dress, we may have recourse to a monochromous uniform of a sombre colour.

### § 2.

ON THE INFLUENCE OF SUPERFICIAL PROPORTIONS ACCORDING TO WHICH CLOTHS OF DIFFERENT COLOURS ARE ASSOCIATED IN MANY-COLOURED UNIFORMS.

(675.) I have already had many occasions to remark that the proportion of superficial extent which different contiguous colours occupy, and the manner in which these colours are distributed, with regard to each other, even if we suppose them well assorted, have considerable influence upon the effects they produce (249. 251. 365.). Conformably to these principles I must add that it will not suffice to choose for uniforms colours of which the association is satisfactory; but, in order to obtain the best possible result, we must employ them in certain respective proportions and distribute them suitably. Although I have no intention of entering into any details upon this subject, yet I shall make a few remarks in connection with it.

(676.) When one colour is relatively in smaller proportion than another, it is necessary for it to be distributed as equally as possible throughout the uniform; an example which supports this proposition is the artillery uniform of blue and scarlet: this latter colour, which is far from being equal in superficial extent to the first, produces a very good effect, because it is distributed over the whole uniform.

(677.) In a many-coloured uniform, where one colour is found on different pieces of clothing,—both coat and trousers, for example,—we must avoid the colour confounding to the eye contiguous or superimposed parts in such manner that a part

of one piece appears to belong to the other; thus some regiments of the French army wear with madder-red trousers a blue coat, the facings of which are of the same red. Now what results from this? Why, at a certain distance, the red facings confound themselves with the trousers; the skirts of the coat appear diminished to their blue parts, and are judged to be too narrow. It would be easy to remedy this defect, by putting facings of blue with a red edging.

In summing up, I am disposed to admit the two following principles:—

    1°. Whenever in a uniform the coat and trousers are of the same colour, and there is in the former a second colour which exists only in small proportion, it must be repeated upon the trousers in broad band if the soldier wears boots, and in simple edging if he wears shoes.

    2°. Whenever the trousers are of a colour distinct from the coat (that is to say, different from that which we make the ground), a band or a simple edging of the colour of the coat will produce the effect of this colour in the trousers.

### § 3.

#### OF THE ADVANTAGES OF CONTRAST CONSIDERED WITH REGARD TO THE APPARENT FRESHNESS OF CLOTHS FOR CLOTHING.

(678.) The contrast produced by the colours of cloths composing a uniform is not only advantageous to the brightness and *apparent preservation* of the colours of these cloths, but also to render less visible the inequalities which a cloth presents on account of the colouring material which the dyer has given to the cloth not having equally penetrated to the centre of the stuff, the surface wearing unequally according as it is exposed to friction of different degrees of intensity, the colour of the cloth becomes lighter, or, as it is commonly called, *whitens* in the parts most exposed to friction: many blue, scarlet, and madder-red cloths present this result especially on the salient parts of the vestment, such as the seams. This defect which certain cloths have of *whitening in the seams*, is much less apparent in a coat of two or more colours than it is in a monochromic coat, because *the vivid contrast of different colours fixing immediately the attention of the spectator, prevents the eye from perceiving the inequalities which would be visible in a monochromic coat.*

(679.) By the like reason, stains on the same ground will always be less apparent in a polychromic than in a monochromic coat.

(680.) By the same reason also a coat, waistcoat and trousers of the same colour cannot be worn together with advantage except when new; for when one of them has lost its freshness by having been more worn than the others, the difference will be increased by contrast. Thus new black trousers, worn with a coat and waistcoat of the same colour, but old and slightly *rusty*, will bring out this latter tint; while at the same time the black of the trousers will appear brighter. White trousers, reddish-grey also, will correct the effect of which I speak. We see, then, the advantage of having a soldier's trousers of another colour than his coat, especially if, wearing this coat all the year, he only wears trousers of the same cloth during winter. We see, also, why white trousers are favourable to coats of every colour, as I have already said (667.).

## CHAPTER II.

ON FEMALE CLOTHING.

### INTRODUCTION.

(681.) ALTHOUGH there are many varieties of the human race with respect to the colour of the skin, yet we may arrange them in the three following divisions:—

*First Division.*—Comprehends the Caucasian or white race.

*Second Division.*—Comprehends the American Indians, whose skin is copper-coloured.

*Third Division.*—Comprehends the Negro race, the Papuans, the Malays, &c., who have black or olive skins.

It is only the dress of women with white skins that is susceptible of being studied in detail; yet when speaking of dress for women with red or black skins, I shall say a few words on the assortment of colours which is most suitable to them.

## § 1.

ON THE ASSORTMENT OF COLOURS IN THE DRESS OF WOMEN WITH WHITE SKINS.

(682.) To give precision to this subject, we must begin by establishing certain distinctions.

The first is that of the two types of women with skins more or less white and in certain parts rosy:—

The one with light hair and blue eyes;
The other with black hair and black eyes.

The second distinction belongs to the juxtaposition of the articles of the toilet, whether pertaining to the hair, or to the complexion; for a colour may contrast favourably with the hair, yet produce a disagreeable effect with the skin.

The third belongs to the appreciation of the modifications of the complexion by coloured rays emanating from the head-dress, and which, being reflected on the skin, tinge this latter with their peculiar colour.

ARTICLE 1.

*Distinction of the two extreme Types of Women with White Skins.*

(683.) The colour of light hair being essentially the result of a mixture of red, yellow, and brown, we must consider it as *a very pale orange-brown;* the colour of the skin, although of a lower tone, is analogous to it, except in the red parts; further, blue eyes are really the only parts of the fair type which form a contrast of colour with the *ensemble,* for the red parts produce with the rest of the skin only a harmony of analogy of hue, or at most a contrast of hue and not of colour; and the parts of the skin contiguous to the hair, the eyebrows and eyelashes, give rise only to a harmony of analogy, either of scale or of hue. The harmonies of analogy, then, evidently predominate in the fair type over the harmonies of contrast.

(684.) The type with black hair, considered in the same way as the type with fair hair, shows us the harmonies of contrast predominating over the harmonies of analogy. In fact, the hair, eyebrows, eyelashes, and eyes contrast in tone and colour, not only with the white of the skin, but also with the red parts, which in this type are really redder, or less rosy,

than in the blonde type; and we must not forget that a decided red associated with black, gives to the latter the character of an *excessively deep* colour, either blue or green.

## Article 2.
### Of the Hair and Head-dress under the relation of their respective Colours.

(685.) If we consider the colours which generally pass as assorting best with light or black hair, we shall see that they are precisely those which produce the greatest contrast; thus, sky-blue, known to accord well with blondes, is the colour that approaches the nearest to the complementary of orange, which is the basis of the tint of their hair and complexions (683.). Two colours long esteemed to accord favourably with black hair, — yellow, and red more or less orange, — contrast in the same manner with them (684.).

Yellow and orange-red, contrasting by colour and brilliancy with black, and their complementaries, violet and blue-green, in mixing with the tint of the hair, are far from producing a bad result.

## Article 3.
### Of the Complexion and the contiguous Drapery under the relation of their respective Colours.

(686.) The juxtaposition of the drapery with the different flesh-tints of women offers to portrait-painters a host of remarks which are all consequent to the principles before laid down: we shall enounce the most general.

#### Red Drapery.

(687.) Pink-red cannot be put in contact with the rosiest complexions without causing them to lose some of their freshness, as a former experiment has demonstrated, viz. :— we were speaking of the inconvenience resulting from the use of pink linings in the boxes of a theatre (592.). It is necessary, then, to separate the pink from the skin in some manner; and the simplest manner of doing this, without having recourse to coloured stuffs, is to edge the draperies with a border of *tulle*, which produces the effect of grey by the mixture of white

threads which reflect light, and the interstices which absorb it; there is also a mixture of light and shade, which recalls the effect of grey, like the effect of a casement window viewed at a great distance (434.).

Dark-red is less objectionable for certain complexions than pink-red, because, being higher than this latter, it tends to impart whiteness to them in consequence of contrast of tone.

### Green Drapery.

(688.) A delicate green is, on the contrary, favourable to all fair complexions which are deficient in rose, and which may have more imparted to them without objection. But it is not as favourable to complexions that are more red than rosy, nor to those that have a tint of orange mixed with brown, because the red they add to this tint will be of a brick-red hue. In the latter case a dark-green will be less objectionable than a delicate green.

### Yellow Drapery.

(689.) Yellow imparts violet to a fair skin, and in this view it is less favourable than the delicate green.

To those skins which are more yellow than orange, it imparts white; but this combination is very dull and heavy for a fair complexion.

When the skin is tinted more with orange than yellow, we can make it roseate by neutralising the yellow. It produces this effect upon the black-haired type, and it is thus (685.) *that it suits brunettes.*

### Violet Draperies.

(690.) Violet, the complementary of yellow, produces contrary effects; thus, it imparts some greenish-yellow to fair complexions. It augments the yellow tint of yellow and orange skins. The little blue there may be in a complexion it makes green. Violet then is one of the least favourable colours to the skin, at least when it is not sufficiently deep to whiten it by contrast of tone.

### Blue Drapery.

(691.) Blue imparts orange, which is susceptible of allying itself favourably to white and the light flesh tints of fair complexions, which have already a more or less determined tint of this colour. Blue is then suitable to most blondes, and in this case justifies its reputation (685.).

It will not suit brunettes, since they have already too much of orange.

### Orange Drapery.

(692.) Orange is too brilliant to be elegant; it makes fair complexions blue, whitens those which have an orange tint, and gives a green hue to those of a yellow tint.

### White Drapery.

(693.) Drapery of a lustreless white, such as cambric muslin, assorts well with a fresh complexion, of which it relieves the rose colour: but it is unsuitable to complexions which have a disagreeable tint, because white always exalts all colours by raising their tone: consequently it is unsuitable to those skins which, without having this disagreeable tint, very nearly approach it.

Very light white draperies, such as muslin, plaited or point lace, have an entirely different aspect. They appear more grey than white, because the threads which reflect white light and the interstices which absorb it, produce on the sight the effect of a mixture of small white surfaces with small black surfaces, as I have before stated (687.); and it is also under this relation that every white drapery must be regarded, which allows the light to pass through its interstices, and which is only apparent to the eyes by the surface opposed to that which receives incident light.

### Black Drapery.

(694.) Black draperies, lowering the tone of the colours with which they are in juxtaposition, whiten the skin; but if the vermilion or rosy parts are to a certain point distant from the drapery, it will follow that, although lowered in tone, they appear relatively to the white parts of the skin contiguous to this same drapery, redder than if the contiguity to the black did not exist: this effect is analogous to that already mentioned (458. & 571.).

---

### ARTICLE 4.

*Of the Head-dress, in relation to the Coloured Rays which it may reflect upon the Skin.*

(695.) We can now readily understand the effect of coloured bonnets on the complexion, and whether it is true, as is generally believed, that a pink bonnet gives a rose tint to

the skin, while a green bonnet will give a green tint to it, in consequence of the coloured rays which each of them reflects upon it. Before going further, I premise that it is no longer a question of those head-dresses which, too small or too much thrown back to give rise to these reflections, can only produce the effects of contrast, as I have said above when treating of the juxtaposition of coloured objects with the hair and skin (685. 686. and following).

(696.) If an object in relief is illuminated exclusively by a coloured light, it will appear tinted of the colour of this light. A white plaster figure, for example, placed in an inclosure where the red rays illuminate it, will appear coloured red, at least to most eyes and under most circumstances; for I dare not assert that certain eyes under some circumstances may not perceive the sensation of the complementary of the coloured rays, in looking at certain parts of the figure.

(697.) But if the figure is placed so as to receive at the same time coloured rays and diffused daylight, there will be produced, on the eyes of the spectator suitably placed, a complex effect resulting:—

1°. From some parts of the figure being white, reflecting to the eyes of the spectator the coloured rays falling from above.

2°. From some parts of the figure reflecting diffused daylight in sufficient quantity to appear white or almost white.

3°. From there being, between the parts which reflect coloured light to the eye and those which send diffused daylight, some parts in a condition which appears to be complementary to the reflected coloured light.

(698.) One very remarkable consequence of the complex effect of which I have just spoken is, that the rays of colours mutually complementary, successively lighting the same object concurrently with the diffused daylight other things being equal, give rise to the same colouration; but with this difference, that the same colours are distributed in an average manner in both cases.

### EXAMPLES.

1°. Red rays and green rays give rise to effects which have this analogy, that the white figure presents in both cases, rosy parts, green parts, and white parts; but

the parts which are green when the incident light is red, appear rosy when the incident light is green.

2°. Yellow rays and violet rays give rise to effects which have this analogy, that the white figure presents in both cases yellow parts, violet parts, and white parts.

3°. Blue rays and orange rays give rise to effects which have this analogy, that the white figure presents in both cases, blue parts, orange parts, and white parts.

(699.) This experiment is in perfect conformity with all I have just said (697.), as may be proved in the following manner:— between two windows, directly opposite to each other, admitting diffused daylight, place a white plaster figure in such a position that each half shall be lighted directly by one of the windows. On completely intercepting the light of one of the windows, and hanging a coloured curtain before the other, the figure appears only of the colour of the curtain; but if we open the other window, the figure is lighted by diffused daylight while it is at the same time lighted by the coloured light; we then perceive some parts white, and some parts tinted with the complementary of the coloured light transmitted by the curtain.

This experiment, then, teaches us that if a bonnet, pink, for example, gives rise to a reflection of this colour on a complexion, the parts thus made rosy by the effect of contrast, themselves give rise to green tints, since the figure, at the same time it receives pink reflections, receives also diffused daylight.

(700.) Matters brought to this point, it remains to consider the real influence of the bonnet; for that purpose we place three white plaster casts of the same model in a position equally illuminated, then observe them comparatively after having clothed the middle cast with a white bonnet, and the two others with bonnets of which the colour of one is complementary to that of the other. *In this way we can satisfy ourselves that the influence of reflection in colouring a figure is very feeble, even when the bonnet is placed in the most favourable manner for observing the phenomenon.*

### Pink Bonnet.

(701.) Pink colour, reflected upon the skin, is very feeble except on the temples: wherever the pink parts are contiguous to parts feebly lighted by daylight, the latter will appear very lighly tinged with green.

### Green Bonnet.

(702.) Green colour, reflected upon the skin, is very feeble except on the temples: wherever the green parts are contiguous to parts feebly lighted by daylight, the latter will appear slightly rosy; the effect of green in colouring it pink is proportionably greater than the effect of reflected pink in colouring it green.

### Yellow Bonnet.

(703.) Yellow colour, reflected upon the skin, is very feeble except on the temples: wherever the yellow parts are contiguous to parts feebly illuminated by daylight, the latter will appear very sensibly violet.

### Violet Bonnet.

(704.) Violet colour, reflected on the skin, is very feeble even on the temples: wherever the violet parts are contiguous to parts feebly illuminated by daylight, the latter will appear slightly yellow; but this colouration is very feeble, because the reflections of violet have it themselves.

### Sky-blue Bonnet.

(705.) Blue colour, reflected on the skin, is very feeble except upon the temples: wherever the blue parts are contiguous to parts feebly illuminated by daylight, the latter will appear slightly orange.

### Orange Bonnet.

(706.) Orange colour, reflected on the skin, is very feeble except upon the temples: wherever the orange parts are contiguous to parts feebly illuminated by daylight, the latter will appear slightly blue.

(707.) It is evident, then, from these experiments, that a coloured bonnet produces much more effect by virtue of contrast arising from juxtaposition with the flesh tints, than by the coloured reflections which it imparts to them.

(708.) Let us now see what advantage the painter can derive from the preceding observations, when he prescribes a bonnet to a model belonging to the light-haired type, or to that with black hair.

#### A.) FAIR-HAIRED TYPE.

(709.) A black bonnet with white feathers, with white, rose or red flowers, suits a fair complexion.

(710.) A lustreless white bonnet does not suit well with fair and rosy complexions. It is otherwise with bonnets of gauze, crape, or lace; they are suitable to all complexions. The white bonnet may have flowers, either white, rose, or particularly blue.

(711.) A light blue bonnet is particularly suitable to the light-haired type; it may be ornamented with white flowers, and in many cases with yellow and orange flowers, but not with rose or violet flowers.

(712.) A green bonnet is advantageous to fair or rosy complexions. It may be trimmed with white flowers, but preferably with rose.

(713.) A pink bonnet must not be too close to the skin; and if it is found that the hair does not produce sufficient separation, the distance from the pink colour may be increased by means of white, or green, which is preferable. A wreath of white flowers amidst their leaves has a good effect.

(714.) I shall not advise the use of a light or deep red bonnet, except when the painter desires to diminish too warm a tint in the complexion.

(715.) Finally, the painter should never prescribe either yellow or orange-coloured bonnets, and be very reserved in the use of violet.

### B.) TYPE WITH BLACK HAIR.

(716.) A black bonnet does not contrast so well with the *ensemble* of the type with black hair, as with the other type; yet it may produce a good effect, and receive advantageously accessories of white, red, rose, orange, and yellow.

(717.) A white bonnet gives rise to the same remarks as those which have been made concerning its use in connection with the blonde type (710.), except that for brunettes it is better to give the preference to trimmings of red, rose, orange, and also yellow, rather than to blue.

(718.) Bonnets of pink, red, cerise, are suitable for brunettes, when the hair separates as much as possible the bonnet from the complexion. White feathers accord well with red; and white flowers with abundance of leaves, have a good effect with rose.

(719.) A yellow bonnet suits a brunette very well, and receives with advantage violet or blue trimmings; the hair must always interpose between the complexion and the head-dress.

(720.) It is the same with bonnets of an orange colour more

or less broken, such as chamois. Blue trimmings are eminently suitable with orange and its shades.

(721.) A green bonnet is suitable to fair and light rosy complexions; rose, red, or white flowers are preferable to all others.

(722.) A blue bonnet is only suitable to a fair or light red complexion; nor can it be allied to such as have a tint of orange-brown. When it suits a brunette, it may take with advantage yellow or orange trimmings.

(723.) A violet bonnet is always unsuitable to every complexion, since there are none which yellow will suit. Yet if we interpose between the violet and the skin not only the hair, but also yellow accessories, a bonnet of this colour may become favourable.

(724.) Whenever the colour of a bonnet does not realise the intended effect, even when the complexion is separated from the head-dress by large masses of hair, it is advantageous to place between the latter and the bonnet certain accessories, such as ribbons, wreaths, or detached flowers, &c., of a colour complementary to that of the bonnet, as I have prescribed for the violet bonnet (723.); the same colour must also be placed on the outside of the bonnet.

### § 2.

##### ON THE ASSORTMENT OF COLOURS IN THE DRESS OF WOMEN WITH COPPER-COLOURED SKINS.

(725.) The tint of the complexions of the women of the North American Indian races is too positive to induce them to endeavour to dissimulate, either by lowering its tone or by neutralising it. There is then no alternative but in heightening it; for which purpose we must use draperies either of white or of blue strongly inclining to green; then the tint will become of a redder orange.

### § 3.

##### ON THE ASSORTMENT OF COLOURS IN THE DRESS OF WOMEN WITH BLACK OR OLIVE SKINS.

(726.) If I have prescribed the harmony of contrast of tone where the colour of the complexion is copper-red, there is a stronger reason for it when we come to drape olive or black skins; then we can use either white or the most brilliant co-

lours, such as red, orange, and yellow. The consideration of contrast determines which one we ought to choose in a particular case. If the complexion is intense black, or dark olive, or greenish-black, red is preferable to every other colour; if the black is bluish, then orange is particularly suitable. Yellow will best accord with a violet-black.

### *Results applicable to Portrait-painting.*

(727.) I have said above (351.) that the portrait-painter must endeavour to find the predominating colour in the complexion of his models, in order that he may enhance it by means of the accessories; and I have added that there are some brown skins, as well as copper-coloured and orange also, belonging however to the white race, which are susceptible of being reproduced in a portrait with more success than is generally supposed. It is evident that the facts exhibited in this Chapter give the painter the means of obtaining, not only the result I have mentioned, but also the opposite result, if he considers it more suitable to neutralise, or at least to reduce a complexion, instead of seeking to exalt it; I shall sum up the results of these facts, by the supposition where he intends to heighten the tint, and by that where he wishes to neutralise it.

1st Supposition.— *The Painter wishes to heighten the Tint of a Complexion.*

(728.) In this supposition, two cases are to be distinguished; that in which all the colours the eye perceives in the model are those of its different parts, modified only by mutual juxtaposition, and not by the coloured rays emanating from one of them and reflected upon the others,— and the case where the colours of the different parts are modified by their juxtaposition, and by the coloured rays emanating from the one and reflected upon the others.

1st Case.— THE SPECTATOR ONLY SEES THE COLOURS MODIFIED BY THEIR JUXTAPOSITION.

A. *Heightening the tint without going out of its scale.*

   1°. Is effected by a white drapery, which heightens by contrast of tone.

   2°. Is effected by a drapery the colour of which is exactly the complementary of the tint, and of which the tone is not too high.

Such as, perhaps, a green drapery for a rosy complexion.

Such as, perhaps, a blue drapery for the orange complexion of a blonde.

B. *Heightening the tint by making it go out of its scale.*

1°. Is effected by a green drapery of a light tone upon an orange complexion.

2°. Is effected by a blue drapery of a light tone, upon a rosy complexion.

3°. Is effected by a yellow, canary, or straw-coloured drapery upon an orange complexion, of which the complementary violet neutralises some of the yellow of the complexion, and heightens its rose.

2ND CASE.— THE SPECTATOR SEES SIMULTANEOUSLY THE COLOURS MODIFIED BY JUXTAPOSITION AND BY REFLECTION.

The modifications resulting from the juxtaposition of parts diversely coloured, are much more positive than those arising from the mixture of the colour reflected by one part of a model upon another.

2ND SUPPOSITION.— *The Painter wishes to dissimulate a Tint of the Complexion.*

(729.) As in the preceding, he must distinguish two cases:—

1ST CASE.— THE SPECTATOR SEES THE COLOURS MODIFIED BY JUXTAPOSITION ONLY.

A. *Lowering the tint without going out of its scale.*

1°. Is effected by a black drapery which lowers it by contrast of tone.

2°. Is effected by a drapery of the same scale as that of the tint, but of a much higher tone.

Such, perhaps, as a red drapery upon a rosy complexion.

Such, perhaps, as an orange drapery upon an orange-tinted complexion.

Such, perhaps, as the effect of a dark green drapery on a complexion of a green tint.

B. *Lowering the tint by going out of its scale.*

1°. Is effected by a green drapery of a very deep tone upon an orange complexion.

2°. Is effected by a blue drapery of a deep tone upon a rosy complexion.

3°. Is effected by a very deep yellow drapery upon a very pale-orange complexion.

2ND CASE.—THE SPECTATOR SEES SIMULTANEOUSLY THE COLOURS MODIFIED BY JUXTAPOSITION AND BY REFLECTION.

The modifications resulting from the juxtaposition of parts diversely coloured, are generally greater than those which arise from the mixture of a colour reflected from one part of a model upon another.

(730.) I have now pointed out to the painter what he may hope for from the employment of white, black, and coloured draperies to modify the complexion in a determinate manner. I have attained my aim, if I am not deceived, in the effects which I have attributed to each of these draperies; but it is the artist's duty to choose the effect which will be most suitable in any particular case. If there is no difficulty when it is a question of the assortment of colours with the complexions of the coloured races, comprised in the second or third division (681.), since he can always have recourse to a harmony of contrast more or less strong, it is otherwise when he seeks to combine colours with the complexions of the white race; for the varieties which are placed between the two extreme types we have distinguished, and which unite them to each other by insensible shades, are causes why the artist only can estimate the harmony most suitable to such of the varieties which he is employing as a model: consequently, it is for him to judge if the dominant tint of a complexion must be exalted or diminished, either integrally, or in one of its elementary colours, or whether it must be altogether neutralised; it is for him to see, in the case where he wishes to weaken it, if this is best done by means of drapery of a darker tone, and thus to form a harmony of contrast of scale or of hue; or else if, on the contrary, it is preferable to attain the same end by opposing to this tint a drapery of its complementary colour, taken at a sufficiently high tone to produce the double effect of weakening by contrast of tone, and at the same time to produce a contrast of colour with that portion of the tint which is not neutralised.

# SECTION IV.

## APPLICATIONS TO HORTICULTURE.

INTRODUCTION (731—732.).

## SUB-SECTION I.

APPLICATION OF THE LAW OF CONTRAST TO HORTICULTURE.

CHAPTER I.—ON THE ART OF ASSORTING ORNAMENTAL PLANTS IN GARDENS, SO AS TO DERIVE THE BEST POSSIBLE EFFECT FROM THE COLOUR OF THEIR FLOWERS (733—748.).

CHAPTER II.—ON THE ART OF ASSORTING LIGNEOUS PLANTS IN GARDENS SO AS TO DERIVE THE BEST POSSIBLE EFFECT FROM THE COLOUR OF THEIR FOLIAGE (749—751.).

CHAPTER III.—EXAMPLES OF PLANTS WHICH MAY BE ASSOCIATED TOGETHER UNDER THE RELATION OF THE COLOUR OF THEIR FLOWERS (752—766.).

CHAPTER IV.—EXAMPLES OF PLANTS WHICH MAY BE ASSOCIATED TOGETHER UNDER THE RELATION OF THE COLOUR OF THEIR FOLIAGE (767.).

## INTRODUCTION.

(731.) The applications I propose to make to Horticulture are of two kinds: the one relates particularly to the arrangement of plants in gardens according to the colour of the flowers; the other relates to the method of distributing and planting ligneous plants in masses, which I suppose to have been previously planned. Doubtless I could have dispensed with treating of the latter subject; but I have been led to it so naturally, and the rules which guided me are so positive and simple, that I have no doubt of their proving profitable to such of my readers who may follow them in laying out plantations, &c.

(732.) This art is termed Gardening, or Landscape Gardening; and the artist who conducts these operations is called a Gardener or Landscape Gardener.

# SUB-SECTION I.

APPLICATION ON THE LAW OF CONTRAST OF COLOURS TO HORTICULTURE.

## CHAPTER I.

ON THE ART OF ARRANGING ORNAMENTAL PLANTS IN GARDENS, SO AS TO DERIVE THE GREATEST POSSIBLE ADVANTAGE FROM THE COLOURS OF THEIR FLOWERS.

### INTRODUCTION.

(733.) AMONG the pleasures afforded us by the cultivation of choice plants, there are few so intense as the sight of a collection of flowers, varied in colour, form, and size, and in their position on the stems that support them. *If the perfume they exhale* has been extolled by the poets *as equal to their colours*, it must be admitted that they never create, through the medium of sight, disagreeable sensations analogous to those which some nervous organisations experience from their exhalations through the sense of smell. Colour, then, is doubtless, of all their qualities, that which is most prized. It is probably because we admire the plants individually, and become attached to them on account of the pains they cost us, that we have hitherto so generally neglected disposing them in such manner as to produce the best possible effect upon the eye seeing their flowers no longer separately, but together.

Thus, no defect is more common than that of *proportion* in the manner in which flowers of similar colours are distributed in a garden. Sometimes the eye is struck by blue or by white; sometimes it is dazzled by yellow. Add to this defect of proportion, the ill effect resulting from the vicinity of many species of flowers, which although of the same kind of colour, are not of the same sort; for instance, in spring we see the leopard's bane (*doronica*), of a brilliant golden yellow, side by side with the narcissus, which is of a pale greenish-yellow; in autumn, the Indian pink beside the African marigold, dahlias of various reds

grouped together, &c. Such arrangements as these cause the eye, accustomed to appreciate the effects of contrast of colours, to feel sensations quite as disagreeable as those experienced by the musician whose ear is struck with discords.

(734.) Previous to my observations on Simultaneous Contrast and the demonstration of the law which governs it, it was impossible to prescribe rules to horticulturists which by instructing them to place, with certainty of success, flowers in proximity whose colours reciprocally enhance each other, would enable them to avoid either the monotony resulting from the grouping of flowers of the same colour, or the disagreeable effect of a collection of flowers whose hues are mutually injurious; and if the good effects of contrast were then spoken of, it was always in a vague and general manner, neither indicating the plants which ought to be grouped together, in order that their flowers should reciprocally enhance one another, nor those which must be placed apart on account of their colours mutually injuring each other. It is evident that after stating the Law of Simultaneous Contrast of Colours, distinguishing their various kinds of harmonies and their associations with white, black, and grey, the grouping of flowers will present no difficulty, since it will only be a simple conclusion from facts previously studied under all the relations which concern horticulture.

Conformably to the manner in which the applications of the law of contrast have been made to all the arts of which we have spoken, we shall distinguish in this place the associations of flowers which give rise to the harmonies of contrast, and those which give rise to the harmonies of analogy.

§ 1.

ASSOCIATIONS OF FLOWERS WHICH RELATE TO THE HARMONIES OF CONTRAST.

ARTICLE 1.

*Associations of Flowers which relate to the Harmonies of Contrast of Colour.*

(735.) We must first distinguish two general cases relatively to the interval which exists between the plants: that where the interval is such that we can see each specimen individually,

and the other where they are so near together, that the flowers belonging to different specimens appear mixed *pell-mell.*

### A. *Associations where the Plants are apart.*

(736.) The associations which relate to the harmonies of contrast of colour, are first those of flowers with colours mutually complementary to each other; such as,

> Blue flowers and Orange flowers,
> Yellow flowers and Violet flowers.

As to rose or red flowers, they contrast with their own leaves.

(737.) White flowers accord more or less favourably with blue and orange flowers already allied together, and perfectly with rose or red flowers, but not so well with yellow or with violet flowers already allied, as we might have presumed from what has been said of the interference of white in this last complementary arrangement (189.). White associates much less favourably with yellow, when the latter is brighter or greener.

Whatever be the effect of this latter mixture and of the want of effect of a clump composed only of white flowers, one cannot, however, refuse to consider these same flowers as indispensable ornaments to a garden, after having once seen them suitably distributed among groups of flowers whose colours are associated conformably with the law of contrast; and, moreover, if during the horticultural year we ourselves seek to put in practice the precepts we inculcate, we shall perceive that there are periods when white flowers are not, in general, sufficiently numerous to give us the best result in the cultivation of our gardens: for in fact, if these flowers do not produce as good an effect with pale yellow and violet flowers as with the red and blue flowers, still their association is never objectionable.

White flowers are the only ones that possess the advantage of heightening the tone of flowers which have only a light tint of any colour whatever.

They are also the only ones that possess the advantage of separating all flowers whose colours mutually injure each other.

(738.) After the associations of flowers the colours of which are mutually complementary, we must arrange the following: —

> Yellow flowers, especially those which incline to orange, accord very well with Blue flowers.

Flowers of a Yellow more green than orange, have a very good effect with flowers of a Red that has a tinge of blue rather than of orange.

Deep-Red flowers accord well with deep-Blue flowers.

Orange flowers are not misplaced near Violet flowers.

It is, doubtless, superfluous to remark that white allies itself tolerably well with all these arrangements.

B. *Associations where Plants are mixed pell-mell.*

(739.) There is a method of arranging the varieties of the same species of annuals or biennials productive of a good effect, which is, to sow their seeds thickly in beds or borders. I will cite, as an example, the seeds of larkspur, china-aster, and, in a word, those which have short stalks, bearing a multitude of white, pink, red, blue, violet, flowers, &c.

We can obtain an analogous effect by planting thickly *anemones.*

(740.) I prescribe the *pell-mell* grouping only for beds or borders, and not for plat-bands. When we wish that the latter should offer flowers only to our notice, we must make the associations conform to the law of contrast, and the plants must be at such intervals from each other as to afford greater room for development than in the preceding case, while at the same time their stalks can spread and conceal the earth under the flowers.

---

ARTICLE 2.

*Associations of Flowers which may be classed in relation to the Harmonies of Contrast of Scale.*

(741.) Among the harmonies of Contrast of Scale which can be made successfully, I shall only cite the associations of the varieties of the Bengal rose, which present red, pink, and white. I consider the flower of the blood-red Bengal rose as the type of Red, and the pink variety as being a low gradation of the preceding colour; it is for this reason that I associate them, in order to form an effective harmony of contrast of tone.

### Article 3.

*Associations of Flowers which relate to the Harmonies of Contrast of Hues.*

#### A. *Associations where the Plants are apart.*

(742.) It is so difficult to succeed in making associations of hues which will have a satisfactory effect, that I proscribe *in general* the mutual association of flowers the colours of which belong to neighbouring scales.

We must then separate

Pink flowers from those that are either Scarlet or Crimson;
Orange flowers from Orange-yellow flowers;
Yellow flowers from Greenish-yellow flowers;
Blue flowers from Violet-blue flowers.

I shall even go further, in advising the separation of

Red flowers from Orange flowers;
Pink flowers from Violet flowers;
Blue flowers from Violet flowers.

I say that I proscribe them *in general*, because I leave to the taste of the enlightened amateur the appreciation of associations of this kind, which may have a good effect, but which it would be difficult to define in writing.

#### B. *Associations where the Plants are pell-mell.*

(743.) Flowers which only present contrasts of hues, and which spring from seeds sown thickly in borders or in beds, will not have the same objection as when the roots are planted at a distance from each other.

(744.) Finally, there is yet one circumstance where flowers, presenting a disagreeable contrast of hues, may still produce a good effect. It is when their assortment makes part of an arrangement of contrasts of colours strongly opposed; in this case, being no longer seen isolated, it becomes, in a manner, the element of a picture. I shall return to this circumstance (815.).

## § 2.

#### ASSOCIATIONS OF FLOWERS WHICH RELATE TO THE HARMONIES OF ANALOGY.

### ARTICLE 1.

*Associations of Flowers which relate to the Harmonies of Scale.*

(745.) It is not impossible to make associations of analogy of scale, especially among the varieties of the same species of plants; yet I only reckon shrubs susceptible of taking it, because it will be found that only perennial plants afford to the horticulturist a guarantee that the flowers of one year will be identical in tone of colour with those of the preceding; consequently, if we plant woody shrubs in such manner as to secure a gradation, in commencing by the variety which presents the highest tone, and finishing with the variety that presents the lightest tone, the successive annual flowerings will be constantly according to that order. I believe that we may apply this kind of arrangement to standard roses.

(746.) But I shall not advise any one to attempt submitting annuals to this arrangement, because of the uncertainty that exists, I do not say in the colour of individual flowers planted, but in the tone of this colour. For example, although it would be easy to establish a harmonious series with dahlias of different tones of the same scale of red, I do not advise the taking of tubers which have given these flowers, for planting the following year, with the object of again realising this series with the living individuals produced from these tubers, because the colours of the new flowers may not only vary in tone, but also go out of the scale of the preceding year.

### ARTICLE 2.

*Associations of Flowers which relate to the Harmonies of Analogy of Hues.*

(747.) If I have spoken against the associations of contrast of hues (742.), I am the more inclined to speak against the associations of analogy of hue, always considering the restrictions I have enounced above (742. 744.). It must not

be forgotten that my intention is to prescribe associations, of which the good effects are certain ; now, the more the colours contrast conformably to our law, the more latitude there will be without the associations ceasing to be agreeable, although the colours of individual flowers associated vary in tone and in hue through circumstances unknown to us.

### Remark.

(748.) I shall conclude this Chapter by replying to an objection which might be addressed to me, *that the green of the leaves which serves as a ground to the flowers, destroys the effect of contrast of these latter.* But it is not so ; and to be convinced of it, it is sufficient to fix upon a frame of green silk, two kinds of flowers, in conformity with the arrangement of the coloured bands (*Pl.* 1. *fig.* 1.), and to look at them from a distance of about ten paces. And this is very simple ; when the eye sees distinctly and simultaneously two colours well defined upon a ground, the attention being fixed by them, the surrounding objects causing but feeble impressions, especially those of a sombre colour, which, being upon a distant plane, present themselves confusedly to the sight. This observation relates also to that which I have made with respect to the modification that the green leaves of a garland of roses on stained paper experienced on a black ground (483.).

## CHAPTER II.

ON THE ART OF ASSORTING LIGNEOUS PLANTS IN GARDENS SO AS TO DERIVE THE BEST POSSIBLE ADVANTAGE FROM THE COLOUR OF THEIR FOLIAGE.

(749.) IF we consider trees and shrubs no longer under the relation of the colour of their flowers, but under that of the manner in which we may employ their foliage in the decoration of gardens by assorting them suitably, we shall perceive that there is only a very small number of contrasts of scale and of hues which it is possible to realise, at least at those periods when vegetation is active; for, in autumn, when plants lose their leaves, the latter, before falling, may assume various colours, such as red, rose, scarlet, orange, and yellow, which by their brilliancy frequently appear to recall the season of flowers. The

greater part of trees and shrubs present in the summer season only the green of their leaves ; and if this green varies in tone and hue according to the species and its varieties, the differences are always very trifling. There is only a small number of ligneous plants, such as the *Bohemian olive,* of which the foliage is quite silvery, that is to say, on both sides of the leaves; there is but very little purple foliage, like that of the *purple beech.* Let us consider this state of things, in order to establish the harmonies of contrast and of analogy.

### A. *Harmonies of Contrast.*

(750. *a.*) The most decided contrast of colour we can establish between the leaves of ligneous plants is that of green of the highest number with foliage nearest to red ; we say the nearest, although we know of none to which the qualification of red is really applicable. In fact, the *purple beech* is more of a red-brown than a dark red, properly so called ; and that need not surprise us, when it is considered that the colour of leaves results from a mixture of red and green, which according to the principle of mixing colours (154. and 158.) must give birth to black, if they are in suitable proportion ; and to a brown tone of the green or of the red scale, according as one or the other colour predominates. From this it is evident that it will be difficult to obtain contrast of colour with foliage.

(*b.*) The contrast of hue is established by the assortment of a bluish-green with a yellowish-green, taken at tones of unequal height ; by the contrast of a bluish-green brown with a yellowish light green, &c.

(*c.*) The contrast of tone will be established between silvery foliage which has always a decided tone of green, and the foliage of a higher tone of this same green, &c.

### B. *Harmonies of Analogy.*

(751.) Nearly all the masses in our landscape gardens planted with various trees, present certain harmonies of hues almost always resulting from associations established according to considerations foreign to those of the assortment of foliage — an evident result, if we recall the remark made above (749.), that the colours of the leaves of the greater part of plants are of greens belonging to scales more or less allied, and of tones but little distant from each other.

(*a.*) Harmonies of analogy of hues formed of allied tones belonging to neighbouring scales, are those which it is least difficult to obtain.

270 APPLICATIONS TO HORTICULTURE. [PART II. DIV. V.

(*b.*) As to assortments of foliage presenting a series of equidistant tones belonging to the same scale of green, they will be exceedingly difficult to realise.

## CHAPTER III.

EXAMPLES OF PLANTS WHICH MAY BE ASSOCIATED TOGETHER UNDER THE RELATION OF THE COLOUR OF THEIR FLOWERS.

(752.) It is not sufficient to have enounced the assortments of flowers in a general manner, as I have just done, in order that every one who cultivates plants may submit to these rules, which require new study, and especially change of habit on the part of gardeners—it is with the intention of rendering the observance of these rules easier, that I now indicate by their specific names the plants which may be associated together, at least under the climate of Paris, the experience of ten years having shown me that they *in general* flower simultaneously. I could have greatly augmented the number by including greenhouse plants, and also many native plants different from those of which I shall speak; but the possible associations being indefinite, it was necessary to confine my citations to chosen examples, and my choice has fallen on the species observed by myself, and which may be found in all the gardens of the Department of the Seine. The horticulturist who will appreciate my principles in studying the arrangements which I am about to give, and on the other hand, in seeing the associations of colours of the fourth paragraph of the Introduction to the Second Part of this book, will acquire every facility for making himself either assortments of plants or of colours that I have not mentioned; and I am much deceived if this occupation will not be a new source of pleasure to amateur gardeners.

(753.) *Arrangement of Flowers for the Month of February.*

The crocuses (*Crocus vernus—luteus*) flower in this month, when the winter has not been very severe or protracted. They present three varieties of colour—White, Violet, and Yellow.

We can arrange them in borders in single lines.

(a) 1. Yellow Crocus.
2. Violet Crocus.
1a.*Yellow Crocus, &c.

(b) 1. Yellow Crocus.
2. Violet Crocus.
3. White Crocus.
1a. Yellow Crocus, &c.

(c) 1. Yellow Crocus.
2. White Crocus.
3. Violet Crocus.
1a. White Crocus, &c.

(d) 1. Yellow Crocus.
2. Violet Crocus.
3. Yellow Crocus.
4. White Crocus.
1a. Yellow Crocus, &c.

(e) 1. Violet Crocus.
2. Yellow Crocus.
3. Violet Crocus.
4. White Crocus.
1a. Violet Crocus, &c.

(f) We may arrange them in fives, making either border or bed.

---

(754.) *Arrangement of Flowers for the Month of March.*

A.) We can oppose Yellow Hellebore (*Helleborus hiemalis*) with the White Snow-drop (*Galanthus nivalis*) and the Snow-flake (*Leucoium vernum*).

B.) There are some winters when the Christmas rose (*Helleborus niger*), flowering from December, can be surrounded without systematic order with bastard Hellebore, Violet (*Viola odorata*), and Snow-drop.

C.) Arrangement of White, Red, and Blue Hepaticas (*Anemone hepatica*).

*In Borders.*

(a) 1. White Hepatica.
2. Blue Hepatica.

* 1a. Signifies that the preceding series must be repeated.

272 APPLICATIONS TO HORTICULTURE. [PART II. DIV. V.

3. White Hepatica.
4. Rose Hepatica.
1a White Hepatica, &c.

*In Beds.*

(755.) *Arrangement of flowers for the Month of April.*

A.) Primroses *Primula elatior — officinalis*).

We can make a great number of assortments with Primroses, because there are numerous varieties. I shall point out the following border: —

(a) 1. Red Primrose.
   2. White Primrose.
   3. Orange Primrose.
   4. Lilac Primrose.
   5. Yellow Primrose
   6. Violet-Brown Primrose.
   7. White Primrose.
   1a. Red Primrose, &c.

(b) If we wish to make a circular or elliptical border, which can be seen by the eye at a glance, we may certainly admire the effect of the following arrangement.

1. White Primrose.
2. Uniform Red Primrose.

3. White Primrose.
4. Orange or Orange edged with Brown.
5. Violet or Lilac Primrose.
6. Yellow Primrose.
7. Violet or Lilac-Blue Primrose.
8. Orange, or Orange edged with Brown.
1a. White Primrose, &c.

Yellow Primroses planted at equal intervals produce an excellent effect, because their upright stalks covered with yellow flowers agreeably neutralise the monotonous uniformity of height in the rest of the border.

I am satisfied that in leaving out from the border the Orange Primroses, it would lose much of its effect by losing some of its symmetry. This observation must be taken into consideration whenever a border in a closed curve is, on account of its limited extent and position, susceptible of being seen entirely at once.

If this condition did not exist, the first border of Primroses (a) might be preferred to the second (b).

B.) (a) 1. Tourette (*Turritis verna*).
2. Siberian Saxifrage (*Saxifraga crassifolia*).
3. Tourette.
4. Leopard's Bane (*Doronicum caucasium*).
1a. Tourette.

(b) When we abandon the Tourettes to themselves, they extend too far relatively to the Saxifrages, thence there is too much White. If we cannot take so much care to maintain the Tourettes, I shall prescribe the following border.

1. Tourette.
2. Saxifrage.
3. Leopard's Bane.
1a. Tourette, &c.

I alluded to this arrangement (251.) when I took into consideration the proportion of the differently coloured surfaces, which form part of an arrangement.

C.) (a) 1. Leopard's Bane.
2. Saxifrage (*Lunaria annua*).
3. Leopard's Bane.

4. Tourettes.
5. Saxifrage.
6. Tourette.
1a. Leopard's Bane.

In order that this border shall produce a good effect, the Tourettes and the Leopard's Banes must be restrained to prevent their flowers from occupying too great an extent relatively to the Saxifrages or Lunarias.

(*b*) Finally, in the preceding arrangement, we can successively alternate a Lunaria with a Saxifrage, and so on; that is to say, a Lunaria between two Leopard's Banes, and a Saxifrage between two Tourettes.

D.) (*a*) 1. Blue Hyacinth (*Hyacinthus orientalis*).
2. Yellow Narcissus (*Narcissus pseudonarcissus*, or *N. odorus*).
1a. Blue Hyacinth, &c.

(*b*) 1. White Hyacinth.
2. Rose „
1a. White „ &c.

(*c*) 1. White Hyacinth.
2. Blue „
3. White „
4. Rose „
1a. White „ &c.

(*d*) We can alternate with the *Doronicas* large beds of Blue Hyacinths.

(*e*) And with Saxifrages large beds of White Hyacinths.

E.) (*a*) 1. Persian Iberis (*Iberis sempervirens*).
2. *Alyssum saxatile*.
1a. Persian Iberis. &c.

(*b*) 1. Persian Iberis.
2. *Pulmonaria virginica*.
3. *Alyssum saxatile*.
1a. Persian Iberis, &c

(*c*) 1. Persian Iberis.
2. *Phlox verna* purple), or *Anemone pavonia* (red), or *Anemone apennina* (sky blue).
3. *Alyssum saxatile*.

    4. *Phlox verna,* or *Anemone paviona,* or *apennina.*
    1*a.* Persian Iberis, &c.

F.) With a bed of Periwinkle (*Vinca minor* and *Vinca major*) white and blue, mixed with violets and white and *Anemone nemorosa* or *Isopyrum thalictroides,* and if the bed has a certain extent of yellow flowers, such as primroses, ranunculus (*R. ficaria*), &c., they will produce a good effect.

G.) (*a*) 1. Double-flowering Peach (*Amygdalus persicus*).
    2. *Kerria japonica.*
    1*a.* Peach, &c.
(*b*) 1. Peach.
    2. *Jasminum fruticans.*
    1*a.* Peach, &c.

H.) 1. *Chamæcerasus tartarica* (red).
    2.     „     „    (white).
    1*a.*  „     „    (red), &c.

But I must not conceal the fact that this arrangement is a little dull. We can interpose between the red or white *Chamæcerasus* a *Kerria japonica;* but on account of the great difference in their forms, there must be a sufficiently large interval to prevent their leaves touching; whence it is necessary that behind this line there should be other plants of an agreeable aspect.

I.) A *Malus japonica* rising in a bush above a bed of violets, produces a good effect by the contrast of its scarlet flowers with the colour of the violets.

---

(756.) *Arrangement of Flowers for the Month of May.*

A.) (*a*) 1. Persian Iberis.
    2. Red Tulip (*Tulipa gesneriana*), or *Lychnis sylvestris.*
    1*a.* Persian Iberis, &c.
(*b*) 1. Persian Iberis.
    2. Red Tulip or Lychnis.
    3. *Alyssum saxatile.*
    1*a.* Persian Iberis, &c.

B.) (*a*) 1. Blue Iris (*I. germanica*)
    2. White Iris (*I. florentina*).
    1*a.* Blue Iris, &c.

    (b) 1. White Iris.
         2. *Papaver orientale* or *P. bracteatum*.
         1a. White Iris, &c.

    (c) 1. White Iris.
         2. *Papaver orientale* or *P. bracteatum*.
         3. Blue Iris.
         4. *Papaver orientalis* or *P. bracteatum*.
         1a. White Iris, &c.

C.) (a) 1. Red Valerian.
        2. White Valerian.
        1a. Red Valerian, &c.

    (b) 1. White Valerian.
         2. *Papaver orientale* or *P. bracteatum*.
         1a. White Valerian, &c.

    (c) 1. Red Valerian.
         2. Blue Iris.
         3. White Valerian.
         4. Blue Iris.
         1a. Red Valerian, &c.

D.)     1. Red Peony (*Peonia officinalis*).
        2. White Peony.
        1a. Red Peony, &c.

E.) Some *Papaver bracteatum*, alternated with Guelder Rose, produce a very beautiful effect.

        1. Guelder Rose (*Viburnum opulus sterilis*).
        2. *Papaver bracteatum*.
        1a. Guelder Rose, &c.

        1. Guelder Rose.
        2. *Linum perenne*.
        1a. Guelder Rose, &c.

F.) (a) 1. Blood-red Bengal Rose (*Rosa semperflorens*).
        2. Red Bengal Rose.
        1a. Blood-red Rose, &c.

    (b) 1. Red Bengal Rose.
         2. White Bengal Rose.
         1a. Red Bengal Rose, &c.

    (c) 1. White Bengal Rose.
         2. Red Bengal Rose.

3. White Bengal Rose.
  4. Blood-red Bengal Rose.
  1a. White Bengal Rose, &c.

(d) 1. Blood-red Bengal Rose.
  2. Red Bengal Rose.
  3. White Bengal Rose.
  1a. Blood-red Bengal Rose.

(e) 1. Red Bengal Rose.
  2. Blood-red Bengal Rose.
  3. Red Bengal Rose.
  4. White Bengal Rose.
  1a. Red Bengal Rose.

We can make effective borders by alternating tufts of Bengal Roses, or of *Rosa cinnamonea*, with

  1. Tufts of *Viburnum tinus*.
  2. Tufts of *Jasmin fruticans*.

We put the tufts at about a yard from each other.

We can also alternate them with Almond-laurels (*Cerasus lauro-cerasus*). In this case there should be an interval of one to two and a half yards between the tufts, and three rose-bushes arranged in an equilateral triangle—

○ ○
○

G.) (a) 1. Violet Lilac (*Syringa vulg.*).
  2. White Lilac.
  1a. Violet Lilac, &c.

(b) 1. Violet Lilac.
  2. *Cytisus Laburnum*.
  1a. Violet Lilac, &c.

(c) 1. *Cytisus Laburnum*.
  2. Violet Lilac.
  3. White Lilac.
  4. Violet Lilac.
  1a. *Cytisus Laburnum*, &c.

(d) 1. *Cytisus Laburnum*.
  2. Violet Lilac.
  3. *Philadelphus coronarius*.
  4. Violet Lilac.
  1a. *Cytisus Laburnum*, &c.

(e) 1. *Syringa media.*
    2. *Spiræa hypercifolia* or *ulmifolia.*
    1a. *Syringa media,* &c.

(f) 1. *Syringa media.*
    2. *Kerria japonica.*
    1a. *Syringa media,* &c.

Although the Kerria flowers a little sooner than the *Syringa media,* yet this arrangement is very good.

(g) 1. White Lilac.
    2. *Cercis siliquastrum.*
    1a. White Lilac, &c.

(h) 1. White Lilac.
    2. *Chamæcerasus tartarica Rose.*
    1a. White Lilac, &c.

H.) 1. *Spiræa hypercifolia.*
    2. *Jasmin fruticans.*
    1a. *Spiræa hypercifolia,* &c.

I.) (a) 1. *Prunus mahaleb.*
    2. *Cercis siliquastrum.*
    1a. *Prunus mahaleb,* &c.

When the *Cercis siliquastrum* blossoms, the *Prunus mahaleb* is not in flower. It is not, then, for the contrast of flowers that we prescribe the association, but for that of the flowers of the first with the leaves of the second.

(b) 1. *Prunus mahaleb.*
    2. *Cytisus Laburnum.*
    1a. *Prunus mahaleb,* &c.

(c) 1. *Prunus mahaleb.*
    2. *Cytisus Laburnum.*
    3. *Prunus mahaleb.*
    4. *Cercis siliquastrum.*
    1a. *Prunus mahaleb,* &c.

K.) (a) 1. Guelder Rose.
    2. *Colutæa arborescens.*
    1a. Guelder Rose, &c.

(b) 1. Guelder Rose.
    2. *Cercis siliquastrum.*
    1a. Guelder Rose, &c.

L.) (a) 1. Judas Tree.
       2. *Cytisus Laburnum.*
      1a. Judas Tree, &c.
   (b) 1. Judas Tree.
       2. *Cornus sanguineus.*
      1a. Judas Tree, &c.

M.) (a) 1. *Philadelphus coronarius.*
       2. *Colutæa arborescens,* or *Coronilla emerus.*
      1a. *Philadelphus coronarius,* &c.
   (b) 1. *Chamæcerasus tartarica.*
       2. *Spiræa ulmifolia.*
      1a. *Chamæcerasus tartarica,* &c.

N.)   Borders of Anemones, planted thickly (739.), generally flower in this month.

---

(757.) *Arrangement of Flowers for the Month of June.*

A.)   There are Pansies (*Viola tricolor*), yellow, white and violet, that is, of the same colours as Crocuses; by which it is possible to submit them to the same arrangements as these latter (753.).

B.)   With the violet, yellow, and white *Hesperis matronalis* and the *Erysimum barbarea floræ-pleno,* which is yellow, we obtain analogous results (753.).

C.)   1. *Linum perenne.*
     2. *Solidago multiflora.*
    1a. *Linum perenne,* &c.

D.)   1. *Antirrhinum majus,* red.
     2. *Antirrhinum majus,* white.
    1a. *Antirrhinum majus,* red, &c.

E.)   1. *Delphinium elatum.*
     2. *Lychnis chalcedonica.*
    1a. *Delphinium elatum.*

F.)   1. *Digitalis purpurea,* pink.
     2. *Digitalis purpurea,* white.
    1a. *Digitalis purpurea,* pink, &c.

---

(758.) *Arrangement of Flowers for the Month of July.*

A.) (a) 1. *Malope trifida,* pink.
       2. *Malope trifida,* white.
       1. *Malope trifida,* pink, &c.

(b) Some *Zinnia violacea* rising from the middle of a mixture of White and Red Mallows, have a very fine effect.

(c) It is the same with the blue *Veronica spicata*, the *Nigella damascena*, the *Delphinium elatum*, the *Coreopsis tinctoria*, and the *Escholtzia californica*.

B.) (a) 1. White Aster chinensis.
     2. Pink Aster chinensis.
     1a. White Aster chinensis, &c.

(b) 1. White Aster chinensis.
    2. Blue Aster chinensis.
    1a. White Aster chinensis, &c.

(c) 1. White Aster chinensis.
    2. Pink Aster chinensis.
    3. White Aster chinensis.
    4. Blue Aster chinensis.
    1a. White Aster chinensis, &c.

C.) Borders of Aster chinensis sown thickly, (739.) have a fine effect.

    1. *Campanula medium*, blue.
    2. *Campanula medium*, white.
    1a. *Campanula medium*, blue, &c.

D.) 1. *Linum perenne.*
    2. Escholtzia.
    1a. *Linum perenne*, &c.

---

(759.) *Arrangement of Flowers for the Month of August.*

A.) (a) 1. *Phlox decussata*, violet.
     2. *Phlox decussata*, white.
     1a. *Phlox decussata*, violet, &c.

(b) 1. *Phlox decussata*, violet.
    2. *Solidago humilis*, or *integrifolia*, or *recurvata*.
    1a. *Phlox decussata*, violet, &c.

(c) 1. *Phlox decussata*, violet.
    2. Yellow *Achillæa filipendulina* or Escholtzia.
    1a. *Phlox decussata*, violet, &c.

B.) (a) 1. *Aster Siberia.*
     2. *Rudbeckia speciosa.*
     1a. *Aster Siberia*, &c.

(b) 1. *Aster Siberia*.
    2. Yellow *Achillæa filipendulina*.
    1a. *Aster Siberia*, &c.

C.)   1. *Ipomœa purpurea*.
      2. Escholtzia.
      1a. *Ipomœa purpurea*, &c.

A circular bed, in the centre of which is a tree, has a very fine effect when the *Ipomœa purpurea* rises round the tree, and when they are themselves surrounded with *Escholtzia*.

D.) A bed where the *Ipomœa* are replaced by nasturtiums, and the *Escholtzia* by violet pansies, is also very agreeable to the eye.

E.) A border of *Delphinium ajacis*, sown thickly (739.), flowers at this period.

(760.) *Arrangement of Flowers for the Month of September*.

The month of September presents the most beautiful assortment of colours it is possible to obtain with flowers. In fact it is at this period of the year that the dahlias (*Dahlia variabilis*) shine in all their splendour, and the horticulturist may decorate a large space with a single species of a plant whose numerous varieties present every colour except blue. Dahlias have for a long time engaged my attention, not with a view of adding to their numerous varieties, but of assorting them in the manner most favourable to the reciprocal enhancement of the colour of their flowers: consequently, I have examined them under certain points of view the results of which I will now describe, as an example of the method which appears to me the most suitable, when we seek to derive the best possible effect from ornamental plants rich in varieties.

I shall occupy myself successively

1°. In classing the varieties by scales of colour.

2°. At the time of gathering the tubers of the dahlias, by marking them in such manner as to avoid all error in planting them with the intention of deriving the best possible effect from the colour of the flowers of each root.

3°. With the different assortment of dahlias planted in single line, in circles, and in beds.

1°. *Of the Classification of the Varieties of Dahlias by scale of colour.*

I have made a selection of dahlias which appears to me the most beautiful in colour; and taking one flower of each variety, arranged them together upon a table by scale, commencing with the lightest tone; in this way the accompanying table was formed. The greater part consists of names of varieties well known in commerce; the others relate to the varieties which were raised from seed by myself or by my neighbours. Under the last name in each column there is left a sufficient blank space to receive such remarks as may be made upon each variety comprised in that column. These remarks have special reference to what the variety is susceptible of yielding, 1°. from one year to another in its height, and the colour of its flowers; 2°. during the same year in the colour of its flowers. (See the adjoining table.)

2°. *At the time of gathering the tubers of the Dahlias, by marking them in such manner as to avoid all error in planting them with the intention of deriving the best possible effect from the colour of the flowers of each root.*

At the end of October, or rather at the period of the first frost, attach to the tuber of each dahlia, by means of a piece of wire, a small zinc label painted in oil-colour with the colour of the scale to which the dahlia belongs. This plate is stamped with a number which corresponds to that of the table. The tubers removed from the earth and cleaned are preserved with their numbers.

3°. *Of the different kinds of Dahlias planted in lines, in circles, and in beds.*

### LINE OF DAHLIAS.

After having placed upon the same line as many stakes as we wish to plant dahlias, at a distance of about a yard apart, and putting upon each stake a label of the colour of the dahlia bearing its number, then deposit at the bottom of each stake the tubers to be planted. When we divide the tubers, we must arrange the parts of the same tuber in symmetrical positions.

### A. *Linear Arrangements.*

| | | |
|---|---|---|
| 1. White Dahlia. | 1. White Dahlia. | 1. White Dahlia. |
| 2. Scarlet-red Dahlia. | 2. Scarlet-red Dahlia. | 2. Scarlet-red Dahlia. |
| 3. White Dahlia. | 3. Dark-green-purple Dahlia. | 3. Dark-green-purple Dahlia. |
| 4. Rose-lilac Dahlia. | 4. Rose-lilac Dahlia. | 4. Rose-lilac Dahlia. |
| 5. Yellow Dahlia. | 5. Yellow Dahlia. | 5. White Dahlia. |
| 6. Violet or Purple Dahlia. | 6. Violet or Purple Dahlia. | 6. Yellow Dahlia. |
| 7. Orange Dahlia. | 7. Orange Dahlia. | 7. Violet or Purple Dahlia. |
| 1a. White Dahlia, &c. | 1a. White Dahlia, &c. | 8. Orange Dahlia. |
| | | 1a. White Dahlia, &c. |

# TAB BY SCALES OF COLOURS,

GIVEN TO...TING THE COLOURS OF A PLANT RICH

No. 1.                                              [*To face p.* 282.

| White... | 6th Scale. Crimson. | 7th Scale. Violet. |
|---|---|---|
| Blanc de l'H...* Blanc à tuy... runs- Blanc à gros Roi des blan... ...ngl.). | 1. Rose de l'Haÿ. 2. Mademoiselle. 3. Dona-Maria (française). 4. Cramoisi de l'Hay. 5. Montebello. 6. Mme. de Mervalle* 7. { Sans égal.* Globe Cramoisi.* 8. Pulla.* | 1. Ninon. 2. Blanche panaché de violet. 3. Duchesse de Berri. 4. Douce Amélie. 5. Lilas gris. 6. Reine de Naples. 7. Royal-lilas.* 8. Mlle. Richer. 9. Anemone flora.* (1) 10. Théodore.* 11. Royal pourpre. 12. Amiral de Rigny. 13. Pourpre de Weis. 14. Duc de Reichstadt.* |
| Commencing...th the larges... | Commencing with the lightest. | Commencing with the lightest. |
|  | The *crimson brown* 8. of this scale is as deep as the *imperiosa* of the Scarlet scale. |  |
| *Observa...* This table ...piled in 1835 ... date many ... rieties named... appeared ... ...merce, or are is the reason marked with ... the varieties w... ...ses (1830). When the ...veral dahlias ...same number it indicates ... are of the sa... of tone. It must n... posed that th... indicate ... tones; they ... dicate that f... from No. 1. increase in t... |  | (1) Approaches the scale 6. a little. |

...IAS BY SCALE OF COLOUR, MADE IN 1838.

| 6th Scale. CRIMSON. | 7th Scale. PURPLE. | 8th Scale. VIOLET PURPLE. | 9th Scale. VIOLET. |
|---|---|---|---|
| 1. Countess of Harrington. Calliope. 2. Mexico. Villageoise. 3. Hope or Metropolitan rose. 4. Mrs. Neville. 5. Don Carlos (a little yellow). 6. Coligny. 7. Thompson. Lord Bath. 8. Thompson's rival. 9. Louthiana or Addison. | 1. Oxford rival. Champion (Wells). 2. Princess Bagration. Robert Buist. 3. Marquis of Camden. Georges. Firmie. 4. Silvia (Widnall's). 5. Lady Kinnaird. 6. St. Leonard's rival. Hillarise. 7. Heroes of Navarino. Marquis of Lothian. | 1. Charles Kenrick. 2. Beauty (Brown's). 3. Stuart Wortley. 4. Marc-Aurel. 5. Mary Wellers. Adèle. 6. Canopy. 7. Rival Purple. (Gaines'). 8. Purple (Gaines'). | 1. Marshame. 2. Mme. de Courteille. 3. Grand falconer. 4. Marquis of Anglesea (a little yellow). 5. Léontine. |

## Observations.

...e arrangements of Dahlias, and ...of flowers, we must prefer the ...to the harmonies of analogy, and ...ringing together Dahlias which ...ring scales.
...here is a great number of varieties ...ve not mentioned in the Tables, ...arts differently coloured, too dis- ...with Dahlias of a single colour. ...ry valuable in arrangements of ...to avoid returning too frequently ...ours: the rules for inserting them ...a single colour are deduced from ...y which we judge which is the ...see mixed varieties, after having ...at a sufficient distance to see only ...uniform.

I name several varieties of mixed Dahlias:—
A. *White with Yellow and Purple.*
   1st *Series.* 1. Angélique. 2. Pindarus. 3. Eliza.
   2nd *Series.* 1. M. de Mondeville. 2. Queen of the Fairies.
B. *Fine Yellow and Red, variegated.*
   1. L'honneur du Belvedère. 2. Cromwell. 3. M. Lemyre. 4. Columbus.
C. *Dull Yellow with Red, variegated.*
   1. Paganini. 2. Hortense. 3. Arlequin.
D. *Yellow with Purple, variegated.*
   1. Beauté de Tivoli. 2. Beauté de Passy. 3. Marsh Parrangon. 4. Louise Marchais.
E. *Yellow with Violet-Purple, variegated.*
   1. Duchesse de Richelieu. 2. Proteus. 3. Clio. 4. Claro perfecto.

### B. *Groups of Dahlias.*

We can make groups composed of five or of seven dahlias. A larger number forms a bed.

Groups of five dahlias are quincunxes. We arrange the one in relation to the others as the two diagrams indicate, in such manner that there are three parallel lines of dahlias.

Those on each line are equi-distant from each other.

Groups of seven dahlias present three similar parallel lines; all the dahlias on the central line are at equal distances from each other. Nothing is easier than to plant them; we fix in any way by the middle three straight rods of about six feet in length, forming six equal angles, or six angles of 60 degrees each, as represented by the annexed diagram. We place this apparatus level, in such manner that one of the rods will be on the central line, then place seven sticks at the places where the seven dahlias are to be planted. We then continue to apply the three rods to the space to be occupied by the second group; that  is to say, the centre of the bundle will be upon the central line, nine feet from the centre of the preceding group.

To avoid all error in planting groups, we should figure them on paper by means of wafers, the colours of which correspond to those of the dahlias; then deposit at the foot of each rod the tubers marked with their little coloured label. If a group of seven contains six individuals of the same variety, we should endeavour to divide a tuber into six equal parts, in order to have every possible chance of the six individuals being identical. In the case where we divide a tuber only into three parts, we must alternate these parts. This precaution must be taken in every case where we would have symmetry.

## Groups of Dahlias.

*a.* 1. Six Orange Dahlias - centre Purple or Violet.
2. Six Purple or Violet Dahlias centre Yellow.
3. Six Yellow Dahlias - centre Purple or Violet.
4. Six Scarlet-red Dahlias - centre White.
5. Six White Dahlias - centre Scarlet-red.
6. Six Pink Dahlias - centre White,
7. Six dark-green-purple Dah. centre Orange.

If we make this arrangement in a straight plat-band, the centre of which corresponds to the principal point of sight, we can place No. 7. in the centre of the group, and repeat on the right side of the group in the following order, in setting out from No. 7, 6, 5, 4, 3, 2, and 1, in supposing that the plat-band will be filled by thirteen groups; if it will hold fifteen, we must put at each end a white group.

If the plat-band is circular, and has no central point of view, after 7 we commence with 1, 2, 3, 4, 5, 6, 7, and so on.

The diagrams *b, c,* and *d,* present various symmetrical arrangements of groups.

*b.* Six Purples or Violets - centre Yellow.
Six Orange - - centre White or Dark-purple.
Six White - - centre Scarlet-red.
Six Orange - - centre White or Dark-purple.
Six Purple or Violet - centre Yellow.

*c.* Six Yellow - - centre Purple or Violet.
Six Lilac - - centre White or Yellow.
Six White - - centre Scarlet.
Six Lilac - - centre White or Yellow.
Six Yellow - - centre Purple or Violet.

*d.* Six Dark Purple - - centre Yellow.
Six Scarlet-red - - centre White.
Six White - - centre Scarlet-red.
Six Scarlet-red - - centre White.
Six Dark-purple. - - centre Yellow.

In a straight plat-band which will hold more than five groups, we can make one of the three preceding arrangements, *b, c, d,* with the following additions: —

If the straight plat-band will hold seven groups, we can,

> 1. Terminate the arrangement *b,* by two White or Yellow groups.

2. Terminate the arrangement *c*, by two White or Violet groups.

3. Terminate the arrangement *d*, by two White or Yellow groups.

We can also place in succession the arrangement *b*, *c*, and *d*.

When we do not require to see from a distance and distinctly arrangements of dahlias similiar to those which I have described we can arrange the following upon the same line:

(1st.)
White. Pink.
O   O
Pink. Yellow. White.
O   O   O
White. Pink.
O   O

(2nd.)
White. Orange.
O   O
Orange. Violet. White.
O   O   O
White. Orange.
O   O

(3rd.)
Violet. Yellow.
O   O
Yellow. White. Violet.
O   O   O
Violet. Yellow.
O   O

(4th.)
Scarlet. White.
O   O
White. Yellow. Scarlet.
O   O   O
Scarlet. White.
O   O

(5th.)
Dark-purple. White.
O   O
White. Pink. Dark-purple.
O   O   O
Dark-purple. White.
O   O

In this arrangement we can substitute Purple for Violet.

In the instance where we wish to make a symmetrical arrangement of nine groups, we must repeat, in setting out from 5, the groups, 4, 3, 2, and 1.

If there is space for eleven groups, we must repeat, at each of the extremities of the preceding arrangement, the group 5.

### C. *Beds of Dahlias.*

I shall make no other remark than insisting upon the necessity of all the individuals of the same variety being symmetrically placed, by taking the precautions of which I have before spoken (page 283.).

(761.) In September, a line of almond laurels, and of *Mespilus pyracantha* garnished with their red fruit, has a good effect. Privets (*Ligustrum vulgare*), adorned with their dark-blue berries, contrast equally well with the *Mespilus pyracantha* or with holly (*Ilex aquifolium.*).

---

(762.) *Arrangement of Flowers for the Month of October.*

The month of October may also be remarkable, if the season is favourable, for the beautiful arrangements it can derive from the varieties of Chrysanthemum of various colours—White, Red, Pink, Orange, Yellow—with which may be associated to great advantage the large blue aster; and these arrangements are much easier to realise when the chrysanthemums have attained their full development in pots.

I now indicate several linear arrangements, and different arrangements in groups and beds.

### A. *Linear Arrangements.*

(a) 1. White Chrysanthemum.
    2. Red Chrysanthemum.
    3. White Chrysanthemum.
    4. Pink Chrysanthemum.
    5. Yellow Chrysanthemum.
    6. Large Blue Aster.
    7. Orange Chrysanthemum.
    1a. White Chrysanthemum, &c.

(b) 1. White Chrysanthemum.
    2. Red Chrysanthemum.
    3. Yellow Chrysanthemum.
    4. Large Blue Aster.
    5. Orange Chrysanthemum.
    1a. White Chrysanthemum, &c.

*Linear Arrangements with Symmetrical Centre.*

(c) 1. Red Chrysanthemum.
    2. Yellow Chrysanthemum.
    3. White Chrysanthemum.
    4. Orange Chrysanthemum.
    5. Large Blue Aster.
    6. Orange Chrysanthemum.
    7. White Chrysanthemum.
    8. Yellow Chrysanthemum.
    9. Red Chrysanthemum.

We can commence with a White Chrysanthemum and finish with the same, if, instead of nine places, we have eleven.

(d) 1. White Chrysanthemum.
    2. Orange Chrysanthemum.

[Sect. IV. Chap. III.]   COLOURS OF FLOWERS.   287

   3. Large Blue Aster.
   4. Yellow Chrysanthemum.
   5. White Chrysanthemum.
   6. Yellow Chrysanthemum.
   7. Large Blue Aster.
   8. Orange Chrysanthemum.
   9. White Chrysanthemum.

If, instead of nine places, we have eleven, we can commence and finish with a Red Chrysanthemum.

### B. *Groups.*

```
        1.                      2.                      3.
      White.                  White.                   Blue.
        O                       O                       O
 Red. O   O Yellow.   Yellow. O   O Yellow.   Orange. O   O Orange.
      Blue.                   Blue.                  Yellow.
        O                       O                       O
Yellow.O   O Red.    White. O   O White.    White. O   O White.
      White.                 Yellow.                   Blue.
        O                       O                       O

        4.                      5.                      6.
      Blue.                    Pink                    Red.
        O                       O                       O
Orange. O  O Orange.  Yellow. O   O Yellow.   White. O   O White.
      White.                  White.                 Yellow.
        O                       O                       O
 Blue. O   O Blue.     Pink. O   O Pink.     Red. O   O Red.
     Orange.                 Yellow.                  White.
        O                       O                       O
```

Here we have six groups in which the colours are well assorted.

### C. *Beds.*

```
 Red.   Yellow.   Pink.    Yellow.    Pink.    Yellow.   Red.
  O       O        O         O         O         O        O
White.  Blue.    White.              White.    Blue.    White.
  O       O        O     Red. O        O         O        O
                           O
 Pink.  Yellow.                               Yellow.   Pink.
  O       O                                     O        O
                 Blue.              Blue.
         White. O     Yellow.  O    White.
           O      O             O    O
                  Red.          Red.
                   O  White.     O.
                       O
```

Represents a mass of Chrysanthemums and Blue Asters of a fine effect.

*Remarks.*

(763.) The plants composing each of the assortments I have just named, observed during several years in the neighbourhood of Paris, on an elevated plain, have each year flowered simultaneously; but in years of extremes there will be differences; then the advantage of contrast of colours resulting from assortment will not occur. But if this enjoyment is lost, we must not make any great objection to the system of assortments; and besides, in the employment of the same plants for the decoration of gardens, the assortment I prescribe, although having the defect of simultaneous flowering, will have nevertheless an advantage over ordinary plantations, because the plant not flowering at the same time as its neighbours, will by its symmetrical position present something more agreeable to the sight than if there was no symmetry between the plants which are in flower and those which are not.

(764.) If, under circumstances differing from those in which I have made my observations on the average simultaneous flowerings, such as different situations under the climate of Paris, or in a different climate from that, we remark that the flowerings which I have given as simultaneous are not uniform, the plant which causes the defect must be replaced by another of the same colour, and which will be also as analogous as possible.

(765.) The associations of plants indicated for flowering in the first months of the year, are more exposed to failure than those of the following months, on account of the mild or the cold temperature of the winter.

(766.) Among the associations indicated for flowering in one month, there may also be some which flower in the succeeding months.

## CHAPTER IV.

**EXAMPLES OF PLANTS WHICH CAN BE ASSOCIATED TOGETHER UNDER THE RELATION OF THE COLOUR OF THEIR FOLIAGE.**

(767.) GARDENERS insist much more upon the result which may be derived from the effects of the foliage of trees and shrubs, than upon that which may be obtained from the effects of flowers; doubtless in consequence of the latter occupying less extent of surface than the leaves, as they are also of shorter duration, and, I add, (conformably to an extreme opinion which excludes them from landscape gardening), as suggesting too strongly the hand of man. From this we should expect to find in works on gardening some indications suitable for making associations of foliage, either by contrast or by analogy, conformably to the principles which have always guided me. But it is not so!

The authors of these works confine themselves to generalities, and in the few examples cited by them, I cannot even say that they have sufficiently distinguished the effects arising from the particular form of the leaves from the effect resulting exclusively from their colour.

If in this Chapter I do not supply what I regard as an omission on the part of writers on gardening, it is because my own observations are not sufficiently numerous to enable me to cite with confidence a series of examples analogous to those which I have given in the preceding Chapter, relative to the associations based on the colour of the flowers. Besides, I shall indicate in the following Sub-section some associations of plants in which I have taken the foliage into account, but subordinating the effects to others which appear to me more important to obtain; such is the reason why I abstain from treating the subject in this Chapter.

# SECOND SUB-SECTION.

### ON THE DISTRIBUTION AND PLANTING OF VEGETATION IN MASSES.

INTRODUCTION (768—770.).

CHAPTER I.—LINES OF VEGETATION (771—781.).

CHAPTER II.—OF HOMOGENEOUS MASSES (782—785.).

CHAPTER III.—OF HETEROGENEOUS AND VARIED MASSES (786—805.).

CHAPTER IV.—ON THE PRINCIPLES UPON WHICH THE SYSTEM OF PLANTATIONS PROFESSED IN THE TWO PRECEDING CHAPTERS IS BASED (806—828.).

## SECOND SUB-SECTION.

ON THE DISTRIBUTION AND PLANTING OF TREES, ETC. IN
MASSES.

### INTRODUCTION.

(768.) The principal object which I propose to myself in the two following Chapters is, to supply a deficiency in works on gardening relative to the manner of distributing and planting trees, &c., conformably with precise rules, in masses the outlines of which have been previously sketched. For authors say nothing on this subject, and the embarrassment of a land-owner who wishes to plant an estate already planned out is further increased by this circumstance, that, in the majority of cases, the author of the plan of the projected garden, after having defined the lines of the plantations, indicated the places where isolated trees must be placed, designated the kinds of trees which should constitute groups, and others which must enter into the formation of masses with trees and shrubs (which generally he does not indicate), leaves the care of planting and other details to ordinary gardeners.

Yet the distribution of trees and shrubs, however easy it may appear, in a piece of ground otherwise perfectly planned, contributes more than is generally supposed to the pleasure of a landscape garden, and presents also more difficulties than to allow of their being made in a satisfactory manner, when they are abandoned, so to speak, to chance, as it generally happens. In fact, if, at the end of a few years, we observe the greater part of masses planted as they so frequently are, we shall be struck with defects which were not at first perceptible, because we were then under the influence of the pleasure we always experience at witnessing the development of plants which have been confided to a carefully prepared soil, and besides, there are some defects which are only perceptible after a certain time; such as, for example—

1. *That resulting from the plants being placed too near together.* It may happen that one being developed more rapidly than another ends by killing the latter; or that all develope themselves at once, but badly, because they reciprocally injure each other.

2. *That which arises from placing in the front row clumps which rise too high, or which lose their lower branches.* Such are the Elder-tree, and Sumach (*Rhus coriaria*).

(769.) It was after many years of lost enjoyments through having planted without fixed rule, masses otherwise well designed in their contours, that I was led to seek, by my own experience, the means of avoiding similar errors in future. The rules I now give are not the result of reflection merely; they have been practised many years, and I am much deceived if those who observe them do not derive great facilities in their application, and experience a lively satisfaction when they compare the effects of plantations made in conformity to the method prescribed, with those planted at random, so to speak. Hereafter I shall substantiate these rules by the principles derived from the faculties themselves which place us in connection with objects of nature and art, when we seek the pleasures of colour, form, and arrangement.

(770.) I will now define several expressions employed to designate the different associations of plants which may form part of a landscape garden.

An association of trees and shrubs occupying a large space is termed a *forest*. But in a landscape garden a similar association, or what amounts to the same thing, that which has been arranged to present the appearance of a vast space, is called a *wood*, if it is composed of trees and underwood; and a *park*, if it consists of trees only.

An association of trees, shrubs, bushes, and underwood, and also of *flowering* herbaceous plants, occupying a medium or small extent, is called a *thicket*.

A similar mass, when formed of trees and underwood, is called a *grove;* when it consists only of trees, it is termed *a shrubbery* or *group of trees*.

There are *thickets* of shrubs, bushes, underwood, and flowering herbaceous plants.

There are *thickets* formed of plants of a single species, and thickets formed of several species. The first are called *homogeneous*, and the second *heterogeneous* or *varied*.

There are *isolated masses*, and *masses subordinated together*.

A small mass of flowers or shrubs, isolated and of a circular or elliptical form is called a *bed*.

The following table represents the mutual relations of all the expressions I have defined.

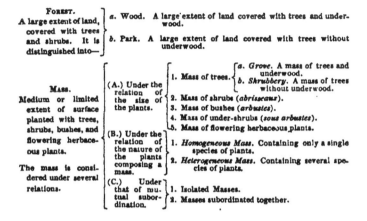

## CHAPTER I.

#### OF LINES OF PLANTS.

(771.) I CALL a *line of plants*, plants placed at equal distances from each other in straight or curved lines; these plants may be trees, shrubs, bushes, underwood, or flowering herbaceous plants.

> RULE.—*To make a line of plants, we place a rope in such a manner that it occupies the centre of the projected plantation; then place stakes at equal distances apart, so that each will represent a centre of vegetation; we remove the rope on making the holes, then plant.*

(772.) A *line of plants* of sufficient extent, and of which the plants are close enough to conceal from view objects placed behind them, is called a *Screen*; such are a hedge of hornbeam, a row of *thujas* concealing a wall, &c.

(773.) All masses planted according to my method are composed of lines of plants parallel to each other, or, in other words,

there is between two similar lines an equal distance throughout: thus, in a mass formed of five straight or curved lines the extremities of which do not join each other, there will appear everywhere the same distance between the first and the second, between the second and the third, between the third and the fourth, and between the fourth and the fifth. But the distance between the first and the second may differ from the distance between the second and the third, and so of the others. The result would be the same, if the lines were closed curves; as, for instance, the circumference of a circle, which has no extremities. The lines of plants considered under this point of view relatively to the *masses*, are the elements of them. It is evident that we must have at least two lines of plants to constitute a mass.

### ARTICLE 1.
*Of the Lines of Plants called* SCREENS (772.).

(774.) When we desire to conceal a wall, or, more frequently, any object of considerable extent, we have recourse to a *screen of plants*. Whenever the extent of the land will not permit of the planting of several lines constituting a mass, the essential condition to be fulfilled is, that the plants which form the screen are, at least, of the height of the object they are intended to conceal, and are covered with leaves to the ground. Evergreens, such as thujas, almond-laurels, &c., are those to be preferred; succeeded by the hornbeam, lilac, privet, &c.

(775.) The most homogeneous screens, that is to say, those which are formed of a single species of plant, are preferable to all others for the object they are intended to fulfil; and if we would avoid the monotony resulting from the sight of a single species, we must have recourse to another which offers varieties. For example, a screen composed of violet and white lilacs will possess at the same time the advantage of homogeneity for concealing what is behind it, and the advantage of variety of foliage; for, as is well known, the violet lilac has darker leaves, or a green less yellow than those of the white lilac. We may alternate one or more plants of violet lilac, with a plant of white lilac.

(776.) It is difficult to give with exactness the distance which should separate the plants intended to form a screen, because there is a relation, which must be observed, between the height of the object we seek to conceal, and the height to which the plant will grow. Thus, when the height of the object is small, we can make the distance between each plant less than when the height is greater. In a word we must attain the double

aim of having a screen sufficiently elevated, and sufficiently covered with leaves from the ground. Some plants, susceptible of high growth, lilacs, for example, if planted too near, injure one another, and, planted too far asunder, they increase in height too much, and lose their lower foliage.

(777.) If we do not wish to make a hedge, we can observe the following distances: —

> Between two thujas (*Thuja occidentalis*), from two to three feet.
> Between two lilacs, from four to five feet.
> Between two privets, three feet.

### Article 2.

*Of Lines of Plants considered as* Elements *of Masses.*

(778.) From the manner in which I have considered a line of plants as the element of a mass, there follow, in my opinion, two conditions, which I regard as absolute, and a third, which, without possessing this character, ought generally to be taken into consideration in the planting of a mass.

> 1st. *Condition (absolute).* If the plants in the same line are not of the same species, it is essential that they do not differ too much from each other in respect to height.
>
> 2nd. *Condition (absolute.)* In the case where a line happens to be entirely seen, the same species must be placed alternately.
>
> 3rd. *Condition (not absolute but general.)* We must avoid placing the same species in two neighbouring lines, when we would employ varied masses which are only composed of several lines.

(779.) Rule.— *When we plant two lines of vegetation to constitute a mass, in planting the first or exterior line we must follow the rule indicated above* (771.), *then proceed with the planting of the second line in the same manner as with the first, except that the stakes indicating the centre of vegetation must be placed chequer-wise relatively to the centre of vegetation of the first line.*

(780.) I will cite an example of a plantation of two lines intended to conceal a wall.

1st *Line*, 1. Almond Laurel.
          2. Violet Lilac.
          3. Laburnum.
          4. Violet Lilac.
         1*a*. Almond Laurel, &c.
2nd *Line*, 1. Clump of *Prunus mahaleb*.
          2. *Idem*, &c.

The distance between the clumps of the first line is four to five feet.

(781.) We may plant the first line in *screen*, and the second with trees larger than in the first; we may also plant the second line with roots of *Prunus mahaleb*, comprehending between two roots three or five clumps of the same species.

## CHAPTER II.

### OF HOMOGENEOUS MASSES.

(782.) The *homogeneous mass* includes only a single species of plant; because the intention of the gardener in forming it being to produce an effect of *individuality*, nothing is more suitable for this object than a collection of identical things.

(783.) In the large French garden designed by Lenotre, where the trees combine so effectually with the elements established by the architect to prolong, so to speak, a similar work, the symmetrical plantations are identical, and generally composed of trees of a single species.

(784.) If, in a large composition, homogeneous masses of trees have a good effect, it is not so with those which are composed of a single species or of a single variety of flower. They almost always present a monotonous aspect, especially if these latter have a definite extent; and if the species of plant of which they are composed is in flower only a part of the year, the defect of monotony will be found greatly increased.

(785.) Homogeneous masses of shrubs or of flowers are only suitable when they are in leaf or in flower during a great portion of the year, as their extent is small, and they serve simply as a bond of union between different parts more or less distant from each other.

## CHAPTER III.

#### OF HETEROGENEOUS OR VARIED MASSES.

(786.) In order to fully understand what I have said of masses of this kind, I shall distinguish two cases; one where it is a *heterogeneous* or *varied* mass, isolated, intended to serve as an individual composed of distinct parts,—and the other where it consists of many varied masses, allied together, and separated by paths, at least in some parts.

### § 1.

#### ISOLATED HETEROGENEOUS OR VARIED MASS.

(787.) This mass may be composed of lines, each of which may contain only a single species of plants, or it may consist of several.

(788.) If each line consists of only a single species, we must arrange them, from the first to the centre, according to their size: for example, we should put

> In the 1st Line, Violet lilacs;
> 2d Line, Laburnum;
> 3d Line, Judas trees.

This mass is only preferable to the following, in the case where it is isolated and intended to be seen without obstacle on all sides.

(789.) If each line contains many species, we must always observe the rule of placing the smallest in the front line. Each line should be planted as I have suggested above (771.).

### § 2.

#### HETEROGENEOUS OR VARIED MASSES SUBORDINATED TO EACH OTHER.

#### ARTICLE 1.

*General Considerations.*

(790.) *Heterogeneous or varied masses* placed together so as to form a whole, are generally separated from each other,

1°. by paths, 2°. by glades, or unplanted intervals, but cultivated or sown in grass.

To thoroughly understand what follows, I must point out the essential difference that exists between landscape gardening and French gardening (geometrical).

(791.) French gardening is regular and symmetrical: the paths are straight, and the eye is only impressed by objects slightly varied; for when there are squares, or straight borders, symmetry necessarily requires that the objects on one side be repeated on the other. The result is, that when the spectator has visited the principal points of this composition, which are never very numerous, he has seen everything it is susceptible of offering to his curiosity.

(792.) I shall not say, with some writers, that landscape gardening is conceived according to the *principle of irregularity*, or after a *method diametrically opposed* to that which governs the design of a French garden; but I shall say it is conceived with an entirely different aim. The spectator who surveys a landscape garden should be excited, so to speak, at every step by the sight of various objects. The different points of view must then be as numerous as possible; the paths must always be traced in such manner that from no point can we discover their whole extent. The plantations must be disposed so as to conceal the walls, the fences, and other disagreeable or ill-placed objects. They must allow the eye the greatest possible scope at all the points the gardener wishes displayed; on the other hand, the views must vary with the different points successively observed by the spectator in his promenade.

(793.) To attain this aim, it is evident that there must be no straight paths, but only curved ones; because, in fact, it is only in the latter that those who walk in them will be unable to see their entire length from any one spot, when all these paths pass between the masses; the intervals between these masses must also permit of our perceiving an *ensemble* of objects, more or less agreeable, which must form planes skilfully prolonging the perspective as far as possible. The masses, each presenting variety, must nevertheless be allied together so that the plantations of the one may harmonise with those of neighbouring masses, as dependent parts of the same whole.

## ARTICLE 2.

*Rules to be followed in planting Heterogeneous Masses subordinated to each other.*

(794.) The contours of paths and of subordinated masses being fixed, the following rules must be observed in the planting.

(795.) 1st RULE.— *With a cord trace lines parallel or concentric to the line which circumscribes each mass, as is shown in the masses,* 1, 2, 3, 4 *of Pl.* 4.

In the mass 1 there are four closed concentric lines.

In the mass 2 there are only two lines concentric with the complete line of circumscription, and a central curved line which divides it into two parts.

I trace a central line in all the masses, in the centres of which I plant trees of much larger size than those which must be placed in the closed concentric lines.

In the subordinated triangular masses placed between three paths, as are the masses 3 and 5, we must distinguish those which are reduced by a line A B, (prolongation of the axis of the path A A), into two very unequal triangles, as A B D and A B C of the mass 3, and those which are reduced into two triangles almost equal, as A B D and A B C of the mass 5. In the first, as in the mass 3, the large plants must be found in the line A B and not at the angles D and C, while in the mass 5 the largest plants will be found not only in A and B, but also in C and D. The principal reason I give for this difference is that the spectator who sees from the path A A the angle A of the mass 3, does not see the angle C; while from the same path, observing the angle A of the mass 5, he sees at the same time the angles C and D. Now this circumstance imposes the condition that we must have as much homogeneity as possible between the two parts of the same whole, which are seen simultaneously.

(796.) 2nd RULE.— *The lines of planting being fixed, I divide each of them into equal parts by means of stakes which represent the centre of the plants we put on these lines; the plants of the second line must correspond as nearly as possible to the intervals of the plants of the first line, and so on; or in other words, be planted chequer-wise.*

Nothing is more important to the producing a fine effect in plantations than to properly space the plants. It is preferable to err by excess of distance than otherwise. In the first instance we may place between one plant and another, either flowers, or small shrubs, which can subsequently be removed.

We must not lose sight of the fact that the greater the intervals the better the plants will be developed, and the more distinct they will appear; now, this condition of distinctly seeing a plant, and, if it is an herbaceous plant or a small shrub, of seeing it detached from the earth which serves as a background to it, appears to me an important condition to fulfil in order to derive the best possible effect from the plants employed to decorate a garden.

*Distance between the Plants which enter into the Composition of Masses.*

About thirty-nine inches for Bengal roses, *Kerria japonicas, Spiræas;* and about four feet if we place flowers between them, such as pansies of different colours, lilies, &c.;

About four or five feet for lilacs, *Philadelphus coronaria, chamæcerasus,* Guelder roses, almond laurels (*cerasus Laurocerasus*);

About five to six feet for *Prunus mahaleb,* laburnums, and Judas tree.

Between the lilacs and syringas we may place white and yellow irises, poppies, spiræas, and roses.

(797.) 3rd RULE.— *Every mass must be viewed as a whole (as the Mass 1, Pl. 4). Every mass placed against a wall to conceal it (as the Mass 8, Pl. 4.), must be composed of lines each presenting the same species, or varieties of the same species, occurring at equal intervals.*

The smallest plants, whether herbaceous, underwood, shrubs, bushes, must be in the front lines, and the larger ones in the lines receding from the first.

For example,—

The Mass No. 1. of Pl. 4., is a clump of Bengal roses: it is composed of four lines of roses, and three lines of herbaceous plants.

1st *Line,* Roses; red, pink, red, &c.

2nd *Line*, Persian iberis, red tulip, *Alyssum saxatile*, bulbous iris (*Iris Xiphium*), *Hemerocallis flava*, bulbous iris, iberis, &c.

3rd *Line*, Roses; pink, white, pink, &c.

4th *Line*, Escholtzia, flax, Escholtzia, bulbous iris, *Hemerocallis flava*, bulbous iris, Escholtzia, &c.

5th *Line*, Roses; red, pink, red, &c.

6th *Line*, Persian iberis, red tulip, *Alyssum saxatile*, bulbous iris, *Hemerocallis flava*, bulbous iris, Persian iberis, &c.

7th *Line*, Roses; pink (or noisette), white (or white noisette), pink, &c.

The Mass No. 8. is composed in the following manner:—

1st *Line*, Roses; red, pink, red, &c.

2nd *Line*, Roses; pink, white, pink, &c.

3rd *Line*. Red Provence rose, *Jasminum fruticans*, red Provence rose, &c.

4th *Line*, Violet lilac, *Genista hispanica*, violet lilac, &c.

5th *Line*, *Prunus mahaleb*, laburnum, *Prunus m.*, &c.

6th *Line*, *Ulmus campestris, Sambucus nigra, Acer pseudoplatanus, Sambucus racemosus, Ulmus campestris*, &c.

Between the first and second ranks there are Persian iberis, flax, *Alyssum saxatile*, Escholtzia, iberis, &c., at a distance of about six feet from each other.

(798.) 4th Rule.— *In the Masses composed of large trees, and which, as the Mass 2 of Pl. 4., are contiguous to a path or to a grass meadow or lawn, a similar concentric line can have in one of its parts, species or varieties differing from those it presents in the remainder of its extent; but this change of species is only allowable when the parts of the line where it is introduced are not susceptible of being seen at the same time, at least in the whole extent.*

For example,—

1°. Every part of the first concentric line of the Mass 2, which borders the path y y, may be planted in a different manner from the rest of the same line which is on the side of the lawn or meadow.

2°. The part C D of the Mass 4 which borders the path x x, may be planted in a different manner from the part A D, and also from the part A C of the same concentric line.

Thus, in the Mass 2,—

The first line from *a* to *d* is composed of *Spiræa ulmifolia*, and of violet lilacs, and from *aa* to *dd*, of a *Spiræa 'ulmifolia* separated from the preceding by a flowering ash: then almond laurel, syringa, almond laurel, white lilac, almond laurel, &c. Between each tuft there is a pink Bengal rose. This line from *aa* to *dd* may be planted with tufts of box (*Buxus sempervirens*) and Bengal roses.

Thus, in the Mass 4,—

The first line from C to D is composed of *Syringa media* and *Jasminum fruticans*; from D to A of *Syringa media, S. vulg., Jasminum fruticans, Philadelphus coronarius, Syringa vulg., Philadelphus cor.*; from A to C of *Syringa vulg., Philad. vulg.*, &c.

The side A D and the side A C of the Mass 5, which are seen at the same time from the axis of the path, are contrary to the preceding planted symmetrically, *Spiræa hypericifolia*, violet lilac, *Spiræa hypericifolia*, &c.

(799.) 5th RULE. — *We must avoid as much as possible putting the same species or varieties in two different concentric lines.*

For instance, if we put lilacs and *Philadelphia coronarius* in the first line of a mass, we must avoid putting them not only in the second line, but also in the third. This remark has been made before (778.).

(800.) 6th RULE. — *In the masses intended to receive trees, these latter must be placed at double, triple, or quadruple distances from the intervals left for the tufts; and between the trees we may place tufts which would be improperly placed in the front rank, because they would be too elevated, and which, like the* Elder, *are without foliage down to the roots.*

For example, the line E F of the Mass 2, Pl. 4., is composed of a clump of *Sambucus nigra*, a *Robinia viscosa*, a *Sambucus racemosa*, a sycamore, a clump of *Sambucus nigra*, an *Æsculus rubicundus*,

clump of *Sambucus racemosa*, a sycamore, a clump of *Sambucus nigra*, an *Æsculus rubicundus*, a *Colutæa arborescens*, a sycamore, an *Æsculus rubicundus*, a *Spiræa ulmifolia*, a *Fraxinus florifera*, a *Spiræa ulmifolia*, and an *Æsculus rubicundus*.

As the distance is considerable which separates the trees from the tufts of the second concentric line in the part E of the medial line, there are planted in fives around the first two trees, four little tufts of *Ribes aureum*, which must afterwards be removed.

(801.) 7th RULE.—*We ought to alternate trees with tufts only in planting an avenue, or in a line of tufts of which we wish to correct the monotony resulting from uniformity of height and form, and whenever there is no objection to seeing the objects placed behind this line.*

*1st EXAMPLE.

*Avenue or Belted Path.*

1. *Platanus Occidentalis.*
   Prunus mahaleb,
   Judas Tree,    } Tufts.
   Prunus mahaleb,

2. *Ulmus campestris.*
   Violet Lilac,
   Laburnum,    } Tufts.
   Violet Lilac,

3. *Sycamore.*
   White Lilac,
   Judas Tree,    } Tufts.
   White Lilac,

4. *Robinia viscosa.*
   Violet Lilac,
   Laburnum,    } Tufts.
   Violet Lilac,

5. *Betulus alba.*
   Prunus mahaleb,
   Judas Tree,    } Tufts.
   Prunus mahaleb,

6. *Robinia viscosa.*
   Violet Lilac,
   Laburnum,    } Tufts.
   Violet Lilac,

7. *Sycamore.*
   White Lilac,
   Judas Tree,    } Tufts.
   White Lilac,

8. *Ulmus campestris.*
   Violet Lilac,
   Laburnum,    } Tufts.
   Violet Lilac,

9. *Platanus Occidentalis.*
   Prunus mahaleb,
   Judas Tree,    } Tufts.
   Prunus mahaleb,

The trees are so disposed that the smallest, the *Betula*, is at equal distance from left to right of the same species, the extremes of which, the *Platanus* and *Ulmus*, must be considerably higher than it.

For greater variety we may alternate two rose acacias with two white acacias (*Robinia pseudo-acacia*); replace one of the two birches by a hawthorn (*Mespilus oxyacantha*); replace one of the planes by a *Celtis australis*.

### 2nd EXAMPLE.

*1st Line*, 1. *White Hawthorn.*
     1. Violet Lilac.
     2. Syringa.
     3. Violet Lilac.
     4. Syringa.
     5. Violet Lilac.

  2. *Red Hawthorn.*
     1. Violet Lilac.
     2. Syringa.
     3. Violet Lilac.
     4. Syringa.
     5. Violet Lilac.

  3. *White Hawthorn*, &c.

*2nd Line, forming a Screen.*
     1. Laburnum.
     2. *Prunus mahaleb.*
     1a. Laburnum, &c.

### 3rd EXAMPLE.

*Plantation of Fruit Trees and Bushes of Twelve Feet in breadth, intended to conceal a Kitchen Garden or any other object, and at the same time to present to the Eye a Background, on the side of the Garden.*

*Line on the Side of the Kitchen Garden.*

1. Apricot (*Armeniaca vulgaris*).
2. Violet Lilac.
3. White Lilac.
4. Violet Lilac.
5. Almond Laurel, or White or Violet Lilac.
6. Violet Lilac.
7. White Lilac.

8. Violet Lilac.
9. Pear Tree.
1*a*. Violet Lilac, &c.

*Line on the Side opposite to the Kitchen Garden.*

1. Cerasus juliana.
   Ribes rubrum.
   Berberis vulgaris.
   Ribes rubrum.

2. Malus communis.
   Ribes rubrum.
   Pyrus cydonia.
   Ribes rubrum.

3. Armeniaca vulgaris.
   Ribes rubrum.
   Berberis vulgaris.
   Ribes rubrum.

4. Pyrus communis.
   Ribes rubrum.
   Pyrus cydonia.
   Ribes rubrum.

1*a*. Cerasus juliana, &c.

There is an interval of about sixteen feet between two trees. The tufts of *Pyrus cydonia* and *Berberis vulgaris* are in the middle. The tufts of *Ribes rubrum* are about three feet and a quarter from the tree, and consequently, about three feet and a half from the tuft of *Berberis vulgaris*, or the *Pyrus cydonia*. It is plain that the eye perceiving more readily the tree and the two little tufts which are on each side, the principle of symmetry bears upon this arrangement, and not upon that of the central tuft with the two little tufts.

If we wish to contrive a clear and distant view from the other side of the line, as in the first example, the distance must be equal between the tufts and from a tuft to a tree.

Between the two lines we may place a line of tufts arranged in the following manner — the spectator being placed on the side opposite to the kitchen-garden, — behind each tree of the first line, a *Jasminum fruticans* —

On both sides of each tree, at equal distance from the jasmine, two privets, and at the next tree two evergreen thorns; behind each tuft of *Pyrus cydonia* or *Berberis vulgaris* a tuft of raspberry.

(802.) 8th RULE. — *To establish Harmony* —
1. Between different masses subordinate together, —
2. Between different masses which, without being subordinated, are in proximity, —
3. Between masses more or less distant from each other, —
We have recourse —
   1°. *To similar vegetable forms; that is to say, to the same species or varieties, or to analogous forms:*
   2°. *To the same colours, or to flowers and leaves of analogous colours, which are suitably distributed in the different masses which we wish to connect or harmonise together.*

(803.) Particularly remarking, —
1. That the concentric lines of the Mass 3 harmonise, on the one hand, with the two lines of the Mass 2 concentric with the alley y y which separates these masses, and, on the other hand, with the line of the Mass 4, which is concentric with the alley x x, which separates this mass from the Mass 3.
2. That our system of planting a small number of species in the same line, recurring at equal intervals, is favourable to the harmony of the line.
3. That the planting of trees in median or concentric lines is favourable to the harmony of subordinated masses, which at a distance become as one.

A. *Example of Harmony between Masses subordinated together.*

First, let us see the composition of the Masses 2, 3, and 4, Pl. 4.

*Mass* 2.

1st. Concentric line of A *a d* c; ash in A, *Spiræa ulmifolia*, lilac, *Spiræa*, &c. . . . . . Box in c.

1st. Concentric line of A *a' d'* c; *Spiræa ulmifolia*, almond laurel, pink, Bengal rose, syringa, Bengal rose, almond laurel, white lilac, Bengal rose, &c.

2nd. Concentric line to A *a d* c; tuft of *Prunus mahaleb*, tuft of laburnum, tuft of *Prunus mahaleb*, &c.

2nd. Concentric line to A *a' d'* c; tuft of Judas tree, laburnum, tuft of Judas tree, &c.

The median line is composed of clumps of elder, a pink acacia, of sycamores, of *Æsculus rubicundus*, of flowering ash, &c., as before mentioned (800.).

*Mass* 3.

Median line A B. A box at A; clump of Guelder rose, *Kœlreuteria*, clump of Judas tree, flowering ash, clump of *Prunus mahaleb*, laburnum.

 1st. Concentric line, violet lilac, syringa, violet lilac, &c.

 2nd. Concentric line on the side A C; *Kœlreuteria*: on the central line, Guelder rose, laburnum, *Prunus m.*, laburnum, Judas tree, *Kœlreuteria*.

 On the side C B D, after the preceding *Kœlreuteria*, Judas tree, *Prunus m.*, Laburnum, *Prunus m.*, Laburnum, *Prunus m.*, Laburnum, *Prunus m.*, Laburnum, *Prunus m.*, Laburnum, Judas tree, *Kœlreuteria*.

 On the side D A, the preceding *Kœlreuteria*, Judas tree, Laburnum, *Prunus m.*, Laburnum, Guelder rose; and *Kœlreuteria* in the median or central line.

 3rd. Concentric line; commencing with the central flowering ash on the side A C, Judas tree, ash, *Prunus m.*, Laburnum.

 On the side C B D, the preceding laburnum, *Prunus m.*, ash.

 On the side D A, in commencing with the preceding ash, Judas tree.

*Mass* 4.

Median or central line of C to D; flowering ash, *Prunus m.*, *chamæcerasus, viburnum, chamæcerasus*.

 1st. Concentric line C D; box, Syringa m., *Jasminum fruticans*, Syringa m., &c.

 1st. Concentric line C A; the preceding box, *Philadelphus cor.*, lilac, *Philadelphus cor.*, &c.

 1st. Concentric line A D; *Philadelphus cor.*, lilac, *Philadelphus cor., Jasminum fruticans*, Syringa media.

 2nd. Concentric line C D; *Æsculus rubicundus*, laburnum, Judas tree; laburnum, Judas tree, laburnum; Judas tree, laburnum, *Kœlreuteria*.

 2nd. Concentric line D A; the preceding *Kœlreuteria*, laburnum *Prunus m., Æsculus rubicundus*.

 2nd. Concentric line A C; the preceding *Æsculus rubicundus*; flowering ash of the central line.

The three Masses 1, 2, and 3, are allied together.
1. By means of the lilacs of the first concentric lines.
2. By means of the tufts of *Prunus m.*, and of laburnum, of the second concentric lines.
3. By means of the syringas of the first concentric lines exterior to the Masses 2 and 4.
4. By means of the flowering ash and the *Æsculus rubicundus*, which are in the central line of the Masses 2 and 4, and the three ash-trees of the Mass 3.
5. By means of two *Kœlreuterias*, one placed at the angle D of the Mass 3, and the other at the Mass 4.
6. By means of two box-trees placed at the extremities of the Masses 2 and 4, and of one box-tree placed at the angle A of the Mass 3.

B. *Examples of Harmonies between Masses not subordinated together, but in proximity.*

The Mass No. 1., composed almost exclusively of Bengal roses, which retain their leaves a long while, is allied,
1. To the Mass No. 2., the line of which is formed of white lilac, almond laurels, and syringas, separated from each other by Bengal roses. Harmony is then established by means of the same species, and increased by means of an analogous foliage; for that of the Bengal roses harmonises perfectly with the leaves of the almond laurels, and that of the box tree, which terminates the Mass 2.
2. To the Mass No. 6., by means of a border on the side of the meadow or lawn, composed solely of pink and white Bengal roses.
3. To the Mass 4., by the foliage of the box.

The Mass No. 2. of the second line of $a'$ to $d'$ is planted with laburnums and Judas trees; and the Mass No. 4., of which the second concentric line includes the laburnums and the Judas trees, is allied to the Mass No. 6., of which the line on the side of the alley v is parallel.

The Mass 4. allies itself to a neighbouring mass, composed in the following manner: —

1st. Concentric line; *Rhus cotinus*, rose bush; *Rhus cotinus*, &c.

Between the Rhus plants there is an interval of six feet and a half.

2nd. Median line; almond laurel, tufts of Judas tree, sycamore, laburnum, *Æsculus rubicundus*, Judas tree, satin maple, laburnum, laurel, black ash.

The effect of the *Rhus cotinus*, covered with its fruit, is most agreeable during autumn.

### C. *Example of Harmony between Masses more or less distant from each other.*

Harmonies are established between distant masses by the same means as they are between neighbouring masses, except that the interval which exists between the first requires that at the principal points of view from which they must be presented simultaneously to the eyes, the forms and the colours which connect them should be plainly perceived.

The foliage in the masses being much more abundant than the flowers, the shades of their greens will not differ so much among each other as the colours of their flowers; consequently, the distant masses, whatever be the variety of their respective foliages, are always in harmony of form and colour if they have been planted according to our rules; and if they are composed solely of ligneous plants which lose their leaves in winter, or solely of evergreens, which do not lose them: but, in the opposite case, that is to say when the distant masses are formed, the one of deciduous trees, and the other of evergreens, some remarks must be made relative to the conditions of harmony, which are the more necessary as landscape gardens generally fail in this respect. For where masses of deciduous trees are found, a clump or a mass of evergreens are almost always out of keeping. To remedy this defect, we must multiply the groups or masses of evergreens, so as to establish between all of them this same correlation which is required by the deciduous trees; but it is not necessary that the trees should occupy a space equal to that occupied by ordinary trees, it is sufficient if their forms recur at suitable intervals. In a word, for evergreens to produce a good effect, they must compose only an *ensemble* which unites itself where it intercalates with the *ensemble* of the masses of deciduous trees.

We may oppose allspice trees to pines, cedars, larches; different groups composed of three or four trees only, sufficient to harmonise a large space of ground occupied with two or three groups, composed of half a hundred similar trees.

(804.) 9th RULE. — *There are certain cases where the want either of perspective or harmony, requires in a large mass a line of trees which is neither concentric with its circumference, nor identical with the central line, if there be one : such for example as the line* P R *which is found in the Masses* 1 *and* 2 *(Pl.* 4.); *for if the planting of this line be correct and consequent of the preceding principles, it is necessary that the trunks which design it, beyond the concentric plantings, be in the points of intersection of the line* P R, *with the concentric lines and the central line, if there be one; and the trunks must be as much as possible at equal distances from each other, and in places which, if they were not planted with trees, would be with some plants which compose concentric lines.*

This rule, necessary in many cases, gives to our system of planting a generalisation which it would not have without it, and by putting it in practice we establish a relation where there would have been none. I shall remark that these lines must generally be composed of plants slightly bushy, a little taller than those in front, and it will almost always suffice to have them placed at wide intervals apart. In fact, they must be regulated with respect to the height of the plants which are both behind and in front of them.

(805.) 10th RULE. — *After tracing the lines of plantations, and putting in the stakes to mark out the centre of the holes to be dug, we must draw upon grey paper lines representing those of the masses we intend to plant, taking as many equidistant points as there are stakes in the corresponding lines of plantation; we then fasten wafers on these points, or little circles of paper of the colours of the flowers or the foliage of the plants, according to the desired effect. We may extend this rule to an* ensemble *of mass on the same system.*

By this means we can judge of the harmony of the colours of flowers with the different hues of green produced by the vegetation of which we may compose a mass, and consequently rectify any defect before we begin to plant.

Although this rule is more especially applicable to the masses of flowers of which the whole extent may be seen at a single glance, it is also advantageous for plants which are intended to act by their foliage.

A system of masses thus represented, will be very suitable to enable us to appreciate not only the effect of plants composing each of them, but also the general effect of subordinated masses and of near and of distant masses. It will be very useful in enabling us to appreciate the distribution of green trees in the *ensemble* of the composition, as we can distinguish the principles of those which lose their leaves by wafers or small circles of a dark-green, different from those we employ for the others.

A similar plan, always easy to make, will allow to a landowner, when once his masses are planned, their concentric lines traced, and the species to be planted determined upon, to order from the nurseryman the exact number of each species he requires.

For a landowner there is in fact no plan more simple or more suitable for representing exactly, I do not say every tree which enters into the composition of the masses, but yet the shrubs, bushes, underwood and also the herbaceous plants which form part of it.

## CHAPTER IV.

#### ON THE PRINCIPLES UPON WHICH THE SYSTEM OF PLANTING DESCRIBED IN THE TWO PRECEDING CHAPTERS IS BASED.

(806.) It will not be useless to give a *resumé* of the principles upon which the system of planting described in the preceding chapters is based; the details into which I have entered may have made us lose sight of the *ensemble* of these principles, and this *resumé* appears to me indispensable to facilitate their application to those who would observe them.

### 1. *Principle of Height.*

(807.) Whenever we see an object occupy a greater extent in space than we had expected before seeing it, its height becomes a striking quality, independent of every other. Thus we admire the height of a tree which surpasses the dimensions we regard as common to individuals of its species.

### 2. *Principle of Form.*

(808.) One of the principal elements in our judgment of the effect of an object observed, is the form under which it appears. Consequently, plants, particularly isolated trees and clumps,

must be trained in height so as to take the form which is most advantageous to them: and this leads us to reflect that the form of the greater part of the trees of our forests is not natural to them; for if we had not raised them by removing their lower branches, instead of the trunks being straight as we see them, they would only appear as larger or smaller bushes. The habit of the trees and bushes which form part of masses, ought then to particularly engage the attention of the gardener, so that they may produce the effects of which they are susceptible.

### 3. *Principle of Nutrition.*

(809.) In order that plants may strike the sight by their height and form, they must be planted in such manner as to attain the greatest possible development of which their species is susceptible. The first condition to be fulfilled for that, is to place them in a soil where their roots will find the nourishment necessary for this development; hence we must never forget, before planting, that a given extent of earth can only nourish a limited number of plants; consequently, we must put a greater interval between them, dig the soil much deeper and to a greater extent, if we wish them to grow quickly.

(810.) The objection to planting *closely*, is generally greater for plants of different species, than it is for those of the same species or variety, because the assimilating force of identical individuals being more equal relatively to each of them than it is between individuals of different species, it establishes between the first a sort of equilibrium of nourishment, which causes a development almost equal in each individual; whilst between the second, the assimilating force being unequal, so will the development of the individuals be; the most vigorous will increase at the expense of the weaker, and the plantation loses its harmony: it may happen that the latter palpably injures the former, not only in exhausting the soil, but also in shading them, and thus checking their development mechanically. It is probably superfluous to remark that this refers to a *close* plantation, *i.e.*, where the individuals are so near together, that if the plants can profit by the excretions from the roots of other neighbouring plants, this effect is much more than compensated by the effect of the wasting of the soil.*

---

* Since this was written, investigations on the Nutrition of Plants have led to the adoption of another theory than that expressed: it is found that every plant extracts from the soil such subtances as are essential to its development; when these are exhausted, the plant is starved, and perishes unless fresh soil is supplied to its roots.—*Trans.*

### 4. *Principle of Distinct View.*

(811.) *With regard to isolated trees.* They only develope properly in proportion as they are equally lighted and consequently isolated on all sides; they must then only be placed where this condition is fulfilled.

*With regard to plants constituting a homogeneous mass.* To obtain the end proposed, all the individuals must be equally arranged, so as to present a homogeneous whole.

*With regard to plants constituting a varied line of mass.* Two or three species or varieties, distinct from each other, placed at a suitable distance, have a good effect.

(812.) Conformably to the principle of distinct view, and to avoid confusion, I do not place the same varieties or the same species in lines too near together.

(813.) But in seeking to observe this principle the plants of different species on the same line must not differ too much from each other in height and form.

(814.) It is also according to the same principle, that every part of a mass intended to be seen as part of a whole, must be planted according to a single system from one end to the other.

### 5. *Principle of Contrast of Colours.*

(815.) This principle, viewed in a general manner, enters into the preceding principle, since a difference in colour will render plants distinct which have numerous analogies together; but viewed in a special manner, it produces among plants, perfectly dissimilar, effects which can only be obtained from the colour; and it is under this point of view that the principle of contrast must be taken into consideration.

In the application of the law of contrast to the arrangement of flowers, we must never forget the difference existing between an association forming a line of plants, and an association of flowers belonging to plants of various heights, standing on different planes, so as to produce the effect of a picture. I have alluded to this association before (744.); for in a linear association nothing is more unpleasant than the blue flowers of the German iris associated with the light violet of the lilac. But if we add to this association large tufts of *Alyssum saxatile*, Persian iberis, and red tulips, so that the golden-yellow, white, and deep red appear on one plane, and the deep blue and the light violets on a more distant plane, we shall obtain an *ensemble* of very agreeable effect.

### 6. *Principle of Repetition.*

(816.) When a line of plants exhibits the repetition of the same species a certain number of times, and presents them regularly at the same intervals, an effect is produced, which, although very agreeable, is but little appreciated, for it is very rarely met with in gardens. It is particularly the repetition of a similar arrangement of colours that is agreeable, and which must recommend the observance of this principle.

(817.) The repetition of a similar arrangement of various plants, and of course distinct to the view, contributes greatly to prolong the extent either of an alley or of a mass; a similar *ensemble*, repeated a certain number of times, becomes a standard (*norme*), by means of which the eye judges the space to be greater than if it saw it bordered with individuals of the same species or variety equal in number to the former. This effect is carried as far as possible, when the arrangement is composed of a certain number of tufts, five for instance, placed between two trees which rise above them, but not too much so.

(818.) The principle of repetition concurs with the principle of distinct view in producing an agreeable effect.

### 7. *Principle of Variety.*

(819.) The principle of variety essentially distinguishes landscape gardening from French gardening (792. and following); for the promenader who walks through the first, perceives objects disposed in such manner as to excite as much as possible new emotions in his mind; while in the French garden he for a long time experiences only a single impression.

(820.) The principle of variety, like every other principle, must never be overlooked; and it is a great mistake to suppose that plantations made hap-hazard, and which appear to possess great variety, necessarily produce, under this relation, more effect than those which have been arranged according to the principles of distinct view, contrast, and repetition.

(821.) Whenever objects must have a certain extent, we gain nothing by multiplying varieties. Thus, the repetition of an arrangement of three colours, including white or black, will generally be more agreeable than that of an arrangement of five colours.

(822.) Diversity of colours pushed to the extreme, can only be permitted in a continuous border or a bed of different varieties of the same species of flowers, as a border of larkspur,

China aster, or anemones; but, for flowering shrubs, we shall gain everything by not indefinitely multiplying their colour in a view which the eye can embrace at once.

(823.) It is the same with forms as with colours; they must not be too diversified in the same arrangement.

(824.) Finally, the principle of variety, in removing identical plants from each other, must generally be more favourable to their development than the contrary principle, according as we plant a mass with the same species or the same variety, at least conformably to the views we entertain at the present time on the necessity of fertilising plants.

### 8. *Principle of Symmetry.*

(825.) We should deceive ourselves very much if we supposed that the principle of symmetry is excluded from landscape gardening. In fact, it presides over the arrangement of a well-designed garden of this sort; but, in order to perceive it or to put it in practice, it is necessary to distinguish

>The *symmetry of similar parts*, and
>The *symmetry of parts merely corresponding.*

#### A. SYMMETRY OF SIMILAR PARTS.

>Is that of two equal parts of one whole, as the two halves of a circle, of a square, of an equilateral or isosceles triangle, &c.

#### B. SYMMETRY OF PARTS MERELY CORRESPONDING.

>*a.* Is that of two parts of the same whole, which, without being equal, have the same form, or nearly so; such are the two triangular parts of the Mass 3, Pl. 4.

>*b.* Is that of two separate parts more or less analogous in form, extent, or nature, which have a correspondence of position relatively to an intermediate object.

>*c.* Is that of two masses or groups of trees, or of a mass and a group of trees which are presented, the one to the left, the other to the right of the spectator, in a position indicated by the gardener.

### A. *Symmetry of similar Parts.*

(826.) The principle of the symmetry of similar parts may be applied to an arrangement which constitutes a line of plants as well as a combination of lines, or, to speak in a more general manner, to a plantation constituting a mass.

For an arrangement to be, strictly speaking, symmetrical, it does not suffice that the same form recurs at equal intervals, conformably to the principle of repetition; it must be reducible into two similar parts. Such as, for example, the following arrangements:—

> A cluster of Judas trees between two clusters of white lilac, or between two clusters of *Prunus mahaleb*.
>
> A cluster of laburnum between two clusters of violet lilac.
>
> A cluster of laburnum, having on each side a cluster of lilacs and a cluster of syringa.

All these arrangements must be made between two trees or between two clusters, such, for example, as almond-laurels, absolutely distinct from those constituting the arrangement.

The analogy of these arrangements with architectural ornaments composed of two similar parts, is remarkable; for, in the former as in the latter, the middle must be larger than the two sides, and these, although distinct, must be intimately connected with it. Consequently, if the middle cluster was stripped of its leaves, while the lateral clusters were covered from top to bottom, the arrangement would be vicious.

Finally, to increase the effect of homogeneity to the sight, instead of framing the arrangement between two clusters very different from the first, it is preferable to place it between two trees.

When we desire to compose a line of three species of clusters, in which the one differs more from the other two than they differ from each other, it will be better to observe the symmetrical arrangement than the simply successive arrangement. For example, if we compose a line of *kerria japonica*, of pink *chamæcerasus tartarica*, of white lilacs, the symmetrical arrangement *chamæcerasus, white lilac, chamæcerasus,* between two *kerrias*, will have a better effect than *kerria, chamæcerasus, white lilac, kerria,* &c., this latter arrangement being quite incoherent.

In a mass reducible into two perfectly equal parts, and which is susceptible of being seen entire at a glance, because it is small and contains only short plants, the symmetrical plant

lines have a good effect, as is proved in the border of primroses, which circumscribes the elliptical mass *A* (*b.*) (755.)

Suppress the orange primroses, *a, a, a, a,* and we destroy a part of the fine effect of the border by destroying its symmetry, for then we have only the four symmetrical arrangements existing between the four red primroses *b, b, b, b.*

B. *Symmetry of Parts merely corresponding.*

(827.) There are three cases where this symmetry is remarked.

> *a.* In speaking of the Mass 3, Pl. 4., I have shown how it is divided into two triangular parts, which, without being equal, correspond to the plantations that have been made.
>
> *b.* The house or dwelling must have on the two sides of its principal façade objects symmetrically placed, but they need not be identical; it is sufficient that they present masses to our view which are nearly balanced.
>
> *c.* Two plantations thus balanced, seen the one to the right and the other to the left of a given position, have a fine effect: but it is essential to remark, that they must not be identical, but simply corresponding, either by their foliage, or by the height of the trees: a mass and a group of trees correspond very well in this case.

9. *Principle of General Harmony.*

(828.) If I considered a single individual as an isolated tree, or a union of individuals constituting an isolated mass, either homogeneous or heterogeneous, or a union of masses subordinated together, I shall not have a new principle to add to the preceding; for these latter suffice to enable us to derive the best possible effect from the harmony of different parts of the same individual, whether we regard the forms and the arrangement of these parts, or the different tints they assume: finally, the harmony which will arise in the masses, from the applications which have been made in planting them, of the principle of contrast of colours in their flowers and leaves, of the principle of variety, of repetition, and of symmetry. But in the general composition of a large landscape-garden, it will not suffice to have satisfied all these principles, if the different masses subordinated together, which we shall now regard as

individuals, as well as the various constructions of wood, or of stone, are not combined by some harmonious relation, suitable for satisfying the principle of *general* harmony. The isolated or subordinated masses, near or distant from each other, must be allied together by the same vegetable form (the same species or variety), or by analogous forms, or by the same arrangements of several species, or, lastly, by the same colours of flowers or of foliage. By the aid of similar means we ally the house and other buildings to the different parts of the garden. When we perceive that the neighbouring masses, especially such as those found near buildings, are not sufficiently allied together, or that the perspective is not satisfactory in their concentric or median lines, we have recourse to a different line of vegetation, which cuts the first and thus adds to the general harmony (804.). Thus at last what I have insisted upon is satisfactorily accomplished, when we decide to plant evergreens in a landscape garden, so that they are distributed throughout the composition.

# PART III.

EXPERIMENTAL ÆSTHETICS OF COLOURED OBJECTS.

INTRODUCTION.

FIRST SECTION.—INTERFERENCE OF THE LAW OF SIMULTANEOUS CONTRAST OF COLOURS WITH THE JUDGMENT WE EXERCISE UPON ALL COLOURED BODIES, VIEWED UNDER THE RELATION OF THE RESPECTIVE BEAUTY OR PURITY OF THE COLOUR AND OF THE EQUALITY OF THE DISTANCE OF THEIR RESPECTIVE TONES, IF THESE BODIES BELONG TO THE SAME SCALE.

SECOND SECTION.—INTERFERENCE OF THE LAW OF SIMULTANEOUS CONTRAST OF COLOURS WITH OUR JUDGMENT OF THE PRODUCTIONS OF VARIOUS ARTS WHICH ADDRESS THE EYE BY COLOURED MATERIALS.

THIRD SECTION.—OF THE PRINCIPLES COMMON TO DIFFERENT ARTS WHICH ADDRESS THE EYE BY VARIOUS COLOURED AND COLOURLESS MATERIALS.

FOURTH SECTION.—OF THE DISPOSITION OF THE MIND OF THE SPECTATOR, IN RESPECT TO THE JUDGMENT HE FORMS OF AN OBJECT OF ART WHICH ATTRACTS HIS EYE.

HISTORICAL REVIEW OF THE AUTHOR'S RESEARCHES.

FINAL CONSIDERATIONS ON CONTRAST.

# PART III.

INTERFERENCE OF THE PRECEDING PRINCIPLES IN JUDGING OF COLOURED OBJECTS WITH RESPECT TO THEIR COLOURS, CONSIDERED INDIVIDUALLY AND IN THE MANNER UNDER WHICH THEY ARE RESPECTIVELY ASSOCIATED.

## INTRODUCTION.

(829.) THE object of this division of my book is purely critical; being, that the exact conclusions at which I have arrived upon the assortment of colours, so as to derive the best possible result for a determined aim, become rules adapted to guide those who would judge a work of art where this assortment is found. The generalisations established in the preceding Parts, with the object of aiding the numerous artists who employ colours to address the eye, now considered under a critical point of view, should serve as the basis of a conscientious and sound judgment upon the merit of a work which grows out of these generalisations, at least in some of its parts; they must, if I am not mistaken, possess the double advantage of all the rules which are derived from the nature of the things which they concern; they guide the workman who does not disdain them, as they direct the critic who judges the work of which these rules govern some element. We cannot, then, refuse to recognise the utility of such an examination for the authors of works to whom they are submitted, and for the public to which it is more particularly addressed, in the hope that a clear demonstration of what is laudable or censurable will form its taste, and which, in teaching it to abandon its first impressions, will itself become capable of expressing a sound judgment, and that from that time we may not hope to enlist its suffrages by falling into the *bizarre*, or in wandering from the truth.

(830.) If a subject exists worthy of being studied under the critical relation on account of the frequency and variety of the opportunities it offers, it is unquestionably that upon which I

am now engaged; for whether we contemplate the works of nature or of art, the varied colours under which we view them is one of the finest spectacles man is permitted to enjoy. This explains how the desire of reproducing the coloured images of objects we admire, or which under any name interest us, has produced the art of painting; how the imitation of the works of the painter, by means of threads or small prisms, has given birth to the arts of weaving tapestry and carpets, and to mosaics; how the necessity for multiplying certain designs economically has led to printing of all kinds, and to colouring. Finally, this explains how man has been led to paint the walls and wood-work of his buildings, as well as to dye the stuffs for his clothing, and for the interior decoration of his dwellings.

(831.) The sight of colours, so simple a thing for the greater part of mankind habituated to it from infancy is, according to some philosophers, a phenomenon entirely out of the domain of positive knowledge, because they consider that it varies with the organisation and imagination of individuals; consequently they think that there is no induction to be drawn from the manner in which two men see an object similarly under the same exterior circumstances: they believe that no generalisation deduced from observation can direct the artist with certainty, either in the art of seeing his model, or in faithfully reproducing a coloured image of it: they also think that no useful generalisation concerning the physiological nature of man can be derived from a profound study of the modifications his organs experience from the sight of colours that bodies present to him.

(832.) On principle, I cannot admit that we ought to abstain from studying a subject because it presents variable phenomena. I go further: I believe that all those who are engaged in the study of the positive sciences should inquire if they could not discover in their labours some fact susceptible of illustrating the study of these phenomena, and put us in the way of determining the cause of one of them: for, what renders the scientific study of agriculture and medicine so difficult is the obstacles which we encounter whenever we would trace to their respective causes the different phenomena presented to the physician and agriculturist by organised bodies. The history of the sciences completely demonstrates that we are not led to this knowledge by synthesis, but rather by the analysis of phenomena which we can scarcely, I think, attempt with hope of success, if we have not made a special study of the causes to which we refer the phenomena of inorganic nature: not that I necessarily recognise these causes to be

immediately those of the phenomena of living nature, although this opinion appears to me extremely probable for a certain number of them to be related to physiology properly so called, but because the researches for the causes of the phenomena of inorganic nature appear to me must serve as the right standard to direct works undertaken with the intention of separating certain complex results and tracing them to their respective causes. It is in this state of mind that I have undertaken the subject of this book, not after having spontaneously chosen it, but because it appeared to me indispensable to study it before pretending to establish a sound judgment on the beauty of the colours which the dyer had fixed upon his stuffs. As soon as I felt the necessity for this study in my capacity of director of the dyeing department of the royal manufactories, I wished to understand the ground I trod upon, and my first care was to discover if I 'saw colours like the generality of persons: I was not long in being perfectly convinced of it, and it was not till then that I ventured to make my researches the objects of public lectures, which have had for auditors, and I may even add for *spectators*, artists, artizans, and the general public. These lectures have been repeated before the students of the Polytechnic School. Certain questions addressed to my auditors to satisfy me that they saw the things I put before their eyes as I saw them myself, have, in the majority of cases, always proved them to be so, and yet my demonstrations were given in the reception hall at the Gobelins, but ill adapted for the exhibition of the phenomena of contrast to a large audience. Certain observations made by myself, tested by a great number of persons in my laboratory, and afterwards publicly exhibited, form the subject of this book: all those who would, I do not say *read*, but *study* it, by repeating my experiments, will discover if my opinion is well founded, or one which pretends that the sight of colours is not susceptible of giving a general positive result, and if, because they can instance some individual whose organ of sight is so imperfect that he cannot distinguish green from red, or who confounds blue with grey, &c., we must write our treatises on optics without mentioning either red, green, or blue, and sweep these colours from the palette of the painter! Truly, human nature is but too limited to allow of our making such a sacrifice to a common infirmity of organisation.

(833.) In order to clearly comprehend how, after I had separated the causes which exercise a determinate influence upon the sight of colours, experiment and observation led me to adopt the opinion that these phenomena are perfectly defined

by the law of contrast, and the conclusions I have allied to it, doubtless it will suffice.

1°. To consider how

   A. The ignorance we had respecting the different states of the eye, which in seeing colours give rise to the phenomena of simultaneous, successive, and mixed contrasts.

   B. And the ignorance we had respecting the definite influence that the direct or diffused light of the sun exercises, according to its intensity, upon the colours of bodies,

have led to the establishment of an opinion contrary to my own, that is to say, the opinion that *the same colour appears so diversely to different persons, and even to the same person, that nothing general or precise can be deduced from the sight of coloured objects under the relation of their respective colours.*

2°. To consider how

   C. The limited number of ideas we have generally upon the modifications of coloured bodies by their mutual mixtures, or, in other terms, upon the colours resulting from these mixtures, have passively contributed to belief in this opinion.

   D. The want of a precise language to convey the impressions we receive from colours.

3°. Of recapitulating, how have

   E. Inexact ideas which are believed to be sound *actively* contributed to establish belief in this opinion.

A (*a.*) It is indisputable that, if we are ignorant of the regularity with which the eye passes successively through stages the extremes and the mean of which are very different, when we view the colours which put the organ into the condition of perceiving the phenomenon of one of the three contrasts (77. and 328.), we shall be led to consider the sight of colours as a very variable phenomenon, *while the successive stages through which the organ passes being once distinguished, the variations of the phenomenon become perfectly definite.*

(*b.*) If we are ignorant of the law of simultaneous contrast, we shall see that the same colour varies in tint, according to the colour with which it may be

associated, and if we are ignorant that contrast affects the tone as well as the colour, we cannot explain how two similiar colours (for instance, blue and yellow taken at the same height) will appear redder by juxtaposition, while if the blue is very deep relatively to the yellow, it will appear black rather than violet, and the yellow will appear more green than orange (663.) Finally, if we are ignorant of the effect of brightness a complementary can give to a dull colour, we cannot explain the great difference there is between the effect of a red ground upon imitation gilt ornaments (painted) and the effect of the same ground upon metallic gilt ornaments (460. and 468.).

(c.) Doubtless, also, if we are ignorant that in a complex object the eye can only see at the same moment but a small number of parts clearly (748.), and that the same part may appear to different eyes with different modifications, according as it is seen juxtaposed with one or another colour, as occurred in the instance (483.) when I compared the pattern of a border for paper-hangings (presenting roses with their leaves) placed upon a black ground, with a similar pattern placed upon a white ground; on comparing the two together, I saw the light green on the black ground yellower than upon the white, while three other persons, who compared the light tones of green with its deeper tones on the same ground, judged the light tones to be bluer upon the black than upon the white ground.

B. We might know the regularity of the successive states in which the eye is found during the sight of coloured objects and the law of simultaneous contrast of colours, and yet if we were ignorant of the influence of various degrees of intensity of light in varying the colour of bodies and in rendering the modifications of contrast more or less evident, we should be led to believe in an indefinite variation in the aspect of colours while this variation is perfectly defined by the following remarks : —

(a.) If the direct light of the sun or diffused daylight illuminates a monochromous body unequally, the part most vividly lighted is modified as it would be if it received orange, and the modification appears

the stronger the greater the difference of light on the parts (280.): thus, the more intense the light the more it gilds the body it illumines; it is thus always easy to foresee the effects of it, when we know the result of the mixture of orange with various colours.

(*b*.) In a very vivid light the phenomena of simultaneous contrast being less evident than in a weaker light (63. 571.), it follows, if we neglected to take account of the difference in the effects, we should greatly deceive ourselves in our appreciation of the phenomena of contrast of similar colours. It is useful to remark that simultaneous contrast which tends to make the differently coloured parts appear as distinct as possible, is carried to a maximum precisely when, the light being feeble, the eye requires the greatest contrast of colour to perceive distinctly the various parts upon which it is fixed.

C. We may perceive the modifications presented by bodies when lighted, and experience much difficulty in accounting for them, for want of knowing how to exactly represent the modifications which the coloured materials experience in their colour, according as they receive light or white, shade or black, or according as they are mixed together. It is partly to make these modifications clearly known that I have designed the *chromatic hemisphere* (159. and following); in describing it I have attached less importance to its material realisation than to the rational principle upon which it rests. On looking at the lines of this diagram independently of all colouring, we understand how any colour is reduced by white, deepened by black, and broken by black and white; lastly, how by mixture with a pure colour, it produces hues. I shall add subsequently some new considerations, which belong to the gradations of colour we make with coloured materials (841.).

D. The object I have had in view would not have been attained, if the chromatic hemisphere had not given me the means of representing, by a simple nomenclature, the modifications a colour undergoes by the addition of white and black, modifications which produce the *tones of its scale;* those which it receives from black yielding *broken scales;* lastly, those

which, resulting from the addition of a pure colour, produce scales which are *hues* of the first colour.

Finally, to the definitions which I have given of the words *tone, scale, hue, broken colours*, I must add the distinction of the associations of colours in *harmonies of analogy*, and *harmonies of contrast* (180.).

I am convinced that all those who accept the small number of definitions I have given, will find much advantage in using them to account for the effects of colours, and to communicate to others the impressions they have received from them; by their aid it will be easy to seize relations which might have escaped observation, or which, in the absence of precise language, could not have been clearly expressed by those who perceived them.

E. It would be ignoring the reality, if I should attribute the opinion combated exclusively to simple ignorance of the facts recapitulated (A. B. C. D.), or to believe that it suffices to dissipate it, in order to establish the contrary opinion I profess: I am under no illusion; if ignorance is passive, and resists only by its inertia, it is quite otherwise with ideas more or less erroneous or pretentious, which exist on the sight of colours and their harmonies; these ideas actively repulse all that is opposed to them. I am satisfied with pointing out the obstacle, without having the least pretension to overthrow it, except by enouncing what I believe to be the truth.

In conclusion, by means of the positive facts which I have just reviewed, the study of the sight of coloured bodies leads to a certainty which all may acquire who henceforth give themselves up to it; they will see how fruitful it is in applications, and independent of all hypothesis, and that it would be impossible to obtain this result if there did not commonly exist among men an average organisation of the eye, which permits them to perceive (other things being equal) the same modifications in illuminated bodies: the difference, I admit, in the perception of the phenomena by divers individuals who have perfect organs of sight, bears only on the intensity of the perception.

(834.) The series of principles upon which my book is founded being reviewed, I next consider these facts under the three following relations, each of which will be the subject of a section :—

1. Under the relation of the certainty they give in judging of the colour of any object whatever.
2. Under the relation of the certainty they give to the judgment we bring to the productions of the various arts which address the eye by coloured materials.
3. Under the relation of the union they establish between the principles common to many arts which address to the eye various languages in employing different materials.

Finally, in the last section, I shall treat of the influence that the disposition of the mind of the spectator may have upon the judgment he brings to any work of art exhibited.

# SECTION I.

INTERFERENCE OF THE LAW OF SIMULTANEOUS CONTRAST OF COLOURS WITH THE JUDGMENT WE EXERCISE UPON ALL COLOURED BODIES, VIEWED UNDER THE RELATION OF THE RESPECTIVE BEAUTY OR PURITY OF THE COLOUR AND OF THE EQUALITY OF THE DISTANCE OF THEIR RESPECTIVE TONES, IF THESE BODIES BELONG TO THE SAME SCALE.

INTRODUCTION (835.).

CHAPTER I.— ON THE COMPARISON OF TWO PATTERNS OF THE SAME COLOUR (836.).

CHAPTER II.— ON THE INFLUENCE OF A SURROUNDING COLOUR UPON ONE COLOUR WHEN COMPARED WITH ANOTHER (837, 838.).

CHAPTER III.— ON THE EFFECT OF CONTRAST UPON THE BROWNS AND THE LIGHTS OF THE GREATER PART OF THE SCALES OF WOOL AND SILK EMPLOYED FOR TAPESTRIES AND CARPETS (839—841.).

CHAPTER IV.— MEANS AFFORDED BY CONTRAST OF ASSURING US IF THE TONES OF A SCALE OF COLOUR ARE EQUIDISTANT (842.).

## INTRODUCTION.

(835.) THE most simple and general conclusion deduced from the law of contrast is certainly that which concerns the judgment we exercise, either by taste or profession, on a colour presented by a coloured paper, a textile fabric, a glass, an enamel, a picture, &c. One condition which all those who have some experience in the matter regard as essential to be fulfilled to avoid error, is to compare the colour upon which it is necessary to judge with another colour which is analogous to it. If we are ignorant of the law of contrast, the result of this comparison is not exact, when the objects compared are not identical; I now proceed to demonstrate this by different examples very well adapted to the application of the principle spoken of. Further, one conclusion more apart from the law gives the means of knowing if the tones of a scale of wool or silk intended for tapestry or carpets are equidistant.

## CHAPTER I.

#### ON THE COMPARISON OF TWO PATTERNS OF THE SAME COLOUR.

(836.) WHEN it is a question of two patterns of any kind, which relate to the same colour, be it blue or red, if there is no identity between the tints of the two patterns when compared together, we must take into account the contrast which exaggerates the difference: thus, if the one be greenish blue, it will make the other appear less green or more indigo, or even more violet than it really is; and, reciprocally, the first will appear greener than when viewed isolated; the same with the reds, if one is more orange than the other, this latter will appear more purple and the former more orange than they really are.

## CHAPTER II.

**INFLUENCE OF A SURROUNDING COLOUR UPON ONE COLOUR WHEN COMPARED WITH ANOTHER COLOUR.**

(837.) SINCE the contrast of colours which are not analogous tends to their improving and purifying each other, it is evident that whenever we would exercise a correct judgment upon the beauty of the colours of a carpet, tapestry, or picture, &c., after having compared them with the colours of objects analogous to the first, we must take into account the kind of painting and the manner in which they are juxtaposed, if the objects compared are not the exact representation of the same subject. For, other things being equal, the same colours not shaded and which are not sufficiently analogous to mutually injure each other, disposed in contiguous bands, will certainly appear more beautiful than if each were seen on a ground which consisted of it exclusively, and which, consequently, produced only a single impression of colour upon the eye. Colours arranged as palms, like those of Cashmere shawls, or as patterns, as in Turkey carpets, produce a much greater effect than if they were shaded or blended, as they generally are in paintings. Consequently if we wished, for example, to compare a stripe of amaranth red, in a Cashmere shawl of various stripes with the aramanth of a French shawl, we must remove the contrast of colours near to the amaranth stripe, by concealing them with a piece of grey or white paper, cut out, which allows us to see only this stripe: it being understood that a piece of paper cut similar to the first is laid upon the ground, so that the parts compared will be submitted to the same influence from the surrounding parts.

(838.) The same means must be employed when we compare the colours of old tapestries, pictures, &c., with analogous colours recently dyed or painted; and for this reason, time acts very unequally, not only on the different kinds of colours which are applied to stuffs by the dyer, but also upon the tones of the same scale. Thus the deep tones of certain scales — those of violet for example — fade, while the deep blues of the indigo-blue scale, the deep shades of madder, kermes, cochineal, are permanent. In the second place, the light tones of the same scale fade during a space of time which has no

sensible effect in altering its deep tones. Whence the colours which have most resisted the destructive action of time being more isolated from each other, deeper, and less blended, appear by that to have more brilliancy than if they were otherwise disposed. There are many pigments used by painters, particularly most of the lakes, which are in the same condition relatively to the others, as the changeable colours of the dyer; such as ultramarine, the oxides of iron, the blacks, which are, so to speak, unalterable by atmospheric agents; but the alteration of the first may, in many cases, contribute to heighten the brilliancy of colours less changeable.

## CHAPTER III.

#### ON THE EFFECT OF CONTRAST UPON THE BROWNS AND THE LIGHTS OF MOST OF THE SCALES OF WOOL AND SILK EMPLOYED IN TAPESTRY AND CARPETS.

(839.) WHEN we look at the *ensemble* of tones of most of the scales made use of in the fabrication of tapestries and carpets, the phenomenon of contrast exaggerates the difference of colour which we remark between the extreme tones and the middle tones of the same scale. For instance, in the scale of indigo-blue applied to silk, the lights are greenish, the browns are tinged violet, while the intermediate tones are blue; but the difference of green and violet at the two extremes is found augmented by the effect of contrast. It is the same in the scale of yellow; the light tones appear greener and the browns redder than they really are.

(840.) I cannot speak of a difference existing between the deep and the light tones of most of the scales of wool and silk which is exaggerated by contrast, without adding some remarks relative to the gradations the dyer produces by means of a colouring material which he applies upon a white fabric, supposed to be absolutely void of any material foreign to the nature of the coloured compound with which it is united. It is only very rarely that this gradation is perfect under this mode of viewing it, as the light tones are exactly represented to the eye by the colour taken at its normal tone reduced with white. Thus, a compound which at the normal tone is pure yellow or slightly tinged with orange, will, by reduction, produce light tones of a greenish yellow. An orange-red compound,

fixed upon silk or wool, will yield light tones tinged violet-red. To obtain a correct gradation, we must, in most cases, add to the weak tones a new coloured material, adapted to neutralise or weaken the defect spoken of.

(841.) Many of the pigments used in painting produce the same result when reduced with white; and I do not speak here of changes which may be the result of chemical action. I allude only to those which result from an attenuation of the coloured material. For example, the normal tone of carmine is a much purer red than its light tones, which are evidently tinged with lilac. Ultramarine, so beautiful in itself, yields light tones, which, with respect to the blue rays, appear to reflect more violet rays than the normal tone. In consequence of these facts, it is difficult to colour the chromatic diagram, because many attempts must be made to foresee the modification of colour which yields the normal tone of a scale by the addition of coloured materials suited to render the gradation correct to the eye.

## CHAPTER IV.

**MEANS AFFORDED BY CONTRAST BY WHICH WE MAY BECOME CERTAIN IF THE TONES OF A SCALE OF COLOUR ARE EQUIDISTANT.**

(842.) CONTRAST which augments the difference existing between two tones of the same colour, gives the means of appreciating with greater certainty than could otherwise be done, if the numerous tones of a scale are at the same distance from each other. Thus, if the tone 2 placed between 3 and 4 appears equal to the tone 1, it follows, if the tones are equidistant, that 3 placed between 4 and 5 will appear equal to 2; that 4 put between 5 and 6 will appear equal to 3, and so with the others. If the tones are too near together to yield this result, we must move them successively, not one degree, but two or three. This means of judging of the equality of distance that separates the tones of the same scale is based upon the fact, that it is easier to establish an equality than to estimate a difference between patterns of the same colour.

# SECTION II.

INTERFERENCE OF THE LAW OF SIMULTANEOUS CONTRAST OF COLOURS WITH OUR JUDGMENT ON THE PRODUCTIONS OF DIFFERENT ARTS WHICH ADDRESS THE EYES BY COLOURED MATERIALS.

INTRODUCTION (843.).

CHAPTER I.— ON THE BINARY ASSOCIATIONS OF COLOURS IN A CRITICAL POINT OF VIEW (844—857.).

CHAPTER II.— ON COMPLEX ASSOCIATIONS OF COLOURS IN A CRITICAL POINT OF VIEW (858, 859.).

CHAPTER III.— ON THE TWOFOLD INFLUENCE, CONSIDERED IN A CRITICAL POINT OF VIEW, THAT THE PHYSICAL CONDITION OF THE COLOURED MATERIALS EMPLOYED IN VARIOUS ARTS, AND THE SPECIALITY OF THESE ARTS, EXERCISE UPON THE PARTICULAR PRODUCTS OF EACH OF THEM (860—890.).

## INTRODUCTION.

(843.) AFTER having applied criticism to the judgment we entertain of the colour of a material object, relatively either to its beauty and brilliancy, or to the place its tone assigns to it in the scale of which this object forms part, we must apply it to the judgment concerning the associations of different colours made with the intention of producing an agreeable effect. In order to give the judgment a solid basis beyond all dispute, I shall examine the association of two colours independently of material form, under which the works of nature or of art can offer them to view; and on this occasion I shall sum up many general facts which are found in the Introduction to Part II. of this work (143., &c.), and in several of its divisions. This summary will permit the reader to follow the co-ordinate generalisation, so as to serve as a basis to a critical examination of the products of all the arts which employ coloured materials. After having drawn the principal important conclusions which flow from the binary associations of colours, then I shall occupy myself with their complex associations under the point of view of the harmonies of analogy and of contrast to which they give rise: finally, under a last point of view, I shall take into consideration the influence which the physical nature of the coloured materials the arts employ must specially exercise to attain the aim peculiar to each.

## CHAPTER I.

#### OF THE BINARY ASSOCIATIONS OF COLOURS CONSIDERED CRITICALLY.

(844.) IN order to sum up in few words the generalities which must serve as the bases of our judgment, not only on one colour compared with another of the same sort, but on the associations of two colours which any object whatever presents to our eyes, for example, a stained paper, a stuff, a vestment, or which form part of a picture, I shall consider the case where associated colours are mutually complementary, and that where they are not.

1st Case.— *Association of Complementary Colours.*

(845.) *This is the only association where the colours mutually improve, strengthen, and purify each other without going out of their respective scales.*

This case is so advantageous to the associated colours, that the association is also satisfactory when the colours are not absolutely complementary.
So it is also when they are tarnished with grey.
Such is the motive which has made me prescribe the complementary association, when we have recourse to the harmonies of contrast in painting, in tapestry, in the arrangement of coloured glass windows, in the assortment of hangings with their borders, in that of stuffs for furniture and clothing, and lastly, in the arrangement of flowers in our gardens.

2nd Case.— *Association of Non-complementary Colours.*

(846.) *The product of this association is distinguished from the preceding in this, the complementary of one of the juxtaposed colours differing from the other colour to which it is added, there must necessarily be a modification of* Hue *in the two colours, without speaking of the modification of tone, if they are not taken at the same height.*

Juxtaposed non-complementary colours can *certainly* give rise to three different results:—

1°. They mutually improve each other.

2°. The one is improved, the other loses some of its beauty.

3°. They mutually injure each other.

(847.) The greater the difference between the colours, the more the juxtaposition will be favourable to their mutual contrast, and consequently the more analogy they will have, and the more chances there are that the juxtaposition injures their beauty.

1°. *Two non-complementary colours improve each other by juxtaposition.*

(848.) Yellow and blue are so dissimilar, that their contrast is always sufficiently great for their juxtaposition to be favourable, although the juxtaposed colours belong to different scales of yellow and blue.

2°. *One colour, juxtaposed with another which is not its complementary, is improved, while the latter is injured.*

(849.) A blue which is improved by a yellow, being placed beside a violet (blue rather than red) may lose some of its beauty by becoming greenish, while the orange it adds to the violet, neutralising the excess of blue of this latter, improves rather than injures it.

3°. *Two non-complementary colours mutually injure each other.*

(850.) A violet and a blue reciprocally injure each other, when the first greens the second, and the latter neutralises sufficient of the blue in the violet to make it appear *faded*.

(851.) It might also happen that although the colours juxtaposed are modified, both neither gain nor lose in beauty; that the one gains without the other losing; lastly, that the one neither gains nor loses, while the other loses.

(852.) *In the association of two colours of equal tone, the height of the tone may have some influence on the beauty of the association.*

For example, a deep indigo-blue and a red of equal depth gain by the juxtaposition: the first, by losing some violet, will become a pure blue; the second, in acquiring orange, will become brighter. If we take light tones of these same scales, it may happen that the blue will become too green to be good as a blue, and that the red, acquiring orange, will be too yellow to be a pure red.

(853.) *In the association of two coloured objects of tones very distant from each other, belonging to the same scale, or to scales more or less allied, the contrast of tone may have a favourable influence upon the beauty of the light tone*, because, in fact, if the latter is not a pure colour, its juxtaposition with the deep tone upon the whole brightening it, will purify what grey it may have.

(854.) It is very necessary for the correction of our judgment of the principles I set up on the binary associations of colours, not to lose sight of all which precedes from paragraph 846., inclusively, concerning colours flat (*mat*), or deprived of gloss, and that their association be considered independently of the form of the object presenting them, for the twofold reason that *the glossiness of the coloured surfaces and the form of the*

*bodies which these surfaces limit in space,* are two circumstances capable of modifying the effect of two associated colours: consequently the analysis I have made of the optical effects of colours will be incomplete, if I do not now speak of the possible influence of these causes.

*Influence of Gloss taken into Consideration in the Effect of Contrast of two Colours.*

(855.) One of the results to which the observation of contrast of *mat* colours leads, is the explanation of how the association of one colour with another is favourable or injurious to the *ensemble*, or only to one of them, in making evident to the eye that, in the most favourable case possible, the optical product of the juxtaposition is composed of two effects: —

1°. The effect arising from each of the juxtaposed colours, receiving the complementary of the colour contiguous to it, being strengthened or tinged agreeably by this addition, independently of any augmentation of gloss.

2°. The effect arising from an augmentation of gloss in the two juxtaposed colours. Recalling these results, is to foresee an objection which might have been made to me, namely, that the associations which I have not prescribed, such as those of red with violet, blue with violet, for instance, have a fine effect in the plumage of certain birds, and upon the wings of certain butterflies; for, according to the preceding distinction, it is evident that in these natural associations, the effect arising from the addition of the complementaries to each of the two colours which would injure the *mat* colours is entirely insensible in injuring colours which acquire *metallic brightness* from the organic structure of the feathers and scales upon which they are found. Finally, I shall add, that it would be necessary, before raising the objection, to demonstrate that the same red associated with green, the same violet associated with yellow, and, lastly, the same blue associated with orange equally glossy, will be less effective than the natural assortments I now take for examples.

*Influence of Form taken into Consideration in the Effect of Contrast of two Colours.*

(856.) If gloss has so much influence upon the effects of

contrast of two juxtaposed colours, the form of the coloured parts presenting them has undoubtedly an influence also ; thus the elegance of the form, the arrangement of the parts, their symmetry, the effects of light and shade upon the surfaces independent of all colour, finally the association of ideas which may connect this form with an agreeable recollection, will prevent the perception of the ill effect of two associated colours which are not at all glossy ; it is thus, for example, that flowers impress us with associations which, without shocking us, yet, nevertheless, would not produce a good effect if we saw them upon two plain surfaces deprived of gloss. We may instance anew, for example, the flower of the sweet plea, which offers the alliance of red and violet. It cannot be doubted that the red and the violet of this flower, being juxtaposed — the red to green and the violet to yellow — do not produce a finer effect than that resulting from their association in the flower mentioned above.

(857.) The relation of the preceding facts to criticism is easily perceived when we proceed to judge of the association of two colours in themselves, or to compare together different binary associations.

In the first case we can inquire if the association an artist has made of two colours has attained the end he proposed, — that of improving both, or that of improving one and sacrificing the other.

In the second case we can compare together the effects of one colour of the same class, — reds for example, — each making part of a binary association, we can compare together the effects of binary associations of different colours, always under the optical point of view, and with the intention, if these associations are the product of art, of judging the artist who has made them. Then the critic must be directed by the considerations which are summed up as follows : —

    1°. The kind of association : the greater the difference between the colours, the more they mutually beautify each other ; and inversely, the less difference there is, the more they will tend to injure one another (845—851.).

    2°. The equality in height of tone (852.).

    3°. The difference of tone, the one being deep, the other light (853.).

    4°. The glossiness of the surfaces which sends them to the eye (855.).

    5°. The form of the body of which these surfaces limit the extent (856.).

## CHAPTER II.

#### OF THE COMPLEX ASSOCIATIONS OF COLOURS REVIEWED CRITICALLY.

(858.) It is evident that the rules prescribed for judging a colour and the associations of two colours in an absolute manner, must serve for judging under the same relation the colours of an association, however complex it may be, when found in a picture, tapestry, carpet, stained-glass window, or in the decoration of a theatre, apartment, &c.; but to view the *ensemble*, we must proceed conformably to the distinctions we have established of the harmonies of analogy and the harmonies of contrast; for, otherwise, it would not be possible to express clearly a sound judgment concerning the specialities of the constituent assortments and the general effect of the *ensemble* of all these assortments; besides, before expressing this judgment, we must *know how to see* colours independently of all form or pattern ; in a word, independently of all which is not colour, even when it is necessary in a picture.

(859.) In this manner we can see a complex association of colours, suppose such as are presented to us by a picture, thus taking the most complicated case. We shall consider the masses of colours which are upon the same plane, the extent which each occupies, the harmony that unites them together. On submitting to a similar examination the colours on the other planes, we then can look at the colours in passing from those of the former plane to the colours of the latter. The critic who is well satisfied with seeing clearly at the same time only a very small number of the objects that a picture presents to him (748., 483.), and who is also accustomed to examine a coloured composition in the manner I have described, is, relatively to the things upon which he successively concentrates his attention, in the position of a person who reads in succession three kinds of writing traced on the same side of a sheet of paper ; one of them composed of lines across the width of the paper, the other composed of lines crossing the first at right angles, and the third composed of lines running diagonally across the paper. After giving himself up to this examination, the critic must review the *ensemble* of the picture under the relation of its colours, and then, having fixed upon their particular and

general associations, he will be in a condition to penetrate the thought of the painter, and of seeing if he has employed the most suitable harmonies to express it; but this is not the place to treat this subject: it belongs to the following Chapter (865., &c.). I will only remark, that if it is easier to form with opposed colours than with neighbouring colours, binary assortments favourable to the associated colours in a composition where a great number of pure and brilliant colours are employed, it is more difficult to harmonise these latter in allying them to one another, than if we proceeded with a small number of colours, which would add only to the harmonies of analogy or of contrast of scale or of hues.

## CHAPTER III.

OF THE TWOFOLD INFLUENCE PRESENTED UNDER THE CRITICAL POINT OF VIEW WHICH THE PHYSICAL CONDITION OF THE COLOURED MATERIALS EMPLOYED IN VARIOUS ARTS, AND THE SPECIALITY OF THESE ARTS EXERCISE UPON THE PARTICULAR PRODUCTS OF EACH OF THEM.

(860.) I HAVE so deep a conviction that the greatest artists cannot free themselves from certain rules without compromising the art itself, that I believe it useful to insist upon everything which can extend my opinion. Such is the motive with which I refer to the results that naturally flow from the physical state of the coloured materials employed in various arts, and of the special object of these arts; results of which I have already shown the importance in the case where we judge if certain innovations have the merit or advantages which their authors promised for them. It is under this connection that I now consider the arts of painting which employ coloured materials in a state of infinite division (so to speak), and the arts which employ them of a certain size, as the threads of the tapestry-weaver, the pieces of the mosaic worker, &c.

### § 1.

OF THE ARTS OF PAINTING WITH COLOURED MATERIALS IN A STATE OF SO CALLED INFINITE DIVISION, CONSIDERED RELATIVELY TO THE PHYSICAL STATE OF THESE MATERIALS AND THE SPECIALITY OF THE ART EMPLOYING THEM

(861.) In the first place, I must explain the meaning of the expression *in a state of infinite division*, applied to coloured

materials employed by painters: in reality, the division of these materials is not infinite, it is not even carried to the point attainable by mechanical means. If it were possible to perceive them in a painting by means of magnifying glasses, we should then see that a coloured surface, which appears of a uniform colour to the naked eye, is composed of distinct coloured particles, disposed in parallel or concentric lines, or in spots, according to the handling of the pencil. By these means we could distinguish in oil-paintings some parts which would resemble an enamel, because they would contain so many opaque particles which the drying oil does not make transparent, while the other parts would resemble a coloured glass, because the oily vehicle does not contain sufficient opaque particles to be entirely deprived of its transparency.

I shall now consider, successively, painting in chiaro 'scuro and in flat tints.

### Article 1.

#### *Painting in Chiaro 'scuro.*

(862.) In commencing with the fact that the pigments of the painter appear to be in a state of infinite division, we come to see clearly the possibility of tracing lines as fine as it is possible to make them, by means of a pencil filled with a fluid charged more or less with colouring materials, of intimately mixing these pigments together, so as to blend them with each other. From this state of things we deduce the possibility of making *a perfect delineation of the different parts of objects of which the painter wishes to reproduce the image, and represent exactly all the modifications of light which exist in the model.*

(863.) I now recall how satisfactory the study has been which we have made of the modifications under which bodies appear, when they are rendered visible by the direct light of the sun, or by diffused daylight, in enabling us to judge if these modifications have been faithfully reproduced by the painter in a given work. I must refer the reader of this subject to the division of this book concerning painting.

(864.) From the perfection of the drawing, and the gradation of white and coloured light, result the perfection of the imitation of all coloured objects, by means of which their images appear upon a plain surface, as if they were seen with the relief peculiar to them. From this possibility of imitating clearly the minutest details in a model, results the possibility of expressing upon plane figures all the emotions of the heart of man which

are manifested by the expression of his countenance. From thence is derived the noblest, the loftiest part of the art which places the painter near the poet, the historian, and the moralist; a part upon which the critic pours his admiration to excite it in others, but which has no rules a master can impart to his pupils. I make this declaration in order that my intention may not be misunderstood, which has dictated to me the developments promised above (859.), relative to the correspondence of the harmonies of colour with the subject upon which they are employed—developments upon which I now enter.

(865.) If harmony of contrast is most favourable to cause two colours to impart value to each other (845.), on the other hand, when we desire to derive the best possible advantage from a union of numerous brilliant colours in any work—a picture for instance—this diversity presents some difficulties for the harmony of the whole, which a smaller number of colours would not present, and particularly of colours less brilliant (859.). Accordingly, it is evident, that if we compare together two effective pictures, well adapted to be judged under the relation of colour, other things being the same, the one which presents the most harmony of contrast of colour will have the greater merit under the relation of the difficulty overcome in the employment of the colours; but we must not conclude that the painter of the other picture is not a colourist; because the art of colouring is composed of various elements, and the talent of opposing pure colours with each other, is only one of these elements.

(866.) Let us now consider the relations existing between the subjects of painting and the harmonies they admit. We know that the more pictures address the eye by numerous contrasts, the more difficulty the spectator experiences in fixing his attention, especially if the colours are pure, varied, and skilfully distributed upon the canvas. A result of this state of things then is that, these colours being much more vivid than the flesh-tints, the painter who wishes that his idea should be sought in the *expression* of his figures, and who, putting this part of his art above the others, is also convinced that the eyes of most people, ignorant of the art of seeing (being carried away by what they see at first), are incapable of returning from this impression to receive another; the painter, I repeat, who knows all these things, and is conscious of his power, will be restrained in the use of harmonies of contrast, and prodigal of the harmonies of analogy. But he will not derive advantage from these harmonies, especially if he selects a scene occupying a vast space filled with human figures, as in the "Last Judg-

ment" of Michael Angelo, unless he avoids confusion by means of correct drawing, by a distribution of the figures in groups skilfully distributed over the canvas, so that they cover it almost equally, yet without presenting a cold symmetry. The eye of the spectator must embrace all these groups easily, and seize the respective positions; lastly, in penetrating one of them, he must find a diversity which will entice him to extend this examination to other groups.

(867.) The painter who misses the effect of the physiognomies in having recourse to the harmonies of analogy, will not have the same advantage in fixing the attention of the multitude as the painter who has employed the harmonies of contrast.

(868.) The harmonies of contrast of colour are especially applicable to scenes illuminated by a vivid light, representing fêtes, ceremonies, etc., which may be sober without being sad; they are also applicable to large subjects, in which we find different groups of men animated with various passions.

(869.) To conclude, in all I have said on the subject of the immediate applications of the law of contrast to painting, I have given precepts adapted to enlighten the artist as well as the critic, since he cannot avoid them without evidently being unfaithful in the imitation of his model. I have stated numerous considerations, in order that clearly separating by analysis the elements of the art which concur with those of which I have given the rules, they will not attribute to me ideas which I do not entertain, but, on the contrary, they will see plainly that I have never misunderstood the qualities which neither instruct nor make the great artist. It is in this spirit that I have spoken of the harmonies of colours; and in distinguishing them into harmonies of analogy, and harmonies of contrast, I have been led to observe that we cannot mistake with respect to the pleasure produced in us by the sight of various colours suitably assorted. When indicating the subjects in which it appeared to me the harmonies of one kind should dominate over the others, I spoke in a general, but not in an absolute manner. I remarked that if the painter, with the intention of attaining the highest rank in his art, would fix the attention by the expression of his figures rather than by colour, and if, in consequence, he makes the harmonies of analogy predominate over the others, it will happen that — if he misses his aim — he will have a marked disadvantage in respect to the case where he would have employed vivid and contrasting colours, the expression of his figures remaining

the same. On the other hand, I have remarked that the painter who would treat a subject to which the harmonies of contrast belong, will place himself in an unfavourable position, other things remaining the same, if he has recourse to the harmonies of analogy.

A result of this view is that the critic must never compare two large compositions under the relation of colouring, without taking into account the difference which may exist in the accordance of each subject with one kind of harmony more than with the other.

## ARTICLE 2.
### *Painting in Flat Tints.*

(870.) To apply painting in flat tints to historical, portrait, and landscape painting,— in a word, to the imitation of any object of which we can reproduce a faithful representation, would be going back to the infancy of art; but to abandon it to practise exclusively the system of painting where all the modifications of light are reproduced according to the rules of chiaro 'scuro would be an error, which can be demonstrated beyond question.

Painting in flat tints as well as painting in chiaro 'scuro is based on the two following facts:—

1°. That the sight of colours is agreeable.

2°. That the sight of a drawing reproducing an elegant form is also agreeable, particularly when the remembrance of a cherished object is connected with it.

(871.) Let us now see the special advantages of the first system of painting.

1°. One part being of a uniform colour, and circumscribed by a faint or strong outline, it is very easy to distinguish the contiguous parts, and at the same distance it is much easier than if the colour of this part was shaded.

2°. More simple than painting in chiaro 'scuro, painting in flat tints is easier of execution and more economical; consequently, in its speciality it is susceptible, at the same cost, of being better executed than the same object would be if painted in chiaro 'scuro.

(872.) From which I conclude,

1°. That in every instance where a picture must be placed

at such a distance from the spectator that the details of the chiaro 'scuro will not be visible, we must have recourse to flat tints; not neglecting, however, to use masses of light and shade adapted to give relief, if it is considered advisable.

2°. That in every case where the picture is accessory to the decoration of an object, flat tints are preferable to chiaro 'scuro, because the use of the object almost always prevents the picture which ornaments it from being clearly seen under all circumstances.

Thus painting in flat tints is preferable to the other,

(*a.*) For ornamenting boxes, tables, screens, which, from the various positions their use requires, only admit of our seeing a part of the pictures which decorate them; or if the paintings are entirely visible, as those of a screen, they will be presented, relatively to the day-light, in a manner quite different from each other, on account of the various positions of the parts of the painted object.

(*b.*) For decorating curved surfaces, as those of vases, the surfaces of which are never plane. Nothing, I think, can justify the expense required by a painting in chiaro 'scuro upon a surface, the curvature of which necessarily contradicts the effects of the picture.

3°. That the qualities peculiar to painting in flat tints are:—

(*a.*) Purity of outline.

(*b.*) Regularity and elegance of forms.

(*c.*) Beautiful colours properly assorted.

Whenever opportunity permits, the most vivid and most contrasting colours may be advantageously employed.

(*d.*) Simplicity in the whole, so as to render clear and distinct view easy.

## § 2.

OF THE ARTS WHICH ADDRESS THE EYE BY EMPLOYING COLOURED MATERIALS OF A CERTAIN SIZE, CONSIDERED RELATIVELY TO THE PHYSICAL CONDITION OF THESE MATERIALS, AND TO THE SPECIALITY OF THE ART EMPLOYING THEM.

(873.) I HAVE remarked, that if we examine paintings with sufficiently powerful magnifying instruments, we shall see that

the coloured material, far from being continuous in all its parts, is in separate particles; and, consequently, if the naked eye does not perceive the intervals separating them, it is because these intervals are too small. This remark should be remembered, because it is the basis of the first distinction we must establish in this paragraph. In fact, the coloured threads (elements of tapestries and carpets), and rigid coloured prisms (elements of mosaics), which are visible to the naked eye, and which differ in that particular from the coloured materials employed by the painter, may, nevertheless, be reduced to such a state of division, and so mixed and combined, that at the distance from which we view them united, they appear a coloured surface continuous in all its parts, like a painted surface: whence we conceive the possibility of making with scales of these elements, sufficiently approximating and graduated, works which correspond to those painted in chiaro 'scuro; and, therefore, it will be easier to execute such as correspond with those painted in flat tints. This position granted, let us derive from the physical condition of the coloured materials and from the object which is essentially offered by the arts respectively employing them, conclusions adapted to serve as a basis to the judgment we bring to the qualities which the products of these arts must possess; and let us examine successively those which correspond to paintings in chiaro 'scuro, and those which correspond to paintings in flat tints.

Article 1.

*Tapestries, Carpets, Mosaics, and Coloured Glass Windows corresponding to Paintings in Chiaro 'scuro.*

A. *Tapestries with Human Figures.*

(874.) Tapestries with human figures derive their origin from the taste of mankind for painting. They adorned churches, palaces, and castles, before they appeared in simple dwellings.

From the filamentous condition of the elements constituting them, their size, the direction the weaver gives them in twisting the weft upon each thread of the warp, results a coloured image presenting two systems of lines cutting each other at right angles. From this structure it results — that a tapestry will not produce the effect of a painting (the surface of which is entirely uniform), if the spectator does not view it from a point sufficiently distant, so that these lines ceasing to be visible, the delineation which separates each part of the design

from the contiguous parts, will appear like the delineations of a painting, as much so as the indentations of the outlines which are oblique to the weft will permit.

(875.) From this double necessity for the furrows and indentations of the contours oblique to the warp to disappear from sight for the tapestry to produce the effect of a painting in chiaro 'scuro, it follows, *that the objects represented by it must be large, of various colours forming harmonies of contrast rather than harmonies of analogy.*

Such are the primary bases upon which the judgment of the critic must rest in the examination of questions concerning the art of the tapestry-weaver, whether it concerns models in the choice of which the weaver is a stranger, or whether it concerns the execution of the reproduction of those models, which exclusively concern the weaver.

(876.) Every model which does not fulfil the previous conditions is bad; and, as it is difficult to meet with the union of pure outline with harmonies of colour sufficiently numerous and contrasted in pictures which have not been painted with the intention of being reproduced in tapestry, it follows, that what would be very advantageous to the art, is the execution of pictures intended to serve exclusively as models, painted broadly, so as to resemble, in a manner, painting in flat tints.

(877.) The weaver not having, at least at present, models painted on the system alluded to, nor by artists who, imbued with the speciality of the art of tapestry, would have executed a painting susceptible of being copied as faithfully as can possibly be done with coloured threads,—the weaver, I say, is almost always obliged, even when his model is as suitably selected as possible, to make, not only, as we say, *a translation*, but also, I add, *a free and not a literal translation*, of the model; and it is this, in my opinion, which distinguishes the *artist*-weaver from the mere *workman*. For, it is not by a weaver's knowing how to mix the colours of the painter on his palette, and how to apply them skilfully to the canvas, according to the rules of chiaro 'scuro, that he will attain perfection in his art; on the contrary, it is in making the tapestry otherwise than in painting a picture according to this system; and, moreover, it is, because a servile imitation of this kind can only give a bad result. Far from contending then with painting, the weaver, on the contrary, must study the circumstances where he should succumb in the contest, so that he may avoid the difficulties with the means at his disposal; and it is then, especially, that he must deviate from his model.

B. *Tapestries for Furniture Hangings.*

(878.) The preceding consideration respecting the size of objects that figured tapestries should reproduce is not applicable to tapestries for hangings, seeing that we have remarked that the threads of the warp produce lines which, far from being disagreeable, are often imitated by the paper-stainer.

(879.) These fabrics being intended for chairs, couches, curtains, screens, &c., the painter charged with composing coloured designs suitable for models in this class of works, must never forget that tapestries may occupy dark places, where they are imperfectly and often indistinctly seen; consequently, he had best select simple and elegant forms, and with harmonies of colour adapted to the objects intended to combine with the tapestry in the decoration of an apartment. These models, even more than those which are intended for tapestries with human figures, must assimilate with painting in flat tints.

(880.) The weaver of hangings for furniture must be impressed with the same ideas, to execute the model quickly and well, according to the preceding observations, without seeking to rival painting in chiaro 'scuro: and in many cases he must depart from his model rather than servilely imitate it.

Among the facts I could quote to support this opinion, I shall select the following : it was a deep-rose-red curtain, the centre representing a large bouquet of flowers of various colours, framed, as it were, in a garland of white roses. The artist had painted the model under the idea of executing this garland with silver thread; but this metal being objectionable on account of its tarnishing through sulphurous exhalations, preference was given to white and grey silks imitating the tones yielded by a silver object in relief. An experiment showed that it could not be attained by employing these means, because the contrast of the ground made all the half-tints appear *green-grey*, and these in their turn made the lights appear rusty-pink, in consequence of the greenish colour of their contrast. This inconvenience being communicated to me, I begged M. Deyrolle, in reproducing the model, to make use of only three light tones of the rose scale in silk, and a white linen thread. By this means I expected that the complementary of the ground, neutralising the rose, would produce a greyish half-tint, well adapted to set off the white: the result realised my anticipations. A second copy made with a mixture of the light tones of the pure rose scale, slightly broken, gave an image less white, less *silvery* than the preceding, or, in other terms, appearing a little greenish

when compared with the first, and presenting more harmony ; it recalled the effect obtained with rose red under lace or tulle, which permits us to see a little of the ground. This example shows how to imitate a model, and indicates the means of executing white designs upon any kind of ground ; in fact, as a general rule, it is easy to arrive at it with light tones of the ground and a bright white.

### C. *Savonnerie Carpets.*

(881.) Carpets are larger than tapestries for hangings: on the other hand, being liable from their position to be soiled by the feet, and to receive furniture on some part, they are in a less favourable condition for being distinctly seen than tapestries. This, then, is one reason why we should choose models of which the design and colour are adapted to the circumstances necessitated by custom ; and for a carpet to produce the best possible effect, it must be in harmony with what is around it.

### D. *Mosaics.*

(882.) Mosaics being constructed with minute prisms, and, on the other hand, with materials susceptible of receiving polish, we can rigorously copy very small subjects, and, consequently, approach much nearer to painting in chiaro 'scuro than by employing threads. But to arrive at this result, without being unfaithful to the speciality of the art, the materials must be sufficiently solid, and joined together so intimately as to resist the agencies which destroy painting ; for if this end be not attained, we cannot see the use of copying a picture in mosaic. So that to justify the production of such works, we must make sure that, in the situations where they are placed they will resist the agents which would destroy the works of the painter.

### E. *Windows of Coloured Glass.*

(883.) A work executed in small prisms of transparent coloured glass, in imitation of painting in chiaro 'scuro, would be a true transparent mosaic. I do not know that such an imitation has ever been executed.

(884.) All the coloured glass windows which I have spoken of as decorations of Gothic churches, are composed exclusively of small pieces of glass of uniform colour, united by strips of lead or of iron ; or altogether of these small pieces of glass, and of glass upon which we have applied with a pencil materials which afterwards have been vitrified ; we can only entertain ɩe question of these latter in this article.

(885.) We may propose two different objects in the production of these windows; the coloured pieces are either altogether secondary in the work, that is to say, occupying a much smaller extent of surface than the others, they do not attain to the perfection of painting: such is the case with the greater part of the windows of large Gothic churches. Or rather, these pieces are the principal parts; then, predominating over the others, we attach great importance to the design and to the gradation of tints; such are several windows executed at the Royal Manufactory of Sévres. In rendering justice to the undoubted merit of these works, I shall say nothing particular about them, only that the more they resemble the preceding windows by the effect of variety, brilliancy, and opposition of colours, the more they attain the object they must essentially fulfil; for I regard these coloured windows not as pictures, but as much simpler works, which I believe are only well placed in large churches.

ARTICLE 2.

*Tapestries, Carpets, Mosaics, and Coloured Glass Windows, corresponding to Painting in Flat Tints.*

A. *Tapestries with Human Figures.*

(886.) Although I have advised for tapestry models executed on the system of painting in chiaro'scuro to resemble painting in flat tints, yet I shall not recommend taking the models entirely according to this latter system.

B. *Tapestries for Furniture Hangings.*

(887.) It is quite otherwise with patterns of tapestry for furniture: I believe that we can make some very beautiful works in copying patterns in flat tints; and that, in the decoration of large apartments, we may obtain an excellent effect from this kind of tapestry. I believe, also, that it would be more suittable for forming part of a general system of decoration, than the kind of tapestry of which I have spoken in the preceding article. Finally, it is more favourable than this latter to the splendour of the colours.

C. *Carpets.*

(888.) The preceding observations (887.), are entirely applicable to the production of carpets.

### D. *Mosaics.*

(889.) Mosaics being composed of more rigid and coherent coloured materials than the arts which combine coloured materials employ, I believe that it will be requisite, in judging works of this sort, to consider the resistance of the materials to friction, to water, and to atmospheric agents as essential qualities; the colour will follow afterwards.

### E. *Windows of Coloured Glass.*

(890.) According to the manner of considering coloured glass windows under the threefold relation of transmitting light into large Gothic churches, of their accordance with the decoration of objects consecrated to the rites of the church, of transmitting a coloured light entirely in conformity with the religious sentiment, I only prescribe windows of uniform colour for rose windows and straight windows with circular or pointed tops, I prescribe the smallest possible number of colours in the glass; glass of uniform colour must predominate over the other to produce the best possible effects of colour.

# SECTION III.

OF THE PRINCIPLES COMMON TO DIFFERENT ARTS WHICH ADDRESS THE EYE BY VARIOUS COLOURED AND COLOURLESS MATERIALS.

INTRODUCTION (891).

CHAPTER I.— PRINCIPLE OF VOLUME (898).

CHAPTER II.— PRINCIPLE OF FORM (900).

CHAPTER III.— PRINCIPLE OF STABILITY (903).

CHAPTER IV.— PRINCIPLE OF COLOUR (905).

CHAPTER V.— PRINCIPLE OF VARIETY (906).

CHAPTER VI.— PRINCIPLE OF SYMMETRY (909).

CHAPTER VII.— PRINCIPLE OF REPETITION (915).

CHAPTER VIII.— PRINCIPLE OF GENERAL HARMONY (920).

CHAPTER IX.— PRINCIPLE OF SUITABILITY OF THE OBJECT TO ITS DESTINATION (927).

CHAPTER X.— PRINCIPLE OF DISTINCT VIEW (933).

## INTRODUCTION.

(891.) This book would have concluded with the preceding section, if I had not been forcibly struck in my own experience with the generality of certain principles relating to very distinct arts, at the time I was arranging objects differing either in colour, form, or size,— sometimes in two of these properties, occasionally in all three. It was chiefly when occupied with the arrangement of vegetable forms that I appreciated, more than ever, the aid which the architect had received in perfecting his art by the contemplation of these forms and their arrangements; and numerous instances strengthened my opinion, that our senses can only be affected by a very small number of things at the same time, just as our reason can at once seize but a few affinities in the ideas which occupy our attention at a given moment.

(892.) It seemed to me not without use to show clearly how experience leads to the observation of facts, which generalised, become principles adapted to establish common affinities between widely different compositions, and to serve as a basis to a deep and critical examination, as well for the progress of art as for the study of the faculties of man, when he experiences deep impressions on beholding works of nature and art.

(893.) It is in this manner that I have been led to distinguish the principles expressing either the intrinsic qualities of objects or the affinities of the parts of which these objects may be composed, or the affinities of subordination which many objects possess amongst themselves; and, finally, the affinities which these objects should have with their destination, and with whoever contemplates them. In conformity with these ideas, I have established the following principles: —

1°. The principle of volume.
2°. ,, ,, form.
3°. ,, ,, stability.
4°. ,, ,, colour.
5°. ,, ,, variety.
6°. ,, ,, symmetry.
7°. ,, ,, repetition.
8°. ,, ,, general harmony.
9°. ,, ,, fitness of the object for its destination.
10°. ,, ,, distinct view.

By the rational application of these principles, we are enabled to distinguish the similitude of the affinities which exist in very different works, and how, when we have to judge of one which is complex, we do not at first see the product of any particular principle, but rather the product of many; and thence how important it is, for the examination of the whole, that each part should be brought back to the principle which governs it.

(894.) But in order to give our analysis the greatest possible precision in showing, on the one part, how we conceive its extension, and on the other part the limits in which we include it, we say that the language of the fine arts being addressed to the eye, is able to present the same object under two general conditions — one in which the object is in *repose;* the other, in which it is in *motion;* and we add, that in both of them the object can be isolated, or made part of an association of objects identical, or at least more or less resembling each other.

Let us cite some examples.

(895.) 1st CONDITION: IN REPOSE.

*First Example.*

A. *Isolated.*— An isolated tree may be presented to the eye by the painter, or by the gardener.

B. *Part of an Association.*— A tree may be presented to the eye by the same artists, no longer isolated, but grouped with other trees of the same species, or of the same genus, or different genera, but having some affinity with it in form, size, or colour.

*Second Example.*

A. *Isolated.*— A human figure may be represented isolated by the painter or the sculptor. The isolation may be absolute, or the figure may be, as in a historical picture, associated with other figures, or it may also be made a portion of a sculptural group.

B. *Part of an Association.*— A human figure making part of an association has no longer individuality, so to speak; it has no name, it becomes part of an aggregation of individuals resembling each other, but which, when the artist has been desirous of avoiding monotony, are not identical.

Such are the soldiers who form a platoon in a picture representing a review or a battle; if the identity is not in the figures, it exists in the uniforms.

Such are the statues which decorate the porch of a Gothic

church; as we have before remarked (431.), these should not be judged as a Greek statue, but as a whole constituting an architectonic ornament.

Such, moreover, are human figures sculptured in *bas relief* which do not form a picture, but serve as ornament in the decoration of an edifice.

(896.) 2ND CONDITION: IN MOTION.

A body produces very different impressions on us, according as we see it in repose or in action. It seems as if the arrow which cleaves the air, the bird which flies, invited us to action.

What difference is there not between the view of a calm lake and that of a river? The particles of water incessantly renewed in a spot on which our eyes are fixed, produce in us ideas of succession which are not awakened by the sight of still water. To the child, the animal in repose *sleeps;* and if, after having touched it, no sign of motion is perceived, the child pronounces it *dead*.

Military evolutions, bodily exercises, and dancing, which present to us the human figure in motion, exhibit it in a condition very different from that when it is seen in repose. When the condition of the human figure in motion is offered to our view, we have to distinguish between the case in which it is isolated, and that in which it is associated with other figures of its species.

A. *Isolated.* — The ballet master presents to us a dancer, isolated, or grouped with one or two others, that is to say, in conditions corresponding to the human figure which the painter and the sculptor represent to us absolutely isolated, or taking part in an action and so making part of a group.

B. *Part of a Association.*—Finally, we see in an assemblage of dancers, in the manœuvres of a battalion, and the evolutions of the line, co-ordinate movements in which the individuals disappear, so to speak, to show themselves as parts of a whole.

(897.) I have entered into these details in order that the extreme difference may be laid hold of which should exist between an object or an individual that the artist presents to us isolated, or making part of an aggregation of objects or of individuals which are more or less analogous to that object or to that individual.

Thus, the gardener should so employ his art that every plant intended to be seen in a state of isolation be large and beautiful, that it receives the light equally on every part;

while the specimen of the same species which is to form part of an association composed of specimens similar or cogeneral, or even of specimens belonging to different genera, should be led by the underwood in such a manner as to connect it with this group. It should not then be judged as if it ought to have the same aspect as the isolated specimen.

Thus, the painter and the sculptor, making a portrait or a statue, or grouping human figures, will give a particular physiognomy to each individual so that it can be named, if it has a name, and that one may know, if it forms a part of a picture, that such a passion excites it, or that such a sentiment animates it; whilst in human figures that are associated there will not be so much difference between the individuals. If there are many distinct associations, it is amongst these associations that the differences will be sought to be established; hence criticism ought not to judge the isolated individual in the same manner as the associated individual, in the sense we have given to that expression. Consequently human figures assorted for ornamenting works of architecture will not be judged as the Apollo, or the Laocoön, &c.

Thus, the ballet master will establish a distinction between the dancers who are intended to fix the attention, and those who form part of a group, because in the first case the attention should be concentrated only on one or more individuals.

## CHAPTER I.

#### PRINCIPLE OF VOLUME.

(898.) It has long been said, that in nature nothing is absolutely small, nothing is absolutely large; but whenever we see a new object, we are led to compare it with that which we know to be analogous to it; and it is then, if its size or volume markedly exceeds that of the object with which we compare it, volume becomes a property which strikes us in proportion to that difference. Of two statues or two busts representing the same model, but differing in size, the largest, though of equal merit, will strike us more than the other. But we must not omit to remark, that if we are accustomed for a certain time to see only statues and busts which both surpass the human proportions, then the influence of volume loses its force; and

moreover, it may happen that, after having seen many of these works, constructed so to speak on the same colossal scale, and having less merit than the work which struck us at first, we should be disposed to recur to figures life size.

(899.) But if the volume of an object has undoubted influence in striking spectators forcibly, we must never forget the inconveniences that result from exaggerating a single object which ought to be associated with others; for in this case the exaggeration may have the serious objection of lessening these latter, and thus breaking the harmony they would otherwise possess.

## CHAPTER II.

#### PRINCIPLE OF FORM.

(900.) Form strikes us at the same time as size in objects which we look at; and the influence it exercises on our judgment is well known. The artist should always endeavour to present an object under that form which is most appropriate to the effect he wishes to produce, and criticism should distinguish between the cases in which the object is isolated, and those in which it is associated.

(901.) Certain objects of art being only intended to address the eye, form is their most essential quality; such are triumphal arches, obelisks, columns, or pyramids, erected either as memorials, or to ornament a city, public place, &c. Other objects, on the contrary, having a special destination, their form becomes an accessory, or at least it is not the only essential part. It is from this point of view that we must consider edifices, such as palaces, churches, museums, theatres, &c., in order to ascertain if the architect has attained the end which he proposed to himself.

(902.) We have remarked elsewhere (856.) the influence an agreeable form may have in the judgment we exercise upon objects whose colours have no affinity with an association suited to their reciprocal embellishment.

## CHAPTER III.

#### PRINCIPLE OF STABILITY.

(903.) WHENEVER any object is to be presented to the eye in a state of immobility or repose, we like to see it in a position of perfect stability, for we are affected by a disagreeable, and even painful impression, if we imagine that a slight effort would suffice to upset it ; thence follows the necessity of submitting the *pose* of the figures of a picture, or of a statue, and of architectural monuments, to the principle of equilibrium. The leaning of the tower of Pisa (*il campanile torto*), and of the two towers of Bologna (*degli asinelli* and *de garisendi*), is not an effect of art, but rather the result of the sinking of the soil, which has been greater on the one side than on the other. The remarks which Condamine has made in his Travels in Italy (p. 13.), in relation to the first of these two towers, it seems to me, carry conviction to every mind.

(904.) A case which has always appeared to me very suitable to show the inconvenience resulting from not observing the principle of stability, is the bad effect of a house built upon a small plane inclining towards a valley or a plain which it commands as an eminence ; for a house so placed seems wanting in stability, and that the least effort would push it from the top to the bottom of the inclined plane. To remedy this evil, it is generally only necessary to elevate the earth in such a manner that the edifice stands on a horizontal plane, which should be extended as far as possible towards the valley.

## CHAPTER IV.

#### PRINCIPLE OF COLOUR.

(905.) COLOUR is seen at the same time as form. It imparts a more agreeable aspect to a smooth body, augments the relief, rendering the parts of a whole more distinct than they

would be without it, and efficaciously concurs in increasing the beautiful effects of symmetry, and of connecting the affinities of the parts with the whole, &c.

Taste for colour has led to colouring drawings, to the composition of pictures, to colouring statues, monuments, to dyeing stuffs, &c.

To enter into these details would be a needless repetition, since the object of the preceding part of this book has been to treat of the influence of this principle generally and particularly, under an abstract point of view, and under that of application.

## CHAPTER V.

#### PRINCIPLE OF VARIETY.

(906.) WHENEVER man seeks distraction from without, whether the pleasures of meditation are unknown to him, or thought fatigues him for a time, he feels the necessity of seeing a variety of objects. In the first case, he goes in quest of excitement, in order to escape from *ennui;* in the second he is desirous of diverting his thoughts, at least for a time, into another channel. In both cases man flies monotony; a variety of external objects is what he desires. Finally, the artist, the enlightened amateur, and less cultivated minds, all seek variety in works of art and nature.

(907.) It is to satisfy this want that various colours in objects please more than a single colour, at least when these objects occupy a certain space; that our monuments have many accessory parts which are only ornaments; that in furniture we use many things which, without being useful strictly speaking, please by their elegance of form, their colours, their brilliancy, &c. Assuredly, as I have endeavoured to show, it is the principle of variety which forms the essential distinction between landscape gardening and French gardening; for, as I have before said (819.), whoever walks in the former will notice objects disposed so as to excite in him, as far as possible, new sensations; whilst in the latter, he will find himself affected by a single and continuous impression; but I will add that, if this garden is of large and fine proportions, an idea of grandeur, perhaps even of sublimity, will be excited rather than by the landscape garden, which produces, especially

[Sect. III. Chap. V.] PRINCIPLE OF VARIETY.

on Frenchmen, an idea of the beautiful. In fact, the idea of the grand and of the sublime, determined by the eye, always reposes upon an idea of noble and majestic grandeur, and hence are engendered a succession of other ideas, which only connect themselves with the external and actually visible world through the medium of the first. Such are the ideas of *immensity*, of *boundless space*, of the *infinite*, which are awakened in us by the view of the heavens sprinkled with brilliant stars in a dark night; such are also the idea of *space* suggested by the sight of the sea; the idea of *force* or *power* which gives motion to its waters; the idea of *time* or of *succession*, presented by the sight of waves which, each in its turn, break on the shore; the ideas relating to astronomy, and to navigation. Finally, such is the affinity even of these great ideas with the weakness of the being who, however, is able to conceive them!
. . . . The idea of the beautiful, determined by sight, results from a certain *ensemble* of varied and harmonious ideas, always more or less immediately connected with the objects that have occasioned them, so that this idea, resting on the contemplation of a certain number of affinities, which the eye perceives in a completely finished object, the mind is no longer under the impression of a single quality, or of a spectacle which, but little varied, while vast, suggests the idea of *infinity*. It is assuredly this idea of the *infinite* springing up in a solitude at the sight of a ruin, which renders such a sight more attractive to many minds than the finest modern structure; in fact, the sight of the latter does not, like the former, transport the imagination back to those distant times when this solitude was covered with structures, to lead it on to the conception that a day may perhaps arrive when the great monuments of the nation will be ruins! . . .
I am not astonished that a man given up to meditation, and admiring the age of Louis XIV. (938.), should prefer those masses of trees at Versailles, so skilfully arranged at a suitable distance from the palace, to the best-arranged landscape garden elsewhere, which can never offer to the sight the imposing harmony of Lenôtre's composition. For, seen from the western façade, these gardens possess a grandeur which results from the fact of the eye discovering only dependent portions of a vast and unique composition. The space to the right and left of the spectator may perhaps appear confined, but by masses of vegetation in front it has all the vastness that may be desired, since the surface of the ground is bounded only by the horizon. If the lover of variety should blame the monotony of this view, and should discover some truth in the Duc de St. Simon's opinion of Versailles, in despite of the very evident bias of its

intelligent author, the lover of the grand will always admire the aspect of a powerful unity, which agrees so completely with all that we know of the court and of the person of Louis XIV. While I attach so much importance to the French garden, I must avow a preference for landscape gardening in every, or nearly every case, in which a private person wishes to lay out his grounds. It is also in this point of view that the interior of a Gothic church with painted windows, admitting of fewer varied ornaments than the interior of churches with plain glass windows (573.), seems to me more favourable than the second to the power and unity of religious contemplation.

(908.) If the principle of variety recommends itself because it is contrary to monotony, in its applications it should be carefully restrained, because, even without falling into confusion, effects may be produced far less agreeable than if they had been more simple. One thing with which I have been forcibly struck, and which I have had frequent occasions of remarking in the associations of colours I have made is, that although I employed coloured circles of an equal size placed in rectilineal series at the same distance from one another, that is to say in conditions the most favourable to a distinct view (933. and following), I have observed that in employing more than three different colours, exclusive of white, black, and grey, the effect of the series was less satisfactory than when only two colours, properly combined with black or white, were employed; such is the reason for my preference of two colours to three in military uniforms.

It is also for this reason that plants composing a single line should not be much varied, and that everything which tends to group different objects, so as to render them more easy to be grasped, exercises a happy influence upon optical effects.

## CHAPTER VI.

#### PRINCIPLE OF SYMMETRY.

(909.) It is very probable that our organisation, combining as it does two parts paired as identically as is possible in an organised being, enters very much into the pleasure that we obtain from the sight of symmetrical objects.

(910.) There are objects which it is necessary to present to

the eye perfectly symmetrical, either because they are so essentially, as a vertebrated animal (mammal, bird, reptile, fish), a radiated animal (star-fish, sea-urchin), or because symmetry pleases us in the form of an object of art which we see isolated, as a column, a pyramid, a triumphal arch, a temple, &c.; and I may here remark that Gothic churches are, for the most part, constructed upon a symmetrical plan.* Symmetry pleases also in a circular or elliptical border of flowers, the whole of which the eye takes in at a single glance (755. [A. b.], page 272.).

Finally, a symmetrical disposition should be observed in the arrangement of many objects grouped around or before a *principal object*, as the arrangement of such a garden as that of the Tuileries, which has a breadth equal to the façade of the palace, or the arrangement of a much vaster garden which is co-ordinate to a great palace, such as that at Versailles.

(911.) When a whole is subdivided into symmetrical parts of a definite extent, we can, in many cases, without injury to the whole, vary each part without going beyond the point at which discord would arise between them. This is what has been done in the park at Versailles, with a portion called *le miroir*, a charming garden, when it is planted with flowers properly assorted.

(912.) The principle of symmetry appears to me valuable for obtaining a general effect from many objects analogous, but differing amongst themselves, like the varieties of one species, or cogeneral species, or even species of neighbouring genera, belonging to the same family.

(913.) If there are objects to which a symmetrical form is suited, to the exclusion of every other — if there are grounds which must be laid out symmetrically, in order to connect vegetable nature with a grand architectonic composition,— there are also objects to which the symmetrical form is not so essential but that it can be dispensed with, and there are grounds which it is more suitable to lay out on the system of landscape-gardening than according to the principle of symmetry, even when it is not designed for the sake of gratifying a taste for variety.

For example, whenever a mass of objects cannot be embraced at a single glance, because they occupy too much space,— or when ground which is made of planes differently placed in regard to one another, also even when this ground, being flat,

---

* See the Chevalier Wiebeking's work, *Les Cathédrales de Reims, de Yorck et les Plans exacts de quarante autres Eglises remarquables*, &c., published at Munich in 1825.

is very irregular, and the buildings upon it are not placed as they should be, in a symmetrical composition,— it is convenient to throw aside the principle, not to carry out a *system* of irregularity, but to attain a pleasing distribution of objects, and even to have parts which, considered in detail, will appear less irregular than they would have done as a whole, if confined to a single plane.

(914.) It is in conformity with these ideas that we have subordinated the planting of masses in landscape-gardening to principles which are very distinct from those absolute ideas of irregularity which some people maintain.

## CHAPTER VII.

### PRINCIPLE OF REPETITION.

(915.) THE repetition of an object, or of a series of objects, produces greater pleasure than the sight of a single object, or of a single series; but it must be clearly understood that we are here speaking only of an object which addresses the eye by its form or its colour, and which is not intended, like a *chef-d'œuvre* of statuary, to be seen in a state of isolation (895, 896.); we are treating, then, of ornaments, or indeed more of plants and human figures, which are to make part of an association (895, 896.), and not to be presented to the spectator in an isolated state.

(916.) The repetition of a well-assorted series of coloured circles is more agreeable than when only one series is seen; this is an experiment easily made.

The repetition of the same ornament in a border, or in a cornice of a ceiling, is more agreeable than the sight of an ornament not repeated.

The repetition of the human figure serving to decorate the portals of Gothic churches (431.) has a fine effect.

(917.) The repetition of the human figure in a platoon, or in battalions performing evolutions of the line, is an agreeable sight to every one.

I shall cite, as a last example, the same movements executed by a number of dancers, because it is particularly well suited to exhibit the extreme difference between the sight of a single

dancer executing a *pas*, and the sight of dancers executing the same movement.

(918.) In the pleasure which arises from the sight of objects repeated, I have no doubt that space rendered more apparent by objects placed one after another and recurring periodically, exercises some influence; it is especially under this relation that I consider the effect produced upon the borders of a long alley, by the repetition of an assortment of five tufts of the same height, or nearly so, but differing in colour, placed between two trees (801., 2nd example).

(919.) We avoid the inconvenience of monotony, when in an extended line the same arrangement is to be repeated, by introducing into this arrangement a greater variety of objects than would be necessary if the line were shorter.

## CHAPTER VIII.

#### PRINCIPLE OF GENERAL HARMONY.

(920.) In order to compose a pleasing *ensemble* it is not enough to combine agreeable objects, it is likewise necessary to establish between them connecting affinities, and it is the suitability of these affinities, more or less easy to recognise, that will show if the principle of general harmony has been more or less thoroughly observed.

(921.) Harmony is observed in a single object, as well as in associated objects, whenever the former exhibits distinct parts. Such is the harmony of proportions in the limbs of an animal.

(922.) Harmony is established between the different parts of the same object, by means of the proportion of the parts, volume or superficies, the form and the colour. Symmetry is indeed one condition of harmony, but if the symmetrical parts of an object are deficient in proportion, this object will want general harmony in the *ensemble* of its parts: symmetry then does not always belong to general harmony.

(923.) Harmony is established between different objects by means of an analogy of size, of form, and colour; by means of symmetrical position; and, lastly, by means of the repetition

of the same form, of the same colour, or of the same object, or even of objects very analogous, if they are not identical.

(924.) Nothing shows more clearly the influence of position and of repetition at equal intervals, in the general harmony of many widely differing objects, than to make homogeneous groups of these objects, and even regular or adjoining each other, or disposing them on a line, and alternately at equal intervals; finally, if these objects are plants, making them subordinate to our principles of planting.

(925.) Conformably to these ideas, we can conceive how harmony will be established between groups each formed of similar objects.

(926.) The absence of general harmony remarked in many classes of compositions, frequently depends upon the endeavour to introduce too great a number of heterogeneous objects, or such as differ too much; this may be remarked in the decoration of many edifices, particularly in interiors, where the accumulation of more or less precious or elegant objects results in confusion, and a want of general harmony. Another cause of this result is the co-operation of several artists employed on the same work, independently of each other, and frequently with views altogether different; it is evident that the result of this state of things must be incoherence in the final effect of the work.

Such is the cause of the deficiency of harmony observable in buildings on which several architects have been employed either successively or at the same time. Strange as it may appear, some examples may be cited of architects, who, without any views in common, have been simultaneously charged with the execution of different portions of a general plan conceived by another, without the obligation of subordinating these portions to the general plan having been imposed upon them.

## CHAPTER IX.

#### PRINCIPLE OF THE SUITABILITY OF THE OBJECT TO ITS DESTINATION.

(927.) It seems to me that this principle should be found in every art; for every object which springs from every art has

its destination; it is necessary, then, for the aim of an artist to be attained, that the object be suitable to its destination. It is in accordance with this principle that I have regarded the qualities of the products of the two systems of painting, of tapestry, of mosaics, and of coloured glass; and in all questions that have been raised on this subject I have distinguished between the *accessory* qualities and the *essential* qualities, and it is upon the appreciation of one or other of these qualities that I have founded the judgment which should be formed on the real value of a work of art; evidently the aim will not have been attained where *essential* qualities are wanting, which is not denying that the work may be of a class to please the eye.

(928.) It is in regarding pictures conformably to the effect which the harmonies of colours produce on us, according as they are analogous or contrasted, that we have considered the difficulties overcome by the painter, and that we have examined whether, in a given work, the harmonies employed are consistent with the effect which the artist has been desirous of producing.

(929.) It is in conformity with the same ideas that we have regarded the interior decorations of churches, palaces, and private houses; that we have indicated the most suitable colours for the decoration of theatres, the interior of picture galleries, and museums of sculpture and the products of nature; but, in order to judge of the value of a theatre in regard to the principle of suitability, we must know whether the spectators are all properly placed for seeing the stage and for hearing the words of the actors. So, to judge of a museum, we must know how the objects preserved therein are presented to view; and here we may recollect that form and decoration are but accessory parts, and not essential to this class of edifices (901.).

(930.) I have no doubt that the faults which may be detected in theatres and museums arise from the fact, that the artist has not been impressed with the aim of his work,—that he has not seen that the ornaments should be accessories; so the painter who has presided over the internal decoration of a theatre would seem sometimes to have forgotten that the colours are not to be seen by daylight, and that the seats will be occupied by spectators, amongst whom will be found ladies adorned with gold and jewels, who themselves should be the fairest ornament of the place. The architect of a museum appears to have forgotten that the entire edifice should be subordinate to the objects it is destined to contain, and that all which interferes with the distinct view of these objects and the effect

which they should produce is opposed to the principle of the suitability of the object with its destination.

(931.) If the observance of this principle should seem at first sight to require no more than *simple good sense*, it will be seen on reflection that genius ought unceasingly to consider it, because it is by conforming thereto that a true artist will be able, in our day, to stamp with originality a building perfectly suited to its purpose, and commendable by the elegance of its parts, which will be subjected to perfectly definite affinities of coordination.

(932.) I may remark, that, in teaching architecture, those parts which are connected with physico-chemical knowledge, and with the arts properly so called, are not sufficiently insisted upon; almost all these teachings relate only to form, and the actual knowledge taught on this subject applies to the monuments of a bygone civilisation, erected for customs which are no longer ours. In the study of these monuments, while developing to pupils the relation of parts with the whole, making them perceive that whatever is beautiful attaches itself to rules invariably allied to our organisation, it must be insisted on, that architectonic forms, however beautiful they may appear, should not be reproduced in edifices to which they are altogether foreign; the distinction between monuments which are intended to appeal to the eye only, and those which have moreover another purpose, must be insisted on (901.): we must show clearly to pupils that it is only after having fulfilled all the conditions necessary for satisfying the purposes of modern edifices, that they should exert their powers in giving to their works such a form as will recommend them to future criticism, as the forms of Greek monuments is their recommendation, in our time, to all study based upon positive rules. If I admit that when monuments like those of the Greeks are in question, such as a column or a temple, we cannot do better than imitate them, it will be granted, I think, that when it is intended to build an edifice adapted to modern customs, very different to those of the Greeks, the first condition being to fulfil such purpose, we must seek in the second place only for the most beautiful and grandest form for our projected edifice; and I confess that unless we maintain that the Greek architects have not profited by the knowledge of other nations, that they have not made attempts before arriving at the construction of these monuments that we admire, that they have not studied the forms of vegetable nature, I do not see why we should not prescribe to pupils, at least to those whom we believe

capable of great things, the study of ancient and modern monuments, to observe the forms of organised beings, particularly those of the vegetable kingdom, in order that they may appreciate how nature varies in her creations without ceasing to be beautiful; finally, why we should not point out to them that it is only after being impressed with the object of a projected building, that they should give themselves up to attempts at producing all the effects they wish to obtain, in order to fulfil all the conditions necessary to satisfy the principle of the suitability of the object with its destination.

## CHAPTER X.

#### PRINCIPLE OF DISTINCT VIEW.

(933.) It is necessary for every work of art to satisfy the principle of distinct view, by which all the parts of a whole intended to be exhibited, should present themselves without confusion and in the simplest manner. In fact, the spectator always feels some want in those works which do not fulfil this condition. I will cite but one example, the view of the façade of the *Palais des Beaux-Arts*, facing which are found the *Arc de Gaillon*, and *a column* which, being placed in front of this arch, cuts it in two in the most disagreeable manner to the spectator who looks at the edifice.*

(934.) I have always considered the principle of distinct view as essential to all those arts which address the eye; it is in obedience to this that we make use of colour and of relief, that we are compelled to present but a small number of objects to the sight, that the larger they are the less they should be laboured and the greater their parts should appear. It is, moreover, in conformity with this principle that we have recourse to the principles of symmetry and of repetition, and

---

* This remark is not a criticism applicable to the architect of the *Palais des Beaux-Arts*, because we know that it was from the fear of its deteriorating one of the *chefs-d'œuvre* of the Renaissance that he was unwilling the *Arc de Gaillon* should be removed from the place it occupied at the period of its removal to the *Musée des Petits-Augustins*.

that, finally, harmony of *ensemble* is wanting whenever there is a confusion of parts.

(935.) In a well-organised mind there exists the closest relations between the co-ordination of parts which the artist renders visible, and the co-ordination of ideas upon any subject whatsoever.

# SECTION IV.

## OF THE DISPOSITION OF THE MIND OF THE SPECTATOR IN RESPECT TO THE JUDGMENT HE FORMS OF AN OBJECT OF ART WHICH ATTRACTS HIS EYE.

(936.) It is not enough to have indicated the rules to be followed, and the principles to be observed in the production of effects, and the judgment of them in relation to art; we must also speak of the disposition of the spectator for receiving the impression of those effects in a manner more or less intense; to take no notice of this disposition, would be to display ignorance of human nature, and of the utility of the examination which should be impartially pursued also in the judgment of the critic, who may exaggerate blame as well as praise.

Without examining the influence the passions exercise in opinions formed on works of art, I will say a few words upon a predisposition which may be remarked in a portion of the public, at least at certain epochs, and which has its source in man's vanity. Then I will point out the part which the association of certain ideas performs in the formation of opinions.

(937.) When a body of painters, called a *school*, has produced some *chefs-d'œuvre*, it frequently happens that a great number of mediocre works executed under the pretence of continuing them, far from being favourable, are injurious to a portion of the public, on account of the monotony resulting from an imitation, more or less servile, of form, colour, and of the subjects themselves. The public, under these circumstances, is ready to applaud every innovation that will excite emotions which it has not for some time found in contemporary painting; and it is then that, amongst the public, voices are raised against great works which have nothing in common with the tame imitations of them produced by mediocrity. Truly, there comes an epoch when innovation losing the only advantage it possessed of presenting to the eye images differing from those which it had been a long time accustomed to see, the public returns to the *chefs-d'œuvre*, and forgets all the feeble works composed in imitation of them by feeble pupils; and, we will add, that if works *professing to be of the new school*, and endowed with

undeniable merit, should exist, they would, in the estimation of connoisseurs, take the places they ought to occupy, whilst those which had arrested attention by innovation only, disappear for ever.

(938.) Finally, I will notice the effect which certain associations of ideas may have on our opinions. For example, any one arriving at Versailles full of admiration for the age of Louis XIV., will repeople the gardens with all the great men that have frequented them, and, recurring in thought to the *fêtes* giving by an elegant and polished court, the admiration of Europe, will judge the work of Lenôtre more favourably than he who, without being, however, hostile to the *grand siècle*, sees nothing but a garden subordinated to a palace. There is no doubt, moreover, that the Christian who associates in his mind the architectural form of the Gothic church, the brilliancy of its coloured glass, and the religious ceremonies, which, when yet a child, he has seen celebrated in it, will be in a disposition of mind to prefer the Cathedral of Cologne to St. Peter's at Rome, or, what amounts to the same, will be more disposed to admire the first of these monuments than a Roman would be, whose mind would be filled with ideas of religious ceremonies linked with the idea of the church of St. Peter's.

HISTORICAL REVIEW

# OF MY RESEARCHES,

AND

FINAL CONCLUSION OF THE WORK.

(939.) THE first opportunity I had of observing the influence of contrast in the juxtaposition of colours was offered me in 1825 by the Directors of the Gobelins. As I have before said (Author's Preface, p. viii.), they inquired of me why the black tints were deficient in vigour when employed for shadows in blue or violet draperies. I found the cause of this effect to lie in contrast; for having compared together two identical black patterns, one of which was placed on a white ground, and the other on a blue ground, I observed that the latter lost much of its intensity. It was after this experiment that I recollected having several times fancied that there was a difference between two portions of the same skein, whenever one was contiguous to a colour different from that which joined the other portion. Having gone, as soon as I remembered this, to the warehouse for coloured wools in the Gobelins, I proved the fact upon red, orange, yellow, green, blue, indigo, and violet skeins, and I speedily comprehended the influence of black and white on the same colours.

(940.) The modifications arising from the juxtaposition of the preceding colours taken in couples being once defined, I sought for an explanation of the phenomenon in scientific works. Amongst the books recently published in France on this subject the treatise by Haüy only, under the head of *accidental colours*, mentioned contrast. Not only did I read the article devoted to this subject, but I referred to the authorities of the writer. I made extracts from the writings of Buffon, Scherffer, Rumford, Prieur de la Côte-d'Or, &c. on this subject. But so

long as I endeavoured to link together the phenomena which I had observed so as to comprise them in one general expression in conformity with the writings I consulted, I lost my time; yet I was incessantly impelled towards that end by my friend M. Ampère, who, whenever in the course of my researches I mentioned to him anything relative to contrast, constantly replied, " *So long as the result of your observations is not expressed by a law they are valueless to me.*"

On the one hand, the difficulty of finding a law which governed phenomena I had never considered, and which probably I should never have studied, but for the circumstances I have already mentioned,—on the other hand, my being preoccupied by a great number of chemical researches necessary to be undertaken to obtain fixed bases for dyes, caused me to lose sight of the phenomena of contrast, and to forget the details I had read on the subject. It was after having been many months in this state of mind, that one day being present at a literary meeting, the phenomena of simultaneous contrast of colours which I had observed recurred to me during a lecture that failed to occupy my attention: I recalled them so clearly, that I saw their mutual dependence, which I immediately imparted to M. Ampère, who sat beside me.

(941.) The conviction of the correctness of the law of these phenomena being once attained, I re-read whatever had been written on *accidental colours*; I then clearly saw that the obscurity of this subject arose from a great number of facts being confounded under one general denomination, without establishing the fundamental distinctions which I had made between two sorts of contrast under the names of *simultaneous contrast* and *successive contrast* of colours. In fact, it was because I had been unable to find this distinction in writers, that while I had before my eyes, or in my memory, their writings upon *accidental colours*, I could perceive no link between their observations and mine, which at this time I looked upon as a simple extension of the first. It was only after losing sight of what had been done before my time, that I was able to generalise my results, to appreciate at once the frequency of the cases in which they were exhibited, and the peculiarities which distinguished them from anterior observations; in short, that I was in a position to subject them to a co-ordination that enabled me to fully appreciate all the value of Scherffer's work specially concerning *successive contrast*, when once I had succeeded in disentangling it from subsequent works on simultaneous contrast, which had been associated as connected with accidental colours. To this association I attribute the cause of the ob-

scurity of the article on this subject in Haüy's Physics, and the explanation therein contained of a phenomenon of simultaneous contrast so unworthy of the reputation of the name under which it is given.

(942.) If I have entered into the preceding details, it is not because they particularly relate to myself, but because they present to him who consults the history of the sciences of observation with the intention of tracing the progress of the human mind in its researches after truth, a striking example of the inconvenience produced by the accumulation of facts, which, incompletely seen, although true at bottom, fail in co-ordination. Not only may the inconvenience I wish to point out be a real obstacle to future works, but it may lead so far, during a certain time, as to cause the value of an old work to be misunderstood, to which contemporaries have not given the attention, which for the sake of its origin it deserved. The conclusion I draw from such a fact is very simple; the number of journals which give accounts of scientific matters increasing with the number of learned societies and experimentalists, and on the other hand the temptation to publish being so great that we prefer giving to a variety of researches the time which ought to be devoted to a single profound research, it follows, that while the former lead to questionable results, they give rise to criticisms which, frequently as shallow as the works they relate to, only excite doubts in minds capable of appreciating the insufficiency of both. Finally, we are driven to say that frequently he who draws from a limited experience a conclusion to which he gives the name of *law*, would no doubt have abstained from establishing a generalization, had he made one experiment more, properly conducted so as to govern that conclusion.

(943.) From the very beginning of my researches on contrast I was convinced of the correctness of my observations by my very mode of experimenting, which, to my knowledge, had never been employed before. In fact, in placing four samples, two of which are identical, as represented in Fig. 1. Pl. 1., we completely establish the phenomenon; and as it is visible with pieces of paper of a foot square or more, we perceive that, in setting out from the line where the juxtaposed papers touch each other, it is much more extensive, with respect to the coloured surfaces, than could have been believed from previous experiments where we had put a very small piece of paper or stuff upon a ground of a different colour, and of indefinite extent.

(944.) My experience tends to show —

That the effect is a radiating, setting out from the line of juxtaposition;

That it is reciprocal between two equal surfaces juxtaposed;

That the effect of contrast still exists when these two surfaces are at a distance from each other, only it is less evident than when they are contiguous;

Finally, that the effect exists when we cannot attribute it to fatigue of the eye.

(945.) Assuredly, if simultaneous contrast of colours had been seen in the circumstances under which I observed it, the universality of the phenomenon would not have been misunderstood even by those who had treated of it, it follows that they would have abstained from employing the name of *accidental colours* to distinguish it, or, what comes to the same thing, if they had employed it, they would have directed attention to the fact that every colour seen simultaneously with another, appears with the modification of an accidental colour; and things being brought to this point, it would be impossible in scientific treatises not to assign a place to the exposition of a phenomenon so frequent as that of which we speak, and which is expressed by a simple and easily verified law. On the other hand, if the phenomena of simultaneous contrast had been established as they now are, men of science who have attached the greatest importance to the knowledge of its application, would have been conducted to points of view less limited than those at which they paused, and would thereby have proved that the phenomenon had never been to them the object of precise or general observations. In reading, for example, what Count Rumford has written on the harmony of colours, we see how circumspect he is when he has to deal with observations made with coloured materials used in painting, on coloured rays of light emanating directly from the sun; how cautious he is in explaining the phenomena he describes; how limited is the application of his idea of harmony in the assortment of colours, since it consists only in complementary association; finally, how vague it is when he is desirous of detecting in the works of the great masters colours springing from this harmony, which have no actual existence, and which he calls the *magic of painting*, because it is useless to seek them on the canvass, and yet he affirms that they are to be seen under favourable circumstances of light and when we are placed at a proper distance from the pictures.

The numerous experiments detailed in the first portion of

this work are more than sufficient to prove that the *magic* spoken of by Count Rumford is to be found in the flat tints of house-painters generally in a more marked manner than in the pictures of the greatest colourists, because the latter in many cases soften the separation of two colours by blending them one in the other. I have entered largely on this subject, in order to show clearly the extreme difference there is in the manner in which Count Rumford has investigated the harmony of colours, and the point of sight where I have placed myself for the application of positive knowledge, deduced from established, definite, and generalized facts, independently of all hypothesis, to painting, and to those arts which make use of assortments of colours.

(946.) It is only after having given the law of *simultaneous contrast* of colours, having shown how much this phenomenon differs from *successive contrast*, and, in short, having defined what I mean by the term *mixed contrast*, that I have pointed out the numerous applications which are deducible from the law of simultaneous contrast.

(947.) I have commenced the study of these applications by defining some expressions which, had they retained the vague sense they possess in common language, would have prevented me from communicating my thoughts with precision.

(948.) I have been compelled to present the results of a considerable number of experiments and observations under the form of *rules* fitted for the guidance of those who, after having repeated my principal experiments, have convinced themselves of the exactness with which I have brought together the generalizations to which they lead.

(949.) All the observations which did not appear to me to possess a character of incontrovertible precision, have been presented with proper reserve, as the expression only of my peculiar views.

(950.) I believe that the rules I have laid down upon the *art of viewing the model* which the painter reproduces, will dispel the notion entertained by many persons, that there is a *great difference* in the manner in which the same colours are seen by eyes of an average organisation, that consequently there will no longer be alleged in favour of this opinion the diversity which may be remarked in the colour of copies made by pupils who have gained no precise notion of the manner of composing mixed colours with the pigments they employ under the names of Prussian blue, ultramarine, grey blue, chromate of lead, nor of the modifications of the local colours of their model

under the various conditions in which they should reproduce them on the canvas: finally, to pupils who have not submitted to proofs analogous to those to which I have subjected the dyers whom I have examined to ascertain whether they have a well-formed eye: very simple proofs, since they consist in showing them coloured objects in juxtaposition, and making sure they perceived the modifications given by the law of simultaneous contrast.

Finally, it will be no longer alleged in favour of the opinion I am contesting, that the dominant colour of the pictures of one painter being violet, while that of the pictures of another is blue, the first one must necessarily see violet, and the second blue. Certainly it is not the possibility of the fact that I contest, it is the *general* conclusion drawn from a particular fact: indeed, if the difference between the manner in which various individuals see the same colour is as great and as general as is pretended, there would no longer be any comprehension of colour at all; and if there were a public who saw a picture too violet or too blue in comparing it with the model, another public would certainly exist who would see it as it is pretended the painter must have seen his model; hence for this public there would be no foundation for saying that the picture is too violet or too blue. However, as it is not so, I conclude that the preceding reason has no foundation, and that the general judgment of the public, in distinctly noticing in a picture a dominant colour which is not in the model, proves that the individuals composing this public see, if not in an identical at least in an analogous manner.

(951.) It was while taking the experimental method for a guide, and after having determined by observation the modifications light is subjected to in relation to coloured bodies, that I have been led to conclude that in a monochromous object, or in a monochromous part of a polychromic object, *all modifications except those which may be the result of coloured rays reflected upon this object or on this monochromous part, are susceptible of being faithfully imitated with the coloured material which corresponds to the colour of the model, the neighbouring scales of this colour, normal grey and white.* This conclusion greatly simplifies the art of painting, and at the same time gives a solid basis to the critic who desires to judge of the truthful colouring of any picture.

(952.) To my conviction that the rules laid down in this work will save a great deal of time to such young painters as may follow them, is joined the hope that they will not take advantage of them in order to multiply their pictures, but

rather those preliminary studies which are always demanded by every definitive performance. I have sufficiently explained myself so that the idea of reducing painting merely to the faithful reproduction of each particular object that enters into a picture cannot be attributed to me; not only have I insisted upon the arrangement, the co-ordination of the principal objects, the subordination of those which are secondary, and upon those harmonies of colour necessary to connect them so as to form but one single whole, but in speaking of the expression of figures, I have expounded my opinion upon those qualities which may be gained from a master, and those which are only to be found in oneself, and which are only perfected by study, and which are the only ones which mark a work with the stamp of genius.

(953.) I have applied the *conclusion* to which I have been led for the reproduction of the model in painting, to the imitations of painted objects which are made in tapestries and carpets. I have shown that the exact representation of the modifications of colour in these models demands a knowledge of contrast still more imperatively than painting properly so called itself demands.

Experience has led me to establish very simple rules suitable for obtaining the most beautiful greens, oranges, violets, by the mixture of blue, yellow, and red threads, and to show that the weaver produces black or grey when he mixes together in certain proportions those three colours, or two colours mutually complementary.

I have, consequently, clearly shown in these rules how we may deceive ourselves if, with the intention of harmonising two colours appertaining to different parts of the same object, we do not distinguish the case in which these colours are complementary, and that in which they are not; when for example it is a rose surrounded by its leaves, and a stem of periwinkle garnished with leaves and blue flowers: so, if, in order to harmonise the local colours, we mix them in certain parts of the flower and the leaves, we obtain grey by the mixture of the red with the green, while with regard to the periwinkle, by blending the local colours of the flower and its leaves, we make blue greenish, and green bluish; hence it is in the latter case, and not in the former, that the colours of the two parts approach each other.

Experiments have moreover enabled me to discover the method of working, in tapestries on coloured grounds, white shaded designs which do not appear of the complementary colour of these grounds.

(954.) In establishing the great difference which exists between paintings and works executed with materials of a certain size—in insisting on the necessity of employing for the latter, colours purer and less blended than those used in painting—in insisting on the necessity of making the harmonies of contrast predominate over the harmonies of analogy,—I believe I have spoken for the benefit of the painter charged with the execution of the models, and for the interest of the artist who has to copy them. In indicating the qualities these models should possess, in pointing out the dangers arising from a desire to execute paintings with materials of a grosser kind, I have indicated the means of rendering the employment of these materials less servile, and consequently of giving more originality to the works of the weaver.

(955.) I have subordinated to observation and to experiment, and not to any hypothetical view, everything that concerns the decoration of the interiors of edifices ; and I have strenuously insisted upon the necessity of subordinating everything to its destination.

(956.) Finally, in applying the experimental method to the arrangement of flowers in gardens conformably with the law of simultaneous contrast of colours, I have had frequent occasions of remarking how much analogy there was in those arrangements between the colours and the forms, in relation to the special effects obtained from each in respect to diversity, symmetry, general harmony, &c., that I have been led to a generalization which I had not in view when I commenced my work : but all the generalities at which I have arrived are the result of immediate observation, as prescribed by the experimental method, and it was only a long time after having seen many of the products of arts which make use of coloured materials, that I have come to the conclusion that this method to which the physical sciences owe their progress, might be applied in many cases to the practice as well as the theory of the fine arts, and that this extension must necessarily give a precise knowledge of the faculties that place man in connection with the works of nature and art.

(957.) In conclusion, I have sought as much as possible the rules in the nature of the things which they concern ; but, in prescribing them, far from being exclusive, I have, on the contrary, avoided presenting a single type of beauty. It is in this spirit that I have spoken of the general effects of the harmonies of contrast and of analogy, leaving to those who employ them, either in painting, or in the assortment of any coloured

objects whatever, all the latitude these rules admit of, without injuring the beauty of the assorted objects. In the same spirit I have spoken of Grecian and Gothic architecture, of geometric and landscape gardens, and, instead of making these works rest on opposite principles, or of considering some as derived from principles, whilst others are the product of artistic caprice, I have sought for their common affinities and the principles to which the differences that distinguish them actually belong.

Criticism made from this point of view of a work which, although very incorrect, has engaged the attention of a class of men, appears to me useful, if not to the author, at least to the theory of art and to the knowledge of our own nature; because under this double relation it is always interesting to trace out the cause that has attracted the attention of men, of those who are the least enlightened, or who are deficient in the elements of education.

Finally, in conformity with this mode of view, it appears to me that when a people has left traces in history by its annals, its literature, and its monuments, far from disdaining the products of its literary genius and its arts, it is, on the contrary, necessary to assiduously seek out what had led this people to adopt the form it has given to its works, and to see if it is possible to go back to the source of the admiration it entertained for them.

# CONCLUDING REMARKS ON CONTRAST.

(958.) I DO not intend to finish the historical sketch of the researches composing this work without adding some remarks relative to the extension of which they appear to me susceptible.

These considerations bear on four different points: —

The first concerns the observation of several natural phenomena;

The second relates to the contrast presented by two objects differing much in size;

The third relates to the question, if any other senses besides the sight are subjected to the law of contrasts;

Finally, the fourth has reference to the light which, as I believe, the study of contrasts is susceptible of shedding upon several phenomena of the understanding.

## § 1.

**OF CONTRAST CONSIDERED IN CONNECTION WITH THE OBSERVATION OF SEVERAL PHENOMENA OF NATURE.**

(959.) In contemplating natural objects we discover many opportunities of applying the law of simultaneous contrast to certain phenomena exhibited by them.

(960.) Thus, whenever a surface on a dark ground reflects uniformly a strong light, the edges of the former appear more brilliant than the centre, whilst those portions of the ground

contiguous to these edges appear darker than the rest of the ground; hence contrast tends to give relief to uniform surfaces.

(961.) When the sun is on the horizon, and when it strikes opaque bodies with its orange light, the shadows that these bodies project, illuminated by the light which comes from higher parts of the atmosphere, appear blue. This colorisation is not due to the colour of the sky, as many persons believe; for if, instead of the bodies being struck by the orange light of the sun at the horizon, they were struck by red, yellow, green, or violet light, the shadows would appear green, violet, red, or yellow. The explanation of these phenomena is included in that which I have given of the colours which appear on white plaster figures, lighted simultaneously by coloured rays and by daylight. (697. and following.)

(962.) The greyish footpath which crosses a meadow, or a lawn, appears reddish, because of the juxtaposition of the green grass.

(963.) Whenever we regard two coloured bodies simultaneously, in order to appreciate their respective colours, it is necessary (especially if these colours are mutually complementary, and one weaker than the other), to view them separately, otherwise the weakest colour would be visible only by the juxtaposition of the strongest colour. Thus it cannot be affirmed that two neighbouring bodies which appear the one green, and the other red, are so actually, till we have tested the fact that each appears of these respective colours when seen separately.

(964.) It is unquestionable that the colours of the rainbow are modified by their juxtaposition, inasmuch as isolated they appear of different hues than we see them.

§ 2.

OF CONTRAST CONSIDERED WITH RESPECT TO THE SIZE OF TWO CONTIGUOUS OBJECTS OF UNEQUAL SIZE.

(965.) We cannot refuse to admit that a contrast of size exists, as well as of two colours of the same scale, taken at different tones. I do not base this solely on the observation that we may daily make relative to the diminution of size appa-

rently presented by an object that we have first seen isolated and afterwards by the side of a greater, but rather on a positive experiment analogous to that which so clearly demonstrates the contrasts of tone and of colour. When we arrange on a black ground of indefinite size two strips of white paper, 7 inches in length and $\frac{1}{8}$th of an inch in breadth, and two strips of the same paper 3 inches in length and $\frac{1}{8}$th of an inch in breadth, as represented in the following figure:

$$o' \text{———} o'$$
$$o \text{———} o$$

$$p \text{————} p$$
$$p' \text{————} p'$$

$oo$ appears smaller than $o'o'$, whilst $pp$ appears larger than $p'p'$. At least so it appeared to many persons besides myself, among whom were two machinists who were not previously acquainted with the proof submitted to them.

(966.) If from the contrast of size we deduce, according to the law of continuity, that an object which would be visible in a state of isolation might cease to be so if placed by the side of a larger object, and if we explain in this manner how it happens that some bodies seen distinctly and without trouble in the microscope, become *extremely difficult to be seen* when they are placed near to larger bodies, — a fact that M. Donné tells me he has frequently noted, — yet, I must remark, that between this phenomenon and that of simultaneous contrast, such as I have already described it, there exists this difference, that in the latter, two objects are seen at the same time very distinctly, which is not the case in the former, where a single object is visible. In fact, without recurring to contrast, and in conformity with what I have before said (748.), that the eye sees at one time but a very limited number of relations in the objects which strike it, we must admit that it occurs when, if an object placed near to another appears much more distinctly than the second, the organ will involuntarily fix itself upon the first, and the second will not be seen, or, if it becomes perceptible, it will only be when, by force of attention, so to speak, we come to receive that impression in ignoring the image of the first.

## § 3.

### ARE THE SENSES OF HEARING, TASTE, AND SMELL SUBMITTED TO CONTRAST?

*Distinction between the contrast of antagonism and the contrast of simple difference.*

(967.) If it is philosophical to seek out those properties which the organs of the senses possess in common in their structure and functions, it is no less philosophical to ascertain the special differences that distinguish them. Under this proposed relation I proceed to examine, in connection with the sense of sight, the senses of hearing, taste and smell in some one of their operations, after having distinguished as clearly as possible *the difference arising from the antagonism of two things, from the difference that arises between two things of greater or less size or intensity in one of their properties.*

(968.) We say that there is antagonism between two properties or between two things each possessing one of these properties, when in virtue of a mutual action these properties disappear. Examples : —

1st. Two discs of glass rubbed against each other, then separated, display electrical properties; but one has positive electricity, and the other negative. Upon re-uniting the discs these properties disappear, they mutually neutralise each other, and are consequently *antagonistic.*

2nd. The same result is obtained from two needles of equal magnetic power : on applying the one to the other, so that the different poles touch, there is a neutralization of their magnetic properties, and we call them two *antagonistic magnetisms.*

3rd. Sulphuric acid reddens tincture of violets, whilst potass changes it to green : here are two actions differing in their results; now if we combine the sulphuric acid and the potass in proper proportions, we obtain a compound which has no effect on the colour of the violets. In this case it is said, the acidity of the sulphuric acid and the alkaline properties of the potass are two forces or properties which are *antagonistic,* the one of which can only predominate at the expense of the other.

4th. In conformity with this manner of considering the acid and the alkaline properties in the preceding example, I regard two coloured lights which produce by their mutual combination

an uncoloured or white light as being antagonistic: thus, for example,—

Separate the red rays from a ray of white light, and the remaining rays appear to us green, slightly tinged with blue; reunite the red rays and the green rays tinged with blue, white light is reformed.

In this case I assert there is antagonism, because two things that affect us differently as *colour*, the red rays and the bluish green rays, when united no longer affect us as such, but as *white*.

Materials coloured green, red, yellow, violet, blue, orange, &c., which by their mixture produce black or grey, also present, on account of the disappearance of their colour, an example of antagonism.

(969.) Further, I assert that *antagonism exists whenever two activities, or in other words, two causes of different effects, being opposed to each other, are mutually balanced in such a manner that the effects they produced in an isolated state, are no longer manifested after their reaction.*

It is in this that two antagonistic things differ from two things we compare under the relation of size, or of intensity of a property, a comparison that gives for result, when there is no equality, a difference in the size or in the intensity of that property.

(970.) From the distinction we have made, contrast of colour, considered under the most general point of view, that is to say, as presenting *contrast of tone and contrast of colour properly so called* (8.), is itself composed of two contrasts:

1°. *Of a contrast of simple difference;* That of tone. In fact, the lightest object augments brightness, as the deepest destroys it.

2°. *Of a contrast of antagonism.* In fact, the modification of two juxtaposed colours, arising from the addition of the complementary of the one to the colour of the other, is really that which can make the two colours widely different, since this addition appears, according to the remarks already made, to take away from the one what it may contain of the other (8.).

(971.) Finally, in successive contrast, simple difference of contrast and contrast of antagonism may exist, as in simultaneous contrast, because

1°. The eye which has first seen a light part $o$ by the side of a dark part $o'$, sees at the second view when it has ceased to regard the whole of the two parts $o$ and $o'$, the image $o$ darker than the image $o'$.

2°. The eye looking first at a body of a certain colour, sees at a second glance, after having abstained from regarding it, an image which is of the complementary or antagonistic colour to that which is really the colour of the body.

(972.) Having brought things to this point, it is evident that, in order to treat the question to which this paragraph is devoted with all the clearness in our power, it is necessary to find out if the hearing, taste, and smell are subject to a contrast of antagonism or to one of difference, and if the contrasts that may affect them are simultaneous and successive. By neglecting to subordinate the subject to these distinctions, I should certainly expose myself to the reproach of obscurity, which would have its cause in the confusion I have pointed out in tracing the critical *résumé* of the history of the works on *accidental colours* (80. and 941.).

## Of Hearing.

(973.) Hearing is the sense which passes as having the greatest affinity with sight; for every one knows the comparison that has been instituted between sounds and colours, not only when considered as sensation, but also when it has been sought to explain their propagation by the wave theory.

### *Comparison between Sounds and Colours.*

(974.) Although I am far from disregarding the relation of colours with sounds when it is a question of their acting on our organs, and of the infinite sensations resulting from their mixture and from their co-existence; although I feel great pleasure at the sight of beautiful colours even when by their delineation they do not recall any determinate object, and when they only affect us by their beauty and splendour; although I have arranged them in various harmonies, and indicated the means of analysing by a sort of reading those which compose a picture, nevertheless I avow that I cannot perceive those close affinities that several authors, particularly Castel, have said they perceive between sounds and colours. I am ignorant what the future may bring forth, relative to the analogy the senses they respectively affect might present from the point of

view of the different kinds of contrasts that take place in vision; but at the present time the marked difference between sounds and colours strikes me much more than their generic resemblance.

(975.) The first difference that I remark between the sensations of hearing and seeing, is the existence of sound as a special thing, whether language or music. It is not only in spoken language or in music executed by the voice or by instruments that this existence is evident, but it is, moreover, in the written sentence and in the notation of music; in fact, sounds expressing the words in conversation and sounds marked by musical signs fix themselves in the memory; the speech, the song and the instruments reproduce them, if not always identical, at least so as to preserve their principal relations. Finally, What is it that gives to these sounds a significance, a real value? In speech it is the succession of words composing the phrase; in music, melody is nothing more than a succession of varied sounds; and harmony presenting the co-existence of several concords, signifying really something like music only by the sounds that have preceded or by those that are to follow it; in a word, I find the essential character of sounds *significant* in their succession, and in the faculty we possess of recalling and reproducing them according to that order of succession, either when they concern speech or music.

(976.) Have colours a special existence similar to that remarked in sounds? I do not believe they have, at least for the generality of men: for if it is true that we can see colours without material forms, so to speak, for example those of a ray of solar light dispersed by the prism and reflected by a white surface, nevertheless, nearly every one confounds colours with the objects exhibiting them; and it is correct to say that they only appear to them as dependent on a material form since, far from being seen exclusively of these objects, they are, on the contrary, fixed by them as one of their essential qualities, so that if their memory preserves the recollection of the colours, these latter are always connected with the form of some material object.

(977.) If we now examine the impressions of colours under the relations of *succession* and *simultaneity*, the first of which relations corresponds to the melody and the second to the harmony of sounds, it will be evident that we shall not find in the sight of a succession of colours assorted according to the laws of simultaneous, successive, or mixed contrasts, anything

that can be justly compared to the pleasure we receive from a melodious succession of sounds; in fine, we are not possessed of the same faculty for retaining a succession of colours as for retaining a succession of sounds. If we consider the simultaneous view of colours assorted conformably to the rules of contrast, it is evident, from what has been said, that it will be the case of the greatest analogy between colours and sounds, because in fact, in the pleasure caused by colours happily associated there is something comparable to what we call a concord of harmonious sounds; with this difference, however, that the former pleasure is of a nature to be more prolonged than the latter; for it is well known that the eye can contemplate the various colours of a picture, without experiencing a feeling of monotony, for a much longer time than the ear is capable of ssutaining the pleasure of an harmonious concord of the same sounds prolonged without variation. It must be remembered that in every case in which most persons are agreeably affected by the sight of associated colours, these colours address them through the form they have clothed.

(978.) Finally, sounds, at least for the generality of men, have a special existence, which colours have not. *Succession* is particularly essential to the pleasure of musical sounds and to the signification of the sounds of speech, as *simultaneity* in associated colours, which requires some time to be felt, is essential to the pleasure we receive through the medium of sight.

### *Is there a Contrast of Difference in Sounds?*

(979.) Are there contrasts of difference in sounds? and, if there are, are they simultaneous? are they successive? I raise these questions less for resolving them, than with the intention of indicating the characteristics of these contrasts and the elements of knowledge we must possess in order to prove their existence.

(980.) If it is true that a very loud sound prevents our hearing a weak sound which we should otherwise perceive were it alone to reach the ear, if this effect exactly corresponds to that produced by a strong light when it obstructs our perception of a weak light, which, however, we should see very distinctly, if it was isolated from the other; finally, if these two effects may be observed without the loud sound, or the strong light offending the organ they respectively affect, nevertheless the first fact does not necessarily demonstrate the existence of a simultaneous

contrast of difference between two sounds which would be analogous to the simultaneous contrast of tone in two colours. It is then only by the law of continuity that we can really deduce it, by admitting that the phenomenon is one of the extreme cases* of a contrast of difference between two effects, the lesser of which disappears before the greater, as that which occurs when a small object, placed near a greater, ceases to be perceptible from the fact of this very proximity (966.).

(981.) But to demonstrate the existence of a contrast of difference between simultaneous sounds, corresponding to the contrast we perceive at the sight of two colours of different tones, it is necessary to prove by experiment, that in the simultaneous perception of a flat sound and of a sharp sound, the former appears flatter, and the second sharper than they would appear if they differed less from each other. Now it is precisely this contrast between the two sounds that we are unable to prove by the fact quoted (980.), that a loud sound prevents us from hearing a weak one, since perceiving then only a single sound, we are unable to compare it with that which we do not perceive.

(982.) If we pass to the question concerning the existence of a contrast of difference between two successive sounds, we shall still find that the weak sound succeeding a loud sound, is not heard, the same as a weak light is not sensible to the eye which has received the impression of a strong light. To absolutely establish the existence of a successive contrast of difference between two sounds, it is necessary to show by experiment that the difference is greater between two sounds perceived successively, than if the sounds were nearly simultaneous.

### *Is there a Contrast of Antagonism in Sounds?*

(983.) We cannot now form any idea of a difference which would arise in sounds from an antagonism of some one of their individual properties, for, in reality, we know of nothing in them that corresponds to white light and to mutually complementary coloured lights. In the actual state of our know-

---

* I say *one of extreme ca s* nd not *the extreme case*, because the extreme case is that where the organ is vividly disturbed, as happens when we are near a cannon fired off,— when we fix our eyes upon a highly luminous body, the sun, for instance. These circumstances place the organ in a truly abnormal position, in respect to the state in which it should be to receive and appreciate an impression from external things.

ledge we cannot then imagine the antagonism between two sounds arriving simultaneously at the ear, only in conceiving them to be mutually destroyed: in admitting this result, we should have a product corresponding not to the white arising from the mixture of coloured solar rays mutually complementary, but to the black which may result from the mixture of coloured complementary materials (968.), and hence we should not see that which in hearing corresponds to the successive contrast of antagonism, in virtue of which the sufficiently prolonged sight of a colour determines the tendency to see, on a second view, the complementary of that colour.

## Of Taste and Smell.

(984.) I cannot apply the question of the existence of contrasts of taste and smell, without remarking the extreme difference that exists between these senses on the one part, and seeing and hearing on the other. In all the perceptions of the two former there is the contact of savoury and odorous bodies with the organ; that is to say, always a physical, and frequently a chemical action; while in the perception of colours and of sounds, there is never a chemical action; it is a simple impression that the eye receives from the light, — it is a simple vibration that the ear receives from the sonorous body. According to this I have arranged the properties we discover in bodies by the medium of taste and smell, amongst those that I call *organoleptics**, in order to distinguish the physical properties, amongst which I class all those that are not made known to us by the eye and the ear.

(985.) It is necessary not to forget that all I say of taste and smell only concerns the sensations we perceive through their medium, when these organs are in contact either with a single kind of savoury or odorous bodies, as marine salt, sugar, camphor, &c., or with several of these sorts at the same time; but in this instance I shall always suppose that the mixed kinds have no mutual chemical action, and when savoury bodies are in question, these latter are not odorous.†

---

* See M. CHEVREUL's *Considérations générales sur l'analyse organique et ses applications*, 1 volume 8vo., Levrault, 1824 (pages 31 and 42.).
† Idem (page 45 and following).

### Is there a Contrast of Difference in Taste?

(986.) If we accept as proof of the contrast of difference the non-perception of a weak light or a weak sound, resulting from the effect of a strong light or an intense sound, either in the case of simultaneity or of succession, we shall be led to admit of a contrast of difference for taste, either simultaneous or successive; for it is well known that a strong flavour is opposed to the perception of a weak flavour, in the case of simultaneity, as in the case of succession; and in both cases the effect may take place without the organ leaving the normal state; for example, a strong salt flavour prevents the perception of a sweet flavour which would be perceived in the absence of the first; strongly sugared water renders insensible the flavour of a slightly sugared water drunk after it.

(987.) But if the analogy of the preceding facts with those which relate to the senses of seeing and hearing is evident, we must own that in our day we know of none that correspond to the contrast of difference, in virtue of which two tones of the same scale of colour appear to the eye more different than they really are. To establish this correspondence, it is necessary that we should demonstrate, in the case of simultaneity, that two flavours, proceeding from two matters differing in taste, placed on distinct parts of the tongue, differ more than they would if they proceeded from matters differing less in taste. Finally, in the case of succession, it is necessary to show, that two flavours perceived successively would present more difference than if they had been perceived separately, supposing that we are able to retain for some time the recollection of the first flavour.

(988.) Experiments on the contrast of difference of flavours ought to be made:

1°. With the same kind of flavoured substance taken in different quantities;

2°. With two different bodies having the same generic flavour, as cane-sugar, grape-sugar, manna;

3°. With bodies possessed of different flavours, such as sugar, marine salt, citric acid, &c.

### Is there a Contrast of Antagonism in Taste?

(989.) Knowing nothing that bears a resemblance to antagonism in the sensations of taste, we cannot cite any fact suitable

to exhibit either a simultaneous or successive contrast of antagonism in flavours.

## Of Smell.

(990.) All that I have said on the contrast of taste is applicable to the contrasts of smell: we can, by analogy, admit of a contrast of difference, either simultaneous or successive, for odours, but nothing corresponds in the perceptions we receive from it to the contrast of antagonism.

### Conclusion of this Section.

(991.) It follows from what I have said in this section,

1°. That the senses of seeing, hearing, smell, and, I may add, the sense of touch, all present, as I have before remarked, the phenomenon of not recognising a weak impression which is received at the same time as a much stronger one.

2°. That the result is the same when the weak impression immediately, or almost immediately, succeeds the strong one.

3°. That the two preceding phenomena may be observed when the strongest impression does not sufficiently disturb the organ experiencing them, as to admit of our considering the latter as being in an abnormal state.

4°. That if we can deduce these phenomena of a contrast of difference, nevertheless we must own that it will be difficult to quote results from experiments adapted to show clearly that in the simultaneous or successive perception of two sounds, two flavours, and two odours, we remark between the two sensations a greater difference than we should detect if the two sounds, flavours, and odours were less different from each other.

5°. That at the present time we have no idea of what a contrast of antagonism in the perception of sounds, flavours, and odours may be.

(992.) We have seen how the study of the contrasts of sight diffuses a light on the history of the other senses. In insisting on the differences of sounds and colours, I believe them to be based on truth; but my readers deceive themselves if they think I believe that ulterior studies would add more to the

differences I have remarked between sight on the one part, and hearing, smell, and taste on the other. In speaking of these differences, my intention has been to show clearly that in the present state of our knowledge we have no actual experimental proof which establishes that hearing, smell, and taste, are submitted to simultaneous and successive contrasts corresponding to the contrasts of difference and antagonism which exist in the phenomena of the sight of white, black, and coloured bodies; it does not signify if future researches cannot demonstrate the existence of these affinities: besides, if I did not fear to go in advance of the result of experiments which, although commenced more than twenty years since*, are still far from being terminated, I would say that I should be more disposed to admit affinities than to reject them (974.).

§ 4.

THE LIGHT WHICH THE STUDY OF CONTRAST APPEARS TO ME SUSCEPTIBLE OF SHEDDING UPON SEVERAL OTHER PHENOMENA OF THE UNDERSTANDING.

(993.) If it is difficult, at the present day, to experimentally demonstrate that in hearing, tasting, and smelling, there exist definite contrasts of as precise a nature as the various contrasts affecting us through the organ of sight,—yet the examination of these latter, in giving the first experimental proof of this fact, that *two different objects, placed side by side, appear by the comparison more different than they really are*, and in placing in its proper aspect a phenomenon generally spoken of under the name of contrast of colours, without knowing either its extent or its importance,—seems to me adapted to throw a light on the study of several of the operations of the human mind.

In fact, when certain persons regard two objects under a relation of difference, does it not happen that the difference exaggerates itself, so to speak, unknown to them, precisely as it happens in regarding two juxtaposed colours, in which all that is analogous between the two colours disappears in a greater or less degree? Does it not happen that these persons, but little

---

* This was written in 1838.

accustomed to reflect on the operations of the mind, give themselves up to the judgment they first brought to bear, always retaining some inexact ideas which they would have been able to rectify, in considering objects under new relations adapted to control their first opinion? Are they not in the position of one who, having concluded, at first sight, that a difference of $1\frac{8}{100}$ yards exists between a measure of one yard placed beside a measure of two yards, preserves that opinion in his memory as correct, because, ignorant of the effect of contrast of size (965. 966.), nothing can make him feel the necessity of having recourse to a counter-proof to rectify his judgment, as he would have been led to make had he possessed that knowledge, and moreover, he had felt the necessity for some motive of having exactly the difference of length of the two measures, for then he would have had recourse to measurement.

This example is very well adapted to the comprehension of my ideas respecting the inexactitude of a great number of opinions brought to bear upon certain objects which we compare in respect to qualities, properties, and attributes we have not measured.

### (a.) *Operations of the Mind corresponding to the Contrast of simultaneous Difference.*

(994.) The inaccuracy of judgment in question, consisting in the exaggeration of a difference between two objects compared, enters into the contrast of simultaneous difference, whenever the qualities, properties, and attributes we compare, belong to objects before our eyes, or rather to objects more or less remote, in space or time, and then our opinions bear on the notions that memory recalls to us or tradition has transmitted.

### (b.) *Operations of the Mind corresponding to the Contrast of successive Difference.*

(995.) I am about to examine those mental operations which appear to me to correspond to the contrast of successive difference, because they refer to a comparison established between two objects seen in succession, or between an opinion at present maintained, and a contrary opinion held at some previous period.

(996.) A man easily susceptible of receiving impressions, who travels through a country for the first time, is much disposed to form exaggerated notions, because he is most struck with the differences between the objects he now sees and those which have been presented to him previously in the country where he has long resided. The best method of correcting his judgment, is to revisit in succession the objects compared, and to bestow particular attention upon those qualities which have struck him the most forcibly, that he may regulate his first impression by newly-formed opinions.

(997.) Finally, is not our disposition of mind with regard to an opinion that is entirely abandoned for another, remarkable for this,— that we almost always form an exaggerated judgment of the opinion we have abandoned in the sense least favourable to it, and that hence the mind gives way to an exaggeration of the difference?

*Influence exercised by the Condition of our Organs upon many Operations of the Understanding.*

(998.) In reflecting upon the condition of our organs under three circumstances, as follows,—

1°. When the difference produced by the simultaneous contrast of two tints is carried to its maximum;

2°. When a small object ceases to be perceptible on account of its proximity with a larger;

3°. When in looking at an object, which however is not very complex, we perceive in a given time, only a small number of relations under which it can be presented to the attention of most persons,—

I have been led to explain to myself clearly the case in which our mind, when certain ideas have become more familiar to it than others, is led to regard the former to the exclusion of the latter.

(*a.*) When the mind is at work in solitude upon a subject.

(*b.*) When a discussion is entered into by two persons.

Let us examine these two conditions.

### (*a.*) *Works executed in Solitude.*

(999.) A mind constantly occupied in seizing only upon the differences between objects, acquires by this very act a dispo-

sition, I will not say to set aside resemblances or analogies between one thing and another, but *a disposition not to perceive them;* while, on the other hand, a man who sets up to establish a broad generality — a so-called universal principle, limiting the examination of the most complex things to a few relations only,— seems *not to perceive a variety of phenomena visible to all those who are moved by a desire to enter into a conscientious and satisfactory investigation of these things.* If the first does not see that the brightest conquest of the human mind in its search after truth, is the discovery of generalities, the second is equally blind to the fact that it is after careful study of details, and consequently after the appreciation of facts widely differing, that we arrive at generalities and at principles, and that the quality of exactitude in these is found in the explanation itself of the variety of phenomena to which these principles refer.

(1000.) When certain ideas have so completely occupied the attention as to become familiar, the brain is so much the more strongly disposed to receive impressions from without which recall the thoughts to these ideas, according as they have been more profound and their mutual connection closer; that as soon as a matter which enters essentially into this system of ideas is presented to the mind under a familiar aspect, the new matter will forthwith be classed in the system; while, should it be presented under an unfamiliar aspect, its classification is delayed, because an ulterior operation is necessary to co-ordinate the new notion with the old ones.

### (b.) *Discussion between two Persons.*

(1001.) The difficulty of inserting in a system of ideas certain matters presented for the first time to the mind, or which, having been previously presented, have not been considered of sufficient importance to be co-ordinated with others, which subsequently have composed a body of opinions, explains the following facts.

(1002.) 1*st Fact.* Two able minds are occupied on a subject, but with this difference, that one applies a system of ideas acquired after long meditation, while the only object of the other is simple inquiry. Now, suppose that in the course of a discussion between them upon this subject, there is presented a new fact capable of being connected thereto by some relation, I say that it may happen, according to the aspect under which this fact is presented, that the former of the disputants may see its

relation to the matter in question less promptly and easily than the latter; this is not going so far as to say, that later reflection may not produce changes in the impression the first mind received at the outset, and that it will not appreciate the importance of the new fact for throwing light upon the subject.

(1003.) *2nd Fact.* Two persons are discussing without auditors; no passion excites them, they are animated solely by the desire of ascertaining the truth on a subject, be it scientific or literary, which is of a nature to divide opinions; after a longer or shorter discussion they separate, neither having yielded a point to the other. I admit, in accordance with the common opinion, that such is the ordinary result of discussions; but under the supposition that I have raised, and provided the discussion has been sufficiently prolonged between two conscientious and enlightened persons, 'I admit that there is *in general* a mutual reaction, and that sooner or later, the opinions held by each person before the discussion will be more or less modified.

(1004.) *3rd Fact.* It is possible for two superior minds, not only not to act upon each other in a prolonged discussion, but, moreover, for the reflection following upon the discussion not to produce any modifications in their opinions, because the ideas of each may be so co-ordinated that it is not possible to intercalate a fact capable of modifying that co-ordination; and more than this, a synthetic mind is less disposed to entertain a fact which forms part of a system of ideas different from its own, when the argument emanates from another synthetic mind, than if that fact was presented to it isolated, or if the argument emanated from some one who had no system to defend.

(1005.) In all that precedes, I have presumed that *passion* exercises no influence; if it did, it is evident that the difficulty of arriving at a mutual understanding would be greater.

---

(1006.) The examples I have cited appertain to the case in which the influence of co-ordinated ideas prevents the mind receiving new notions; I have now to speak of the case in which a mind, after having been long occupied with a subject, suddenly and for the first time perceives, either in the course of discussion or as a consequence of its own reflections, a fact which strikes it so forcibly, as to cause it to pass suddenly from one mode of viewing to another more or less opposite; it is then especially that it is liable to be led astray by the impor-

tance it attaches to a newly-formed opinion relatively to one that has been abandoned (997.); this case, far from being opposed to my views, is only an extension of them.

*Inconveniences in oral or written Teaching which may arise from the Opposition established between two Facts.*

(1007.) There would be a void in the exposition of my views on the extension which the study of contrast appears to me to be susceptible of, if I did not add some remarks applicable to the result which may follow from a teaching in which, while proceeding specially by placing two facts in opposition, the differences only which they exhibit is insisted on without regard to their essential analogies. If such teaching is easier for the professor, and more accessible to most understandings, because it gives more saliency to a very small number of facts, it has, in my opinion, the objection of greatly exaggerating the differences which actually exist between the objects compared; or, which comes to the same thing, of leading to a belief, or to a tendency to believe, that differences have an importance in the distinguishing of these objects which, in truth, they are far from possessing. When a professor in a lecture, or an author in a book, brings forward two different opinions, or two hypotheses, or advances two propositions, it may happen that they will, for the sake of greater clearness, insist upon an opposition, while they omit the analogies that may restrain within its true limits the two terms of the comparison. From this mode of proceeding may result not only an exaggeration of difference, but also a notion altogether incorrect, if, for example, the two terms of the comparison being two propositions, they should be presented to the auditor or reader as altogether opposed, so that if one be true, the other must of necessity be false; whilst to be exact, the boundary which circumscribes each circle within whose limits the truth is, should be traced.

(1008.) When we study several object so as to know them thoroughly, there is every advantage in viewing them in the order of greatest mutual resemblance, instead of placing them in opposition to each other, for the purpose of distinguishing them. Perhaps we cannot insist too strongly upon declaring that, in the study of organised beings, the advantage of the *natural method* over *classifications* or *methods called artificial* belongs, in a great measure, to the exactness the former gives to the mind, in essentially presenting to it an *ensemble* of beings according to their mutual resemblances, whilst the artifical

classifications have for their special aim the distinguishing these beings from each other, and of finding the specific name of each; it proceeds, moreover, in presenting them to the student by the characteristics in which they differ the most. Hence he who habitually employs the artificial method will never obtain a precise idea of the objects he wishes to know, if he neglects to consider them conformably to the order of subordination prescribed by the natural method; and, further, if he does not devote himself at an early period to the study of this latter, the habitual use of the artificial method will render it extremely difficult for him to appreciate the real value of the relations that exist between them (999.). Finally, still in conformity with my ideas, instruction based on the natural method will be more or less exact, according to the manner in which the professor presents the analogies which combine several beings in the same group, and the differences which distinguish them in various groups.

SUMMARY AND CONCLUSION OF THIS SECTION.

(1009.) 1°. If I am under no illusion in the comparison established between objects considered under the relations we do not take into account, there may frequently be an exaggeration of the difference that really distinguishes them, especially if we have already, before establishing the comparison, some tendency to see this difference, and if we do not recur to it after having established all means of controlling the judgment that immediately results from a first comparison. I conclude, then, that a control exercised with this intention is necessary to a severe mind which seeks out every possible means of seeing the differences existing between the objects it compares, such as they are in relation to the most rigorous judgment that we are able to bring to bear on them; for the man with exceedingly limited faculties cannot flatter himself that he knows the absolute truth of things.

2°. I think that, in opinions where exaggerations of a difference exist, the organs that contribute to these operations of the mind find themselves in a physical state corresponding to that of the organs which are affected in the phenomena of the simultaneous contrast of view; so that it is difficult, whilst this state continues, to perceive ideas differing from those to which this state relates. The consequences deduced from this are, that

every sound mind that is brought to perceive a relation of non-appreciable difference between objects ought, before retaining them in their thoughts as an exactly correctly limited fact, to be careful that the brain is brought into a state that will permit it to control the fact, by calmly submitting it to a verification directed from points of view differing from that in which it was when it first fixed his attention.

(1010.) In the case in which we do not admit the relationship I seek to establish between the physical state of the brain, when on the one hand we compare two objects by the affinities of their abstract qualities, and on the other when we perceive the impressions that give rise to the phenomena of contrasts of vision, it seems to me that we should not refuse to acknowledge that, in summing up this relationship in these words, *the brain perceives and judges ideas as it judges colours which it perceives by the medium of the eye*, we establish a *comparison* which, by simply attaching value to it as a *figure of rhetoric* suited to enliven some part of a discourse, is not without utility for the light it is susceptible of throwing on the understanding.

It is then to simplify this study that I now consider contrast as *simple comparison;* either when we see two differently coloured monochromous objects, or when a greater number are before our eyes, we can only perceive at one time some of the affinities, instead of the whole, which it would be indispensable to see in order to arrive at a complete and perfect knowledge of these objects.

1°. The well-established fact that red, isolated, appears differently than when it is juxtaposed with a white, black, blue, or yellow surface, and that under these circumstances five *identical* red patterns would appear five *different* patterns; is important as a limit of comparison fitted to show clearly how the same object may give rise to different opinions among those who judge in an absolute manner, without regard to the possible influence of some relative circumstance. We here suppose the opinions are the result of the comparisons of coloured patterns with the tones found in the *chromatic diagram* (159.). The fact in question is applicable to many cases. I will cite two as examples.

(*a.*) A person, ignorant of the effects of the juxtaposition of colours, judging that the five red patterns are different, although really identical, presents an example of the circumspection it is necessary to exercise in the opinions formed of compared objects slightly differing from each other, and which are not observed under the same conditions.

(*b.*) Five persons know that the same red has been placed in the five conditions indicated, but are ignorant of the influence of juxtaposition, and, consequently, of the influence of these conditions: they have each seen only one of the five patterns; a discussion arises on the optical quality of this red: if the one that has seen the isolated pattern says, that it remains as he first saw it, the four others will say that the red, after having been placed in one of the prescribed conditions, does not seem as it did before; but they will not agree when they come to decide upon the kind of modification which the red has experienced; the person who has seen the red juxtaposed with black will maintain that the tone is lowered, whilst he who has observed it juxtaposed with white will, on the contrary, maintain, that the tone is heightened, but both of them will agree in asserting that the red has not gone out of its scale; an opinion which the two last will combat, who, having viewed the red in juxtaposition with yellow and blue, have seen it go out of the scale to which it belonged before it was placed in this latter position; but of the two latter the one who has seen it near the yellow will assert that it possesses a violet hue, whilst, on the contrary, he who has seen it juxtaposed with the blue will maintain that it is tinged with orange. The five persons who have each seen the same red in a different condition of juxtaposition *are right in declaring, that they see it in such a manner, and each has cause for maintaining his opinion; but he is evidently wrong, if he pretends that the others ought to see the red as he himself does.*

The conclusion to be deduced from this, is, that in a *bonâ fide* discussion, in which neither interest nor conceit bears a part, if we wish to arrive at an exact conclusion, it is first necessary to know the principles on which each supports his reasonings, the terms of comparison that enter into each opinion, and, finally, to ascertain if we really view the object of discussion from the same point.

Another result to be deduced from the preceding fact is, that when we must believe in the interference of passion in an opinion differing from our own, by regarding it closely, we may find that there is only a simple difference of position. After that, in many cases where we have been led to assign a less honourable motive to an opinion or action, it is probable that we shall be nearer to justice and truth by interpreting these things with indulgence rather than with severity.

2°. In considering that the eye sees at one time only a small number of objects that compose a whole, when it desires to penetrate into the details of that whole (748.), and that several individuals are able to see the same part differently modified

because they see them in connection with different parts (483.) —in considering, finally, that these differences in the modifications of the same part may be observed by the same individual (499.),—we are led to acquire a clear idea of the manner in which the human mind proceeds in the study of nature. In fact, we see, first, how man, wanting in power to embrace the whole of the objects with which he wishes to be thoroughly acquainted, is forced to have recourse to analysis; how that, by not fixing his attention upon one fact at a time, he can only arrive at his aim by successive efforts, after having studied piece by piece each element of the whole he examines. If we now consider that the human mind is composed of the minds of all,— that the edifice of science it has raised up is the product of the efforts of minds which, far from being identical, present the same differences as the forms of the bodies they animate,—we shall then comprehend how the various minds that study the same subject consider it under extremely different relations, when the fact that will strike each of them in particular will not be identical, because their diversity of nature is an obstacle to their being equally accessible to the same fact; it will then be the thing which strikes them the most that they will examine; but superior minds will distinguish themselves above others, because they will bring their meditations to bear on facts which, considering the epoch in which their minds labour, it will be more important and more essential for the advancement of human knowledge to know.

If the faculty of reasoning, in order to discover the relations of the phenomena which strike us,—if the faculty we possess of communicating the discovery of these relations to our fellow-creatures distinguishes us from the animals properly so called,— lastly, if to attain this end we make so extensive a use of the *faculty of abstraction,*—it is nevertheless important to remark that this necessity man has for decomposing a whole into its elements in order to understand it is a token of the feebleness of his nature, and that this feebleness is revealed in all the results of his analysis, because it has not yet been permitted to an individual, nor to his contemporaries, to make a complete analysis of any object out of pure mathematics; for the desire which leads man to study nature leads him always, or almost always, to extend the results of his investigations beyond the boundary where he must stop in order not to pass beyond the limits traced by rigorous reasoning.

<center>THE END.</center>

CPSIA information can be obtained
at www.ICGtesting.com
Printed in the USA
LVHW020024170720
660847LV00008B/164